Cultural Democracy

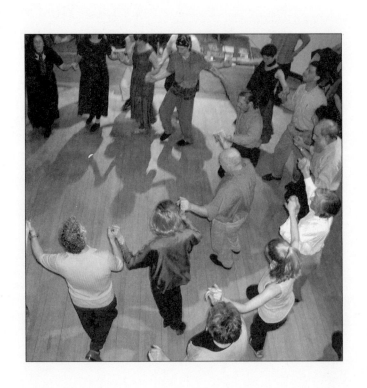

Cultural Democracy

The Arts, Community, and the
Public Purpose

James Bau Graves

University of Illinois Press
Urbana and Chicago

© 2005 by the Board of Trustees
of the University of Illinois
All rights reserved
Manufactured in the United States
of America
1 2 3 4 5 C P 5 4 3 2 1

∞ This book is printed on acid-free paper.

Library of Congress
Cataloging-in-Publication Data
Graves, James Bau, 1952–
Cultural democracy : the arts,
community, and the public purpose /
James Bau Graves.
p. cm.
Includes bibliographical references
and index.
ISBN 0-252-02965-8 (cloth : alk. paper)
ISBN 0-252-07208-1 (pbk. : alk. paper)
1. United States—Social life and customs—
1971–2. Arts and society—United States.
3. Arts, American. I. Title: Arts,
community, and the public purpose.
II. Title.
E169.04.G739 2004
306.4'7'0973—dc22 2004008912

Frontispiece and title page photos by
Phyllis O'Neill.

We have learned to say that the good must be extended to all of society before it can be held secure by any one person or any one class; but we have not yet learned to add to that statement, that unless all men and all classes contribute to a good, we cannot even be sure that it is worth having.

—Jane Addams, *Democracy and Social Ethics,* 1913

Right now our boom industry is security . . . because the lines of communication have been shut, and somebody, in order to get your attention, has to plant a car bomb—in *your* car. What would it mean if those lines of communication were open? If violence was not the only alternative that most people felt they had? What would it mean if those lines of communication permitted difficult things to be said, with art, with care, with grace, with intelligence—and with reciprocity, communication moving in both directions? That's what artists are here for. We are here to defuse the car bombs. And America is about the democracy that allows both voices—all ten voices, all twenty voices—to be heard.

—Peter Sellars, *Marketplace* radio commentary, 2003

Contents

Appreciation

This book reflects the prolonged engagement of hundreds of artists, community activists, nonprofit administrators, foundation directors, and scholars in an ongoing experiment in making culture meaningful for ordinary citizens. Any lesson that I've presented in these pages was gained through the work that I have shared with all of these collaborators. My energetic and thoughtful partners have taken a handful of ideas cooked-up over a couple cups of coffee, and through their commitment, spirit, and artistry turned them into reality. Their partnerships have provided the most continually surprising and satisfying moments of my career in public culture, and their contributions to this text are manifest. To all of you, thank you! And I look forward with pleasure to continuing the conversation.

The Center for Cultural Exchange has been my employer for nineteen years, during which all of the ideas presented here were tested. I am indebted to the Center and its Board of Directors for their experimental approach to the fulfillment of our mission, a pervasive attitude that has allowed staff to pursue many projects that must have occasionally raised eyebrows. This book could not have been written without an extended

Audience at a gospel performance. Photo by Tonee Harbert.

leave of absence that the board granted to me in the winter and spring of 2002, and for which I remain extremely grateful.

Portions of this book are extracted and modified from several previous publications, and I thank all of the original publishers. Several quotations in the text are drawn from interviews that I conducted with cultural leaders or from our recollected discussions. For their candid comments and permission to use this material, I thank Guy Bouchard, fiddler extraordinaire; Robert Browning, executive director of the World Music Institute; Hal Cannon, founding director of the Western Folklife Center; Dudley Cocke, artistic director of Roadside Theater at Appalshop; Burt Feintuch, director of the Center for the Humanities at the University of New Hampshire; Dan Sheehy, former director of the Traditional Arts Program at the National Endowment for the Arts and currently director of Smithsonian Folkways; Nick Spitzer, former producer of the Folk Masters Series at Wolf Trap and Carnegie Hall and current host of *American Routes* on Public Radio International; Juan Tejeda, former Xicano music director at the Guadeloupe Cultural Arts Center; Jeff Titon, director of the Ethnomusicology Program at Brown University; and Joe Wilson, executive director of the National Council for the Traditional Arts.

Photographers whose work appears in these pages include Tonee Harbert, Phyllis O'Neill, Jim Daniels, and Rosemary Siciliano. I deeply appreciate their permission to use their work in this book. Thank you to James Clifford, and to the Rand Corporation of Santa Monica, California, for permitting use of their figures.

Several colleagues have taken the time to reflect on portions of this manuscript during its long gestation. I especially thank Holly Sidford, Adrienne Southgate, Tom Borrup, and Erica Quinn-Easter for their penetrating suggestions, corrections, and encouragement. David Locke at Tufts University offered a careful critique of early drafts of several chapters. Judy McCulloh, my editor at the University of Illinois Press, was enormously helpful, both in her critique of the work and in her steady guidance of my passage through the system of publication. The contributions of copy editor Angela Burton and designer Dennis Roberts are present on every page. I owe them an enormous debt of gratitude: thank you!

For twenty years, Phyllis O'Neill has been my professional partner. Our journey of discovery in the field of community culture has been, from the outset, a joint endeavor. Our work has been so densely collaborative that it is impossible to lay personal claim to any part of it. Phyllis's insights and intelligence have shaped every aspect of the Center for Cultural Ex-

change's programs; indeed, the Center owes its existence to her vision and persistence. If there is some wisdom in these pages, she deserves the lioness's share of the credit; the errors and omissions are all mine.

Phyllis O'Neill is also an incisive and insightful editor. Her many thoughtful questions have shaped virtually every page of this manuscript, and I am grateful for her willingness to risk confrontations with a crabby author. Phyllis is also my spouse, and I thank her, and our children, Hannah and Guthrie, for their forbearance during the writing of this book. Their patience in dealing with a preoccupied husband and father is appreciated more than they can imagine.

Cultural Democracy

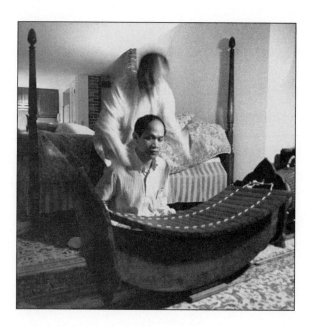

Introduction

"What does your community need to keep its culture vital and meaningful?"[1]

In 1994, I posed the question to a group of elders from Watt Samaki, a Cambodian Buddhist temple in Portland, Maine. We were seated on hundred-pound sacks of rice in the back room of an Asian grocery, sipping soy drinks and passing a paper plate of shrimp crackers. The group was agitated by what they viewed as the rapid deterioration of their community and troubled by a sense of isolation from the local mainstream. They were also a little mystified as to why a white bureaucrat was concerned about their problems, and dubious about the prospects for any action. But I had suggested that there might be some money involved, so they'd agreed to the meeting.

In the decade following the U.S. defeat in Indochina, thousands of Southeast Asian refugees were resettled in cities throughout the United States. Portland was a typical destination: a small city with a dominant European American culture, but a relatively liberal attitude regarding

Master musician Ngek Chum instructs Pirun Sen on the roneat. Photo by Jim Daniels.

diversity. Portland viewed itself as a welcoming new home, a place where refugees could settle into the community and build new lives for themselves. Within a few years, thousands of Cambodian and Vietnamese newcomers had established the largest Asian enclave in the state. They were followed by new waves of refugees from Afghanistan, Russia, several African nations, and Bosnia. But by the early 1990s, even as the pace of refugee resettlement accelerated, Portland's Asian communities had entered a state of crisis. Things hadn't turned out quite as expected: white anti-immigrant backlash had created a series of ugly incidents; parents were alarmed at the directions their children seemed to be headed; and families were choosing to move away.

Asian culture in Portland, fragile to begin with, was breaking down. The Vietnamese and Cambodians were striving to make a place for their families. Many of them worked two or even three jobs to get out of the subsidized housing projects and into American-style prosperity—exactly as generations of immigrants had done before them. Finding prosperity wasn't the problem. Existing social services offered basic English instruction and job training, and in-school English as a Second Language (ESL) education for their children. But access to the welfare state wasn't their problem. They had lost their roots. The loss of their culture, and the subsequent disintegration of their communities' sense of cohesion, was the problem.

The question "What does your community need to keep its culture vital and meaningful?" elicited blank stares from the assembled elders. Most of us are not accustomed to contemplating such questions. Few people devote much time to ruminating on what our culture even *is,* much less prescribing what it might need to keep itself healthy. I tried a different tack. "Name the things that you and your grandparents know and care about— that twenty-five years from now nobody will remember any more."

This was more successful. "Our language" was the quick response. "Our children all speak Khmer around the house, but they can't read or write. If our language disappears, our culture will surely follow." A chorus of assent.

"The soul of Cambodia is etched onto the walls of Angkor," said another elder. "The celestial dances shown there are the most perfect embodiment of Cambodian heritage. But none of our children knows these dances. They have never seen them performed; they don't know what they look like. They're cut off from what it means to be Cambodian."

The meeting erupted into several intense discussions, all in Khmer and unintelligible to me. Occasionally, someone would offer a summary trans-

lation, usually reducing a long speech to something like, "He disagrees!" It was clear that, after fifteen years in Maine, this was the first time any public agency had posed the question of cultural assessment to the community's assembled leadership. My inquiry was the beginning of an explicit attempt to bring Cambodian culture into the public realm. To answer it, the elders had to focus their attention first on what it really means to be a Cambodian. What were the traits or practices that most profoundly shaped their identity? Only then could they begin to imagine how that vision could be supported.

I came to the discussion with the resources of an institution at my back, some experience about how to deploy and sustain them, and a willingness to listen. What I heard was that sustaining community culture is a long-term proposition. The Cambodians were disinterested in staging one big, splashy public event. They wanted something for their children to grow up relying on, something that would become a tangible and continuing presence in their lives. My job, if I was to avoid contributing to the general disillusion with American civic institutions, was to facilitate a consensus on the nature of the community's aspirations, and attempt to build a pathway to realization. If this was going to work, it would require a huge commitment of time and resources, and thoroughgoing, open-ended collaboration. "Okay," I said. "We're prepared to move forward in whatever directions you choose; and we'll continue to work with you for as long as the programs continue to generate positive results, and we can keep on raising the funds to make them possible." It was a beginning.

This book is a report card on American culture. Not the culture of Wal-Mart and the cineplex but culture as it is lived closer to the ground, local culture, neighborhood culture. It is about the kind of cultural activities that actually engage Americans, things people do, rather than passively consume. It is about making your own dinner, rather than going to McDonald's. It is about dancing, not about watching somebody else dance on television. There is a big difference.

My focus is on the choices that individuals make about how to shape the fabric of their lives, and about the mechanisms that make those choices available. Thomas Jefferson recognized the importance of "the pursuit of happiness" and enumerated it right up front along with life and liberty as the motive behind the American experiment. The cultures that we inherit, and the systems they support, play a fundamental role in the

narrowing or expansion of the array of choices that we have before us in that inalienable pursuit. And our decisions about how to conduct our lives in turn feed back into the next evolutionary cycle of our cultures.

Culture is important. People kill each other about it. Surely, Karl Marx and Adam Smith were correct: lots of wars get fought for reasons that are fundamentally economic. But just as surely, they were mistaken. Cultural clashes are frequently the dominant factors in the instigation of armed conflict. The prolonged state of violence between Israel and Palestine is enormously costly to both sides, but it persists because the cultural chasms are so wide. Agitation for a more equitable economic distribution may have contributed to the breakup of Yugoslavia, but culturally motivated tensions allowed for the "ethnic cleansing" of Bosnia and Kosovo. Basque, Québécois, and Timorese separatists surely believe they are getting a raw economic deal from their respective central governments, but it is their cultural identity that propels them toward independent nationality. Our cultures tell us who we are. Along with bread and freedom, that's what people are prepared to die for. "In the post–Cold War world," says political scientist Samuel Huntington, "the most important distinctions among peoples are not ideological, political, or economic. They are cultural."[2] The cultural choices we make are fundamental building blocks of the political world we inhabit and the legacies we leave to our children.

Culture is big business, too. Including a significant portion of global tourism, plus the arts and entertainment, music, and film, culture is the largest industry in the world, generating trillions of dollars in gross world product annually.[3] American culture exceeds all other sectors of the economy as our greatest export. Criminals, too, find wealth in culture. International smuggling of stolen objets d'art is exceeded in total value only by narcotics.[4]

Taken as a whole, and including the literary, media, and performing arts, America's culture industry is responsible for about 6 percent of our gross domestic product. That's substantially larger than the entire construction industry (4.8 percent of GDP) and on a par with all wholesale trade (6.9 percent of GDP). In the area of consumer spending, culture is even bigger, absorbing over 12 percent of Americans' after-tax income. Each year, the performing arts attract more people than all spectator sports combined.[5] Our culturally based decisions have far-reaching economic impact, particularly given U.S. dominance of world trade and finance. How we conduct ourselves culturally in Peoria has a ripple effect that is now global; anyone who has traveled outside the United States can verify this.

On a recent visit to Montreal, I happened to see a film at a big down-town shopping mall. I was surprised and slightly embarrassed that none of the dozen Hollywood movies were either dubbed into French or subtitled. Here I was in the Francophone capital of the New World, and nothing whatsoever had been done to accommodate the moviegoers' primary language. One can easily understand the concerns of separatists who fear for their culture's *survivance.*

But even more disturbing was the parade of images that flashed across the screen. The theater must have played trailers for every single film showing at their facility, all first-run American movies. Here was a real reason for a Yankee traveling abroad to feel embarrassed. Even in their souped-up come-ons, one blockbuster after another looked, well, stupid. Try it out at your local theater and see for yourself. We've all become inured to the sex and violence, but the vacuity of the cinematic content makes a bold statement about the status of contemporary American culture: it's boring.

Turn on the radio. Empty ear candy rules the airwaves. Overproduced mush from L.A. or Nashville carries so little content that the performers themselves can't formulate much of an identity and feel almost inter-changeable. Even the grungy so-called alternative music that tries to push against the bland amorphousness of the mainstream just ends up sounding like recycled punk: another big yawn. Most of *that* was pretty boring the first time around; do we really need additional helpings?

Or open the newspaper and check out the theater listings. You'll find the Great White Way dominated by reruns, or in some cases revivals of reruns. Apparently the smart money says we'd all rather be seeing the same familiar, reassuring shows our parents loved. Does the sunny world-view embodied in 1950s show biz still possess the power to dazzle? Can it have any conceivable resonance in our own very different zeitgeist? Or is it just filling a vacuum, standing in for the absence of compelling con-temporary voices?

Then there's the nonprofit cultural sector, the independent theaters, modern dance companies and performing arts centers, where a deaden-ing uniformity holds sway. I have had the opportunity of serving on grant-making panels for numerous large foundations and governmental enti-ties. They send you large notebooks full of applications from the leading arts organizations all over the country, dozens, sometimes hundreds, of proposals. The reading gets soporific very quickly because it is so difficult to distinguish one applicant from another. It's as though the entire country is generating its programming from a narrow, prescribed list of accept-able artists. It doesn't matter whether you live in Florida or Montana,

you're going to get the same, predictable, safe, politically correct performances you had last year, or the year before. Look over the season brochure from your local arts venue. You'll find nicely packaged multiculturalism—that has conveniently purged itself of any substantive encounters with another culture.

Even our avant-garde has grown stale and flabby. Experiments that held the excitement of creation three or four decades ago have turned to tedium. Dissonance still sounds dissonant. Minimalism has gotten even smaller. The shock value that once clung to all the old taboos—homosexuality, race, class, mental illness, mundane middle-class morality—evaporated long ago. Cross-dressing actors onstage talking about deviant sex plays in every small town now—daily on *Jerry Springer*. The generation of pioneering experimentalists that created a new American cultural elite is now either dead or very gray. They pushed the envelope pretty far, and in their wake, younger successors feel like the title of one of John Cage's famous works: *Cheap Imitation*.[6]

In the moment of triumph, as our country strides the globe as a colossus, American culture is putting the rest of the world to sleep, and our own creative impulses have gone into hibernation. The global commercial success of American popular entertainment should not obscure its artistic impoverishment. The fact that a billion people are watching reruns of *Seinfeld* tonight doesn't make the program any less idiotic. The *National Enquirer* supposedly has the largest circulation of any "newspaper" in the country, but that doesn't mean anybody takes it seriously as a source of news. Likewise, the international dominance of American mass culture says little about the health of our nation's creative arts. In fact, the least-common-denominator aesthetic that is presupposed by box-office triumph carries with it an obvious down side. Where hype and mindless spectacle are so richly rewarded, authentic artistry cannot find a toehold. Commercial success implies an enormous risk to artistic vitality, and our national culture has long since struck that Faustian bargain.

✧　✧　✧

Why did this happen? What went wrong with American culture? We weren't always so bland—quite the opposite. The hurly-burly of ethnicities that faced off to create jazz, country, and rock 'n' roll, pushed American culture around the globe. The same anything-is-possible spirit that fostered the emergence of Tennessee Williams, Jackson Pollock, Alvin Ailey, Frank Lloyd Wright, and Aretha Franklin still reverberates. How did all that American energy and vitality dissipate?

In the first half of the twentieth century, our country was a lot closer to the fundamental bedrock of ethnic heritage that provided our most essential cultural building blocks. Young artists could not avoid a very wide range of encounters with people who didn't think, talk, or act the same way they did. On a basic level, they had easy access to a lot of cultural substance. These pervasive influences offered pathways to the innovative work that came to define American culture. They were an open door through which artists could enter into their own careers. Overt multiethnic pilfering is a defining factor in most of America's treasured cultural assets. Consider Gershwin's *Porgy and Bess,* a Georgia O'Keeffe canvas, the choreography of George Balanchine, the novels of Saul Bellow.

What's different today? Assimilation has surely eroded much of the ethnic social fabric that once delineated Russian, Italian, Irish, Portuguese and Jewish Americans. Despite valiant efforts in many communities to "save it before it disappears," most European heritage in America has been seriously compromised. Chances are your grandparents communicated at home in a language other than English. Do you?

This deterioration of cultures is not exclusively an American problem. While we have perhaps pushed assimilation to an extreme, the problem is global in scope. In 1977, the great American folksong collector Alan Lomax sounded an urgent warning about the inevitable cultural "greyout" that would result from the destruction of traditional societies and the homogenizing influence of mass communications.[7] A quarter century later, much that he predicted has come to pass: local traditions, the languages and communities that sustain them, and the cultures that they represent are disappearing faster than rain forests. The loss to our collective human heritage is beyond reckoning. The enormity of this problem seems to elude our capacity to envision a response.

UNESCO's Report of the World Commission on Culture and Development points out: "Our generation has inherited a wealth of tangible and intangible cultural resources that embody the collective memory of communities across the world and buttress their sense of identity in times of uncertainty. Held in trust for humankind, these resources are essentially non-renewable. Awareness of responsibility for this fragile wealth has crystallized mainly around the built environment: historic monuments and sites. . . . As a result it is physical objects—great monuments and works of art and craft—that are the main beneficiaries of the notion of heritage preservation. . . . The intangible heritage has not fared so well."[8]

Traditional musicians, dancers, poets, and dramatists—the living bearers of an enormous global legacy—are central to the entire concept of

human culture. As the enactors of social identity, they simultaneously provide the bedrock upon which all cultural forms are built, and are a primary engine for innovation and change. Elite, "classical" arts are immediate descendants of folk traditions and draw on them routinely for vitality and inspiration. Without traditions to push against, most avant-garde experimental arts would be rendered irrelevant. Pop culture owes its very existence to traditional artistry that has been appropriated and re-created. And as communications technology overrides national bound-aries, traditional cultures continually respond to new influences, creating adaptations and hybrids that will in turn become tomorrow's global cul-ture.

Heritage—culture with a long view that nurtures human beings—is the foundation supporting the entire edifice of human expression. In his book on globalization *The Lexus and the Olive Tree,* Thomas Friedman represents the forces of technological advancement with the luxury automobile and employs the olive tree as a metaphor for the traditions that bind commu-nities. "Olive trees are important," he writes. "They represent everything that roots us, anchors us, identifies us and locates us in the world—whether it be belonging to a family, a community, a tribe, a nation, a religion, or, most of all, a place called home. Olive trees are what give us the warmth of family, the joy of individuality, the intimacy of personal rituals, the depth of private relationships, as well as the confidence and security to reach out and encounter others. We fight so intensely at times over our olive trees because, at their best, they provide the feelings of self esteem and belonging that are as essential for human survival as food in the belly."[9] While Friedman remains far more impressed with the immedia-cy of the cars than he is with the longevity of the trees, he is correct in noting that it is from these deep wells of tradition that communities draw their sustenance.

Yet there are few resources available to support heritage-based intan-gible cultural development. The commercial culture industry generally ignores traditional artistry, focusing its resources on mass marketable commodities that can generate profits. "It can be argued," says Marian Godfrey of the Pew Charitable Trusts, "that the aspects of our culture least likely to be sustained by the marketplace are those that add most value to American society: creative innovations, the preservation of cultural heritage and the enrichment of the lives and capacities of children."[10] When the marketplace does address traditional artistry, it is usually through highly curated, "blockbuster" performances or exhibitions that, due to their high cost, can only serve upper-income audiences in major

metropolitan areas, completely bypassing the communities with an actual stake in the art. The current growth of the "world music" industry, which purveys popularized versions of various national and regional styles to highly educated audiences in the developed world, is a case in point.

The most vibrant sectors of our culture today are being driven by recent arrivals from Latin America, Asia, and Africa, who continue to diversify our population at a rapid rate. They could provide the impetus that a revitalized culture requires, and, in fact, Latino artists are becoming a prominent and promising force, certainly in music, dance, and cinema. But today, the mediated nature of most Americans' cultural consumption largely mitigates the impact of the diversity factor. Movies, radio, magazines, and especially television tend to smooth out most of the ethnic edges before they reach the public, effectively neutering the very things we need the most.

This syndrome is amplified by the breathtaking brevity of our contemporary perception of time. "Civilization," says visionary observer Stewart Brand, "is revving itself into a pathologically short attention span."[11] Andy Warhol's fifteen minutes of fame is starting to feel like a long time beside the nanosecond trajectory of twenty-first-century fashion. Politicians can't think past the next election, businesspeople beyond the next quarter, but the growth of meaningful culture tends to require a long lead time. America's great artists could draw on a wealth of ethnic heritage because they were able to look back across generations and then process their material over a period of decades. Their creative touchstones and referential motifs felt like immutable parts of the human experience and were received as such by their audience, whose outlook encompassed the Bible, Shakespeare, *and* Mark Twain.

Today, many of our most prominent culture producers don't think past yesterday. Last year is ancient history. It's no wonder our popular culture has so little staying power. Britney Spears can't find inspiration in the singing of Billie Holiday or Janis Joplin because she's never *heard* Janis or Billie. Mariah Carey is about as far back as she goes. How can artists reference and draw on historical masterworks if they don't know about anything that happened before themselves? We're left with performers who have no anchors, whose only points of reference are to their own work. If it's not happening right now, it doesn't count.

The consolidation of entertainment industries under a few corporate conglomerates does not portend a bright future in the commercial sector. Unfortunately, our public institutions, that might offer a countervailing force to marketplace fashions, are tragically locked into systems that fail

to nurture culture in the communities where it grows. Despite decades of multicultural rhetoric, the greater share of governmental arts subsidies continue to support the elite Eurocentric canon at the expense of the multifaceted traditions of our communities. Corporate support is little more than marketing and is devoted to the popular entertainments that spell sales. Foundations, those tax havens of the wealthy, reflect the passions of their founders. These institutions' priorities rarely coincide with the real and compelling needs of grassroots culture as it is experienced by millions of Americans. The cultural resources that give our nation its unique identity languish with no champions in the public arena. Meanwhile, artists from Africa, Asia, and Latin America whose work embodies the very attachment to tradition and community that our culture has lost, are challenging America's international stature. Without a systematic turn toward a far more democratic approach to the development of our cultural resources, we will be seeing a lot more imports as our own products continue their slow dissolve to gray.

Rachel Davis DuBois, an early twentieth-century educational theorist, developed the concept of cultural democracy as a necessary prerequisite for the fulfillment of America's promise. Our electoral and economic achievements, she felt, would remain hollow without a commensurate growth in our collective cultural capacity, a dramatic broadening of the spectrum of choices for how to pursue life. "Political democracy—the right of all to vote—we have inherited," she wrote in 1943. "Economic democracy—the right of all to be free from want—we are beginning to envisage. But cultural democracy—a sharing of values among numbers of our various cultural groups—we have scarcely dreamed of. Much less have we devised social techniques for creating it."[12]

DuBois suggested that these three domains—political, economic, and cultural—are inseparably linked and that the American dream cannot be realized without equal attention to each (she lived in an age when social theorists still spoke about "the American dream"). She believed that only democratic principles, applied to all three, could allow each individual and every group "to be its true self." To do less would be a failure to fulfill our American potential. "The welfare of the group . . . means [articulating] a creative use of differences. Democracy is the only atmosphere in which this can happen, whether between individuals, within families, among groups in a country, or among countries. This kind of sharing we have called cultural democracy."

DuBois's vision all but disappeared in the postwar years that saw the growth of large arts institutions but little attention to ethnic artistry. In Europe, however, there was a growing realization that the elite halls of culture were not serving the needs of much of the population. By the 1970s, notes Danish dramatist Jørn Langsted, "cultural democracy became the key phrase in discussions of European cultural policy among high-ranking politicians and government officials. This mode of thought has had substantial influence on ministerial rhetoric."[13] The 1976 Oslo Conference of the European ministers of cultural affairs issued a report that echoed DuBois. "The theory of cultural democracy assumes that there is not only one culture, but many cultures in a society," wrote the ministers. "The aim of present cultural policy must be to create fertile conditions for the many subcultures, both local and regional, as well as for those which spontaneously grow forth from certain groups of the population. Cultural democracy implies placing importance on amateurs and on creating conditions which will allow people to choose to be active participants rather than just passive receivers of culture. A cultural policy which aims at creating cultural democracy must necessarily be decentralized. Decentralization must be considered both a means and an end in cultural policy."[14]

The steady shifting of governments throughout Europe has partially diluted this commitment. Left-leaning ministries' attempts to build an infrastructure for the practice of cultural democracy are eliminated when center/right governments replace them. Since a more democratic approach to cultural regeneration must take a very long view, the seesaw of cabinet offices has effectively limited the application of a new cultural policy. American governmental support for the arts has been so weak that these arguments are largely irrelevant.

For eighteen years after Ronald Reagan pulled the United States out of UNESCO in 1984, the country had no voice in the major global cultural forum. (George W. Bush rejoined in 2002 while trying to rally U.N. support for attacks on Iraq.) But UNESCO has emerged as a champion of the concept of cultural democracy. Its 1995 publication *Our Creative Diversity* explicitly tied concerns for culture with basic human rights. "Cultural freedom properly interpreted is the condition for individual freedom to flourish. It embraces the obligations that are embedded in the exercise of rights, the bonds that have to accompany options. Core individual rights are situated in a social context."[15] The UNESCO report situates cultural freedoms in a community setting. "Cultural freedom is rather special; it is not quite like other forms of freedom. First, most freedoms refer to the

individual—freedom to speak one's mind, to go where one wishes, to worship one's gods, to write what one likes. Cultural freedom, in contrast, is a collective freedom. It refers to the right of a group of people to follow or adopt a way of life of their choice."[16]

On November 2, 2001, UNESCO's General Conference adopted the *Universal Declaration of Cultural Diversity.* Director-General Koichiro Matsuura expressed hope that it would "one day acquire as much force as the Universal Declaration of Human Rights."[17] The text reads in part: "Culture takes diverse forms across space and time. This diversity is embodied in the uniqueness and plurality of the identities of the groups and societies making up humankind. As a source of exchange, innovation and creativity, cultural diversity is as necessary for humankind as biodiversity is for nature. . . . The defense of cultural diversity is an ethical imperative, inseparable from respect for human dignity. . . . Creation draws on the roots of cultural tradition, but flourishes in contact with other cultures. For this reason, heritage in all its forms must be preserved, enhanced and handed on to future generations as a record of human experience and aspirations, so as to foster creativity in all its diversity and to inspire genuine dialogue among cultures."[18]

✧ ✧ ✧

Cultural democracy, and how it gets practiced in America today, is the topic of this book. The perpetual and symbiotic relationships linking the cultural with the political and economic spheres are a recurrent theme. Just as voters' selections at the local ballot box determine specific electoral outcomes and also reflect macropolitical trends, individuals' cultural choices have importance within their personal lives and in the livelihood of their communities, and are also extended into mass-cultural phenomena.

Take, for example, a Texas teenager's interest in buying a recording by local star Selena. Her purchase is personally gratifying, but it also helps to fuel the singer's meteoric popularity; when Selena is murdered, Hollywood smells a potential hit; because of the film treatment of Selena's scandalous demise, Jennifer Lopez becomes the country's most prominent Latina media star at a moment when Hispanic culture is rapidly entering the mainstream; but she is a singer as well as an actress, and she chooses to produce her biggest hits in partnership with African American hip-hop stars; all of this media exposure exponentially amplifies the border-crossing nature of Lopez's career. That teenaged girl in Brownsville has come a long way. A local and personal interest in Mexican pop music

reaches out into the highest realms of Hollywood finance and political symbolism. Almost every cultural transaction carries within itself these seeds. Beyond DuBois's notion of the cultural sharing importance with politics and economics, the culture circles back to directly address politics and the market. What you practice locally gets acted out globally.

Most people assume that their cultural legacy is inherited, but this obscures the real-time mechanics of cultural transmission. Culture is created every day in countless enactments between generations, among peers, in groups, and by courageous individuals. Our societies have evolved multiple systems to support the celebration and extension of their cultures. Much of this takes place informally, often within a family setting. Much is institutionalized, with important roles assumed by religious organizations, social clubs, educational institutions, and the workplace. Certainly, America's leisure and entertainment industries play a substantial role in cultural communication. These domains overlap with the evolving realm of public culture, the sector where the private is transformed into the social, and where democracy becomes a relevant paradigm.

Have America's public cultural institutions—our libraries, symphony orchestras, museums, and civic theaters—embraced cultural democracy as the core of their missions? On the whole, they have not. "This country does not have an historic commitment to a democratized culture," writes William Cleveland. "Our Puritan 'forefathers' considered the secular arts to be an instrument of the devil and our earliest industrialist patrons related to culture as elitist decoration."[19] Little has changed in the politics of public arts. A vast gulf still separates the halls of high culture from the culture that is actually in daily use in our neighborhoods. "The establishment cultural and educational institutions that determine what is the core American experience, that determine what is and is not good and precious in the United States of America . . . often operate as if they do not know that ours is a nation of many peoples and many cultures," states Bernice Johnson Reagon, the great African American freedom singer. "They dominate access to the resources that rightfully belong to all whose labor and lives generated the resources."[20] The arts in America are out of touch with Americans.

This book examines the reasons behind this national disconnect in our cultural food chain and explores a range of remedies, asking the questions, How is culture generated? What does it need to sustain itself, adapt to changing circumstances, and remain vital? How can our public institutions support cultural advancement and protect local heritage? How does the Saturday night dance at a rural roadhouse relate to the global

art market or computer downloads of bubblegum pop songs? Is our na-
tional culture in the highest flower or headed for life support? What would
cultural democracy look like in practice?

✧ ✧ ✧

Culture and *democracy* are both words that possess long pedigrees of dis-
pute and dissension. People think they "know it when they see it," but
culture and *democracy* tend to be slippery of definition and subject to
change over time. America's founding fathers thought they were build-
ing a democracy; but many of us today would hardly use the word to
describe a government that systematically excluded women, blacks, Na-
tive Americans, and even many white men. Despite our changed assump-
tions about what constitutes democracy, vestiges of the founders' vision
continue to render our Senate and presidency profoundly unrepresenta-
tive institutions.

Many people confuse *culture* with *the arts* and use the terms interchange-
ably. In their view, culture resides in Greek revival art museums and on
the stages of opera companies and symphony orchestras. This archaic
perspective is a bit like defining *sport* as major league baseball, ignoring
the millions of soccer, basketball, hockey, and tennis games taking place
every Saturday throughout the planet. It even leaves out most of the art
world, the contemporary painters, performance artists, garage bands, and
production potters who provide the fodder for the arts marketplace. The
arts—all of the arts, including objects or activities that you might not rec-
ognize as *art,* and others that you might consider artistic but have prosa-
ic utilitarian uses for their makers—are a subset of the vastly larger project
of culture.

Art and culture are inseparably bound together, but they operate on
different levels in the overall organization of civilization. Art, and the
world of fashion that it largely overlaps, operates on a short timeline. The
numerous movements within modernist fine art exemplify this. Impres-
sionism, cubism, surrealism, minimalism, realism, abstract expression-
ism: the *isms* proliferate decade after decade, and the markets, with their
limited attention span, follow them willingly. Since the content changes
so quickly, it takes a lot of our time and attention to stay current. If you
don't pursue them relentlessly, fashion and art will pass you by. Mystified
by the music your own kids like to hear? You haven't been keeping up with
the most recent trends.

Culture moves at a far slower pace. It consists of beliefs and practices that
have persisted while hundreds of fads have come and gone. Culture con-

stantly draws corrections and modifications from the domain of art, but it is far bigger than today's hottest properties. "Culture," writes Stewart Brand, "is where the Long Now operates. Culture's vast slow-motion dance keeps century and millennium time. Slower than political and economic history, it moves at the pace of language and religion. Culture is the work of whole peoples."[21] Individuals make art; culture is made by the collective.

Anthropologists have offered a string of evolving definitions for culture, ranging from the very narrow to all-encompassing universals. Victorian ethnographer Edward Tylor's classic summation cited culture as "that complex whole which includes knowledge, belief, art, morals, law, custom, and any other capabilities and habits acquired by man as a member of society."[22] In 1952, anthropologists A. L. Kroeber and Clyde Kluckhohn enumerated 164 published definitions for *culture,* including "learned behavior," "a logical construct," "a statistical fiction," and "a psychic defense mechanism."[23] Arjun Appadurai, an influential contemporary theorist, points to culture as a frame for distinction. "The most valuable feature of the concept of culture," he writes, "is the concept of difference, a contrastive rather than a substantive property of certain things."[24]

As the term is deployed in this book, *culture* is broadly inclusive. It reflects all of the component parts of our lives that define who we are; it provides the building blocks of our identity as social beings. Culture is a fundamental enactment of human community.[25] It is the practices communities select to express themselves, the glue that binds them together internally, and the displays that represent them to the world. Culture is expressed in what we wear, what we eat, how we dance, who we revere, how we worship. It is an Indian woman's sari, Italians making pasta, fishermen's knowledge of how to read the weather signs, the etiquette of a society wedding, Franco-Americans dancing *Lady of the Lake,* and the stories refugees tell their children about their homelands. Every community has its own culture that interacts with and influences every other culture with which it coexists. This ongoing process of cross-fertilization is part of what keeps cultures and communities dynamic and healthy.

This conception of culture is reflected in the performing and visual arts, which provide vital tools for community cohesion. It contains the classical and traditional art forms of dance, music and craft, as well as contemporary sculpture, free jazz and avant-garde theatre—all expressions of a community-based aesthetic. But it is not restricted to the domains usually associated with *the arts,* reflecting instead a far more generalized approach to human activity. Culture isn't something you can *get.* You've already got it.

Democracy is not quite so prevalent. "Of the people, by the people, for the people." Abraham Lincoln's elegant phrase is perhaps the most revered and succinct description of what Americans mean when they use the word *democracy*. We've come some distance in figuring out what he was talking about since Lincoln coined the phrase during the middle of the Civil War. When he stood up to speak at Gettysburg, America was controlled by a small group of rich white men. Since then, our democracy has allowed the vote for blacks (Fifteenth Amendment, 1870), women (Nineteenth Amendment, 1920), blacks again (Voting Rights Act, 1965) and all those eighteen years or older (Twenty-sixth Amendment, 1971). American democracy is popularly hailed as the most perfect system of governance yet devised, a model we seek to "export" to less privileged nations around the globe.

However, many believe, and daily statistics confirm, that the United States is still under the control of a small group of rich white men. Perhaps DuBois's claim that we have inherited political democracy was premature. But even though we may have some distance to travel before we can truly lay claim to the mantle of democracy in our governance, there is probably a fair consensus on what the word really means today. *Democracy* means the fair, equitable, proportional, and transparent representation of all in the process of building a civic society. When we talk about the importance of building democratic institutions in third-world countries, that's what we're talking about. One person equals one vote, no exceptions. Government of the people, by the people, for the people.

The ideal of unfettered individual freedom to participate in the shaping of group governance is embedded at the center of the democratic concept as it has evolved in the United States. "Democracy is not a natural form of association; it is an extraordinary and rare contrivance of cultivated imagination," writes historian and educator Benjamin Barber. "Empower the merely ignorant and endow the uneducated with a right to make collective decisions and what results is not democracy but, at best, mob rule: the government of private prejudice and the tyranny of opinion—all those perversions that liberty's enemies like to pretend constitute democracy. For true democracy to flourish, however, there must be citizens. Citizens are women and men educated for excellence—by which term I mean the knowledge and competence to govern in common their own lives."[26]

Democracy is a sham unless everyone has an equal opportunity to be heard, and the contributions of many are needed to find democratic solutions. Early in the twentieth century, Supreme Court Justice Oliver Wen-

dell Holmes, who had fought in the Civil War and knew firsthand the results of failed democracy, found, "We do not permit the free expression of ideas because some individual may have the right one. No individual alone can have the right one. We permit free expression because we need the resources of the whole group to get us the ideas we need. Thinking is a social activity."[27] In a democracy, not only is everybody in, but everybody counts.

At the point where these two concepts—culture and democracy—intersect, we would experience fair, equitable, and proportional attention to each community's cultural aspirations. According to Bill Ivey, former chair of the National Endowment of the Arts (NEA), John Adams, our second president, envisioned as the ultimate goal of the American experiment an age that "would be characterized by intense citizen engagement in art and art making, and by a heightened role for cultural heritage and creativity in the everyday practice of citizenship."[28] As the UNESCO *Universal Declaration of Cultural Diversity* states, the collective right of each community is and should be considered on a par with individual liberties. Democratic culture is implicitly within the public sphere. It is not simply a private enactment within a community but an exploration of how our civil forum relates to that enactment. Cultural democracy lends an importance to private ritual that pushes it into the public square to challenge our received notions of what constitutes artistry. The images and assumptions that we receive through the media and revere in our temples to high art are representative of an extremely narrow cultural perspective. They reflect the tastes and values of elites, but they are distributed indiscriminately to us all as though they were our own. Indeed, they are designed to profoundly shape what we ourselves claim as our own.

Cultural democracy offers a different paradigm, a system of support for the cultures of our diverse communities that is respectful and celebratory, that gives voice to the many who have been historically excluded from the public domain, and that makes no claims of superiority or special status. It assumes a fundamental acceptance of difference. "Cultural democracy is predicated on the idea that diverse cultures should be treated as essentially equal in our multicultural societies," write culture theorists Don Adams and Arlene Goldbard. "Within this framework, cultural development becomes a process of assisting communities and individuals to learn, express and communicate in multiple directions, not merely from the top—the elite institutions of the dominant culture—down."[29] Few of us can be cognizant enough of the inner dynamics of someone else's culture to be able to accurately perceive meaning. We don't possess the in-

sider's code; the most basic distinctions elude us. And this makes cultural democracy very challenging to realize, because those who practice it must often work on unfamiliar terrain. It is as if roomfuls of people are speaking different languages very rapidly.

This inadequacy in accurately apprehending other cultures is a universal. We reflexively grasp the subtle nuances of our own but miss even the gross outlines of somebody else's. Most white people, for instance, just can't get much of a handle on Native American music. Wailing and the beating of drums: it all just sounds the same—monotonous. Early in the twentieth century, Robert Winslow Gordon, the first director of the Archive of Folk Song at the Library of Congress, feared (rightly) that much Native music would be lost if it wasn't captured soon. He brought a succession of chiefs and holy men from many of the western tribes to Washington to record their singing on the primitive wax cylinders that were then the height of audio technology. After one particularly arduous session, Gordon thought to demonstrate his appreciation for his visitors' hard work by treating them to an evening at the opera. The chiefs dutifully sat through the performance. When it finally ended, Gordon turned to them and asked what they thought. There was a long moment of embarrassed silence. Finally, one of the chiefs said, "It was interesting. But why did they keep singing the same song over and over again?"[30]

Our assumptions about what is beautiful and valuable, detailed and rich, are simply that—assumptions based in our own cultural grounding. The chiefs brought their own cultural ground to their encounter with Verdi, just as Gordon surely brought his own to the Native singing. Neither one was *right*, but neither could reflexively grasp the aesthetic within which the other operated. The history of race relations in America offers a lengthy series of tragic encounters that might have ended differently if the opposing sides had been able to apprehend this reality. In a cultural democracy, all cultures and communities are in contention, and no one possesses the skeleton key to unlock all of their codes. It means that we cannot judge another's culture, only accept it. That acceptance is the beginning of tolerance.

✧ ✧ ✧

My own interest and concern with the ideal of cultural democracy has evolved over two decades of trying to put it into practice in my own town. As one of the directors of the Center for Cultural Exchange in Portland, Maine, my job has been figuring out how to responsibly serve the interests of our rapidly changing demographic. Early in my career in arts ad-

ministration, I tried to program events that I hoped my constituents would like as much as I did. It turned out that most of those events drew an audience that reflected me: well-educated white people. If I expected to see Africans, Asians, and Latinos in my theater, obviously I had to try something different.

So I disposed of the notion that my own taste, or training as an ethnomusicologist, could ever properly inform my ability to make choices on behalf of some other culture. Only a thoughtful group of insiders could make selections that would be of relevance to their communities. Finding and forming such groups became the foundation of our programming process: accuracy demanded that the communities had to be seated at the head of the decision-making table. The Cambodian meeting that opened this chapter was an early and important experiment in democratizing our culture-making process.

My own position as a curator was eclipsed by a new role as community action facilitator, a role that is a recurrent motif in these pages. Our organization opened its doors and its budget to a dozen different ethnic communities and in the process completely altered our position in the cultural life of our city. We abandoned life as a small concert presenter and moved into a new realm, in which our programs play a significant role in forming and sustaining communities through the practice of cultural democracy. We are midwives to the birth of culture of the people, by the people, for the people. Our role as mediators, I have come to believe, is as important and necessary as the access to money that the institution brings to the table. In the dynamic interchange between communities and the marketplace, a facilitator often stands at the fulcrum. We are not the main actors, but we play *fifth business*[31] to the leads. As the fate of so many tragedians attests, it can be a dangerous role. And it is always difficult to play well.

Local cultures are up against the same media giants that we all face, but their resources are often meager. As long as the wealth of their cultures is practiced only behind closed doors, it will continue to diminish. Culture needs to grow and evolve if it is to remain vital. Cultural democracy gives traditional heritage—as well as the latest innovation—a public face, moments in the spotlight that call for response. It is the vehicle that can allow our diversity to really "be its true self," to stake out its territory in the jostle of our national identity.

The chapters that follow detail some of the mechanisms and strategies that can help to realize this potential and examine the complex tangle of roadblocks that stand in the way. They address the nature of commu-

nity and ethnicity, and the flexible dynamic that links traditional heritage with innovative new experimentation. Our public institutions are challenged to respond to the needs of a diverse population—the complementary models of cultural presentation and participation are the tools we possess to engage communities' imaginations. These strategies interact with the commercial marketplace at every turn, exploiting and being exploited by the dollar. Subsequent chapters focus on the troubled nature of financial supports for community culture in America and the reluctance of the educational system to fully embrace a democratized and full-blooded vision of our national identity. Finally, I address the importance of the mediative role of the nonprofit sector in developing community cultural resources and conclude with some reflections on the implications of the global information economy for local cultures.

Much of the material presented here is drawn from my own experience in cultural facilitation. As such, it certainly reflects my own enthusiasms and areas of expertise—there are many and varied musical references in these pages. But I believe that the content of the arguments could be equally well illustrated with examples drawn from visual arts, literature, theater, craft, dance, or food. Or, for that matter, auto body decoration, tattoo imagery, Web design, or fashion: anywhere expressive creativity comes into contact with a simpatico community.

Understanding the wild diversity of our competing cultures and subcultures could hardly be a more pressing imperative. The daily news offers a vivid depiction of cultural valleys with no bridges to cross, and the hazards of life among them.

"The need for respect of all cultures is particularly urgent at a time in which the uneasy acceptance of global culture and reactions against the alienating effects of large-scale modern technologies are reflected in the fast spread of religious fundamentalism and social intolerance," says Cristina Losito of the Centre for Creative Communities in London.[32] "A major problem of the twenty-first century," says John Brown Childs, "will be the crisis of diverse, often competing, social/cultural identities among people uprooted by corrosively powerful global economic combines."[33] Learning how to practice cultural democracy offers a path, perhaps the *only* path, to a socially sanctioned and wide ranging respect for diversity.

"In a world that has become familiar with 'ethnic cleansing,' religious fanaticism and social and racial prejudice, the obvious question is how hatred can be replaced by respect," writes former U.N. secretary general Javier Pérez de Cuéllar. "Policy-makers cannot legislate respect, nor can they coerce people to behave in a respectful manner. But they can enshrine

cultural freedom as one of the pillars on which the state is founded. The legislature, the judiciary and the executive can implement the principles of equality, civil rights and cultural freedom."[34]

This book attempts to untangle the knots of cultural practice, to examine how culture is made in America today and explore how it could come closer to a democratic ideal. But behind the details, the idea of *cultural democracy* hangs as an overarching metaphor for a society we might yet become: a society that balances the American creeds of liberty and equality, that places the liberty of individuals within the context of their free communities, nurturing and protecting the aspirations of the many, not just the few. Culture of the people, by the people, for the people. "What does your community need to keep its culture vital and meaningful?" turns out to be a much larger question than I once imagined. The process of finding its answers holds portents and promises for every local community, and for the global community.

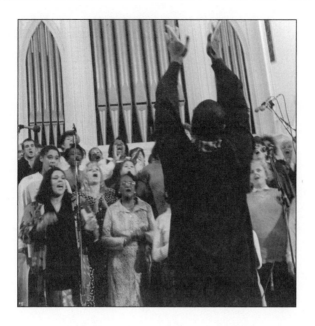

1

Communion

Early in my career as a facilitator of community cultural programs, I thought it might be possible to build some social bridges between Portland's African American community and our newcomer population of African refugees.[1] They are all of African descent, I figured, so they must share some common cultural roots. Surely, the African Americans will have an interest in probing a piece of their own heritage; and the Africans, I imagined, would have a compulsion to connect with their American cousins.

We convened a planning meeting in the basement of the local AME Zion Church, inviting everybody we knew in both communities. It quickly became apparent that building consensus within the group about what kind of project to develop would be difficult. An African American proposed assembling a program around percussion traditions from both sides of the Atlantic. But a Nigerian countered with a demand for "real drummers"—drummers from Africa.

Gary Hines energetically leading the Maine Mass Gospel Choir. Photo by Tonee Harbert.

"What do you mean, *real* drummers?" came the heated response. "Do you think our drummers here are somehow less than *real?*"

"Everybody knows the best percussionists in the world come from Africa," the Nigerian flatly stated. "Why settle for anything less?"

Ultimately, the meeting swung away from the conflict around real percussion and into the hands of a pair of preachers—one African American, one Congolese. With my enthusiastic support, they agreed to bring their respective choirs into a large mass chorus that would perform both American gospel and African hymnody. Together. To lead this new ensemble I hired two of the most inspiring singers and teachers I know—Gary Hines, director of the Grammy-winning gospel group Sounds of Blackness, and the supercharged South African singer Thuli Dumakude. Each artist was engaged to spend three weeks in Portland over the course of a year, culminating in a public unveiling of this new collaboration.

At least that was the idea. In reality, nothing worked out as planned. During the first week of rehearsals with Hines, the pastor of the African Fellowship turned up for one session—but he was the sole participant from the refugee community. Where, I wondered, were all the Africans? Their pastor was equivocal. Many of the refugees work nights and can't attend. Child care is always a challenge. They're busy with other things.

Soon we followed up with a second residency, this time with Thuli Dumakude. The results were even bleaker. Only two African Americans, out of a large group that had just enjoyed a fabulous experience working with Hines, showed up for the rehearsals. Where were *they?* I demanded. Their pastor was more straightforward. "They're just not interested in singing in *African,*" she explained on behalf of her choir. "They love the gospel music, but they just don't want to have to sing something that is strange and they can't understand. Bring back Gary Hines and they'll be there. I promise." But that wasn't the worst of it: no African refugees showed up this time, either.

What went wrong? In my naiveté, I'd made a series of mistaken assumptions about the prospective participants. I violated the first rule of anyone who has ever tried to do any kind of community organizing: know your community. The African American singers were simply not interested in African music. They sing gospel with celebratory abandon, but a song in Zulu was well outside their comfort zone. And Gary Hines's brilliance was irrelevant to the Africans, most of whom harbor a deep ambivalence about African Americans in general. Hines's artistry simply doesn't show up on their cultural radar as something worth pursuing. Neither did they care about Thuli Dumakude's South African songs. Most

of Portland's Africans come from the horn countries—Somalia, Sudan, Ethiopia. Sudan is twenty-five hundred miles from South Africa, about the same as the distance between Madrid and Moscow. I would probably not have assumed that a Spaniard would have a passion for Russian music, but my own cultural blinders allowed me to assume that as "Africans" these diverse ethnicities would have something in common. They don't. I had failed to perceive where the insiders draw the boundaries around their communities. And those communities provide the context in which culture is invented and sustained. Without an understanding of that context, cultural development is rendered meaningless.

What is *community?*[2] Any group of individuals who share something, anything, in common, and consider themselves to have some allegiance to each other as a result, forms a community. We all begin life within the community of our own families but quickly become part of other participatory communities as well: second graders, baseball players, dancers, college students, workers, parents, senior citizens. We are born into some communities, such as nationality, ethnicity, or religion. Others we select for ourselves: political affiliation, occupation, place of residence, pursuit of interests. Within each of these spheres, we share with the other members of the group a set of common experiences and assumptions about what is valued, how it is to be cherished, and how to interact with each other and the world. Each of us is part of many different communities, effortlessly shifting conceptual gears as we move among them. The internal rules that govern what is proper and what is unacceptable will vary substantially between the dance hall on Saturday night and the church on Sunday morning. Still, many people participate in both communities without committing social gaffes or feeling any sort of conflict.

It is this complex matrix of coexisting and overlapping community allegiances that forms the core of personal and social identity. We determine who we are by finding our grounding in relationship to others, through seeking our own place in the web of social obligation. Growing through childhood is largely a process of gradually looking further and further beyond ourselves, first to our families and later through the accumulation of community connections. That's where we find out who we are.

The evolution of the human species is a long history of expanding social awareness. Game theorists and evolutionary psychologists suggest that this process is built into human nature, that the grand trajectory of

humanity consists of our learning to play increasingly complex non-zero-sum games: win/win interactions as opposed to I win/you lose contests. "Indeed," says Robert Wright, "even if you start the survey back when the most complex society on earth was a hunter-gatherer village, and follow it up to the present, you can capture history's basic trajectory by reference to a core pattern: New technologies arise that permit or encourage new, richer forms of non-zero-sum interaction; then social structures evolve that realize this rich potential—that convert non-zero-sum situations into positive sums. Thus does social complexity grow in scope and depth."[3] Advances in non-zero-sum community cohesion create the social capital that allows for the evolution of cultures that are perceived as positive and healthy by their participants.

Like financial capital and human resources, social capital is an essential link in the drive chain of human activity. A society with a low capacity for accumulating social capital, one that stresses zero-sum games offering some members advantages at the expense of others, will be unstable and probably dangerous. Dynamic, progressive societies develop mechanisms to enhance the web of social capital.

Robert Putnam's book *Bowling Alone* offers a striking statistical portrait of the decline of social capital in contemporary America, as we increasingly become observers, rather than doers. He suggests that the creation and sustenance of social capital is vital to the functioning of any society, and offers an analysis of how it functions. "Of all the dimensions along which forms of social capital vary, perhaps the most important is the distinction between *bridging* (or inclusive) and *bonding* (or exclusive)," he writes. "Some forms of social capital are, by choice or necessity, inward looking and tend to reinforce exclusive identities and homogeneous groups. Examples of bonding social capital include ethnic fraternal organizations, church-based women's reading groups, and fashionable country clubs. Other networks are outward looking and encompass people across diverse social cleavages. Examples of bridging social capital include the civil rights movement, many youth service groups, and ecumenical religious organizations. Bonding social capital is good for undergirding specific reciprocity and mobilizing solidarity. . . . Bridging networks, by contrast, are better for linkage to external assets and for information diffusion."[4]

In our ancestral environment, early hominids learned that there was more security from predators and other hominids in a band of nomads than in the solitary life (bonding social capital). By the time of the agricultural revolution, this epiphany had grown to encompass large tribal

groupings, other people with whom we felt a common bond of fealty, if not kinship. With farming came permanent settlements that slowly evolved into towns and cities. Some tribes joined forces to create larger regional identities (requiring bridging social capital). Most of these jealously guarded a common set of racial, religious, and social characteristics that set them apart from all the others. Usually, the champions of this kind of ethnic identity scorned those of other ethnicities, particularly those close at hand. When the Hebrews were preparing their conquest of the land that became Israel, God was explicit in his instructions: they were to have nothing whatsoever to do with the locals:

> When YHWH your God brings you to the land that you are
> entering to possess,
> and dislodges great nations before you
> —the Hittite, the Girgashite, the Amorite, the Canaanite, the
> Perrizite, the Hivvite, and the Yevusite—
> seven nations more numerous and mightier (in number) than
> you,
> and YHWH your God gives them before you and you strike them
> down:
> you are to devote-them-to-destruction, yes, destruction,
> you are not to cut with them a covenant, you are not to show-
> them-mercy!
> And you are not to marry (with) them:
> your daughter you are not to give to their son, their daughter
> you are not to take for your son—
> for they would turn-aside your son from (following) after me
> and they would serve other gods,
> and the anger of YHWH would flare up against you, and he
> would destroy you quickly.
> Deuteronomy 7:1–4[5]

Gradually, the divisions between city states merged into national identities. Athens and Sparta made peace, but each continued to maintain its own ethnic character, as any contemporary Athenian or Spartan will tell you. Empires rose, governing vast territories that included numerous ethnicities. Sicily and Britain were both part of the Roman Empire, but their inhabitants remained Sicilians and Britons. Despite their long occupation by the Ottomans, the Greeks remained Greek, and the Arabs stuck to their Arabic. Among Woodrow Wilson's Fourteen Points following World War I was the remarkable notion of ethnic self-determination.[6] In a world still

under the heel of empire, this was a radical departure. The wisdom or folly of Wilson's vision is still being tested all over the globe as nations are dismembered along ethnic lines or join forces, usually to face a common threat.

In the world that we have inherited, ethnicity remains among the most powerful organizing forces in human societies. It plays a central role in the formulation of the personal identities of most of the world's people, and it is the fundamental base of human culture. An examination of how culture is created begins with a consideration of ethnicity and its implications.

Ethnicity manifests itself through a remarkable range of possibilities for group identification. Some tribal cultures that might include only a few hundred individuals form ethnic communities and identify themselves as distinct populations. They share a set of characteristics that symbolize, for them, their membership in a unique portion of humanity, endangered though it might be. Every member of such an ethnicity would be likely to have direct and personal acquaintance with every other culture bearer, bringing an immediacy to their group identity not shared by most of us. Among larger ethnic groupings—Ukrainians or Japanese, for example—individuals are linked to an abstract concept of *the people* that separates *us* from *them*. Although they are for the most part anonymous to one another, members of such ethnicities are bound by a common understanding and acceptance of what constitutes normalcy in human relations. In many of the world's languages, the names cultures use to identify themselves translate literally as *human beings*. Other ethnic groupings tend to fall outside of this linguistic and social classification—their status as less than fully human makes for easy justification of brutalities that would be viewed with horror if practiced within the insider circle.

Ethnic identity expands, contracts, and shifts in response to circumstance. Two hundred years ago, Genoans or Milanese would have considered themselves distinct ethnic groupings and would have recognized little mutuality with Calabrians. Today they can all join together to riot on behalf of the Italian World Cup team. Although the linguistic and cultural distinctions have not been erased, most Italians have embraced a national identity that is expansive enough to incorporate their regional differences. Italians who emigrated to the United States, while maintaining ties to old country traditions, have constructed their own forms of Italian American ethnicity. "Displaced populations often conceive of themselves as living in exile," writes folklorist Roger Abrahams, "and they

artfully deploy their traditions as a means of maintaining their sense of self-respect and value."[7]

This was certainly true of Africans who were brought to America as slaves. The continent of Africa supports hundreds of distinct linguistic and cultural groupings, some of which do not live together peacefully. In this hemisphere, chattel slavery erased consciousness of those discrete tribal identities and forged a new African American ethnicity, drawing on the traditions of the innumerable cultures that endured their joint captivity. Many of the characteristics that combined to form this unique ethnic identity were surely lost, but the resiliency of African heritage in adaptation to the circumstances of America is manifest in the contemporary traditions that have made African American culture a driving force in worldwide aesthetics.

With its wildly diverse population, the United States is a continuing encounter with ethnicity. "The sheer magnitude of American ethnic communities," according to economist Thomas Sowell, "makes them autonomous cultures with lives of their own—neither copies of some 'mainstream' model nor mere overseas branches of some other country's culture. Chow mein, the St. Patrick's Day parade, and the Afro hairdo all originated on *American* soil."[8] These overt expressions of ethnicity have historically struggled with the tide of assimilation to a denatured American standard.

White America has provided, perhaps, the world's grandest experiment in the systematic denial of ethnic traditions. From the Industrial Revolution onwards, the dominant American ideology ostensibly demanded the surrender of ethnicity as a part of the passage to American citizenship. Many immigrants to this country have viewed the trappings of ethnicity as barriers to full participation in the bounties of the golden land. As the children of immigrants were educated, they often became less dependent on adherence to tradition as a mainspring of identity. Socialism and liberalism focused their attention on theoretical models for group identification unrelated to ethnicity. Many individuals married outside their own ethnic communities. Third- and fourth-generation offspring have freely crossed ethnic lines to the point that today a large number of Americans feel little or no allegiance to any ethnic grouping, simply considering themselves to be *American*. The United States has been perceived as a synthesis of cultures, creator of the homogenized American rather than a panoply of hyphenated Americans. The definition of *American*, however, has historically been a received concept based around a northern Euro-

pean standard that excluded people of color, Jews, and any group that persisted in exhibiting traits of ethnic heritage. If you were white, Protestant, and of English or German descent, the country club was open; all others need not apply.

Despite challenges from proponents of an American multiculturalism, this melting pot ideology remains widespread. Not surprisingly, its insufficiency is generally perceived far more by minority cultures than by the white majority. Unreconstructed ethnicity still retains social stigma in America, as can be seen in recent referenda declaring English the official language and a wide variety of educational programs aimed at assimilation rather than celebration of cultural distinctions. "We're losing all this culture for what?" complains Chicano cultural activist Juan Tejeda. "For this 'melting pot?' We're losing the language—all these other things that make life so much more interesting and richer."[9]

The dynamic of assimilation and continual cross-ethnic fertilization is the standard model in contemporary America. Ethnic purity is the exception, not the rule. Alan Jabbour, past director of the American Folklife Center at the Library of Congress, writes: "One must account for the American Indian powwow honoring World War II veterans; the Louisiana Cajun with an Irish surname singing a blues song in French; the Washington, DC, Jewish family adopting current Israeli pronunciation for Hebrew words instead of their parents' Ashkenazi pronunciations; the Afro-American blues singer from Virginia who incorporates songs of the white country singer Jimmie Rodgers in his repertory; and the second generation Hungarian steelworker who prefers the company of Irish and Slovak fellow workers to that of post-1956 Hungarian immigrants. What is needed, then, is a more elaborate and supple model of ethnicity in the United States."[10]

In his book *The Opening of the American Mind,* Lawrence Levine contends that the expansive diversity of our population is a fact that our institutions need to fully embrace. "It's difficult to see how community is fostered by condemning pluralism as 'un-American' and ignoring all the evidence we have of the complex and multiple ways in which people in our country envision themselves and others even as they manage to create a common culture that thrives alongside the many discrete separate cultures that have characterized the United States from its origins," he writes. "Community has to be built on what exists, not what some of us would like to exist."[11]

✧ ✧ ✧

Closely linked to ethnicity as a marker of community, but functioning somewhat differently, is religion. Religious practice is often among the central components of ethnicity. Greeks are Orthodox, Italians are Catholic, and Germans are Lutheran—even if many or even a majority are lapsed churchgoers. Jewish culture is so closely associated with its religious base that even wholly secularized Jews who have never set foot in a synagogue must contend with their religious heritage. Religion frequently becomes a vehicle for bridging ethnic divides. While history is replete with religious clashes, a common faith has also become the vehicle for bonding nations that might have been hostile in other circumstances. Catholic Ireland's long alliance with France or the global reach of contemporary militant Islam comes to mind.

At other times, religion offers a profoundly conservative force in the maintenance of ethnic identity. For two centuries, the Québécois deployed religion as the major bulwark in opposition to their British overlords, maintaining their language, traditions, and sense of themselves as a separate nationality.[12] Roman Catholicism was central to the shaping of this identity, and among many Québécois, the sustenance of French culture in America became a religiously sanctioned obligation. According to the ethos of *le survivance,* it was the sacred mission of the Québécois to preserve Catholicism in America, and the maintenance of their mother tongue and customs became vehicles to that end. Surrounded by Anglophones, the French Canadians stuck to their farms, their churches, and their culture.

Ethnicity, religion, nationality: these are the overlapping and contending factors that dominate the formation of communities. Most of us take them for granted as our birthright. But there are other markers of community that we choose for ourselves. Voluntary communities form around professional and lifestyle choices. For some people, they can become defining factors in shaping their social presence. Think of the generations of "Deadheads" whose lives revolved around following their favorite psychedelic band on tour, or the bars that spring up across the street from factories and become second homes to many workers.

All of these communities compete with each other for our time and attention, and the balance among them that we select helps define how we relate to the world, the uniqueness of who we are as individuals. Of course, every other member of each community must make similar internal decisions: are they going to mass every day or taking off Wednesdays for the bridge club? Everyone is flagrantly multicommunal and so

must make these choices continually. Since everybody moves through their various community obligations at their own pace, and with a sense of commitment that ranges from total to negligible, it becomes difficult to define where the boundaries of community identity might lie.

In fact, there is no solid ground in community dynamics. Rather, within each community there is a sliding scale of adherence. Every community has a core group of participators whose level of dedication is extremely high. They are the motivators who sustain community over the long haul. But they always depend on a somewhat larger group that is less compelled to participate, will not likely lead in any substantial manner, and whose participation is inconsistent. Most of these people consider themselves to be community members in good standing; they've just got other priorities that sometimes divert their attention.

Then there is a group of infrequent or lapsed participators, people who hover on the edges of community identity. At one point in my life, I was a very active folkdance aficionado, driving long distances to attend events three or more nights each week. I was an inside participator in the community of folkdancers in my region. It's been many years since that particular enthusiasm waned in my life, but I still keep myself informed about dance activity around New England. Although I am now irrelevant to the vibrancy of the dance community, I still keep my store of experience tucked away as a small piece of my identity, a part of my past that I can draw on in case my daughter wants to learn how to polka or schottische. Communities really need all three types—the core participators, fair-weather friends, and lost sheep—and gain or lose adherents as individuals move through their lives, pursuing enthusiasms, assuming responsibilities, or finding themselves pulled into a different orbit by the attraction of a competing interest.

The sliding scale of adherence means that the definition of any community's limits is always provisional; there's always a fairly large gray area at the edges. This is exacerbated by the internal divisions that afflict communities. Every community is a divided community. The fractures can be based around politics, class, belief—or simply on personality clashes. Power struggles are the order of every day. Any basketball coach can testify to the difficulties of building a team with players who come from different socioeconomic backgrounds, enjoy widely varying social status off the courts, display a range of athletic prowess versus academic achievement, and demonstrate all of this in their supercharged teenage personalities. The biggest challenges are not with the opposing team; they are sitting on your own bench.

Some communities have evolved systems to mitigate the damage that this can cause, effectively institutionalizing non-zero-sum outcomes for the group as a whole (not necessarily for each individual). Many find that their internal struggles are the dominating theme of participation. Outsiders are often mystified by the importance that embattled community members attach to seemingly arcane splinters of dissension. But to insiders, the same apparently petty issues can be the hinge on which the community's self-definition swings, taking on dramatic importance. It seems crazy to us now that several generations of Europeans were prepared to die over the issue of transsubstantiation versus consubstantiation. But within the dynamic of their own cultures, the resolution of this question carried far-reaching implications. This is the reason many communities seem to devote so much more energy to fighting among themselves than to the pursuit of any larger objective. The internal battles reflect a community struggling to define itself, and until there is at least a measure of agreement about who they are and what they stand for, moving forward is nearly impossible.

For example, take Portland's largest ethnic community, the Irish.[13] There are easily twenty thousand Irish Americans in Portland, but most of them are second, third, or fourth generation and maintain little interest in their Irish heritage. The remainder who do self-identify as Irish are divided between those who adhere to a nostalgic Irish Americanism—the cable-knit sweater–wearing, "Danny Boy"–singing crowd—and those who strive to keep abreast of the very dynamic contemporary global Celtic cultural scene. The first group is generally scorned by the second group. There are substantial class and generational divisors at play here, too. Both groups are further divided by politics: we have institutionalized Irish Republican groups in Maine, as well as an organization that brings both Catholic and Protestant kids from Belfast to Maine for summer camping experiences. And then the communities are divided by their interest in competing traditional dance styles. There are the step dancers—young girls in short skirts doing *Riverdance* imitations. They have no interest in ceilidh dancing—a form of called social dance. And neither steppers nor ceilidh fans make common cause with the set-dance fanatics—that's a fast and complicated social dance performed by clusters of four couples much like an American square dance.

By the time you've layered these various divisors over your population base in the attempt to determine how the community defines itself, you may have whittled your core participants down to a relatively small group. But if you're trying to find a mechanism to support cultural activity, you have to parse it down to the point where there is at least a modicum of

internal cohesion around defining whatever that culture might be. That means figuring out what is included and what is excluded from a community's frame of reference.

Sometimes this can mean that the community you imagined is really nonexistent. We once received a large grant for an extended program serving Maine's Sudanese refugee community. Well, it turns out that there is no consensus among this small minority population about what constitutes Sudanese culture. Sudan itself was the creation of European colonial powers who carved up Africa according to their own whim with little regard for the inhabitants. Sudan contains hundreds of linguistic and ethnic divisions—we have sixteen different tribes represented right in Portland. Some of these have heated internal disputes about leadership and political direction. Ultimately, we learned that our "Sudanese" initiative had to break down to the level of community identification, in this case, the multiple tribal communities. Our idea of what constituted a community was not shared by the community members.

Some of these communities consist of only a handful of adherents. Such cultures are truly under threat of extinction. Any community needs a critical mass of participants to maintain itself. If individual commitment is powerful enough, this doesn't have to be a large number. The religious community of Shakers at Sabbathday Lake, Maine, has sustained itself for many decades without ever having more than a dozen members. But most communities cannot sustain themselves under such marginal conditions. Putnam points with alarm to the demise of many social communities that once shouldered a large burden of American civic culture. "Americans today feel vaguely and uncomfortably disconnected," he writes. "We tell pollsters we wish we lived in a more civil, more trustworthy, more collectively caring community. The evidence from our inquiry shows that this longing is not simply nostalgia or 'false consciousness.' Americans are *right* that the bonds of our communities have withered, and we are *right* to fear that this transformation has very real costs."[14] It is within this rather amorphous context of hazy, conflicted, and often marginalized communities that culture is produced.

✧ ✧ ✧

Culture defines communities; communities create culture. Although culture exists in the Long Now and is inherited by its practitioners, it is invented daily in countless acts that are, in themselves, the glue that binds communities. It is these enactments that give community shape and meaning. Setting the table just so and serving particular combinations

of food offer sustenance beyond mere nutritional value. Heritage is a renewable resource, but it needs regular use to maintain its resilience.

Joe Kaloyanides Graziosi is a master of regional Greek dance styles. His life has been a constant sharing of the wealth and sophistication of this enormous legacy with dance fans; school children; Greek communities; and, increasingly, with non-Greek Americans, Japanese, Australians, and many others. At a local *glendi* (Greek dance party) the band had selected an unusual dance rhythm called a *zeybekiko,* but the dancers had nonetheless crowded the floor. "Just look at them trying to do this dance," laughed Graziosi. "This dance has almost completely disappeared from common knowledge. The only people left who still know the steps are older Greek Americans. Now, look at him," he said, pointing out an elderly gentleman. "That guy knows how it goes. Beautiful. Most of these kids are just improvising. They've forgotten this dance back in Greece many years ago. It's guys like him who are the only living links to this piece of our heritage."[15]

The act of memory carrying that dance into the precarious future, repeated endlessly, is central to an understanding of the culture that it expresses. It is a bite of information, joining a stream of megabites like it to make a culture intelligible to its users. Insiders deploy this information strategically as a roadmap to right livelihood and a filter for their experience in the world. It provides the fundamental frame through which they can make sense of events. "A work of art has meaning and interest only for someone who possesses the cultural competence, that is, the code, into which it is encoded," writes Pierre Bourdieu. ". . . A beholder who lacks the specific code feels lost in a chaos of sounds and rhythms, colours and lines, without rhyme or reason."[16] Possession of enough information to read the code constitutes cultural competence, and is generally assumed among any group of insiders. "A fish only discovers its need for water when it is no longer in it," says globalization guru Fons Trompenaars. "Our own culture is like water to a fish. It sustains us. We live and breathe through it."[17] You needn't explain to your neighbor why shoes are left outside the mosque, or eggs are decorated for Easter. Everyone in the community has already internalized the practice, which is an assumed part of the cultural code, known to all.

All—except outsiders who lack the common experience and insight into the inner mechanics of another culture, who lack cultural competence. All of us move freely among different cultural domains as a matter of course. We are competent within multiple cultural realms, which may overlap or be quite discrete. But most Americans also encounter other

cultures in which they lack the basic codes on a regular basis. On the streets, at school, in the workplace, through the media, we all encounter the *Other* all the time. Often, the experience can be disquieting. Usually, our instant response is to view the Other through the frame of our own culturally patterned assumptions. Through this lens, most other cultures will seem strange, exotic, or frightening, depending on the circumstances. With complete faith in our own judgments, it is easy to diminish or dismiss something that we are not equipped to grasp. Errors based in the lack of cultural competence are among the greatest stumbling blocks in the pursuit of a just and diverse society. It is so easy to miss the mark and to not even know what you've missed.

Portland's Cambodian community is the largest refugee population in Maine.[18] The outcome of our exhaustive planning process with the Cambodians was a decision to focus our resources on developing classical dance and music traditions locally. There was a lot of interest in dance as a vital expression of Khmer culture, but there were no professional-level dancers resident in our state. What the elders ultimately determined they needed was cultural access.

The Center received a grant to bring in the highly esteemed master performers Sam-Ang Sam and Chan Moly Sam for a series of residencies, culminating in the first of many Cambodian New Year festivals our organization sponsored. This was a large public event, with food, games, and performances. As Chan Moly's students, and then Sam-Ang and Chan Moly themselves, performed, I became increasingly alarmed at the disrespectful attitude that our audience was displaying. No one, it seemed, was paying much attention to the exquisite dance/drama unfolding onstage. Instead, people were eating, talking, cracking jokes; children were running up and down the aisles; the din in the hall seemed deafening to me.

Driving the artists back to their hotel after the performance, I admitted my embarrassment. After all the trouble and expense of bringing their artistry to Portland—I moaned—just look how rudely our audience had treated them! Sam-Ang and Chan Moly just laughed and said, "That shows how little you know about Cambodians!" Had they been at the Palace in Phnom Penh, they explained, it would have been exactly the same. That's just the way Cambodians enjoy their dance traditions. My lack of cultural competence allowed me to view as troublesome a phenomenon that, with their insider's code, they assumed as perfectly normal, or even desirable.

Ironically, contending with all the various Others that present them-

selves for our consideration is the most useful tool in forming our own cultural awareness. To fully live within a culture one must understand its codes, but often these are defined in relation to other surrounding cultures. We need something to push against to find out where we really stand. "The reason man does not experience his true cultural self," suggests anthropologist Edward T. Hall, "is that until he experiences another self as valid, he has little basis for validating his own self."[19] Our comprehension of the cultures that we inhabit is only complete when seen in the reflected glow of the cultures that surround us. Fundamentally, we can only know ourselves fully in relation to someone different, thus the dance of cultures in collision and in collusion. We need each other in order to validate our differences.

In America, this process has always been taken to extremes. Our cultures here don't stop with the first encounter but fight among themselves, move in together, and spawn a generation of multiethnic offspring, who take the process a step further in their turn. The community that nurtured our grandparents is gone. It has morphed into something new, a community that holds relevance as a frame for their grandchildren. And the culture that it embodied has shifted to accommodate this new identity. "Welcome to post-ethnic America," proclaims the *Washington Post*. "You may not have heard much about it yet, since it hasn't fully seeped into the intellectual and political realms that define the national discourse on racial issues. But it's in full bloom on American streets and in the marketplace."[20]

This is now the culture that tests itself against the avalanche of social complexity that makes its case to the world. We can hold one part of it up for examination, but we cannot separate it from its own relational context. "It is increasingly clear," says anthropological theorist James Clifford, ". . . that the concrete activity of representing a culture, subculture or indeed any coherent domain of collective activity is always strategic and selective. The world's societies are too systematically interconnected to permit any easy isolation of separate or independently functioning systems."[21]

✧ ✧ ✧

Within this complex and contingent social context, communities devise methods for creating and maintaining their cultural selves. Cultural practice may seem like an immutable given, but it is not: it has to be taught. Each generation carries the responsibility for passing along its received heritage, which means that rituals need observance, traditions need cel-

ebration, and children need instruction if they are to assimilate the community's cultural codes. Much of this happens easily, without any conscious effort: families worship together, celebrate religious and ethnic holidays, and eat the food Mom puts on the table every day.

But some cultural conditioning only comes through conscious effort. Most immigrant communities in the United States rightfully worry that their languages are disappearing. Without disciplined and extensive instruction, children do not master their parents' language, and within a generation it is often lost, and with it an enormous legacy of cultural access. This frequently puts an end to continued communication with homeland relations, severing another cultural bond. Many other traditions require careful tutelage: the informal or explicit apprenticeships that young musicians, dancers, or artisans serve with elders in their community; the special processes involved in kosher or halal butchery; the specialized skills of ritual healers and religious leaders.

In some cultures, the entire history of a people is carried in the oral tradition. As an amateur genealogist, I once traced my ancestry back six generations to a soldier who fought in the American Revolution. A Somali friend told me that he could recite his family tree back twenty-five generations! Thinking he was boasting, I asked several other local Somalis about their own ancestors. Without hesitation, they unanimously insisted that they *all* knew their entire lineage extending back at least twenty generations, most of them much more. Here is a culture that places a high premium on an intimate and exhaustive knowledge of ethnic history: ancestry and identity in congruence.

Not surprisingly, many Somalis also pride themselves on their ability to recite epic poems that embody the foundational legends of their communal identity. A Sudanese scholar once told me that the cultures that have elevated poetry to the highest levels all tend to be pastoral societies: shepherds with a lot of time on their hands. "The more settled the tribes become," he insisted, "the less poetic they become, and the more musical."[22] The point is, all of those poems and genealogies have to be carefully and painstakingly taught if they are to survive. Maintaining the core of these cultures requires a prolonged and conscious educational process, reinventing the culture for each successive generation. In this way, a community actively preserves its culture.

To successfully do this, communities require substantial internal supports. Some communities have their own institutions that oversee these processes. Religious Jews send their children to Hebrew School; Catholic kids attend catechism classes; numerous social and fraternal organiza-

tions play substantial roles in maintaining community heritage. But many communities, especially those of small minority populations and recent immigrants, do not possess such organizational assets. And while informal tutelage between elders and youth is prominent in every healthy community, it cannot always be immediately and easily accessible. Given the choice between cultural and physical survival, most refugees choose to work multiple jobs to keep food on the table, and they have little time or energy left for cultural pursuits. The lack of institutional supports for ethnic heritage has put many cultures on the endangered list.

✧ ✧ ✧

This is precisely where America's cultural infrastructure has failed. Our major cultural institutions—both funders like the National Endowments and the foundations or corporations that provide financial backing, and the most prominent organizations that represent culture to the public—have shown little regard for culture in its community setting. Culture that is made and used by the collective, with the nurture that it requires to maintain its dynamism, has been all but ignored by our systems of support for the arts. An exaltation of the work of individual genius—as if that brilliance wasn't firmly grounded in a community's heritage—coupled with the historical dominance of European elite arts, renders our public arts sector blind to the needs of the very communities that generate its most basic energies.

It is ironic that this is the case at a historical moment that calls on our cultural resources as never before. A recent report by the nonprofit Center for Arts and Culture outlines our position within the world economy: "Our cultural capital has become increasingly valuable in a global, knowledge-based economy, and as a key social source as people in the United States and around the world seek to preserve their identities and understand others."[23] This cultural capital requires sustenance.

Public cultural agencies, educational programs, artist advocacy groups, and the projects of individual artists and companies continue to be overwhelmingly guided by a set of cultural assumptions that is not shared by the vast majority of the public. "The European cultural hegemony that we call *Eurocentricity* does not include most of the creative forces of Europe," points out Peter Pennekamp of the Humboldt Area Foundation. "It is limited to a narrow range of culture defined by patrons, royalty, academics, and the financially privileged. Within that narrow range exist many wonderful expressive beliefs and practices. When we talk about Eurocentrism, however, we are really leaving out most Europeans."[24]

Many of those excluded live and practice their cultures right here in America. The traditions that they carry inform *all* contemporary art. Without Bojangles Robinson and Honi Coles, we wouldn't have Savion Glover's noise or funk. Without Hank Williams, we wouldn't have Hank Williams Jr. or III. But tradition has been denied the place of honor that it deserves in our national cultural dialogue. Local governments and historic preservation committees have developed a keen sensitivity to the needs of historic buildings, which are being protected and renovated for contemporary usage around every corner. But the carriers of our intangible cultural assets, the traditions that informed the construction of those buildings in the first place and that now struggle to hold their own, have not been invited to the table. Tradition, and its cradle within each community, sustains the whole American cultural edifice, and its exclusion from our civic culture is shameful and shortsighted.

2

Tradition and Innovation

Community heritage comes to ground in tradition. Tradition needs continuous innovation to maintain its vitality. Tradition and innovation are synergetic opposites; neither can stand alone, since they both provide justification for their counterpart's existence. Given the slippery definitions and complex interactions that characterize the community setting, how does this dynamic work?

First, identity is inseparably bound to tradition. The accumulated attitudes, assumptions, beliefs, and prejudices that constitute the self-image of a particular group of people in a particular place and time are the fruits of tradition. The ways people view the world, think about its events, and discuss them with their peers are determined in large measure by the traditions of the culture into which they are born and live their lives. "People turn to culture as a means of self-definition and mobilization and assert their local cultural values," writes Javier Pérez de Cuéllar. "For the

Cambodian monkey dancer Amarin Sam on his skateboard. Photo by Phyllis O'Neill.

poorest among them, their own values are often the only thing they can assert. Traditional values, it is claimed, bring identity, continuity and meaning to their lives."[1] Ethnicity is the expression of these traditions that combine to create distinct cultures, usually based on shared racial characteristics, language, locale, and religious system of belief. These broadly inclusive ethnic traditions are fundamental, like the communities that sustain them, lying at the root of most of the world's cultural output.

Second, traditions are supple, constantly shifting fields; though they embody vestiges of times past, living traditions are dynamic forces that reflect their own present. Ethnicity itself, as we have seen, is an elastic concept, subject to interpretation and reinterpretation as history augments, diminishes, dilutes, and replenishes its constituent generations. Tradition is the past, or a collection of similar but slightly differing pasts, grappling with the present. In the process of this dialectic, traditions are renewed, updated, transformed, or discarded. Indeed, they are continuously and creatively invented to serve the present moment.

Ethnic identity, then, is provisional, subject to cultural and historical forces that constantly reshape its essence. The sense of belonging to a unique portion of humanity, of sharing traditions that recede beyond memory, may seem to be a self-evident and eternal truth to the bearers of contemporary ethnic traditions. But those same apparently immutable laws of behavior, belief, and social interaction are the result of a long evolution. They have changed to accommodate themselves to the twenty-first century and will no doubt continue to develop as long as people survive to alter them.

Many people can acknowledge other people's reliance on traditions far more easily than they can see their own. Everyone seems normal to themselves; we assume our own frame as typical and universal. Others who deviate seem strange to us. The mythology of American cultural synthesis was created by Anglo-Americans with the tacit assumption that newcomers would assimilate to the northern European cultural norms that they held to be universally true and right. "Since the early part of the twentieth century," writes Richard Kurin of the Smithsonian, "American popular culture has represented this country as a 'nation of nations' that employs a 'melting pot' or similar crucible to blend or eliminate differences and produce national unity. Henry Ford actually devised a ritual pageant for workers at one of his plants which involved an 'Americanization machine.' At an appropriate phase of their assimilation, Ford would have workers—mainly from central and eastern Europe—dress in their various national costumes, march onto a stage waving their national

flags, and enter the machine. The latter was a large and elaborate stage prop replete with smoke, control levers and gauges. Workers would emerge from this crucible of factory experience dressed in American work clothes and waving American flags. . . . Many Americans have long been aware that the 'melting pot' was an inadequate metaphor for American society. For in this melting pot, American Indians were long invisible, African Americans were excluded, and the cultures of others were ignored."[2]

But the attempted liquidation of ethnicity in the creation of an American cultural identity has not destroyed tradition, even within the dominant European American culture. Ethnicity surfaces in European American homes in the way we trim our Christmas trees; the foods we choose to eat; the music we enjoy; our attitudes about labor, leisure, and childrearing; and especially in our feelings about other ethnic groups. Our reliance on the traditions of our parents and grandparents, often unconscious, tie us to ethnic communities that may have first landed in the New World a hundred or more years ago but continue to have resonance in our daily lives. Each community nourishes art forms that have an ongoing impact on American culture at all levels. These ties are replicated throughout the diverse populations whose interactions catalyze the continual reformation of America's numerous identities. We experience them in the music of Beethoven and Wagner as much as we do in that of Charlie Parker or Chuck Berry; they are represented—usually in piecemeal and distorted forms—in Hollywood films, the latest sitcom, and the rhetoric of politicians. Tradition dictates the ways we express ourselves and how we receive the cultural output that surrounds us. The expression of traditional and ethnic identity—in the broadest sense, the folk arts—is the food that makes American culture healthy.

What qualifies as *tradition?* What is meant by terms such as *folk* and *folklife?* Tradition is the building block of culture, the glue connecting the present with the past and securing the creations of community into the future. Tradition references the pride of history, connecting this generation with its ancestors and providing the cues needed to make sense of the disparate data of the present. Tradition provides the rock for innovation to push against, the value of the old, and the springboard of the new. Tradition is never static but is fundamentally flexible, contingent, changing. According to folklorist Henry Glassie, "[D]efine tradition as culture's dynamic, as the process by which culture exists, and it emerges as the

swing term between culture and history, the missing piece necessary to the success of a cultural history that would bring anthropology and history, with folklore as the mediating agent, into productive alliance."[3]

Folklore is an expression of tradition within its own community. It is an aesthetic act, reflecting the values associated with its own internal dynamic. It is the way tradition manifests itself in the creative acts of daily life. Folklore is created within small pastoral groups and among cosmopolitan urban dwellers, among those who view their lives as explicitly tied to tradition—and among those who eschew allegiance to ethnic, racial, or class distinctions. The folk who create and nurture it are all, however, heeding the call of specific traditions to which their creative folklore must cleave. Folklore grows from traditions that are carried by specific communities, and it expresses the aesthetic of these communities in a manner generally removed from the engines of mass entertainment.

In twenty-first-century American culture, most people carry unexamined misconceptions of what terms like *folk* and *tradition* are all about. I have never heard a single traditional performer—and I've worked closely with hundreds of them—describe himself as a *folk* musician. Meanwhile, singer-songwriters who have no connection to any community-based tradition call themselves *folksingers* and their compositions *folksongs;* the bins designated as *folk* in most record shops actually include a variety of popular music while the real folk performers are relegated to much narrower bins marked *ethnic,* or *gospel,* or *international*—usually at the back of the store. "Thus," point out festival organizers Joe Wilson and Lee Udall, "in common parlance, folk artists often are not called folk artists; instead, artists who are *not* folk artists are so labeled."[4] Given this situation, how can we apprehend the nature of folk culture?

Folk culture is just what it says: it is a way of life that displays a fealty to the traditions of a particular community or subculture that evolves through its own independent dynamic. Individuals associated with any given community through birth or lifelong participation enjoy a direct linkage to tradition unavailable to outsiders. Traditional artists, like all members of their culture group, perform within the bounds of a shared aesthetic, an intimate and detailed knowledge about the ways artistic and social interactions occur. This cultural patterning has a substantial impact on the style, content, and delivery of traditional performance (and on contemporary ethnic arts as well), and on the appropriate responses to it. Folklorist Barre Toelken states that "the members of any given culture perceive reality in terms of culturally provided sets of ideas and premises, and that the world of reality is processed somewhat differently from

culture to culture. Not only are the incoming data interpreted according to the pattern of a particular culture, but expressions and communications with others are based on those same premises."[5]

Any kind of tradition, then, is first and foremost situated within the context of a community, where folklife is created and nurtured. "The performances shared by folk groups have certain characteristics which make them folklore," writes folklorist and ethnomusicologist Jeff Todd Titon. "For one thing, the communication is face to face; personal presence is very important because communication is multileveled, not just verbal. One person sitting and watching something on television does not comprise a folk group; but a few people listening to a record and interacting over that record form a small, face-to-face community so long as they share an aesthetic and interpretive framework. Second, because of the shared framework and personal presence, there is a certain informality, and this is missing in encounters with people who are differently attuned. . . . For the folklorist or ethnomusicologist, the beginning of understanding involves *being there*."[6]

This model of folklife—the way it is lived by its participants and observed by outsiders—centers on *affect*, the moving power behind tradition. "Affect," Titon writes, "is at the center of the barn, the ballad, the folktale, the religious rite—the various and sundry activities folklorists study. Affect cuts across them all, is the common element."[7] This is not to imply that artists don't have many, and often mixed, motivations behind their work—such as money or function. It is focused instead on the emotional content of their work, which may or may not contribute to its utility but certainly adds value for an insider. Conveyance of affect provides the yardstick by which we may measure the ultimate success or failure of efforts to bring traditional culture into the public sphere.

Affect is actualized through the dynamic of the performative experience, which unfolds according to unarticulated but implicitly understood assumptions that frame the folk event. "First," Titon's analysis continues, "a performance is intentional."[8] The performer intends to move people in specific ways, and tailors the performance in keeping with its purpose. "Second, a performance is rule-governed. In other words, certain rules or principles operate in any performance to guide exactly how it goes along. . . . Performance is organized, coherent and purposeful." The rules in any folk performance, occurring in its traditional setting, are generally well understood by those in attendance. Within the folk-insider knowledge of symphonic audiences, for example, it is understood that we don't applaud between movements and everybody stands for the "Hallelujah

Chorus." When a south Texas *conjunto* kicks into a polka, the dancers move as though choreographed into the rhythm of the appropriate steps.

The third characteristic of the performance is that it is interpreted. "Performers interpret as they go along: they understand what goes on, and their continuing performance is based in part upon their interpretation." Anyone even loosely involved in the performing arts is aware of the impact that an audience's response can have on a performer. This feedback loop can generate both moments of epiphany between artist and audience and disastrous stage events that emotionally drain performers and bore or anger the public. Finally, "performance is keyed and marked. People who perform call attention to it as performance." Examples of this could include the introductions of new songs or portions of the performance and various kinds of acknowledgment of the understood moments in the passage of a performance, such as walking offstage at the conclusion of a concert only to return (surprise!) for the encore or the simple emotional interjections of "Amen!"

This constellation embedded within the concept of performance takes place within a given community, in a context familiar to both the participants and those in attendance (between whom the line is not always clearly drawn). When a folk event is removed from its context of origin, it is no longer a folk event but becomes something else: a presented manifestation of a traditional culture that cannot operate within the same parameters of community mores from which it is drawn. The presentation of ethnic art to outsiders immediately raises fundamental issues. "Egyptian tomb furnishings and Renaissance altars—to say nothing of African art—are routinely exhibited in art museums without a clear examination of even the most basic questions," writes curator Susan Vogel. "Can they be regarded as art in our sense? Were they made by people who thought of themselves in terms that correspond to our definition of 'artist'? If not, how do we acknowledge that while displaying them in art museums?"[9]

The importance of context to the validity or authenticity of folklife has been the subject of some debate, but it seems certain that the pleasures of singing *Sacred Harp* hymns in the traditional square in a meetinghouse somewhere in southern Appalachia are at some remove from the experience of hearing shape-note hymnody presented, however carefully, from the proscenium stage of a performing arts facility in an urban center. For the folks in that Carolina church, the performance of those stanzas is intertwined with their own individual and collective memories, stretching to include the times past when they were learning the songs and sang them

equally beautifully, evoking recollections of neighbors and the ongoing sagas of the community they call home. Thus, community resides within the embrace of memory, in which dwells the traditions of a culture.

Human memory, however, is notoriously fallible. Our perceptions of the past are constructed, at least partially, by the needs of the present and can change over time. "What is *traditional*," points out Robert Cantwell, "at a particular historical moment, may already have been constructed commercially, a generation or so earlier."[10] Homi Bhabha points to the multitude of pressures that bear on the creation of any tradition. "The recognition that tradition bestows is a partial form of identification," he writes. "In restaging the past it introduces other, incommensurable cultural temporalities into the invention of tradition."[11] Bluegrass music, a style that many Americans would identify as the quintessential backwoods musical tradition, was only invented in the decade following World War II. In fifty years, it has gone from the startling and brilliant innovation of Bill Monroe and Earl Scruggs to a piece of hallowed heritage replete with hidebound traditionalists who will brook no compromise with their concept of the genuine article.

Traditions are put to varying and sometimes oppositional uses by different segments of any community. Cultural conservatives—religious fundamentalists, for instance—often invoke them as rigid guidelines for social behavior. Many contemporary artists utilize them flexibly as meaning-laden tools for expression both within their own communities and across cultural borders. Political and social activists employ them tactically as symbols of ethnic pride, resistance, and individual identity. During the several referenda on Québécois independence, traditional music was deftly employed as a political tool by separatist politicians. "It got to the point," recalls fiddler Guy Bouchard, "that just getting onstage and playing those tunes was considered to be a major political statement."[12]

While all of these connotations for traditionality spring from the common source, the varying perspectives of individual culture bearers results in a wide range of insider attitudes regarding what does or does not constitute an authentic representation of tradition. Moreover, none of their positions can be reasonably declared by an outsider to be more valid than another. If an insider says it's art, then it *is* art.

❖ ❖ ❖

Therein lies an enigma for those involved in facilitating public culture, who must make selections about what to engage and what to avoid based

on determinations of authenticity. The modest funding available for traditional and ethnic arts in America is distributed by agencies that are dominated by academic folklife professionals, not by traditional ethnic artists. "Authenticity is not about factuality or reality," a museum curator once quipped. "It is about authority. Objects have no authority; people do. . . . The work of university-based scholars is the voice of authority upon which history exhibitions frequently rely."[13]

Anthropologists, ethnomusicologists, and folklorists in public agencies and private foundations have promulgated determinants of authenticity that often diverge from the viewpoint of insiders and may not always serve the immediate needs of ethnic communities. But they are cycled through the cultural stream as important and officially sanctioned conceptions, often returning to affect insider perceptions of their own culture. Fiddle tunes approved by the festival's folklorist, basket weaves found desirable by the museum curator—these are traits that are often selected by culture bearers as particularly valuable and passed down as such in tradition.

Most bearers of ethnic traditions have very finely tuned aesthetic sensors, which can tell them who is getting things right by their cultural standards and who isn't. This often boils down to matters of personal taste. The concept of genuine or authentic culture as a measurable quality isn't a part of their equation. It is a construction of the academy, embodying a set of implicit assumptions that are part of the received traditions of scholarship. "Claiming to unveil the truth to convey information regarding some aspect of social reality, scholars construct the very Other they purport to describe," points out anthropologist Charles Briggs. "By invoking hierarchically ordered oppositions, such as folk or traditional versus modern, authentic versus inauthentic, or Western versus non-Western, scholars construct images of themselves and the objects of scholarship, as well as link them, often hierarchically."[14]

Authentic, as it has been used by academics to describe ethnic traditions, carries with it a Eurocentric frame in which both a genealogical specificity and a romantic association are at play, becoming determinants of worth. In nineteenth-century Britain, when collecting the songs, tales, and artifacts of a rapidly disappearing pastoral culture became popular among the educated classes, salvage folklore—which continues as a major force in the growth of archives and collections throughout the world—was born. "That a class struggle was involved becomes evident when we notice that the pattern of life surrounding the country gentry and the manor house was developed during this period of early modern Europe," writes

Roger Abrahams. "These country seats grew out of an official enclosure policy that took land out of active agricultural production and turned it into parklands, pasturage and new woods, thereby dislocating much of the peasant population from the country landscape. There are manifest ironies involved in this process of sentimentalizing a way of life only after those who once practiced it have been taken from the land."[15]

Romantically idealized cultures, the endangered remnants of which folklorists seek to nurture, are viewed as the prey of a rapacious industrial era and international mass culture. "Both folklore and anthropology emerged in the late nineteenth century in some part out of this desire to counter the excesses of modernity," continues Abrahams. "In constructing a notion of tradition out of commonsense ideas of the past, the two fields shared a discomfiture with what Franz Boas called 'the overbearing self-sufficiency of modern culture' and the ongoing feeling that many valuable dimensions of the human experience were being lost in the face of rising cosmopolitanism."[16] The elite gentlemen who were in the process of creating the social sciences constructed a vision of traditional culture that compensated for the ethical deficiencies of industrialization while maintaining a position of dominance over its practitioners.

Since its foundation, then, academic folklore has had this explicit mission toward traditional culture of "saving it before it disappears." The academy legitimizes the folklorist's authority to determine what is to be saved and what is not. Its classifications of artists and art forms, and determinations of authenticity, have been superimposed on the subjects of inquiry, restricting acceptance to specific genres or repertoire that fit into the examiners' hierarchy. When early folksong collectors such as Cecil Sharp visited Appalachia, they came with a predetermined concept of what constituted folklore, and it didn't include ragtime or Tin Pan Alley songs. They were completely disinterested in enormous portions of the music mountain musicians actually played: they wanted ballads.

Such prejudicial cultural screening is far from dead. I was approached recently by a folklorist working for a major arts festival who was looking for Franco-American performers. He wanted the *real thing*, he explained, not "just recycled *Bonne Chanson*"—a reference to the famous collection of French Canadian folksongs. Published in Québec in 1937 by Father Charles-Emile Gadbois, *La Bonne Chanson*[17] popularized folksongs selected for their religious and patriotic inspirational value. Advanced by the clergy as representative of the best of Québécois musical culture, the book was actually a collection of bowdlerized versions of those songs that supported the church's position and teachings. Gone was the repertoire of

risqué ballads, songs that pointed to the failings of priests, encouraged social mobility, or questioned authority. Simple and popular children's songs prevailed, songs that everybody knew. The energetic Father Gadbois organized dozens of festivals, concerts, and congresses to advance his version of French Canadian heritage. His proselytizing yielded substantial fruits. As the memories of emigrant Québécois south of the Canadian border lapsed, *La Bonne Chanson,* which was present in every church and many homes, became canonized as *the* source for the music of the old country. Franco-Americans embraced and passed down this repertoire, often unaware of its actual source. Today, *Bonne Chanson* material is the mainstay of Franco-American song traditions. Its songs are known and well loved by most New Englanders of French descent—but it is not approved by folklorists who know its history.

Such manifestations of arbitrarily labeled inauthentic popular culture have frequently been scorned by folklore professionals, as have genuinely traditional traits, such as overt racism or anti-Semitism, which exist in some communities but do not suit academic ideology. This construction posits a dichotomy between tradition and modernity as static, mutually exclusive states, denying the interpenetration of cultures that is perhaps the most prominent feature of tradition in the United States. The general reflexive reappraisal within anthropology and related disciplines during recent years has adopted a far more flexible model of tradition, but the old versus new posture remains deeply embedded in popular consciousness.

✧ ✧ ✧

A cornerstone of this reified value system of authenticity is based around the primacy of race or nationality as a cultural determinant. "Ordinarily," states a federal traditional arts grant application booklet, "those most valuable and most authentic practitioners of the folk arts have been brought up within a traditional community, learning the repertory from their own seniors and absorbing the style as they live the life that the style and the repertory represent."[18] Ethnic bloodlines, then, are one of the primary criteria for an officially authentic and thus valuable traditional artist.

These notions about authenticity have invariably drawn prickly distinctions between traditional artists and interpreters who have learned the art forms of cultures into which they were not born. "The former," writes folklorist Shalom Staub, "are implicitly understood to be the true folk artist and, therefore, the appropriate subject of public programming."[19] He continues, "The characteristic division between traditional and revival

artists . . . reduces a complex process into static categories and those cat-egories then become the basis for funding consideration."[20] Outsider in-terpreters of ethnic culture are viewed as tainted with the forces of com-mercialization and modernity, which pose a threat to the real folk artists. Ironically, such revivalists frequently project more extreme attitudes about the conservation of their adopted cultures than do the real ethnic tradi-tionalists, adopting stringent guidelines of purity sometimes far removed from those of communities. Such purists might adamantly defend a par-ticular phrasing or fingering as the *right* way to play a famous Sidney Bechet clarinet solo—even though Bechet was known to be a florid im-proviser who would never have played the piece that way twice.

Something about allowing these interpreters to represent communities that have been marginalized by American mass culture—particularly nonwhite cultures and those of distinctly working-class lineage—strikes many within the arts funding establishment as just plain wrong. "White, middle-class people who are seen as folk music revivalists are the enemy," says folklorist Burt Feintuch. "And it's really problematic: when your au-dience is sometimes those revivalists; when representing traditions that are seen as marginalized or in decline in some way has an intention of revitalization or revival as part of it; when major figures in the field are old revivalists in the folkie sense of things—it's really complicated."[21]

Increasingly, too, the divisions between traditional and interpretive artists are not always clear. There are revivalists who are part of ethnic communities and make conscious efforts to reinvigorate fading traditions. Conversely, there are also aesthetic pioneers within each culture, who may use ethnic traditions as a point of departure but introduce all manner of new and foreign material to their work. Performers such as jazz saxophon-ist Ornette Coleman or Norteño accordionist Esteban Jordan are without question a part of the grand sweep of their respective traditions, but they are also responsible for the introduction of wholly new aesthetic attitudes that fly in the face of the folklorist's idealized notion of tradition. Within their own communities are conservatives who disavow their work. In other cases, revival musicians who have worked extensively with the bearers of endangered traditions (sometimes of little or no interest to insiders) have themselves become the culture bearers within ethnic communities. Some-times, outsiders find more value in a community's traditions than the children and grandchildren of senior insiders. They occasionally become informal apprentices, absorbing practice until one day they are in a po-sition to pass the knowledge along, perhaps to another generation of in-siders, often not.

Barre Toelken suggests that some of the reasoning behind this *can a white boy really sing the blues?* argument may be specious. "[T]he question of whether the group is a folk group will rest not on surnames or skin color or genetics, but on the existence of a network of dynamic traditional interactions," he writes. "An African American who does not participate in any Black traditional systems is not a functioning member of any Black folk group. Anglo Americans who *do* participate fully (language, custom, dance, food, etc.) in an American Indian tribe may be said to be members of that folk group—whether or not their grandmothers were Cherokee princesses—while someone who is genetically one hundred percent Native American may not be a member of a tribal folk group if he or she does not participate in its folk customs. Thus we must look at the nature of the dynamic interaction, not at superficial details."[22] Or, as Hal Cannon, creator of the Cowboy Poetry Gathering, describes his own criteria for determination of folk authenticity: "It's a matter of devotion. If somebody from outside of a community shows devotion and longevity, they're there as far as I'm concerned."[23]

This leads to a more flexible model of membership in a traditional community. One can gain entry by chance or by choice—an individual may claim membership to the extent that he or she embraces and participates in the community's myriad manifestations. A flexible approach also can account for individuals' frequent participation in multiple communities and their adherence to several, even conflicting, modes of tradition. This sliding scale would result in multiple versions of insider knowledge, varying with the subject's position along the continuum and rendering academic determinants of authenticity meaningless. If authenticity can be judged from any point along a yardstick, its measurements become subjective. "I see all arts existing along a kind of spectrum," says Toelken, "ranging from expressions in which community values and aesthetics impinge upon the artist to expressions in which the artist impinges upon culture."[24]

Such a position surely presents a more realistic perspective on the complexities of tradition, representing ethnicity as a multiplicity of distinct insider possibilities, but it also tends to blur the emergence of ethnic identity that has been central to the multicultural agenda. Forming a collective identity from disparate individual positions is a challenge; recognizing and responsibly presenting the produce of such a collective from the perspective of an outsider from the dominant culture requires a high degree of sensitivity to nuance—much of which, due to their own accumulated cultural baggage, outsiders are certain to miss.

This relativistic approach can also minimize the real distinctions among ethnic groups, the differences in worldview that are at the center of cultural identity and practice. Most African Americans really do experience reality differently from most European Americans, and no matter how much devotion an outsider might have for the study of another culture, on a fundamental level, he or she will always remain an outsider. Barre Toelken's primary area of scholarly research over a long career was the interpretation of traditional Navajo trickster stories—until he inadvertently stumbled on a domain of Native witchcraft. After his investigations had disastrous results for his friends, and informants within the tribe had threatened him and his family, he came to the "bothersome realization that the substance of my fieldwork has brought me to things beyond my capacity to understand or control. That it took me forty years to learn enough to know I was over my head should stand as a precautionary example for anyone engaged in fieldwork outside his own culture; that my flawed preliminary findings are still quoted approvingly by colleagues who have not followed later developments should stand as a lesson as well as a sobering comment for all of us on our shared scholarly disinclination to re-think."[25]

Perhaps it is exactly such rethinking, and further rethinking, that offers the possibility of approaching the understanding of another culture. Its dynamic traditions present a moving target; our own cultural preconceptions create a shifting field that renders accurate calibration on that target exceedingly difficult. How close we can come will depend on our resilience, candor, dedication, and willingness to continually revise our assumptions in light of the incoming data. If we are doing our job properly, we will have few answers and many questions. Apprehending the traditions—the many competing, cohabiting, and conflicting microcultures—of an ethnic group remains the first and most daunting challenge of arts professionals who are engaged in culturally diverse initiatives.

American mythology holds that this is a country where individuals can make of themselves whatever they choose. If tradition provides an anchor to the roots of culture that sustain community identity, postmodern America presents the individual with a range of choice that exceeds comprehension. Traditions from hundreds of ethnic cultures meet in the marketplace with those of corporate capitalism; they intersect and penetrate each other, creating recombinant formations that assume the mantle of tradition themselves. "I'm not for a solid anything," says the social philoso-

pher Cornel West. "I begin with radical cultural hybridity, an improvisational New World sensibility. I always think that we are in process, making and remaking ourselves along the way. I see it in Louis Armstrong, I see it in Sarah Vaughan, I see it in Emerson's essays, I see it in Whitman's poetry about democratic vistas."[26]

America puts ethnicity to the test. It presents a multiplicity of challenges to the sovereignty of tradition in the formation of social solidarity. Here, our traditions are rechannelled into new social configurations. We join into new associations with their own traditions as bulwarks of group identity. Religious affiliations; occupational associations; shared circles of political and social awareness; voluntary communities of enthusiasts for reggae music, computer hacking, or hot-dog skiing all depend on maintenance, and continual updating, of internal traditions to function effectively for their members.

The facets of ethnic identity that successfully compete in the maelstrom of American society must be based in supple, adaptable traditions that can be reconciled within the totality of the contemporary environment. Many traditions associated with ethnicity are quickly discarded by immigrants to the United States. Agricultural folkways are no longer relevant in an urbanized population. Habits of conservation appropriate within economies of scarcity seem miserly in the abundance of the American supermarket.

But many other traits of ethnicity are selected for continuation in this new land. Muslims are building mosques, and Buddhists are building temples all over the country. Thriving circuits of ethnic wedding bands—from Croatian *tamburitzans* to Cambodian *mohori* ensembles—exist throughout the United States, operating completely outside the sphere of public arts presentation. Members of ethnic communities select these traditions for continuance because they answer the needs of individuals living in contemporary society. Such traditions have to be supple enough to withstand various kinds of alteration to fit within their new environs. Offerings once made of bamboo fronds are now created from recycled plastic. The muezzin's call to prayer is broadcast through a public address system—at a volume that will not disturb the neighbors. In Greece, wedding bands typically play songs and dance music strictly within distinct regional styles. In America, since few local Greek communities can generate the critical mass to support musicians performing in only a single regional idiom, wedding bands have shifted to a pan-Hellenic repertoire that satisfies the musical tastes of guests from throughout the country. By selecting specific desirable traits and adapting themselves to the local

conditions, such traditions maintain a role in the lives of the communities they serve.

"A second feature, functioning in tandem with selectivity," writes Alan Jabbour, "is tenacity. Americans partake amply in the custom of bewailing the loss of customs. The fact is that, within the parameters of selectivity, ethnic traditions maintain themselves very well and for long periods in the United States. Once selected for maintenance, traditions are clung to with surprising vigor, belying the predictions of those who assume they will vanish within a generation."[27] These living traditions continue to be touchstones in the lives of millions of Americans, people who deploy their customs in building their own communities, and in the process encounter their neighbors.

These folks have their own traditions. Sometimes, they have traditions of intolerance for others' traditions, but often enough ethnicities coexist peacefully, if not in complete harmony. After a time, they might start borrowing selected features from each other, subtly incorporating them within the context of their own traditions. But then, this being America, Juanita and Abdul elope (in a car they borrowed from their friends Yitzhak and Yoshiko). Cohabitation can frequently have a dramatic impact on the traditions of ethnicity, with children being the chief beneficiaries of dual or multiple heritages and a primary battleground upon which ethnicities contend.

The process is often confusing, sometimes exhilarating, but the resulting hybridized cultural forms are pervasive. "Recombinant development," adds Jabbour, "that is to say, creativity—must be regarded as fundamental to the concept of tradition everywhere; but on the American scene, with its extraordinary flux and interaction, recombinant development is so conspicuous and continuous that it must be regarded as a special hallmark."[28] Some of the results rank among America's greatest contributions to world culture: hybrid artforms such as jazz (African American blues and improvisational chutzpah wedded to European song forms and instrumentation) and rock 'n' roll (hillbilly country and western meets African American gospel and rhythm and blues) are symbols of the vitality of American culture throughout the world and support billion-dollar industries.

This process of *creolization* (a term borrowed from linguistics, which means mixed cultures) is the subject of much recent scholarship that examines culture as a dynamic. "Creolization is cultural creativity in process," write Robert Baron and Ana Cara. "When cultures come into contact, expressive forms and performances emerge from their encounter,

embodying the sources that shape them, yet constituting new and different entities. Fluid in their adaptation to changing circumstances and open to multiple meanings, creole forms are expressions of culture in transition and transformation."[29]

When cultures collide, they frequently unleash great bursts of creativity among a portion of each culture's artistic community. Aesthetic sensibilities like to be fed, and a neighbor's culture can often provide a hearty meal. The results of this synthesis can provide peak moments. "I'm interested in where the bonds creatively dissolve," says *American Routes* radio host Nick Spitzer. "When Jerry Lee Lewis walked into Sun Records and just *drummed* on the piano like he learned from black blues and gospel performers back home—and producer Sam Philips, who was looking for white musicians that 'crossed over' in their sound, said, 'Let's put a big slap of echo on that'—I think that's great American art history."[30]

Such extraordinary innovations could not have developed without their grounding in local traditions. The fact that the whole world listens to country music today doesn't change its lineage. Any visitor to Nashville should be able to tell you how it grew from the traditional music of small mountain communities in the American South. The great innovators of the country sound—Uncle Dave Macon, Hank Williams, Roy Acuff, Ernest Tubb, Patsy Cline—considered themselves to be traditionalists. In fact, they were the heroes who kept their tradition vital by pioneering its forward boundaries. The distinction between *traditional* and *contemporary* represents a false dichotomy. Plenty of artists, including most of those we revere most highly, are both, without compromise.

I once saw Seamus Egan, who is regarded as among the greatest flute virtuosos of Irish traditional music, performing for a group of high school students.[31] One student asked, "Do you just play the same tune over and over again?" (Like Native American music or European opera, Irish music can all sound the same if you're an outsider.) Egan offered a brilliant explanation. "Here," he said, "is how the tune is written in O'Neil's"— referring to the weighty standard book of Irish fiddle tunes. He picked up his flute, and played a straightforward sixteen-bar melody, without any ornamentation. "That's how the tune is written," Egan explained. "But no musician would ever play it that way. The written score is just a skeleton. What you can do with it is the measure of your musicianship, and unless you want to get bored very quickly, you won't play it the same way twice. Let me demonstrate: I'll play the tune straight one more time, and then I'll show you how *I* might play it."

Egan proceeded to play through six or eight cycles of the tune. As prom-

ised, the first iteration was plain, a stripped-down version. The second time through, he introduced a series of trills, slurs, and other embellishments. The third time, he transposed sections of the tune into different octaves and embellished it further. The fourth repetition introduced wholly new and original melodic fragments. By the time Egan got to his last repetition, the only thing left of the original tune was the introductory phrase, the final cadence, and the general shape of the melody. You could recognize where it came from, but between start and finish, he had improvised an entirely new piece of music. It was still very firmly within the frame of the Irish tradition, but it was also a totally original exposition of creativity. He might as well have been playing jazz; such was the freedom that his virtuosity afforded. Egan was able, in that same instant, to be a devoted master of his chosen tradition and a radically innovative artist, using the raw materials of his heritage to create something wholly new.

It is a great irony that innovation and tradition are such close friends. Without constant reinvigoration, traditions ultimately falter and fail; without tradition as an anchor and constant point of reference, innovation is empty of content. Tradition and innovation need each other. It can even be said that in America we have a longstanding tradition of innovation. Restless searching for the next new thing is an assumption among many, even most contemporary artists. Painters, writers, rock bands, and cinematographers make a fetish out of freshness.

The Center for Cultural Exchange once commissioned a new piece of choreography from two dancers from opposite sides of this aesthetic chasm.[32] Chan Moly Sam learned Cambodian classical dance as a girl under the strict tutelage of dance masters at the royal palace in Phnom Penh. Among the foremost surviving bearers of her tradition, she strives to impart her artistry to students as exactly as she possibly can, without altering a single detail. Continuity is the dominant value. English choreographer Jonathan Lunn comes from a very different world. In postmodern dance, it is innovation that is demanded; every dancer aspires toward creative originality. In practice, the two dancers found themselves drawn into their opposite's realm, in effect changing places. Lunn had been thinking for some time about ritual, its place in performance and importance in our lives, and found in Chan Moly a deep source of experience and inspiration. Chan Moly, who had never considered the act of making up her own steps, used Lunn as a mentor as she created her own very first choreography. The result was neither Cambodian nor contemporary choreography, but both simultaneously.

The commercial sector, of course, plays a dominant role in the turbu-

lent relationship of tradition and innovation. Omnivorous and ubiqui-
tous, popular culture appropriates, assimilates, and abandons facets of
ethnic heritage faster than most communities can react. And the market-
place is immune to concerns about authenticity. The heated polemics
among traditional artists and academics (actually, it's mostly among the
academics—the folk artists just go on doing their work without too much
regard for the finer points of theory) are irrelevant to the perpetual require-
ment of something new to sell. If apparent association with a traditional
culture is deemed a commercial advantage, produce will be marketed and
accepted as *authentic.*

The factions contending over the concept of authenticity each view the
concept from substantially varied perspectives. What you see depends on
who is doing the looking. Tradition bearers and academics will not share
the same frame of reference—and neither will adhere to the fickle deter-
minations of the marketplace. The idea of authentic cultural representa-
tion has importance for all three groups, but it is deployed differently in
each case and used to suit each group's own purposes. Perhaps the most
interesting zones are the areas of overlap, where culture change takes
place.

In some cases, commercially motivated outsiders catalyze tradition
bearers into reformulating and energizing their own heritage. In the ear-
ly 1960s, Chris Strachwitz, an expatriate Silesian record producer, was on
a music scouting trip through Louisiana, when he encountered a Creole
accordionist named Clifton Chenier. Chenier and his brother were play-
ing the blues in a bar, and immediately attracted Strachwitz's attention.
"He realized that something important had happened," recounts Joe
Wilson, "that this music from the back porch, and the little push and pull
accordion and the rubboard had been moved over to the bar. He was
bright enough to know that that was an important step. He recorded some
of these people and he persuaded Clifton Chenier—who'd been doing
blues for years and had some big blues records—he persuaded him to sing
a song in French. Clifton was all against it. Clifton said, 'Well I like that,
my grandma likes that—but these people out here in these clubs, they
don't want to hear any of that. You've got to be crazy!' But he did it."[33]

Strachwitz recalls the encounter: "Then when we were recording, he did
this one song, and it just sounded so great. As soon as he finished, he came
out and said 'I gotta call my old lady; she gotta hear this one.' And he
called her up and had the engineer play it for her over the telephone. It
was all in French, and it was actually called *Tu les Jours C'est Pas la Meme
Chose,* but I had no idea what he was saying and when I asked him how

to spell that he said, 'Spell it any way you want to.' I said 'Can I just call it *Louisiana Blues*?' and he said, 'Yeah, put that on there.'"

"That little forty-five record," says Wilson, "became a regional hit. Clifton was quite astonished. It went on to make Clifton a regional star and all that. . . . If I were naming the people who were the creators of the zydeco form, the person who I'd have to name as being most important would be Chris Strachwitz."[34]

Today, of course, zydeco has become more than a regional phenomenon. Artists from Louisiana routinely tour throughout the country, and many metropolitan areas have their own local zydeco ensembles, who perform with accordions, rubboards, and French lyrics. Strachwitz stumbled onto a completely new market for an entire form of cultural expression that came into existence through his own urging. He didn't create zydeco, the way Thomas Edison invented the light bulb, but acted as a catalyst for cultural innovation, and the invention of a new tradition.

Widespread commercial success does not go unnoticed by traditional artists, and local styles shift to accommodate popularity, to the distress of folklorists and many other cultural observers. Repeated endlessly, this process has a homogenizing impact on local cultures that poses an enormous threat to our collective global heritage: Alan Lomax's "grey-out."[35] Like the rain forests or petroleum reserves, he identified humanity's wealth of traditional folkways as an essentially nonrenewable part of our global heritage. Because of the unprecedented reach of international pop culture, much of this legacy is now threatened.

This process is taken to an extreme in the contemporary art market. "If there is a main problem in American art today," says critic Tom Piazza, "it is not that we need the new to unshackle us from a suffocating and outmoded tradition. The new is constantly pumped out, by the ton and 24 hours a day, into the esthetic rivers, reservoirs and gullies of our culture, and nobody needs to go looking for it. With all the economic force of corporate profit and advertising behind it, pop culture, with its Billy the Kid ethos, has in fact become the new establishment. In a truly Orwellian irony, the new *is* the status quo."[36]

That much of the fizz of mass cultural phenomenon lacks staying power is evident in the rapidity of turnover. Last year's model no longer holds allure; in a decade it will be utterly forgotten. This is not often the case with innovations that draw their inspirations from ongoing tradition, that engage Long Now culture through a fresh lens. Bubblegum pop is disposable; hip-hop draws on ancient roots in African American toasting traditions and the wandering griots who preserved the history of West Africa.

The former is new on the surface but possesses no center; the latter is a brilliant synthesis of traditional linguistic play and contemporary technology, using an old strategy to address the most contemporary of issues.

The point here is that the innovative strategies that offer substance to their communities of users tend to be those that maintain their connection to the traditions that spawned them. These evolutionary cultural traits flourish because they embody meaning, as understood within a community. Often, such innovations become the vehicles for reaching beyond a community's borders, to find new audiences. Hip-hop comes straight out of the African American aesthetic but is now popular across racial lines and across international boundaries. Tradition's focus is inward; innovation usually looks out to the world.

Traditionalists often decry the results of innovators' purloining of their resources. The Rolling Stones got far richer than Muddy Waters. The information revolution that made vast oceans of raw aesthetic material available for anyone with a camera or tape recorder has generated an equal ocean of denatured appropriations, art that attempts to draw on traditions as if they existed free of any contextual underpinnings. This is art that borrows the forms of traditional artistry while missing the substance behind them. The results are short lived, like this season's runway fashions. Such borrowings are a permanent and prominent part of the cultural landscape.

The art world, always replete with bohemian pretensions and self-styled pioneers, was an early champion of the multicultural agenda and victim of its pitfalls. Debates about the uses of tradition continue. Did the early modernists and their many progeny have the "right" to appropriate, and profit by, the creativity of "primitive" peoples? Were black and Latino artists suddenly fashionable because of their art, or their race? Did postmodernism usher in an era of free access to fragments of everybody's cultures, or did multiculturalism, like Black Power, demand separate but equal recognition for all as discrete entities? Was intercultural collaboration valid at all? Or did it invariably contribute to the dissolution of the distinctions that give culture its shape? "Understanding intercultural process," says art critic Lucy Lippard, "is equally divided between understanding differences and sameness. . . . We have not yet developed a theory of multiplicity that is neither assimilative nor separative."[37]

All of these questions turn on the relationship between tradition and innovation, an interaction that demands a both/and analysis, rather than an either/or. It is not as though we must exchange the political convenience of cultural specificity for the open-ended ambiguity of a broad

cultural relativism that encompasses the range of recombinant cultural formations. If we don't assume both, we deny the dynamic that sustains culture. "A creole metaphor of culture accepts that this is a realm where complexity, instability, ambiguity, semantic elasticity, contingent meaning, and creativity converge and where the focus on the processual, combinatory, and emergent aspects of culture is paramount," writes Spitzer.[38] Cultural democracy embraces both new and old and finds no conflict there. On the contrary: cultural evolution is a non-zero-sum game.

Presentation and Participation

At an Irish community meeting, I pressed the assembled activists to define what their culture required to sustain itself locally. "We need access to the best Irish artists," said one woman. "Our children don't even have the opportunity to *reject* their heritage," she moaned. "They get to see so little of it, they have no basis to make a comparison!" I had heard this before—an internal imperative that is echoed in nearly every ethnic community in America. "We need to put on a big show," insisted another participant. "Most people in Maine don't even know we're here. Our culture feels invisible most of the time." This, too, is the overwhelming perception of minority communities from coast to coast. They disappear under the deluge of the mainstream.

These two poles—the need for internal cultural development and the desire to demonstrate ethnic vitality to the rest of the world—are the hubs around which cultural democracy turns. One is aimed at insiders and is

Franco-American accordionist Dickie Morneau plays for dancers at Biddeford High School. Photo by Tonee Harbert.

all about participation; the other is directed externally and involves public presentation. There is substantial crossover between the two realms, as insider participants become the subject of presentations, but each embodies a unique set of characteristics. Communities, their audiences, and the cultural facilitators who catalyze their interactions stand to benefit from a clear understanding of the processes of participation and presentation. Both are important, necessary, and largely assumed without examination by all parties.

During the last quarter of the twentieth century, a branch of anthropology called performance studies uncovered many of the implicit assumptions present during the realization of any cultural event. From random encounters on street corners to majestic religious rituals or the grand opera, our experiences are culturally patterned. They all also share some degree of adherence to an abstract set of rules governing the performative process: events are prepared, begin, unfold over time in a fashion that is culturally determined, and end, having created variable levels of emotional experience for those in attendance, both performers and audience. These experiences can vary greatly in their intensity and meaning, but they are predicated on a complex interaction of environmental, political, social, technological, theatrical, and aesthetic referents, penetrating each participant's cultural frame. To understand what happens in the course of any sort of performance, it is important to consider the dynamic play of these various elements and how they combine to create the event.

Eurocentric scholars have generally focused their attention regarding performance theory on the event itself, the show that is of paramount importance within the Western aesthetic framework. But in many cultures, performance is merely the residue of a process of far-reaching community involvement; preparations for the big ceremony can carry more content than their actualization as performance. Theorist Richard Schechner points out that the performative process contains substantially more than just the obvious public component. "[E]very performance event," he states, "is part of a systematic sequence of occurrences. Performance includes six or seven phases: training, rehearsal, warm-up, the performance, cooldown, and aftermath. Not all performances in all cultures contain all these phases—but finding out what is emphasized and what is omitted is very instructive. For example, codified traditional performances—kutiyattam and noh, for example—demand extensive training but little or no rehearsal. . . . But where newness is prized, where performers are expected to be able to play a number of different kinds of roles, training is less important than intense *ad hoc* workshops and rehearsals to develop the

idiosyncratic quality of each individual production. The cool-down and aftermath phases of performance are also very important. Aftermath can be a slow unfolding process involving how performances are evaluated, how the experience of performing is used by the community. . . . Cool-down is more immediate, dealing with knitting the performers back into the fabric of ordinary life. . . . In America, many performers, after a strenuous show, will go out to eat, drink and talk—often boisterously. Someone who doesn't know performers wonders at how much energy they have left. But these celebratory bouts are not really 'after the theatre' but part of it—a way of cooling down, of reintegrating into ordinary social life."[1]

In many performances, from the beginning, a psychic gap separates the performers from the public. Performing artists often view the content and meaning of their work in terms very different from their audience, even within the same culture. Most dance-band musicians are usually very focused on tunes; they have an avid melodic interest. Their audience, the dancers, perceives the sound much more in terms of rhythmic drive; the melody is nearly irrelevant. A performer's conception of what happened in a given event can be dramatically at odds with the version given by a member of the audience for the same performance. "The great big gap between what a performance is to people inside from what it is to people outside conditions all the thinking about performance," comments Schechner. "These differences can be as great within a single culture as they are across cultural boundaries."[2]

This dichotomy between the performer and the audience, between those engaged in creation of an event and those involved in receiving it, was analyzed by Erving Goffman.[3] He used as a distinguishing characteristic the individual's access to *front* and *back regions*. The front region is the public area where access is open and the audience is welcomed. In a theater, this would be the lobby, concession areas, and those portions of the theater proper that are not specifically designated as performance zones, usually everything beyond the footlights. Back regions are the areas, out of the public's view, where the performance is prepared, props are readied, artists relax or warm up, and technical needs are addressed. In a theater, the back regions consist of the stage and wings, fly loft, light and sound booths, dressing rooms, scenery and costume shops, and business offices. This is a privileged domain. The audience is unwelcome here, as a rule, and the success of many performances depends on the audience's ignorance of various theatrical contrivances. When Toto pulls back the curtain revealing the Wizard of Oz, the performance is botched because the sanctity of the back region has been violated. "A back region," writes

sociologist Dean MacCannell, "closed to audiences and outsiders, allows concealment of props and activities that might discredit the performance out front. In other words, sustaining a firm sense of social reality requires some *mystification*."[4]

It is a form of mystification, though, to which the participants willingly submit. Through this process of self-mystification, or implicit agreement to accept the staged event as authentic, the audience opens itself to the power inhering to the performance. As a performance event unfolds, the various aspects that combine to flavor the performance—the time of day; the weather; the ambience of the theater or performance space; the temperature and smell of the room; the size, composition, and disposition of the audience; the lighting and acoustics onstage; the attitude and comfort level of the artists; and the ritualized flow of the event—focus themselves in the energy generated through the performance. "While performing, a certain definite threshold is crossed—that moment when spectators and performers alike sense a 'successful' performance is taking place," writes Schechner. "This intensity of performance has been called 'flow,' 'concentration,' and 'presence.' Performances seem to gather their energies almost as if time was a concrete and manipulable thing. . . . Understanding intensity of performance is finding out how performances build, how they draw spectators in, how space, scripts, sounds, movements—the whole *mise-en-scéne*—are managed."[5]

Psychologist Mihaly Csikszentmihalyi has analyzed how individuals generate and respond to what he calls the *optimal experience,* moments when we are so perfectly attuned to our environs and activity that our perceptions of reality are altered. "Flow," he writes, "is the way people describe their state of mind when consciousness is harmoniously ordered, and they want to pursue whatever they are doing for its own sake."[6] Artists at work find such a state frequently accessible.

Cultural experience can also unquestionably generate the flow episode, bringing to audiences a sense of transcendence, a heightened consciousness. "Before the advent of sound recording, a live musical performance retained some of the awe that music engendered when it was still entirely immersed in religious rituals," continues Csikszentmihalyi. "Even a village dance band, let alone a symphony orchestra, was a visible reminder of the mysterious skill involved in producing harmonious sounds. One approached the event with heightened expectations, with the awareness that one had to pay close attention because the performance was unique and not to be repeated again. The audiences at today's live performances, such as rock concerts, continue to partake in some degree in these rit-

ual elements; there are few other occasions at which large numbers of people witness the same event together, think and feel the same things, and process the same information. Such joint participation produces in an audience the condition Emile Durkheim called 'collective effervescence,' or the sense that one belongs to a group with a concrete, real existence. This feeling, Durkheim believed, was at the roots of religious experience."[7] Indeed, the patterning of ritual in all religious traditions carefully builds exactly such liminal experiences, providing a time and place where believers can feel secure and supported in allowing themselves to undergo personal and collective transformation.

This intensity of performance experience generated in the course of an event is responsible for communicating the affect, which contains the value of the presentation. As MacCannell notes, cultural rituals "carry individuals beyond themselves and the restrictions of everyday experience. Participation in a cultural production, even at the level of being influenced by it [as an audience member], can carry the individual to the frontiers of his being where his emotions may enter into communion with the emotions of others 'under the influence.'"[8] In other words, the performance process can lead the individual into an altered consciousness and effect a temporary or permanent transformation in that person's being. Most events fall short of this level of intensity, but the energies generated through performances, the little epiphanies experienced by both performers and audience, surely lead in this direction. A great performance *should* change the audience somehow.

Bart Giamatti, the Yale president who went on to become commissioner of Major League Baseball, theorized that art, sport, and religion all serve the same essential purpose: getting us out of ourselves into a realm of communion. "The purpose of autotelic activity, whether called play or study or leisure or artistic activity, is to fulfill itself without regard to consequence, and in that fulfillment to achieve a state of being, as I have suggested, that is like what religion often describes," he writes. "I believe that sport in Western culture has functioned occasionally as a part of religion but much more expansively and powerfully as part of our artistic and imaginative impulse. . . . Differently but nevertheless in concert, participant and spectator seek that *agon*, that competition with self to make the self over, to refashion or refigure or re-form the self into a perfect self, over and over again."[9] It is this moment of collective recognition that draws people to stadiums, as well as to concert halls, movie theaters, and cathedrals—and that is amplified by all the attendant rituals and rules, the special seating, and awe-inspiring architectural scale.

Anthropologist Colin Turnbull points to "the connection between ritual, drama, and entertainment, all of which are key elements of any rite of passage, and hence of the liminal state to which such rites may lead.... [I]t is a connection that is both explored and exploited expertly and rigorously at almost every stage of the theatrical process."[10] He insists that active participation in such processes and entry into an altered state of heightened perception are prerequisites for accurate understanding of other cultures. Until you're prepared to give yourself over to the Other's gods, you're not likely to attain more than an oblique understanding of another culture. That's a substantial commitment for most of us.

<div align="center">✧ ✧ ✧</div>

Every performance, indeed every social encounter, as Goffman points out, takes place within a *frame* that distinguishes it as a performance. The psychological framing of the event, in the mind of the performer or audience or both, defines what sort of performance takes place. "To frame is to discriminate a sector of sociocultural action from the general on-going process of a community's life," writes anthropologist and performance theorist Victor Turner. "It is often *reflexive* in that, to 'frame,' a group must cut out a piece of itself for inspection (and retrospection). To do this it must create—by rules of exclusion and inclusion—a bordered space and a privileged time within which images and symbols of what has been sectioned off can be 'relived,' scrutinized, assessed, revalued, and, if need be, remodeled and rearranged."[11]

Some performers become performers owing only to the frame through which their audience views their actions. These people, called "Goffman performers" by Schechner, are always unaware that a performance, per se, is taking place. Examples would include a drunk singing to himself on a street corner or a woman whose children have perished in a house fire pouring out her grief for the television cameras. They are acting in a way that seems straightforward and normal to them but is transformed into a performance by the framing provided by the media or by individuals in the audience. A traditional artist, a basketmaker, for instance, is generally not aware of staging a performance, but when a folklorist encounters them, their routine handwork is framed as such.

If some individuals are framed as performers without self-awareness of the frame, others, such as some advertisers and criminals, assume the frame themselves with the intent of deceiving their audience, who should remain unaware of its existence. For the scam to "work," its victim cannot be aware that a performance is taking place. Finally, some performa-

tive frames are present and acknowledged by all, as in athletic contests or most public sector artistic presentations. Everybody knows that a show is taking place, with actors and audience well defined. Some presentations are ambiguously framed. Some cynics would claim that politicians or preachers are masters of the hidden frame, engaged in performances intended to dupe their audiences. Others see their orations as theatrical events that should be viewed as such. Successful orators are able to bridge both hidden and acknowledged frames.

"The main question one asks," according to Schechner, "is whether a performance generates its own frame, that is, is reflexive (self-conscious, conscious of its audience, the audience conscious of the performer being conscious of being a performer, etc.); or whether the frame is imposed from the outside, as when TV crews arrive at the scene of a 'tragedy.' In between these extremes are many gradations of purposeful concealment or information sharing—even what the U.S. Government calls 'disinformation' (what the Nazis called propaganda, what Madison Avenue calls a 'campaign')."[12]

In most performance situations, the frame consists of everything that exists or takes place at the boundary between front regions and back regions. It includes the whole of the visual environment as perceived by an individual in the audience. In a darkened proscenium theater, this focus can become extremely narrow, limited only to a single performer onstage. At outdoor festivals, the frame includes the rest of the audience, what is happening with the weather, the aromas of barbecue wafting past from the adjacent food area, sound bleed from other activities, and the stage manager pacing back and forth next to or behind the performance area. The frame includes the manner of presentation, the presence or absence of interpretive commentary, as well as strictly technical aspects such as the quality of sound amplification. It also includes a bundle of implicit associative components that impact the perception of the event: Is the performance taking place at a location (such as Carnegie Hall or a major national festival) that adds prestige to the presentation? Or does the presentational format detract from the performance? Is the presentation part of a major community holiday, which has positive associations of its own that are borrowed by the event—a gospel concert on Easter Sunday, for instance? Or is its presence an anomaly, without any direct tie to anything? "Frames may be relatively clear and stable in a situation or they may be ambiguous and shifting," say festival hands Richard Bauman and Patricia Sawin. "They may be shared among participants or they may be

held differentially. They seldom, if ever, occur singly, but are characteristically layered or combined in shifting hierarchies of dominance."[13]

The frames offered by public presentation are sometimes dissonant with those assumed by a community. Many African cultures, for example, make little distinction between audience and performers. The "fourth wall" separating front and back regions is porous, allowing traffic in both directions that is usually off limits in arts presentations. Children play and babies cry throughout events; audience members jump onstage to dance along with the performers or "dash" their favorites with dollar bills—and are fully accepted as a part of the routine by all involved; everyone devotes at least as much attention to socializing as they do to onstage content. The typical frame of public presentation, borrowed from the European proscenium theater, clashes with the reality that the community brings to the event, serving neither the artists' nor the audience's needs. A local arts center or theater is probably not the best place to experience such cultures in a manner that resonates with their own social and aesthetic norms.

Obviously, the efforts of presenters have a substantial impact on the shaping of this performative frame. Their actions in back region preparation directly influence what transpires within the frame, and their presence within the performance frame itself—only rarely completely absent—can set the tone for the entire event. Traditional arts advocate Bess Lomax Hawes writes, "On bad days we tend to think of framing as the ultimate co-option of the innocent by a society that is determined to make a buck out of everything that it touches, turning every act into a packageable and saleable commodity. On good days, we hope that we are providing smaller cultures with a defense mechanism whereby they can protect their art forms and carry them into the future."[14]

In a public setting, all of this process, presence, and mystification is rolled into the frame of a *presentation,* a deliberately created event that displays some aspect of a specific culture to an audience. When our contrivances work, what begins as a presented event is, over the course of the performance, transformed into a real event, with the power to change participants and audience. As Robert Cantwell says, "It is magic when the frightful and tangled forces that divide human beings suddenly vanish, effaced by the sheer power and excellence, the authenticity, of performance on the one hand and by the willingness of visitors on the other hand to rec-

ognize power and excellence as such, even if they are unacquainted with the specific cultural values that inform it."[15]

Concert promoters, museum curators, festival organizers, and the directors of urban performing arts centers are all in the presenting business. We take a piece of art and shine a public light on it; we remove a bit of culture from the environment that created it and hope that it will translate to an audience in a dramatically different setting. The act of presentation carries with it substantial authority. Through our choices about what to present, and how it is to be presented, presenters wield power over how cultures—frequently not our own—are perceived. We implicitly assume the responsibility for shaping public discourse about the communities that made the art on display. The quality of our work is a function of our awareness of the complex issues at play in the representation of culture in a public setting.

Obviously, much of the character of a presentation depends upon who is doing the presenting, and to whom they present. A group of Navajo Indians creates a distinctly different event when performing in a ritualized community setting without the presence of non-Navajo than in the performance they deliver for a busload of tourists. A country fiddler who might perform with abandon for dances every Saturday night back home can feel awkward and dispirited standing before a microphone and a seated audience at an urban arts center. Who the performer is in relation to the audience is a central question.

Many traditional performances occur in their own context, with both performers and audience sharing the same knowledge about and expectations for the event's unfolding. A cantor at temple and a rhythm and blues band at a juke joint enjoy this bond with their audiences. In most public presentations of ethnic culture, though, insider artists perform before outsider audiences. The performers onstage have a different set of preconceptions concerning the event that is taking place than the members of the audience. The artists embody a community's frame of reference, and they conceptualize and value the performance in terms of their own culture's aesthetic guidelines. The audience of outsiders—an Anglo-American audience for a Latino dance band, for instance—lacks the intimate knowledge of the tradition bearers themselves. They interpret the performance based on their own culturally conditioned responses.

Sometimes, this response misses the point. The best presenters go to great lengths to bring insiders to events in enough numbers to satisfy the performers' needs for validation on their own terms. The hitch is that, without an infusion of properly responsive ethnic participation at the audi-

ence level, the presentation becomes a shell of its authentic incarnation. Performers fail to receive the appropriate feedback; the crowd fails to correctly interpret the artists' presentation; lacking their customary cues, the performers alter the content of the event. What was already an artificial presentation of an event removed from its context of origin begins to move inexorably away from its roots, usually in the direction of a denatured vision of performance provided by the mass media. Moreover, the attending outsiders miss out on the ambience of ethnicity, the feeling of being in the presence of the Other that significant numbers of ethnic community members in the audience can provide, a component of the performance experience every bit as important as what might be happening onstage. Most people in attendance at such events have no idea that their experience has been compromised in any way.

Attracting ethnic populations to their offerings continues to be a major challenge for public presenters. We're still a lot better at putting ethnics on stage than at getting them into our seats. Language barriers, class, and attitudinal differences make it extremely difficult for arts managers to learn how to make even the most tentative approaches to ethnic communities, some of which, according to Robert Garfias, "have become so large as to be virtually impermeable to entry by outsiders and as difficult for insiders to find a way out. This has been the cause for considerable frustration because now that the arts in America has decided to roll out the welcome mat to all those other Americans, they still seem unwilling to venture forth."[16]

Part of this is attributable to inappropriate content—the programmers do not know enough about insider aesthetics to make informed choices that might attract the community. But programming is only a part of the problem. Often, public presenters can't attract insiders, regardless of the presentation, because the institutional and attitudinal frame that they place around the event is a mismatch with the community's. Ethnic artistry that is presented in a format foreign to the ethnicity will feel distorted and devalued to insiders. Most ethnic communities don't partake of their performance traditions in darkened rooms with all the chairs bolted to the floor facing forward. The frame that most mainstream presenters assume as a positive—the power of beautiful performance facilities— is actually a detriment to acceptance by many communities. In the dialogue about who is presenting to whom, the proscenium stage makes a definitive statement about whose aesthetics dominate before the performer even walks onstage.

Sometimes, ethnic outsiders perform for community members. I am

Croatian by descent, but I have frequently performed at Irish community dances, and I currently perform in a band that plays Middle Eastern music. Occasionally, outsiders can even attain positions of esteem within adopted communities, becoming important tradition bearers themselves. I know an Irish American who is the mainstay of the musical culture of a small Finnish community in Maine. Finally, there is the outsider performing for outsiders, as when Pete Seeger sings a Chinese folksong for his audience at Town Hall, which most likely includes few Chinese. Nobody onstage or off knows if the words are being pronounced correctly— and they don't care. The affect that Seeger's audience bought their tickets to savor was not one of unadulterated authenticity. This is not to denigrate his artistry—none of these classifications comes value laden; great performances happen in all of them—only to point up a distinction in the expectations both the artist and audience bring to an event.

In presentation, this is very important. If an audience has been led, via promotional efforts or interpretive program components, to expect something that is at odds with what comes across in performance, the event will not be successful for the artists, no matter how skillfully they perform. Conversely, if the artists do not understand whether and how their audience fits into the insider/outsider frame of reference, their performance is likely to be troubled.

In the midst of this dialogue between artist and audience stands the presenter. When insiders perform for insiders, there is often no need for presentation. The priest performs mass for his congregation without being contracted to do so by a third party. Uncles tell tall tales to their nieces and nephews without the mediation of an arts administrator. The other performative situations, however, usually require the intervention of an agent who makes it all happen. This person or organization—the cultural facilitator—must have at least some degree of mobility and access within both the sphere of the audience and that of the performers. They must possess enough insider knowledge from both realms to be able to make accurate and responsible decisions about the process of the event.

Cultural specialists such as anthropologists, folklorists, and ethnomusicologists are enabled through their training to act as bridges between ethnic cultures and mainstream arts presenters. Their work sometimes assumes sufficiently long-term, in-depth study within an ethnic community to allow cultural specialists to assemble the multileveled experiential data necessary for an accurate representation of that culture. The folklorist's representation is still simply that—a model of the culture's dynamic, not the real thing. Reasonable issues may be raised about the validity of ac

ademics' claims to be able to speak on behalf of minority communities. But they do hold a key position in the public presentation of ethnic art. A folklife professional who has devoted years to immersion within an ethnic community is likely to have a more thorough understanding of its values and means of expression than most arts administrators. This knowledge affords that professional the power to make decisions affecting both ethnic communities and public cultural expression. This usually takes some form of interpretation, an explanation of the presented culture for outsiders.

Public presentations provide patently artificial contexts for performances; the role of interpretation is to introduce enough elements from the art form's natural context for the presentation to make sense. This is extremely important to the integrity of an artistic offering. "To my knowledge, no low-context communication system has ever been an art form," writes Edward T. Hall. "Good art is always high context; bad art, low context. This is one reason why good art persists and art that releases its message all at once does not."[17]

Over the years, public programmers have devised numerous models for conveying information to their audiences, providing context to their presentations. These include verbal interpretation, ranging from relatively brief introductions of performers, with some background on the tradition practiced by that particular artist and its place within its community, to lengthy minilectures couched in the language of academe; informal workshops that abandon all pretense of presenting even a contrived version of performance, becoming explicitly educational ventures; written program notes or signage that provide detailed interpretive data and tend to be ignored by the majority in attendance; and ethnic self-presentation, in which some experienced artists can provide to their audience enough contextualization for their performance to take wings.

Some traditions, however, defy easy translation. Their customs are far enough away from the American mainstream that presenter interpretation or artist self-presentation becomes difficult for audiences to grasp. "I've had some disasters in terms of the musicians themselves not being able to properly present themselves in a concert situation," says Robert Browning of New York's World Music Institute. "Long gaps in between songs where there's a discussion as to what will be done next, which in some circumstances—in Afghanistan for instance—would be quite normal because it would be done in a café situation, where everybody would

be drinking coffee, smoking, or gossiping. And, fifteen, twenty minutes later there would be another song and everybody would join in. But of course that's one sort of thing, in terms of recontextualizing, that one has to deal with, and it doesn't always work out in as flowing a manner as one might hope."[18]

A few lavish presentations are able to go to some lengths in actually re-creating portions of indigenous context for their staged performances. This can be a small gesture, such as hanging an appropriate backdrop in a theatrical performance, or a major effort. The Festival of American Folklife has been a notable workshop for this kind of contextualization. They have built on the Mall in Washington, D.C., entire saddle-making shops (complete with authentic Colorado saddle makers) for a western states presentation; ersatz rice paddies for demonstrations of Japanese fertility rituals; old-time country churches for gospel performers to sing in; entire Mardi Gras krewe parades for New Orleans bands to march behind; and complete "villages" of one ethnicity or another, accurate down to the last bunged joint, rivaling the Imagineers' subdivisions at Disney World. The Smithsonian's pioneering efforts at producing this ultimate form of interpretation has been dubbed *induced context*.

The term has trickled down to attach itself to the other interpretive formats as well: all forms of interpretive presentation are, in effect, attempts to provide the audience with induced context. Radio host Nick Spitzer suggests that the best methodology for creating such a setting lies within the oral tradition itself, that actualization of the artists' own traditions' communicative power represents a paradigm for nonmanipulative but informative presentation. "We should be really seamless in what's entertaining and what's edifying—and *that's* the oral tradition," he says. "To learn through laughter and tragedy and drama and all the traditional artistic devices. I'm a believer in working in that mode. I don't try to have a lecture here and a concert there, or even an artificially set-up workshop. I try to keep the context flowing—at best from the performers' mouths."[19]

The ability of presenters to provide appropriate contextualization is a function of their insight, experience, and financial resources. Unfortunately, many arts presenters lack these qualities, and as a result, their attempt to engage multicultural artistry can have unhappy consequences. Condescending onstage introductions of traditional artists by academics or arts administrators have been a nagging commonplace at many festivals and concerts for years. Artists have had to contend with either ignorant emcees, whose knowledge of the presented tradition is insufficient to introduce it accurately for a general audience, or lengthy commentary in the

stentorian language of the academic lecture hall. Presenters have appeared to be the ones with the specialized knowledge, whereas the artists were merely manifestations of a folk (tinges of quaint or backward) culture.

Performance artist Guillermo Gomez-Peña works far from most folklorists. He is an avant-garde performer who moves in art world circles of both Mexico and the United States. But he faces many of the same difficulties in the way his work is often presented within mainstream institutions. "Some frequent mistakes," he writes, "include homogenization (all Latinos are alike and interchangeable), decontextualization (Latino art is defined as a self-contained system that exists outside Western culture), curatorial eclecticism (all styles and artforms can be showcased in the same event as long as they are Latino), folklorization and exoticization (needless to explain)."[20] The complexity of the presenter's role in mediating the sometimes conflicting needs of audiences, artists, and arts managers while attempting to provide adequate contextual information to give the artist the best chance at conveying their performance can frustrate even the best-intentioned professionals.

Artists experience the same challenges, but from a different perspective. Many of the same processes are in play for creators: they participate in the various stages of the performative sequence of events, participate in the way their presentation is framed (while observing it from their own frame of reference), and contend with audiences' ignorance or enlightenment. But artists experience all of this from the opposite side of the footlights. Anyone who has ever spoken to a group of people in public will know how extremely different the anxiety of the performer is from the casual ease of the audience.

Public presentation represents only a small fraction of the culture participator's commitment. Participation in culture—as a dancer, painter, cook, poet, musician—is fundamentally different from consumption. Participants and spectators are linked through the unfolding of events, "each existing for the other," says Giamatti, "in a mysterious bond of energy, resentment, and awe,"[21] but their experiences of those events can be wildly variable. The concertgoer, museum patron, reader, or diner enjoys an experience that is highly mediated by a variety of presenters and their many contrivances. The artists' relationship to their work is of a different order of magnitude. It is immediate and visceral, involving them aesthetically, emotionally, and kinesthetically in the moment. It

draws on a well of experience and training that encompasses the individual artist's life, as well as the history and cultural legacy that his or her work rests upon. Every work of art contains the reflection of an enormous heritage, if we can only hone our receptors enough to perceive it.

In most cases, public display is preceded by years of devoted study, practice, trial, error, and emulation. By the time an artist is ready for the stage, he or she has passed through an extended immersion in the subtleties of genre, digested the intricacies of various competing styles, and emerged with a unique vision and voice. The public showing is a culmination, but it is one that most participants never achieve. For every successful artistic career, there are a thousand apprentices; for every aspiring artist, a legion of amateurs. Behind all those beginners, there is a community. The New York Yankees are a presentation; participation is the million Little League teams that nurture baseball, train baseball players, and create baseball fans. It is engagement on a completely different plane. Cultural participation is about the hours and years that masses of people devote to making art. In the process, they build communities.

Cultural participation reveals itself in the pinnacle experience of public exhibition, but it lives in the daily activities of individuals. It is the ladies' auxiliary quilting together, tango aficionados dancing, church choirs rehearsing, and Italian men playing bocce. Our cultural antennae are so attuned to the spectacle of presentation that much participatory culture passes by without our notice. It seems prosaic, utterly unremarkable. Participation is so broadly based, so magnificently diverse, so *democratic,* that our public institutions have a hard time even recognizing it, much less developing adequate support mechanisms. Institutions like the Metropolitan Opera deserve our attention—but does community theater?

Participatory culture lacks the star power of Hollywood; it doesn't attract the notice of tabloid journalists. In fact, participation offers the antidote to the binge of mass culture. "The supreme achievement of consumer culture," write Don Adams and Arlene Goldbard, "is the *couch potato,* the individual who has succumbed to the virtual existence available via remote-controlled television, eschewing the flesh-and-blood contact of social intercourse and direct participation in community life. Mass media substitute vicarious exposure for actual experience. Instead of sorting through the multiple layers of information one derives from real-life encounters, deciding for oneself what to treat as figure and what as ground, the couch potato orders from a limited menu cooked up by TV programmers and advertisers, with all information predigested for ease of consumption. Entertainment is a fine thing, necessary leavening to existence.

But a core belief of community artists is that an excess of such passivity is antithetical to civil society: the muscles of cultural participation atrophy with chronic under use, leaving a population in thrall to urgent-sounding messages beamed over the airwaves."[22]

Participation challenges this syndrome, and it operates through the same mechanisms as the Little League. Interested activists volunteer their time to instruct young people about some aspect of their heritage; funds get raised through raffles and bake sales; parents drive their kids to lessons, rehearsals, and recitals that are attended by aunts, uncles, brothers, and sisters; a handful of participants become lifelong practitioners and take their places, in turn, as volunteer mentors. The difference is that sports in America have secured the financial support of civic institutions—our schools and town governments—to an extent that dwarfs investment in cultural affairs. Every town has at least one baseball diamond, and every school's football team has new uniforms; few have even a single decently equipped arts facility.

The institutions that we do have to encourage cultural activity were not designed with ethnic communities in mind. They want to build participation, but on terms that strike most ethnics as less than accommodating. Decision making about the cultural opportunities a town might have represents a power that administrators are reluctant to relinquish. The paradigm of curatorial vision—the notion that the nature of cultural consumption is best left in the hands of educated and enlightened individuals—is solidly entrenched in our arts bureaucracy. It is replicated in our galleries and concert halls, and it is amplified within the entertainment industry. And the choices all those curators make are largely irrelevant to most ethnic communities. "Regardless of exhibition content," says curator Elaine Gurian, "producers can choose strategies that can make some portion of the public feel either empowered or isolated. If the audience, or some segment thereof, feels alienated, unworthy, or out of place, I contend it is because we want them to feel that way."[23] A new standard that insists on grassroots participation—not simply in program activities but in the shaping of what those activities can be—is the only solution to this dilemma.

✧ ✧ ✧

The practice of cultural democracy requires mechanisms for opening the public cultural process. We need participation from the participators, not simply on the receiving end of programs but throughout the chain of development. Not only the products but also the culture-production pro-

cess requires democratization. When the Center for Cultural Exchange began experimenting with a new operational paradigm in the early 1990s, we were beginning to grasp what this might mean to arts organizations. We were then a successful small-city presenter with an annual series that was spinning off regional tours, and a steadily growing audience was keeping us in financial health. But even while over 50 percent of our artists were Asian, African, or Hispanic and represented many countries and cultures throughout the world, we had to recognize that we were still well-educated, affluent white presenters providing a service for (mostly) people like us.[24] The communities whose cultures we were representing onstage were out of the loop.

Breaking out of this cycle meant giving up a measure of control over artistic product. We had to create a new process seating the community at the institutional table of public culture, in a primary decision-making role. No arts administrator is equipped with enough insider information to make the most basic assessments of quality across the divisions of ethnicity, race, class, religion, gender, and voluntary association that comprise the American public. If you don't have a well-informed guide from inside whatever community you intend to serve—or better, a whole room of insiders who embody at least a piece of the diversity existing within that community—then your uninformed decisions are likely to undermine your programs.

A hundred years ago, Jane Addams had the same realization as she struggled to build programs at Chicago's Hull-House. "She found that the people she was trying to help had better ideas about how their lives might be improved than she and her colleagues did," writes historian Louis Menand. "She came to believe that any method of philanthropy or reform premised on top-down assumptions—the assumption, for instance, that the reformer's tastes or values are superior to the reformee's, or, more simply, that philanthropy is a unilateral act of giving by the person who has to the person who has not—is ineffectual and inherently false."[25]

At the Center, our first tentative step toward community-generated cultural programming involved the formation of partnerships with four local ethnic groups. We had worked with each of the communities during the course of past projects, and we had already established positive relationships with many local leaders. The Center convened planning committees including representatives from all of the major ethnic service organizations, artists, community activists, and scholars specializing in studies specific to each ethnicity. We challenged each committee to assess the most pressing needs of its community and devise programmatic strat-

egies to address these concerns, and we stated our commitment to working toward the realization of each community's vision. Separate sessions were devoted to needs assessment, to debating what kinds of programs could best address the community's expressed desires, to determining how these programmatic choices could be funded most appropriately, and to selecting master artists to work in Portland with local performers and tradition bearers.

Our planning with each ethnic committee started with some basic questions: What do you like? What *don't* you like? What does your community already have plenty of? What does it lack? What kinds of programs would have the most positive impact? Who are the target audiences, and how can they be reached? We moved on from these to other issues: What specific performance genres are you most interested in pursuing? Who are the artists that exemplify these traditions and are esteemed within your community? Which artists should be avoided? How much should the general public (outsiders) be involved? How should programs be structured so that they have the right feeling, the appropriate presentational format in tune with your community's aesthetic standards?

All of these questions required thought and sometimes difficult, uncomfortable debate. Reaching the threshold where these conversations could take place at all required the gradual establishment of trust between our staff and representatives of the ethnic constituencies. Some individuals in American minority communities have a justified distrust of establishment institutions, which have not always served their best interests. The burden was now on us to demonstrate, with deeds as well as words, our commitment to making the full expression of cultural diversity the center of our organizational mission, and to meet our partners' cultural agenda with our own developmental and organizational resources.

Our planning process brought to light the fact that Maine's minority populations are dramatically underserved by public and private cultural institutions. There exists a profound need for a wide range of cultural services, from access to rehearsal, performance, and meeting spaces, to language instruction, to programming on radio and television that addresses ethnically specific issues. These needs were debated at the community meetings, but the distilled outcome of several months of deliberations focused the agenda on two major concerns: access to professional level artistry and the need to publicly display ethnic heritage in our state.

This planning process resulted in the development of short-term micro-cultural plans for each community. It created ongoing partnerships placing community interests at the center of the project's purpose and rely-

ing on community members' knowledge of their own heritage in the development of the most relevant programs. The communities bring their insights about which artists are esteemed and about how to present their culture in a manner accurate within the context of their ethnicity. The Center brings its background in fund-raising, event production, and marketing, providing the institutional infrastructure for the project to evolve. Confronting the many issues raised during the planning process led to a fundamental shift in the way we view our role as cultural facilitators. We have become a new kind of community cultural agency, utilizing the arts as a powerful tool for effecting positive social change. Our role is to assist communities in the articulation and realization of the visions they hold for themselves and to adequately and accurately project their vitality to the larger community of Portland and the state of Maine.

Most of this work has turned on building participation for programs within each ethnic community. We initiated weekly Irish set-dance classes, formed an ensemble of African refugee teenage girls to work with a master dancer from Angola, and trained a generation of Maine Cambodians in their dance and music traditions. The participators in such projects are not professional artists. They are students, workers, and senior citizens who care about their cultures. In time, some of them do cross the footlights to become performers. But public presentation is not the raison d'etre of their involvement; it is a by-product. They do it to support their souls and each other.

There are millions of such advocates participating informally in the creation of their own cultures. They devote countless hours, week after week, because they find personal value in the effort. Art offers its own rewards. It provides ready access to the "collective effervescence" that nurtures emotional well-being, the "flow experience" that comes through creativity. "Flow helps to integrate the self because in that state of deep concentration consciousness is unusually well ordered. Thoughts, intentions, feelings, and all of the senses are focused on the same goal. Experience is in harmony. And when the flow episode is over," says Csikszentmihalyi, "one feels more 'together' than before, not only internally, but also with respect to other people and to the world in general."[26] The people who participate in cultural practice keep on doing so because it makes them feel so good. A recent Chicago Center for Arts Policy study "found substantial evidence that the informal arts are an important reservoir of social capital, significant for life-long-learning, building civic engagement and strengthening communities."[27]

The Wallace–Reader's Digest Foundation commissioned a Rand study

concerning the motivations behind cultural participation (see figure 1). What, they asked, makes some people arts participators while others are not? What is the pathway to engagement, and how can cultural institutions intervene in that process to effectively build participation? Culture, they found, competes with everything else in our lives: jobs, family, leisure, television. It has a complex relationship to all of these, and our choices about it are based on our ethnic, educational, and socioeconomic background, and on our attitudes, assumptions, and feelings about prior cultural experiences: "The [Rand] model recognizes that an individual's decision to take a specific action involves a complex mix of attitudes, intentions, constraints, and behaviors, as well as feedback between past experiences and the mix of attitudes and intentions."[28]

How facilitators approach this matrix of factors depends on what kind of participation they seek to engage. If presenters desire to build a more diverse constituency, they will be contending with people who have been disinclined to participate in the past. They must address the *perceptual* factors in the chart and examine how their own frame impacts the attitudes within the target population. "[T]he uninclined are adults for whom arts participation—through an avocation or attendance at an arts event— is not part of life activity; in many cases it's likely not within these persons' consciousness as a potential activity," write Nello McDaniel and George Thorn. "Traditional marketing techniques have no impact on this group, because their lack of participation is personal, not a function of

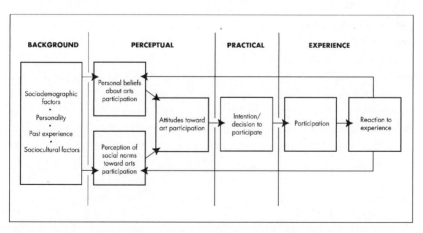

Figure 1. Participation Model. Adapted from Kevin McCarthy and Kimberly Jinnett, *A New Framework for Building Partipation in the Arts.* Santa Monica, Calif.: Rand Corp., 2001.

sales. They aren't a part of the arts marketplace; arts participation simply does not appear on their radar screens. There is a large number of uninclined adults in this country; and there is a multitude of reasons, including socio-economic and cultural barriers, why they are disconnected from the arts."[29]

Cultural activists have to offer these individuals a good reason for participating, and abstract appreciation of the aesthetics on display will probably not be particularly persuasive. Their desires, biases, and attitudes must be taken into account, and taken seriously. Some arts professionals seem to feel that if only they could get these people into an event, they would surely see how wonderful art really is, and somehow magically they would all become routine patrons. The tactic is to somehow trick an audience into attendance by offering a populist subterfuge. Symphony orchestras do this all the time, including romantic warhorses on the program so they can slip in some of that difficult music that they feel is good for their listeners, most of whom would never willingly pay to hear Schoenberg or Messiaen. But it is a stratagem that insults the audience's intelligence and calls the presenter's ethics into question.

Thoughtful arts practitioners have developed strategies for respectfully engaging community members in cultural activities. This almost always involves an invitation for community members to be expressive of their own realities, often to engage their own sensibilities about their lives and places within an artistic context. "When Roadside Theater sets down its stakes in the small towns and urban neighborhoods where it conducts extended residencies, one of its first activities is to create a story circle," says director Dudley Cocke. "A story circle is an open event where the people of the community are invited to share stories about their lives, their ancestors and the history of the place where they live. The shape, tone and content of each story circle is unique to a particular locale, and forms the basis for all Roadside's subsequent activities while there. It establishes a neutral ground where disparate members of a community can come together to tell their stories, rather than voice their opinions. It draws individuals unwittingly into 'performing' one of the earliest forms of theater. And it lays out the themes, conflicts and characters the community can draw on if it decides to take up Roadside's invitation to develop its own plays."[30] Cocke's theater company doesn't come to town with a mission of imparting culture to the masses; it comes with the hope of collaborating with the masses in examining whatever their *own* cultural challenges might be.

I was once involved in what felt like a nightmare when the son of an

African refugee on our staff was arrested following a racially tinged street fight with a gang of white youths. While trying to pry her bloodied son away from the police, our staffer was herself hauled off to the county jail. As refugees, their status as resident aliens could be jeopardized by the situation, and the entire refugee community was up in arms about what felt like a case of police brutality and racial bias (none of the whites was arrested). I was working with this community to try to build cultural programs, and the events seemed to reduce my efforts to insignificance. But when I described this situation to Dudley Cocke, he pointed out that such moments of crisis are frequently the axes around which social dynamics turn. Conflict shapes antagonists' attitudes, and revealing their roots is a vital step in the process of reconciliation. "You've got everything you need right there," was his comment. "Get them all into the same room and let them talk. Make art about it."[31] For Roadside, every member of each group—the police, the gangs, the media—is a potential actor. They *are* actors in their real-life dramas; by framing them and their concerns as art, zero-sum confrontations can be converted into positive social capital. Suddenly, they've become cultural participators in a drama that has total relevance to their world. Using a moment of conflict as the germ for socially awake theater allows participants to fully express the dimensions of their experience in a manner that is unavailable during "real-life" events. The process of deconstruction that art making demands provides openings for understanding across disputed terrain that are lacking in the adversarial arenas of law and politics.

Broadening the participation of those that are already moderately engaged requires dealing with practical issues that stand in the way of enhanced activity. These are often mechanical considerations such as hours of operation, transportation, and child care. For years, we struggled to get an after-school youth program off the ground. We engaged great artists and offered exciting workshops. But the programs struggled until we realized that transportation to and from these events was crucial for kids whose parents work. Once we figured that out, there were plenty of students anxious to participate. A driver and a slice of pizza were necessary prerequisites to arts engagement. Most cultural organizations don't see themselves as taxi agencies or food kitchens, but these are exactly the barriers that keep many people away from arts participation. A modest expenditure and a little organizational effort go a very long way.

Those who seek a deeper level of commitment from proven participators must focus on experiential components. What is the nature of community members' experience with the organization? Does it meet their

needs and satisfy their aspirations? Is the program supported within the community? Are these criteria being measured according to the community's standards? The Maine Mass Gospel Choir—organized by Gary Hines back in chapter 1—started out with thirty singers drawn from historically black churches. But each time Hines came to town, we organized workshops for him at high schools, colleges, and community centers. Every time he met a good singer he'd invite them to join the choir. After a few years the directorship passed to JD Steele, an amazingly energetic choirmaster and motivator. Steele became a one-man recruitment drive for the Mass Choir. Within a few years, the ensemble had doubled in size. But most of the new singers were white Mainers, and many of them were not Christians. They came to have a flow experience, to rub up against another culture, and Steele captured them. Although I myself had misgivings about the relative balance of African Americans and whites in the choir, none of the church singers ever acknowledged the presence of any racial issue. There *were* substantial concerns regarding their religious commitment. Gospel is explicitly religious music, and there is little doubt that the fervor that epitomizes the gospel sound comes directly from the revealed religious experience of the performers. My church singers didn't care if the new recruits were white but worried that they didn't really have the right spirit in their souls to be capable of the extraordinary singing that is at the heart of the gospel experience. The community that we were trying to serve insisted on a change in tactics. We could serve both groups, but they each had different agendas that had to be addressed. The most effective strategies are carefully targeted to specific communities and kinds of participators, and accurately identifying them takes time and careful observation. Building participation, like nurturing community, is a labor-intensive process that takes place one person at a time.

Every individual actor—regardless of his or her background, perceptions about participation, or experience with the arts—is also situated in a social matrix that influences that person's level of involvement. The decision to engage in cultural practice is often a function of what one's friends are doing tonight, of how it fits with one's family's activities and expectations. Most people who become cultural activists are initially engaged through the influence of mentors or guides, individuals whose experience they respect and trust who spark or encourage their interest. We rely on such trusted informants to assure us that participation is safe and socially sanctioned. At every phase of the process of engagement, the reinforcement provided by such guides can be critical. Such mentoring is usually ad hoc, but cultural institutions that allow for intensive and personal

interaction with constituents can begin to play such roles. Roadside Theater's facilitators, working in the same towns for years at a time, offer community-based participants guidance and the personal example of how art can change lives.

While the tactics and constituencies vary considerably, these conceptual categories are equally applicable for generating a core group of insider ethnic participants or for finding a broad general audience for presentations. Like tradition and innovation, both aspects are necessary to the support of community culture; they complement each other and interweave content and intention. In a functioning cultural democracy, participation flows from the needs of community members to cherish their traditions and renew their heritage. It is supported by a broad public that explicitly recognizes its own stake in maintaining cultural vitality through cross-pollination, and actively appreciates a range of community presentations. Doing this requires institutions that are sensitized to the needs of communities through continuous collaboration. They must be dedicated to conserving the cultures that their communities hold dear and act as bulwarks against the continuous pressures of commercialization.

Conservation and Commercialization

In 1954, Elvis Presley recorded his own rendition of a song that had been written by bluegrass pioneer Bill Monroe. "Blue Moon of Kentucky" had been a small-time hit for Monroe, and he used it as his band's theme music in every performance. Although Monroe's musical style had been innovative in the 1940s, by the time Elvis got around to reworking the song, it had settled into the well-defined formula that still commands respect among musicians all over the world (one of the biggest annual bluegrass festivals now takes place in Tokyo). Elvis ignored the tradition, appropriated "Blue Moon" to his own purposes, and turned it into one of his first hit rock 'n' roll records.

The Nashville establishment was not unanimous in its enthusiasm. They had not yet adopted Elvis as one of its own, and this rough treatment was more than some could bear. "*Blue Moon of Kentucky* had been a hit for Bill Monroe in 1946, well before the term 'bluegrass' came into popular usage," writes Presley biographer Peter Guralnick. "In Monroe's

Baskets for sale at a folk festival. Photo by the author.

version it was a beautiful waltz familiar to anyone who listened to the Grand Ole Opry and revered by every hillbilly musician who ever picked up a stringed instrument."[1] Monroe may have had some reservations himself, but these were quickly disposed of when the royalty checks started arriving. He subsequently became a big supporter of Elvis and even recorded his own up-tempo version of "Blue Moon." Those checks were a persuasive demonstration of the direction music was headed.

Monroe would remain a profoundly conservative defender of tradition throughout his long career, but this would not be the last time his music was appropriated for commercial purposes. Traditionalists recoil, and some look for a way to fight back. Many local communities feel that their customs are in danger of being submerged in the ocean of mass culture, and they reflexively seek the means to protect their legacy. But those royalty checks are extremely hard to turn down. Even the most isolated communities still participate in the mainstream cash economy; often the more isolated they are, the more desperately they need to enhance their bottom line. Many culture professionals have come to view this precarious position of local cultures through the lens of *conservation*. Borrowing a page from the environmental movement, they declare our cultures to be endangered species.

"We recognize the fragility of the California condor; a sea island fishnet [a Georgia fishing tradition being eliminated due to overdevelopment] may symbolize an equally fragile cultural system," writes Burt Feintuch in *The Conservation of Culture*. "Connections between the concerns of the environmentalist and the cultural conservationist are obvious. Our ecological stewardship must extend to cultural policy, just as our concern for those intangibles we call the quality of life must direct our thoughts to cultural conservation."[2] Certainly, most public arts professionals feel confident that their work contributes to the quality of life in their communities—but so, too, do executives of steel mills and chemical plants. If environmentalists have a bad reputation in some circles, it is due in part to their well-advertised belief that their idea of the quality of life is the one that really counts. As a social movement, cultural conservation runs a similar risk.

Framers of the concept of cultural conservation make strategic use of the ecological referent. A Smithsonian publication repeatedly draws parallels with the field of ecology: "The concept of *ecosystem* for example, has helped us to understand interrelationships between natural species and to devise strategies for conserving threatened parts of our environment. In the understanding of traditional cultures as well we are learning to look

at larger economic, political and social contexts as elements in systems of which traditional cultures are also parts. . . . [W]e have come to understand that it is possible to foster the continued vitality of 'endangered species'—natural or cultural—without dismantling or derailing national and international economic, political and social institutions. Conservation can be made a part of development plans."[3]

The projection of natural science terminology onto the cultural domain immediately places it outside of the realm of the contemporary socioeconomic and political order. Like endangered species, cultural traditions become something one can read about on the inside pages of newspapers or see at the zoo or folk festival but that are essentially irrelevant to ongoing social discourse. And like the natural scientist that becomes the guardian of a plant or animal species, protecting it by means of congressional testimony from the oblivious advance of civilization, the cultural conservationist forms a partnership with the bearers of "endangered" traditions and develops projects designed to nurture their growth. Such mediators focus on ethnic culture at the community level in an attempt to both shield it from the influence of, and reveal its beauty and meaning to, the rest of America. Collaborations of academics and public figures with local communities have frequently brought recognition, and sometimes remuneration, to otherwise marginal populations.

Creating forums where a community's aesthetic may be publicly displayed can provide a sense of empowerment for the artists and for the community at large. The artwork itself often has an element of power embedded within it. Lucy Lippard states, "The arts are often pleasurable and entertaining, apparently unthreatening (if intimidating in certain contexts), but they can also be redemptive and restorative, critical and empowering."[4] In addition to developing avenues that can give voice to a community's traditions, empowerment of the bearers of culture entails providing them with tools for grappling with the forces of mass consumerism, the very forces that threaten to overwhelm them.

In this sense, conservation is a somewhat curious concept for public cultural advocates to have adopted as a rallying cry. Early American conservationists, such as Theodore Roosevelt, were anxious to preserve natural resources and wilderness primarily so that they could be exploited. Ducks Unlimited is a classic contemporary example of this approach to resource management, raising money for the preservation of birds so that people can shoot them. The links between protection and exploitation are powerful; strategies intended to buffer cultural heritage often result in

consequences that are ruled by the model of the marketplace rather than the ecosphere.

This chapter examines the conflicted role that public culture plays in the process of objectifying heritage, turning it into a commodity, a caricature of itself marketed to tourists as authentic. It might be appropriated in a denatured form by mass culture trendsetters or become temporary fodder for the commercial media's appetite. Cultural democracy doesn't occur in isolation, but within the context of a nearly limitless marketplace. How can the small voices that matter find a place here?

Culture as process—rather than as product—is a vantage shared only by insiders and the very few outsiders who take the time and personal commitment of thorough immersion in another culture. It is extraordinarily resistant to any presentational format: aside from attempting to provide some basic information about how this style of music or that method of hog butchering fits into the routine of the people who use it, arts managers can do little but present the produce of ethnic cultures. The music, or bacon, is stripped of most of its inherent significance and presented as a totality, a whole object in and of itself, to which a new set of signs are implicated by virtue of its place within the presentation and within the audience's frame.

This apprehension of cultural manifestations in an objectified manner is a longstanding tradition within the academy. "The structural approach—music as an object—has . . . dominated musicology ever since the days of its earliest recorded history in the sixth and fifth centuries of ancient Greece," wrote the doyen of ethnomusicology Charles Seeger. "Thus, students of the music of folklore have agreed in their approach to their study regardless of whether their preparation has been in literary or in musical studies. They concurred in the supposition that the stream of orally transmitted music has been dried up by 'outside' events."[5]

This focus on music—or any other cultural phenomenon—as an artifact, as something that can be understood independently of a supporting contextual background, is reflected in academics' interactions with public culture. The results as far as the presented cultures are concerned tend to be dictated more by market forces than by aesthetic or cultural considerations. "Cultural objectification, which is at the heart of what we do, is a complicated process with unpredictable results, one of which is the canonization of particular traditions, individuals and forms," says

folklorist and performance theorist Barbara Kirshenblatt-Gimblett.[6] As product dominates scholarship or presentation, the affect embedded within a contextual matrix is increasingly diluted or lost.

The agenda of cultural democracy demands a reevaluation of the ideology of objectification and how it is manifested in public arts productions. The process that distinguishes among traditional artists and art forms, validating some and ignoring others, and conveys these nonindigenous value judgments to the marketplace, implicates public sector actors in the ultimate commodification of the art forms they study and present. "Willingly or not," points out Kirshenblatt-Gimblett, both academics and arts managers "contribute to the rampant commodification of culture. . . . [T]he line between custodians of culture and cultural cannibals is blurred; the museum and the department store become extensions of each other."[7]

Severed from its roots and its community, objectified by credentialed professionals as an exemplar of traditional authenticity, the newly commodified artwork enters the marketplace, where it is either accepted for reasons that may have little to do with the values it embodied for its creators, or it is rejected for equally specious reasons, such as lack of adequate public relations expenditures. It becomes a valued expression of cachet for consumption by the upwardly mobile, an exotic symbol of sophistication to hang on the wall or play on the phonograph. Because it has been certified as genuine, a piece of reality in a patently ersatz world, it takes on additional symbolic resonance, moving its disconnected audience in a fashion very different from any contemporary product.

Anthropologist James Clifford offers a schematic of this circulation of value and meaning among ethnic artists and their communities, academics whose imprimatur "authenticates" art works, the elite art marketplace, and popular consumption. Clifford's diagram classifies objects (it could as easily apply to performances with only minor modifications) as authentic or inauthentic, masterpiece or artifact, and assigns them value according to the contemporary art-culture system (see figure 2). "It establishes the 'contexts' in which they properly belong and between which they circulate," he writes.[8]

Much of the cultural produce of ethnic traditions resides in the zone of *authentic artifacts,* although it has a tendency to migrate. Buildings, blankets, and bedtime stories represent their cultures with little fanfare except when they are promoted into the realm of *authentic masterpieces,* usually by attracting the notice of some outsider specialist who declares the object to be a work of art. "Examples of movement in this direction, from ethnographic 'culture' to fine 'art' are plentiful," says Clifford. "Tribal

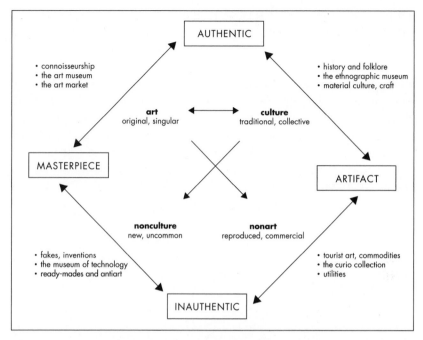

Figure 2. The Art-Culture System: A Machine for Making Authenticity. Adapted from James Clifford, "On Collecting Art and Culture." In *Out There: Marginalization and Contemporary Cultures,* edited by R. Ferguson, M. Gever, T. Minh-ha, and C. West, 141–90. New York: New Museum of Contemporary Art/MIT Press, 1990.

objects located in art galleries (the Rockefeller Wing at the Metropolitan Museum in New York) or displayed anywhere according to 'formalist' rather than 'contextualist' protocols move in this way. Crafts, 'folk art,' certain antiques, 'naïve' art all are subject to periodic promotions. Movement in the inverse direction occurs whenever art masterworks are culturally and historically 'contextualized,' something that has been occurring more and more explicitly. Perhaps the most dramatic case has been the relocation of France's great Impressionist collection, formerly in the Jeu de Paume, to the new Museum of the Nineteenth Century at the Gare d'Orsay. Here art masterworks take their place in the panorama of a historical-cultural 'period.'"[9]

There is also substantial traffic from tradition's base to the zone of the *inauthentic artifact.* In this case, items having a place within a traditional culture become commodified and valuable to outsiders, thus creating industries to produce them for outsider consumption. "One of the last areas of social life where a modicum of authenticity can be found is the

music scene," writes Richard Florida. "But today music clubs that used to be dynamic, street-level places to enjoy 'real' music are being replaced by late-night versions of those multimedia circuses."[10] The "folk art" found in tourist curio shops is an example of this demotion in value. In other cases, mass-produced items, from tortilla presses to electric guitars, may become valued objects within a traditional community, becoming authentic expressions of ethnicity. With the exception of some objects that are endowed with religious or spiritual value within their communities and thus have value associated with them not properly accounted for on this chart, most cultural produce can be located either at one of the four zones represented here, or in transit between them. The shifting ideological winds of the linked academic and art-business communities have much to say about where, exactly, a particular manifestation of ethnicity is to be found at any given moment, and the value placed upon it.

The exercise of this authority, and the selective manufacture of taste that it involves, links academics and public cultural institutions to the process that brings heritage into the mainstream economy. Money is a notable motivator, and artists are no less ready to provide goods to a willing buyer than anybody else. If there is a sudden fad for Puerto Rican carnival masks, the street price in Poncé will go up. Some will accuse artists of selling out. Others will be delighted that their work is selling, period. Music producer Kalamu ya Salaam states, "[T]he marketplace forces each artist who wants to be successful to make a choice regarding artistic expression. In this way, modern society can present itself as liberal and based on freedom of expression, while actually offering a very narrow window for cultural expression."[11]

Often, the only attention ethnic cultures receive from the mainstream is when some aspect of a local style gets picked up by a pop star and pumped into the media. Elvis's recording of "Blue Moon of Kentucky" and the popular success of Paul Simon's synthetic ethno-pop point in this direction. *Graceland* is only the best-known example of a phenomenon of appropriation that has always been a characteristic of the music industry. Ever seeking something that seems new, popular music easily swallows disconnected fragments of diverse music cultures and reduces them into a monocultural pop standard. From the Beatles' invention of raga-rock to contemporary pilfering of West African polyrhythms or Argentine tango by top-forty songsters, to the rampant sampling of all manner of recorded sound, decontextualized appropriation of ethnic music is the order of the day.

Of course, its affect is substantially altered in the process. The power of

actual indigenous performance exists on a different plane than that of mainstream, disposable popular music, but it is often accessible only to insider groups. "[I]n the past at least great works of art—and effective ritual performances—have always been very definitely situated in this or that culture," writes performance theorist Robert Schechtman, "while efforts to transcend or to accumulate cultures fail at precisely the point they want to make: creating actions as powerful, or even more powerful than the sources."[12] If this is true, then it is likely that the depth of affect offered by indigenous music will continue to resist homogenizing transcultural influences. The rapidly changing key to this formulation rests with the impact of mass electronic media on a worldwide scale, an impact of exponential importance.

"There is no music made today that has not been shaped by the fact of recording and duplication," writes new economy guru Kevin Kelly. "In fact the ability to copy music has been deeply disruptive ever since the invention of the gramophone. When John D. Smoot, an engineer from the European company Odeon, carted primitive recording equipment to the Indonesian archipelago in 1904 to record gamelan orchestras, local musicians were perplexed. Why copy a performance? The popular local tunes that circulated in their villages had a half-life of a few weeks. Why would anyone want to listen to a stale rendition of an obsolete piece when it was easy to get fresh music? As phonographs spread throughout the world, they had a surprising effect: folk tunes, which had always been malleable, changing with each performer and in each performance, were transformed by the advent of recording into fixed songs that could be endlessly and exactly repeated. Music became shorter, more melodic and more precise."[13]

In the early, freewheeling days of broadcasting, before the industry had fully grasped the power inhering to the medium, it was not unusual for musicians from small, relatively isolated communities to find their way onto the airwaves. This is no longer the case. Except for a few low-power community radio stations, ethnic populations are locked out of the broadcast media. Artists who are viewed as pioneers of country music, such as A. P. Carter, Riley Puckett, or Jimmie Rodgers, could not now achieve the widespread broadcast syndication that propelled them to celebrity—they are too representative of a particular regional and socioeconomic aesthetic to be able to break into contemporary radio or television. Today, those ethnic enclaves have scant hope of controlling how they are depicted on the air; usually their only presence is as stereotypical hicks or ignorant rednecks.

It would be difficult to exaggerate the impact of broadcast technology on the perceptions of culture by people the world over. Despite the proliferation of independent record companies and the Internet, access to the mass media is largely restricted to a few multinational conglomerates who hold shares in publishing, the recording and broadcasting industries, and now in the hardware of broadband connectivity. Through the control of mass distribution and most radio and television outlets, they are able to directly determine what information—and music—is heard most frequently by billions of people.

The mass media offers a carefully scrubbed version of culture, which adheres to the dominant political and social ideology. "I can't get on television," says author and activist Ishmael Reed. "I get censored. Black men threaten these people. There seems to be this tendency to drive black males out of the market. The reason, I think, is that black male vision is always subversive. We're always at the bottom of society. We see things that other people don't want to see."[14] Even a figure as mainstream as Bill Cosby agrees: "It's HBO. HBO tells African-Americans 'You can't come on the show unless you undignify your Africanness'—unless you become what *they* think is black. They want to dictate what is black. And as soon as you come on, you put three sentences together, there's a white male or female who says, 'You don't sound black.'"[15] The popularity of hip-hop immediately seems to contradict Reed and Cosby's argument. But popular hip-hop's pervasive emphases on sex, violence, misogyny, and fashion actually place it squarely within the favored domains of mainstream entertainment. That gangsta rap can simultaneously exaggerate whites' stereotypical fears of black males only makes it a more compelling product, as is apparent in its embrace by the entertainment industry.

When the range of cultures, styles, genres—possibilities—is so thoroughly restricted in the dominating medium of access, the resulting homogenization is a threat to cultural continuity. "Critics of popular culture see it as leading to a deterioration of both traditional high culture and folk culture," points out sociologist Graham Vulliamy, "since not only are potential artists lured away by the lucrative rewards of involvement in popular culture, but also the products of past and present high [or folk] culture are actually exploited in the production of popular culture."[16] Driven by the ever-urgent need to maximize profits, the corporate engines of mass culture have a leveling effect. "On national and international levels there are strong forces for cultural homogenization," notes Richard Kurin. "If all consumers can be trained to have the same tastes, for example, product and market development become easier and more pre-

dictable. Diversity is more cumbersome and troublesome to large multinationals when a myriad of differences in taste, attribution of value, and motivational goals inform consumer choices. International marketeers would prefer unanimity—today, generational, tomorrow, global—on what the 'real thing' is and how to become identified with it."[17] Variation in the color and cut of one's chinos substitutes for authentic diversity—and people think they are being offered fabulous "choice."

Cultural conservationists are positioned as a countervailing force, defending the integrity of the small and local against the large and global. Technology has, in a relative heartbeat, provided universal access to all those small and local cultures, or at least their marketable aspects. The cultural fragmentation that typifies our time challenges cultural activists to balance the stewardship of heritage with support for the edges of innovation. Clifford notes, "Twentieth-century identities no longer presuppose continuous cultures or traditions. Everywhere individuals and groups improvise local performances from (re)collected pasts, drawing on foreign media, symbols and languages."[18] This creolization represents the fastest growing realm of traditional culture on earth, and one that often produces great art—Louisiana zydeco or Nigerian jùjú. It deserves the same care and tending as "old" traditions.

While the marketplace provides some of the impetus towards these dynamic syntheses, it does not offer the kind of long-term care that traditions require for their sustenance. This can only come from the public sector—government and the nonprofit arts sphere. Some "conservative" politicians have argued for the abandonment of the entire public cultural edifice, for leaving culture, like any other commodity, up to the market to support or not. "Advocates of 'privatizing,' suspicious of government meddling in the arts, may think that they are supporting a liberal domain of the private when they call for laissez-faire," writes Benjamin Barber. "But in an era when civil society has been collapsed into the commercial market sector, privatization may turn out to mean commercialization and the arts will not be 'left alone' but subjected to the harsh interventionist dynamics of commerce. Under such conditions, neither high art, rebellious art nor even ordinary amateur art (community theater for example) are likely to thrive. The market pushes toward uniformity of taste, a levelling of standards, and the commodification of art product in ways that will satisfy almost no one—whatever perspective they represent."[19]

What would the end result of a culture left to the devices of the commercial markets look like? It is easy to project this by looking at the areas of popular entertainment that have gone the furthest from any semblance

of anchorage in community heritage: network television and big budget Hollywood films. Culture becomes, simultaneously, a commodity and a shill for the sales of other commodities. Consumption itself is the content, driven by sex and stylized violence to offer vicarious thrills between commercials. What we see is the unfettered market's use of cultural fragmentation, without ever a full representation of any *real* culture. The media dominance of mass popular culture means that the tastes and interests of minorities have few public outlets. Do we ever see much Polish, Malay, or Native American culture represented on *Friends* or *Letterman*? To get that, people have to go looking, in the back roads of their own communities and much farther afield.

✧ ✧ ✧

"Changes in technology and the global economy compel us to think in new ways about creativity and cultural heritage," states the report *America's Cultural Capital*. "Some countries, and now even some states, counties, cities and towns in the United States, have begun to consider 'cultural industries' as a distinct sector of their economies. Some have begun to analyze the significant contributions that 'creative clusters,' 'creative communities,' or the 'creative workforce' are now making to domestic productivity, job growth and export earnings."[20]

Richard Florida, an economist at Carnegie-Mellon University, suggests that this creative workforce is not just a community asset but the major driver behind economic expansion. Creativity, he says, "is now the *decisive* source of competitive advantage. In virtually every industry . . . the winners in the long run are those who can create and keep creating."[21] The Creative Class, broadly defined, includes the most highly educated and affluent third of the American workforce and, according to Florida, is responsible for both steering business in profitable new directions and stimulating local growth through its own acquisitive habits. The cities that cater to the needs of this new dominant class enjoy prosperity that is lost on working-class or service-class centers. "The emerging geography of the Creative Class," he writes, "is dramatically affecting the competitive advantage of regions across the United States."[22]

The impact of the arts economy is visible in the most progressive American cities, as well as internationally. Where governments embrace cultural activity, the economic benefits flow. "Canada and England have restructured their governments to focus more attention on creative industries, and what they mean to the public purpose," reports Jennifer Gottlieb. "The European Commission recently concluded that creative activi-

ties have a huge role to play in their economy as demand for cultural and creative goods and services grows, and technology opens up new opportunities in the global marketplace for reaching new audiences and customers."[23]

Domestically, the arts have become the magnet for the revitalization of urban centers. "An increasingly popular approach for lending governmental support to the arts is the creation of 'cultural districts,'" says economist Bruce Seaman. "About 30 cities currently have adopted one of the several models for such districts."[24] Whether in Charleston, Seattle, or San Diego, culture makes a big difference in the way people perceive their environment. "The abundance of the arts in a particular city or town lends itself to enhanced quality of life," according to a report on the arts economy in the Northeast, "which makes it more attractive to workers as well as companies looking to relocate or expand operations. For this reason, many municipalities are now integrating cultural components in to their plans for community development and using the arts to revitalize and restore their downtown areas."[25]

While the commercial downtowns of many cities have suffered serious declines because of the malling of America, cultural activity is among the few magnets that can still attract large numbers of humans to many center cities. The creation of arts districts has offered a salvation to otherwise blighted urban areas and has had a significant impact in bringing some cities off life support. However, as noteworthy as these trends may be, their actual benefit to the arts and artists is less certain.

Urban arts programs are generally focused on the high-status arts or tourist fare, vehicles for bringing white people back to the city center. As always, the kinds of events that are capable of drawing large audiences tend toward entertainment spectacles, highly produced events tailored to mass audiences. The artistry, such as it is, represents only a relatively small fragment of such blockbuster events. Far more expenditure is allocated for design, construction, security, technical concerns, crowd control, and parking than ever gets into the hands of actual artists. The vital culture that is produced in community settings is very rarely supported through these urban renewal exercises. When it *is* supported, the impetus is economic, not cultural development, so resource allocation to ethnic artists is perpetually at risk: next year exhibiting the Batmobile may be deemed more attractive than presentations of traditional artistry.

Often, the creation of urban arts districts is an administrative response to the de facto concentration of artists and arts organizations within specific precincts. Since most artists and nonprofits exist on the econom-

ic margins, these zones are usually run-down neighborhoods, warehouse districts, or depressed industrial areas—places where the spaces are big, the rents are cheap, and the streets have an interesting character. Typically, once the artists move in, they attract a more affluent, educated audience, and are soon followed by upscale restaurants and boutiques catering to the artsy clientele. Gentrification is here: rents begin a precipitous rise, soon becoming prohibitive for artists. When the artists start to leave for cheaper pastures, the district's businesses become alarmed and call on the government to "save" the cultural district. Mayors who have watched their downtowns coming back to life are responsive to this call, and another downtown arts district is born.

Such urban planning answers an economic imperative, not a cultural one. If we examine the actual budget allocations of municipalities on behalf of the *arts* in their arts districts—as opposed to beefed-up police patrols, extra trash collection, and glossy brochures at the interstate tourist information booth—the hollowness of the designation becomes obvious. The few funds directed to cultural activity are almost always dedicated to the established homes of Eurocentric high art. "For more than a century, the mark of a cultured city in the United States has been to have a major art museum plus an 'SOB'—the high-art triumvirate of a symphony orchestra, an opera company and a ballet company," says Florida. "In many cities, recently, museums and the SOB have fallen on hard times. Attendance figures have declined and audiences are aging: too many gray heads, not enough purple ones. . . . Meanwhile the Creative Class is drawn to more organic and indigenous street-level culture. This form is typically not found in large venues like New York's Lincoln Center or in designated 'cultural districts.'"[26] The community-based artists, many of whom were responsible for the evolution of the district in the first place, are left out of the equation. In Portland, there is less cultural activity in our downtown arts district now than there was when it was created ten years ago. But the district has become a tourist attraction.

"One of the most significant ways the Creative Cluster attracts income is through cultural tourism," states *The Creative Economy Initiative.* "In 1998, approximately 15 million people traveled throughout New England primarily for cultural events, spending more than $6 billion; 8 million of these visitors came from outside the region."[27] According to the National Endowment for the Arts, cultural tourism on a national level attracts over ninety-two million visitors, most of whom are above average in education and affluence.[28] Culture is a big draw.

How culture plays to the tourist market, its place in the spectrum of

entertainment, and the nature of cultural exhibition raise thorny issues. It is far from certain that given current demographic and social trends, the cultural development envisioned in many areas is appropriate or economically beneficial. "The physical attractions that most cities focus on building—sports stadiums, freeways, urban malls and tourism-and-entertainment districts that resemble theme parks—are irrelevant, insufficient or actually unattractive to many Creative Class people," writes Florida. "What they look for in communities are abundant high-quality amenities and experiences, an openness to diversity of all kinds, and above all else the opportunity to validate their identities as creative people."[29] The experiences sought out by this bellwether demographic are substantially less targeted at large-scale, big-ticket, highly mediated spectacles and more devoted to intimate events embodying passion and substance. They want something that feels genuine, a sensation that can be difficult to absorb from the 103rd row. Jazz clubs and coffee houses win out over Broadway musicals.

These Creative Class culture hunters are the major outsider audience for traditional music, the reason that the bluegrass soundtrack for *O Brother, Where Art Thou* went triple platinum and won a Grammy. As tourists, they seek an experience at odds with that offered at Opryland. "Because traditional arts are grounded in the cultural traditions of particular communities," points out a recent Urban Institute report, "the artists and arts organizations involved in producing traditional arts have great economic value that can be harnessed to increase regional economic growth."[30]

Fred's Lounge is one in a string of bars that lines the downtown of Mamou, Louisiana. Early on Saturday mornings, the competition is sleepy, but Fred's is doing a brisk business. The time of 7:30 A.M. hardly seems like the appropriate hour for one of the more important music sessions in Acadiana, but many years ago Fred's turned over the Saturday morning red-eye slot to an energetic proponent of traditional Cajun culture, Revon Reed. Along with Dewey Balfa, Reed had been a member of the first Cajun band invited to the Newport Folk Festival in 1964. He subsequently initiated a series of live radio broadcasts from Fred's Lounge that included, over the years, virtually every major and minor performer of traditional Cajun music in an ongoing program that had substantial impact on the revival of French culture in Louisiana.

When I visited Fred's in 1980, the Saturday morning session was already legendary. By 8:00 A.M., the bar was filled with partying Cajuns, drinking beer and eating fresh boudin. About 10:00, the first of the tour buses arrived, and the local audience started to drift away; by noon, the pre-

dominant language in the lounge had shifted from French to English. Friends who have visited Mamou more recently tell me that Fred's has expanded, and business is booming. Cajun culture has made it on the national scene, and formerly inaccessible western Louisiana (the freeway only penetrated the bayous in the middle 1960s) has become a tourist magnet.

Fred's Lounge exemplifies the good and bad sides of tourism's ambiguous influence on local cultures. It can make the cash register ring, but as is so frequently the case with rapid development, there is a steep price. "The recognition which the world has shown to older Cajun musicians has caused many non-Cajun musicians to turn into Cajun musicians," says singer Ann Savoy. "Much of this is for the sake of following trends and not for a genuine love of the music. Many of the older musicians resent these new interpretations of Cajun music and the vast, more far-reaching popularity that these new interpretations have received. There is also marked confusion in the voices of the Cajun dancehall band members today when they see the very styles that are no longer accepted by the Cajun people to be the ones emulated and acclaimed by outsiders and the modern youth in Louisiana."[31]

Rather than empowering practitioners to cherish their traditions and carry them forward, tourist culture tends to reduce the participants to acting out hollow, stereotypical re-creations of their community's activities. Repertoire freezes in a parody of itself or takes on aspects of mass culture to make it more appealing to outsiders. Objects once created for utility and beauty are now mass-produced for quick, cheap sales. Touristic presentations are often ciphers of the performances in their natural context, stripping away all but the most superficial representations of tradition; they represent heritage sanitized and made safe for consumption by the average traveler. Creators of tourist culture carefully gauge just how much exoticism will intrigue and titillate their audiences without putting them off. Tourists' limited attention spans are accommodated by abbreviated and denatured presentations. There is often a disparity in the relative wealth of visitors and the locals on display, whose poverty is depicted as picturesque.

Dean MacCannell, in his book *The Tourist: A New Theory of the Leisure Class,* writes, "For moderns, reality and authenticity are thought to be elsewhere: in other historical periods and other cultures, in purer, simpler lifestyles."[32] The managers of "tourist traps" attempt to stage this authenticity for travelers in the same way that arts professionals attempt to provide induced contexts, by creating an artificial reality that conforms to

the needs of their situation. "Touristic consciousness is motivated by its desire for authentic experiences, and the tourist may believe that he is moving in this direction, but it is very difficult to know for sure if the experience is in fact authentic," says MacCannell. "It is always possible that what is taken to be entry into a back region is really entry into a front region that has been totally set up in advance for touristic visitation."[33]

The models tourist events provide are designed to induce an atmosphere of excitement, euphoria, and easy spending. Not surprisingly, their staging frequently requires dramatic alterations to the content of the performances, which become focused on answering the tourists' needs rather than those of the community of origin. "When a performance moves to a new place, encountering new audiences," writes Schechner, "even if everything is kept the same, the performance changes. The same happens when an audience is imported, as when tourists or anthropologists see 'the real thing.'"[34]

As the level of touristic influence increases, the changes can have substantial and long-term effects on the visited community, as culture bearers scramble to accommodate themselves to financial opportunity. This often forces abrupt changes in the culture of the community, sometimes eroding the very assets that attracted visitors in the first place. "In particular," says Diedre Evans-Pritchard, Costa Rican grassroots organizer, "tourism tends to divide communities, encourage people to sell their long-held lands, sterilize traditional arts and performance, bring crime, prostitution and pollution, and promises much more than it can actually deliver."[35]

On the positive side, the interest of tourists can provide a much-needed economic stimulus to regions that have otherwise limited resources. For this reason, cultural tourism has been loudly heralded as the saving grace of many marginal communities. "The excitement [about cultural tourism] is well founded in as far as judicious, locally controlled, planned tourism development could give communities an alternative to cutting down their forests, subsistence-level survival, and being forced to move to the cities to seek employment," continues Evans-Pritchard. "In addition, many politically marginal groups, such as the indigenous communities of Central and South America, receive national and international attention which can foster a great sense of pride in their heritage and cultural life."[36]

Jaime Litvak King, former director of Mexico's Institute for Anthropological Research, makes the case: "You have heard of *Nouveau Riches*. My country is *Nouveau Pauvre*. Our biggest resource now is tourism and that means the sun and our beaches, the beauty of our mountains, the incom-

parable aroma of the Mexico City smog and, what else? The cultural patrimony. If you count how many tourists come to our cities to look at museums, churches, and archaeological sites you understand why we try to protect our cultural property. We make a fair living out of it. If we want to survive, we have to preserve it."[37]

As communities grapple with becoming the objects of tourist interest, the basic issue revolves around control. Who determines how a culture is to be represented to an audience, and where do the money trails lead? Are large corporations from outside the community reaping the benefits of a collective culture, selling weekend vacation packages and filling tour buses that stop at chain restaurants, effectively taking the value of the culture out of its own community? Or are insiders able to take the lead in formulating plans that can take advantage of popularity and funnel resources to the community's benefit? "As 'cultural tourism' has sometimes harmed the assets on which it feeds," points out a UNESCO finding, "the issue of control has been raised, particularly on behalf of small communities."[38]

The small island of Bali, in Indonesia, is among the most heavily touristed areas in the world. The Balinese have worked hard to protect their culture from the ravages of the international tourist trade while simultaneously taking full advantage of their economic opportunity. When Hyatt built a high-rise hotel on the beach, the Balinese were scandalized. They moved to protect their island by passing a law limiting all buildings to the height of a coconut palm. They require temple visitors to dress modestly in traditional sarongs and headscarves, thereby maintaining proper decorum and providing a steady market for the island's textile industry. They charge tourists admission to the many dance, music, and theatrical performances that take place on a nightly basis—and allow islanders to enjoy all of these for free. Such systems, keeping control in the hands of locals, contribute to the sustenance of culture; but old Bali hands still fret that the island's aura is on the wane.

The touristic influence occurs specifically because an aspect of the traditional culture *is* of interest to an outsider public, which is willing to pay for the experience. Bali's local economy, now largely tourist dependent, collapsed after the 2002 terrorist bombing as travelers sought "safer" destinations. In the case of Louisiana, the nationwide interest in Cajun culture brought millions of tourist dollars into a rural area with substantial need for the income. Its influence has been felt in the popular music industry, particularly within the country and western genre. But, of course, the music that has found such wide acceptance is very different from the

roots music of Acadiana, having tailored itself to the popular music marketplace. This is a pattern repeated over and over as mass culture selects from ethnic traditions for traits that it can manipulate to its own ends.

Appropriation of art for commercial gain is as old as art. Artists learn their trade by borrowing from other artists, and the line between stylistic imitation and outright copying is often blurred. Mozart lifted tunes from Haydn, who stole them from Bach. Early modernists spent their weekends hanging around Paris's Musée de l'Homme and created a whole aesthetic movement by copying the works of "primitive" artists on display there. Pop art exists almost entirely through appropriation of images from advertising and the popular press. Even the folk music revival of the 1950s and 1960s was driven by the appropriation by affluent white people of the songs, mostly, of poor minority communities. The Kingston Trio became famous by recycling songs from African American and southern Appalachian mountain people.[39] In none of these cases were the communities that created the art in the first place compensated. George Frideric Handel, Pablo Picasso, and Peter Paul & Mary did not share their paychecks with the sources of their material; in most cases they were not even acknowledged.

The mechanics of commercial appropriation rest on an area of law that is undergoing rapid changes due to the challenges inhering to new technologies. Copyright law protects creative artists from the use of their materials without compensation for a length of time that is steadily lengthening (under pressure from corporations that hold copyrights nearing expiration). But there is nothing to stop the Elvis Presleys of the world from using other people's material in whatever fashion they choose, with royalty payments. The digital age has also greatly expanded the concept of *fair usage*, which allows for limited—but recognizable—fragments of artworks to be freely appropriated and reassembled without artists' knowledge or consent. Sampling and digital recording have rendered the basic stuff of audio so malleable that any teenager with a computer can become a remix engineer, essentially re-creating to their own tastes any music that they can download with an MP3. Technology is eroding the protections of copyright while endowing individuals with unprecedented creative control.

Of course, copyright was never any stronger than its enforcing authority. Most music in the United States has been sold as licensed commercial produce, but there has always been a large black market in bootlegs and

smuggled live recordings, fostering a scene that maintains its own sense of community, channels of communication and exchange, and rules of etiquette (just like any other community). And outside the United States, especially in third-world countries, copyright has always had a tenuous hold. For decades, the international cassette conspiracy has been a primary engine for the circulation of music, both local indigenous styles and the latest American pop hits. Visit any market in Mexico or Morocco and you'll find the newest mariachi and rai bands alongside illicit Britney and Madonna discs—all at a small fraction of the price you'd pay at Tower Records. In this case, the local performers are probably the only ones getting paid, since they produce the recordings and sell them directly to the vendors. The hijacked produce of international stars is beyond the arm of the copyright police.

Copyright law never applied to communal creations of communities. Copyright was enacted to protect individuals from trespass of their intellectual property, and the possibility that creative genius could reside with a group, rather than a gifted individual, did not occur to the lawyers. Thus, the fruits of long collective invention—recipes, stories, quilting patterns, poetry, specific tunes, and songs—were unprotected and available for plunder. They weren't assumed to be part of the public domain, like a copyright that has expired; they were just available. When the Weavers first started recording old Appalachian ballads, they found that each song required a copyright and a publisher. Nobody knew who had composed "Barbry Allen." It had made its way over from Britain, and people in the mountains had been singing it for longer than any of them could recall. But if it was going to be issued on a record, it had to have a copyright. In this way, the Weavers became the copyright holder for dozens of songs that came from a traditional repertoire, including songs such as "When the Saints Go Marching In," "Rock Island Line," and even "We Wish You a Merry Christmas."[40] "Sometimes," says Pete Seeger, "songs have been copyrighted in my name without my knowing it. For example, *On Top of Old Smokey* appeared in sheet music with the by-line 'New words and music by Pete Seeger'—quite untrue. The Weavers' publisher was responsible."[41] We all know our own versions of "On Top of Old Smokey," and the composer is lost in the haze of time, but Pete Seeger owns the copyright to that song. Again, the community was not compensated—and who should conceivably receive the check? I'm sure Seeger would agree that it is among the ironies of cultural history that he—a white man—is listed as copyright holder on "We Shall Overcome."

"Any discussion of copyright law must be placed in the context of the

societies in which the currently observed laws were developed," writes Pete's nephew Anthony Seeger, whose career as an archivist and record producer has rubbed up against the law in several directions.

> They should be seen as the production of a specific group of people in specific societies at a particular moment in their histories. . . . Today's copyright laws reveal their origins in the Enlightenment, when philosophers looked to the individual rather than the group as the fundamental element of society. . . . The laws addressed only new creations by literate creators that were printed on paper and sold commercially to a literate public. . . . Any folklorist or anthropologist will immediately notice that quite a lot of human knowledge and wisdom was not included in formulations of the copyright law including the creations of the illiterate and nonliterate, ideas created and controlled by a group rather than individuals, and protection of knowledge not intended for commercial use. Not only were these left unprotected, they were specifically made available for creative artists to use without restriction to produce new materials that could be copyrighted. . . . For example, a composer might take a sacred song from a South American Indian community and turn it into a commercial for replacing the rain forest with cattle pastures. This can be done without acknowledging either the original creators of the work or the possibility of any objection on their part that their own sacred art forms are being used to destroy the land they hold sacred.[42]

This syndrome is reflected in contemporary battles of Native Amazonian tribes with American pharmaceutical companies over compensation for revealing the secrets of their indigenous medicines, now being synthesized by drug companies to their substantial enrichment. We simply have not arrived at a legal mechanism for the recognition, much less the reward, of communally created and owned ideas or goods. "The issues involving the kinds and uses of property—intangible and tangible, individual and community, ownership and usufruct—continue to emerge as the industrial and post-industrial economy appropriates the creativity of traditional cultures," writes Richard Kurin.[43]

The appropriative process, as fragments of ethnicity are suddenly seized upon and thrust into the public glare, can be especially insidious. At first blush, media attention can feel like genuine recognition, if not validation. It is only later that insiders realize that the mainstream has carved out a little piece of them that now stands for the whole culture. Some may prefer invisibility to misrepresentation. Mexican Americans were thrilled when Ritchie Valens's song "La Bamba" became a hit. Forty years later, many wish it had never been written, since the song has become a cliché

for Latino culture, locking them into the stereotype of the only Spanish song that most gringos can recognize. Of course, "La Bamba" is now played as Muzak in elevators, reducing Latin America to disposable background noise.

This process is replicated endlessly during every television day. Any parent with small children can attest to the rampant ethnic stereotypes that populate the daily cartoons. Arabs are oily villains; blacks are happy but dumb; Latinos are lazy. Older cartoons are particularly egregious in their depictions, and although contemporary animation reflects some shift in social attitudes, Disney's treatment of *Aladdin* stirred protests from Arab Americans. The opening of the Euro-Disney theme park outside Paris was viewed with hostility by many of the French, who saw their own culture being reduced to treacle. Former minister of culture Jack Lang commented, "They claim to present our folklore and culture, but they have taken it and returned it to us in unrecognizable form. . . . Look, not even the french fries are French."[44]

Of course, the kids continue to stream through the gates of the Magic Kingdom. "Millions of Americans," comments Kurin, "learn about world cultures at Disneyland and Disneyworld where they see the pirate-like people of the Caribbean drinking, and pygmies of Africa rising out of a river to aim their spears at your body—with knives and forks presumably to follow. Only slightly less dismaying is Disney's 'It's a Small World After All,' a tableaux of cute, little, formulaically but differentially costumed doll figures meant to represent all the world's people singing the same song—each in its own language. Ersatz and fakelore abound."[45]

The public arts community has tended to view itself as a bulwark against this onslaught of the marketplace. However, through the public nature of their work and the demands that presentation, in any format, entails, they are inextricably involved within that same marketplace themselves. The public sector and the commercial world are so thoroughly linked economically that it is often difficult to distinguish between them. As Seaman points out, "[T]here has always been a strong symbiotic relationship between the 'high' arts and the 'commercial' arts. However, cooperation between these two arenas goes well beyond subtle interaction to include explicit coordination, resulting in an even more dramatic blurring of their boundaries in the creation, distribution and marketing of cultural products."[46] Public arts presenters' implication in the mechanisms of the marketplace renders their position vis-à-vis traditional cultures ambiguous.

Cultural democracy offers a struggling alternative in putting ethnic art into the public eye, in all its messy diversity. Just as in the tourist indus-

try, the question is one of control of the nature of exhibition and the finances that flow to it. Few communities are equipped to deal with these issues, and few public institutions are sensitive and savvy enough to embrace their needs. If cultures are to be conserved, rather than aggressively commodified, we will need to develop new mechanisms for funneling resources to the grassroots level, where it is needed the most. Communities need repeated opportunities, in every generation, to decide for themselves whether and how they want their own cultures to be exploited. They require assistance and expertise from public sources that are not driven by the demands of development. And they need access to all of the communications technology of today to be able to loudly trumpet their vitality.

Public agencies have thus far scarcely turned their energies to advancing this agenda. But the potential for action lies within the public domain. We cannot expect the marketplace to circumscribe its own activities, even when they are demonstrably harmful to people and the planet. Academics are embedded within the problem as often as they contribute to solutions. Communities themselves usually lack the resources and infrastructure necessary to sustain their own cultures, much less promote them against commercial challengers. Cultural conservation is up to the public, nonprofit sector, where there is an enormous role waiting to be played in mediating the real needs of the small and powerless within the complex and symbiotic systems of governance and commerce. This role will require a new vision, a new template for approaching the needs of local cultures. "The rhetoric of 'sustaining'—as opposed to having the freedom to grow and develop—frames the cultural debate in prematurely conservationist terms," writes economist Amartya Sen. "There is a dis-analogy with the environment here. When it comes to the natural environment, we don't try to improve the best that nature gave us; we try to 'conserve' what we have got, and perhaps return to what we had earlier. But culture is the fountain of our creativity and progress. Sustaining is too feeble a role for it to play in development."[47] It remains to be seen whether and how our public agencies will mobilize their resources to address these issues.

Local cultures face a long uphill struggle. They are pitted against the forces that are the most powerful engines in the world. The power of the global economy to alter people's lives is far greater than that exerted by previous political empires. The small and local are fighting a perpetual rearguard action against a giant. As Alan Lomax claims, "The medium is not the message; whose culture is getting on the air, that's what the message is."[48]

5

Donation and Deduction

Historically, the arts have depended on patronage from large institutions: royalty, religion, the aristocracy. Most of the world's major ancient monuments—the Egyptian pyramids, the Great Wall of China, India's Taj Mahal, Machu Picchu of the Inca—were built by the state. Religious temples and shrines, including Europe's medieval cathedrals, Cambodia's Angkor Wat, majestic mosques throughout the Middle East, dozens of Hindu shrines in South Asia and Buddhist statuary from India to Japan, attest to the centrality of the role faith has played in supporting the grand flourishing of art. The artists and craftspeople engaged in the creation of these global treasures live on as exemplars of the communities they depicted in their work. Often, their efforts are the most enduring legacy of their civilizations, attaining an immortality that far exceeds that of their patrons, who are often forgotten or neglected. Who gets the press today—

Audience and corporate sponsorship signage at the National Folk Festival. Photo by Phyllis O'Neill.

Michelangelo, or the pope who hired him to paint the Sistine Chapel? Mozart, or the Archbishop of Salzburg?

In Europe, beginning with the Renaissance, this patronage system gradually passed from the church to wealthy aristocrats who could commission artists, architects, and composers to create monuments to themselves, or simply provide elite entertainments. The cultivated appreciation of music, theater, and fine arts became an important marker of status. High art was for the refined tastes of the educated upper classes; popular entertainment was for the masses.

Such pretensions to the cultivated life came to the New World with European colonists and were exemplified by founders such as Thomas Jefferson, who built his Greek revival home at Monticello and played chamber music in his spare time. America's cultural elite knew that they were the masters of a wild and untamed continent that could scarcely aspire to European refinement, but they were determined that the new nation's culture would one day compete. Europe's high-art traditions of opera, symphonic and chamber music, neoclassical sculpture, and figurative painting were assumed as the ideals toward which American artists might strive. Gradually, a supporting system of elite training facilities—art schools, conservatories, ballet studios—emerged to further this goal.

Meanwhile, the Industrial Revolution was producing a class of wealthy Americans who aspired to the pretensions of Europe's nobility. American heiresses married down-on-their-luck English aristocrats, exchanging wealth for titles. Vanderbilts and Carnegies turned Newport into a veritable subdivision of faux European country estates and then went on to build universities and libraries to foster an appreciative clientele for their vision.

This was, and remains, a vision that excludes most of the world's cultural output. Popular entertainments such as traveling theater troupes, barn dances, or epic poetry recitations were left out of the equation. Ethnic folk traditions, including those from Europe, were scorned. Art of any kind from Africa, Asia, the Middle East, or Latin America was not even considered (except the occasional Chinese porcelain vase, displayed as an exotic curiosity). And Native American culture was most unwelcome: European Americans were still in the process of annihilating Indians. The culture of most Americans was systematically excluded from the academy and from the halls of public art. This bias is so entrenched in our institutions that it is still part of the received tradition in every school. Ethnomusicologists today are fond of pointing out that European "classical"

music accounts for less than 5 percent of the planet's musical output but still receives over 95 percent of the attention in American universities.

In 1913, with the inception of the federal income tax, a system was put into place that effectively ensured that elite cultural patronage would dominate the evolution of American public culture. With the income tax came the idea of the tax deduction: those with wealth could avoid paying it in taxes to the government if they donated to "charity." The idea was to encourage private patrons to assume some of the social burdens of the age. Many social ills—urban slums, homelessness, illiteracy, inadequate health care—resulted directly from the primitive capital accumulation of the early industrialists. Government was—and remains—reluctant to assume these burdens. The tax deduction was deemed a mechanism for encouraging the wealthy, who had gained tremendously through industrialization, to bear some of its costs. It has proven to be extraordinarily successful. The donation and deduction system has created an unprecedented, permanent pool of wealth dedicated to the public good. The thousands of American hospital wings, university buildings, sports facilities and arts centers bearing the names of wealthy patrons stand as testimony to the use of this grandest of tax loopholes.

But this is capital that remains privately controlled. Rather than vesting the people's elected representatives with the responsibility to decide how to best support our communities, the tax deduction effectively cedes that power to the wealthy.

We need to be very clear that donated dollars are *public funds,* monies that have not flown into the treasury precisely because they are dedicated to support of the public purpose. Through our tax codes, we have granted those in a position to donate the privilege of determining how those funds will be allocated; but the money belongs to the public. Economics reporter David Cay Johnston points out that "gross incomes are commonly seen as just rewards for one's commitment to work, as well as one's willingness to take investment risks. But that belief assumes that the market rewards each endeavor according to its value, an assumption that collapses under scrutiny."[1]

A billion dollars is more money than most people can really imagine. If somebody started depositing one thousand dollars a day into your bank account at the time Jesus was born—and kept on putting in another thousand every single day until now—you'd still have another seven hundred years to go before you hit the billion-dollar mark. The notion that someone could earn that much money, in any conceivable sense of the word *earn,* is absurd. America has numerous billionaires today because we have

made political decisions that allow individuals to monopolize wealth at the expense of the public and of the planet.

According to the United Nations Human Development Report, "the three richest people in the world have assets that exceed the combined gross domestic product of the forty-eight least developed countries." Kofi Annan tells us that "the world's 225 richest individuals, of whom sixty are Americans with total assets of $311 billion, have a combined wealth of over one trillion dollars, equal to the annual income of the poorest 47 percent of the entire world's population." And: "It is estimated that the additional cost of achieving and maintaining universal access to basic education for all, basic health care for all, reproductive health care for all women, adequate food for all and clean water and safe sewers for all, is roughly forty billion dollars a year—or less than *four percent* of the combined wealth of the 225 richest people in the world."[2] Under the circumstances, one might hope that the ultra rich would put that last 4 percent to work for the public purpose. But they do not.

The problem is that wealth does not answer to public need. "Civic spirit? Civic duty? That any rich American should conceive of this antique virtue, let alone act on it, seems preposterous," writes Nelson Aldrich in the *New York Times*. "For twenty years we've witnessed—hell, participated in—the most egregious display of acquisitive individualism since the Gilded Age. Government, steward of the civic commons, bowed to our sociopathic sense of entitlement to our acquisitions with tax cut after tax cut, principally for the rich."[3] It is to this same group that we turn for support of public culture, in all of its manifestations.

According to NewTithing Group, a San Francisco nonprofit that generates statistics on charitable giving, "individuals and couples whose adjusted gross income is $1 million or more a year have investments worth, on average, about $18 million. NewTithing estimates that with reasonably clever deployment of the charitable deduction on income and appreciated assets, such a statistically average household could give away as much as $1 million a year and suffer no loss of capital. And what does our statistical couple actually give each year? About $120,000."[4] And that's the average. When you consider that a handful of individuals donate exceptionally large sums each year, the actual contribution from most of our wealthiest citizens is an even more modest portion of their fiscal capabilities.

While smaller than they could be, these contributions provide the most important financial support of culture and civil society in America. In the absence of substantive public funding mechanisms, private donations rule

the cultural kingdom. And by the magic arithmetic of compound investments, even relatively modest endowments can grow in time to become significant assets. In practice, most of the resources that our nation has for culture are allocated by an extraordinarily small group of individuals. The disbursement of these funds by such an elite group has a profound effect on the content of our civic culture.

No alternative paradigm to the Eurocentrism of the elite class has been able to compete in the public arena. No one else, including the government, has comparable resources to devote to cultural activity. In 2000, 4.2 billion dollars contributed by foundations and corporations was allocated to the arts and culture (out of total contributions of over 35 billion).[5] The National Endowment for the Arts' budget that year was 105 million dollars, less than 3 percent of the total given privately. These numbers represent only institutional bequests, excluding gifts from wealthy individuals that tip the scales further. The vision of art that is enshrined in all of our major cultural institutions necessarily reflects the fiscal muscle and aesthetic tastes of the moneyed class, to the exclusion of almost everything else. A significant consequence is the overall weakness of public culture in relation to the commercial domain.

✧ ✧ ✧

The major vehicle that elite culture uses to ensure its legacy is the foundation. By the early years of the income tax, many of the wealthiest industrialists had accumulated a great deal of capital, and some found difficulty in giving it away in amounts sufficient to their tax needs. They struggled with the need, experienced often by large contributors, to control the course of activities that their cash supported. An outright gift to a worthwhile charity might be squandered or spent in ways unacceptable to the donor. Once the gift was made, the money was beyond the donor's control. Moreover, many felt that they should be getting something back, a return on their largesse (in addition to the tax deduction). Establishment of "legacies" to carry out donor's wishes into perpetuity was a mechanism for answering these concerns.

The solution was, basically, for rich people to start their own charitable organizations and then give most of their money to *them*—essentially funding themselves. Thus, wealthy individuals could avoid having to pay taxes, and also avoid having to send their money to some other charity beyond their own immediate control. A foundation is a nonprofit that is usually set up with a single large donor's funds, with a mission of supporting whatever activities the benefactor might choose. There are foun-

dations that are devoted exclusively to providing scholarships for students of Norwegian descent to attend the University of Chicago, to sending Baptist missionaries to Africa, and to supplying professional quality basketball courts to high schools in Texas. Whether or not those things are among the most pressing needs of their communities is not a question that is addressed in the creation of foundations. Even from beyond the grave, stipulations of the original benefactors put a limit on how foundations can spend their money. The continuing appeal of this system to rich donors is manifest: three-fifths of the largest foundations were created during the 1980s and 1990s.[6]

Many American foundations, small and large, include support of the arts and culture as a prominent part of their missions, reflecting the interests of their founders. A 1999 survey of roughly half of the fifty thousand foundations tracked by the Foundation Center showed that 88 percent gave to the arts.[7] These include some of the largest foundations in the country. John D. Rockefeller created his foundation as soon as his income was taxed, in 1913. The Ford Foundation was started in 1936; the Pew Charitable Trusts in 1948; the John P. and Catherine T. MacArthur Foundation, famous for its genius grants, came online in 1978; the Wallace–Reader's Digest Foundation and Doris Duke Charitable Foundation became major arts donors during the 1990s.[8] All have their own idiosyncratic arts and cultural initiatives.

Foundation funding priorities tend to be highly focused, and they are capable of great flexibility. Government arts programs differ from their foundation brethren in that they are politically accountable. The 1990s culture wars resulted in smaller budgets and a more cautious approach to the government's support of potentially controversial projects. Private funders suffered no such problems. Melanie Beene, of the William and Flora Hewlett Foundation, states that "one of the things foundations can do is take the kind of risks that funders with direct public accountability can't take. We can be more idiosyncratic. At least at this juncture, we can do things in a more novel way than government can, if we really want to."[9]

This flexibility has attracted some of the most talented and thoughtful arts professionals to work in the foundation world. A few of the large culturally focused foundations are far more creative and judicious in how they deploy resources than a typical state arts agency that is as likely to be headed by a political appointee as an arts leader. Foundations are able to target specific problems and funnel money to them to the exclusion of everything else, in a way that governments cannot. They can be very ef-

fective in the development of innovative program areas, and their dissemination through the field.

Some foundation directors are visionaries whose interests and initiatives shape the cultural consumption of millions. "I'm not sure of the relationship between boards and staff," comments David White of New York's Dance Theater Workshop. "But in terms of staffing, there is a real understanding that we are at a point now of conceptualizing differently what the infrastructure of U.S. culture is. And there are people there [at some foundations], and they're beginning to do it."[10] The annual meetings of Grantmakers in the Arts, an organization including most of the prominent foundations, are full of discussion and debate about the vital role of community to the cultural equation and the importance of sustaining grassroots partnerships. Their proceedings over a period of recent years offer a picture of a gathering wave of awareness and intent.[11]

The growing stress on community as the vehicle for positive social change of all kinds has introduced culture as a consideration of foundations that typically support non-arts-related economic development projects. Culture is beginning to be addressed alongside sanitation systems, remote rural hospitals, and AIDS prevention programs. The investments that can vitalize community cultural initiatives are not large. Indeed, most community-based projects do not have the institutional infrastructure to handle enormous cash infusions. "This is not about huge sums of money," says David White. "This is about what that money mortars together, which is the bricks of mutual education, the requirements to practice citizenship within a community of peers, many of whom have very different agendas, just as your neighbors and cohorts in life would have. Then process that and move back out into the community with something that helps to trigger the tools, and for you to then practice."[12] Here is an opportunity for private funders to make a large difference with a relatively small investment, the very thing that most foundations strive to do.

Unfortunately, although many foundations publish annual reports touting the importance of community, few have chosen to devote more than token sums to its support. The majors, and most other arts-oriented foundations, have remained extraordinarily conservative in their funding choices. Among the top fifty recipients of arts and culture grants in the United States, there is no organization devoted to developing community-based culture. Instead, foundations gave nearly half a billion dollars (numbers for fiscal year 2000) to art museums.[13] The performing arts, largely dominated by symphony orchestras and opera companies, were

equal to museums. In 1999, 3 percent of the total number of grants accounted for 50 percent of total donations—all of which went to the large institutions: museums, orchestras, universities, and other foundations that reflect their founders' cultural orientation.[14] Some of the more progressive foundations have initiated new programs designed to impact communities. While these experiments point in a very positive direction, they have thus far remained relatively modest pilot projects, accounting for a negligible portion of overall foundation priorities.

Foundations are very nearly unaccountable. Unlike governmental programs that must (theoretically at least) undergo some form of review and be held to a public standard, foundations can do with their tax windfall pretty much whatever they choose. "And none of them," says Vince Stehle of the Surdna Foundation, "is required to demonstrate the immediate social benefits to society to justify the tax deductions that are used to encourage creating those endowments."[15]

With little public accountability or media scrutiny, it is not surprising that most foundations are not pushing a progressive agenda. "The foundation world has long been a backwater of lazy thinking, uncritical attitudes, self-satisfaction, and backslapping," writes Pablo Eisenberg in the *Chronicle of Philanthropy*. "[A] few top foundation executives have written thoughtful speeches and articles challenging institutional practices and encouraging more effective performance. But their work stands out precisely because most of American philanthropy suffers from intellectual torpor and a lack of critical analysis."[16] The lack of vehicles for challenging foundation priorities makes it easy for trustees to believe that they are wisely stewarding the public's funds.

Foundations are required by law to pay out a minimum of 5 percent of their assets in grants each year. To do this, they have created a range of structures that strive to give the foundation control over how its funds are used in support of its stated mission. This theoretically adds value to the strictly financial transaction of a grant, by interposing the foundation's policies and screening system between the grantee and the public's money. It is assumed that enlightened philanthropists have a clear sense of society's needs, and will act accordingly.

Actual foundation giving hovers just above the legal minimum, averaging about 5.5 percent, indicating an overwhelming preference for protecting and building assets over funding social programs. The bull market of the 1990s powerfully enhanced most foundations' capital, but payouts failed to keep pace with asset growth. In recent years, there have been growing complaints about the meager amounts of foundation giv-

ing in relation to the size of the tax breaks that they receive. "When an individual contributes $100 to a charity, the nation loses about $40 in tax revenue, but the charity gets $100, which it uses to provide services to society," write Michael Porter and Mark Kramer in the *Harvard Business Review*. "The immediate social benefit, then, is 250 percent of the lost tax revenue. When $100 is contributed to a foundation, the nation loses the same $40. But the immediate social benefit is only $5.50 per year that the foundation gives away—that is, less than 14 percent of the forgone tax revenue."[17]

In 2003, Congress proposed a rule change that would require foundations to actually disburse 5 percent of their asset base each year, without deducting the cost of foundation operations first. Some foundations, it is claimed, spend lavishly on opulent offices and executive salaries while making few actual grants. According to the *New York Times*, "The bill has created a furor in the philanthropic world, with foundations warning that they could be forced to squander their assets and spend themselves out of existence."[18] As this book goes to press, the bill has quietly died in committee.

Foundations hold an enormous legacy of capital in trust. As such, they represent vital public endowments that society can draw upon into perpetuity. However, when communities are denied access to current support for the sake of growing foundations' capital through speculation, the public's funds are being abused. Indexing foundation payout rates to asset growth is an obvious legislative response to this problem. Other means of control and oversight might be tried. Foundations could be granted time-limited charters and be required to address benchmarks of efficacy through periodic review. If the foundations are not fully responsive to the public purpose, they should have their charters revoked and assets turned back to the treasury. Finding mechanisms to bring grant recipients into decision-making authority over funding priorities offers a clear strategy for holding foundations accountable to the public purpose. Efforts to open and democratize the process of disbursing these public resources should be aggressively pursued.

✧ ✧ ✧

Does the public get a fair exchange by giving fiscal power over to foundations? The alternative—more stringent taxation of wealth and government support for social programs—is the norm throughout most of the industrialized democracies. In Canada, Germany, Britain, or France, cultural organizations do not rely on private funding as they do in the Unit-

ed States. Rather, governments support the arts on a level that is lavish by American standards. Finland spends more than fifteen times as much on the arts and culture, per capita, as the United States, including all federal, state, and local cultural programs combined. Taken as a percentage of gross domestic product, Germany is eighteen times more generous to the arts.[19] Even Ireland spends more (see table 1).

Conservative critics have long argued that the government has no business in the arts, which ought to be left to the private sector. Even the modest expenditures that are currently allocated are too much, they say, and should be eliminated. Despite the controversies surrounding the NEA in the 1990s, Congress and the states have sustained at least a minimal infrastructure for our public culture. "A government that supports the arts and the humanities is not engaging in philanthropic activity," argues Benjamin Barber, "but assuring the conditions of its own flourishing. This is perhaps the most important single argument in favor of a democratic government playing some role in the arts: not in the name of the needs of the arts, but in the name of the needs of democracy."[20]

During much of the twentieth century, there was no direct state subsidy of culture in America at all. For a brief period during the Depression, Franklin Roosevelt's Works Progress Administration (WPA) supported cultural programs that very quickly yielded some enduring results: James Agee's chronicle of southern sharecropping and Walker Evans's luminous photographs, Thomas Hart Benton's heroic plains post office murals,

Table 1. Comparative Government Expenditures on the Arts

	U.S.	Canada	France	Germany	Britain
Total govt. arts spending (in $U.S. millions)	$1,530	$1,272	$3,275	$6,886	$1,518
Govt. arts spending as % of all Govt. spending	0.13	0.93	1.31	1.79	0.65
Govt. arts spending as % of GDP	0.02	0.21	0.26	0.36	0.14
Per capita arts spending (in $U.S.)	6	46	57	85	26

Source: National Endowment for the Arts, *NEA Research Division Note #74: International Data on Government Spending on the Arts.* Washington, D.C.: NEA, 2000. Available online at <www.arts.endow.gov>.

Benjamin Botkin's championing of folk culture through the Federal Writers Project. But funding for these initiatives was short lived (1935–39). It wasn't until 1965 that Congress created the National Endowments for the Arts and Humanities with a charge of stewardship over America's cultural resources. The advent of the NEA and the NEH was met with much fanfare and hope. According to Livingston Biddle, who helped shepherd through the authorizing legislation and went on to become chair of the NEA, "The Endowment became known for a bold and progressive outlook."[21] But its promise has only been partially fulfilled. Paltry budget allocations and constant controversy have limited the federal government's role in the arts. Private contributions to the arts outstrip the NEA's budget by a factor of one hundred to one.[22] One of the results of the culture wars of the 1990s was congressional mandates for ever larger portions of the NEA's budget to be paid out to the state arts councils, effectively shrinking the NEA's budget even further. The states collectively control far more arts money than the federal government.

Because of its status as the nation's cultural flagship, the NEA is a player, but not one with enough resources to do more than influence the range of possible outcomes; it is not in a position to set cultural policy or dramatically restructure the distribution of arts support in our country. Moreover, since its inception, the NEA has been hostage to the same high-art bias that afflicts foundation giving. Despite steady rhetoric about being "committed to supporting equitable opportunities for all and investing in a diverse reflection of our society, including works of all cultures and periods,"[23] the endowment has consistently and unashamedly championed the same academically sanctioned version of the arts that prevails at the foundations. There was not even the pretense of support for traditional culture within the NEA until the Folk Arts Program was finally created in 1974. Then this program—charged with supporting the heritage of all of America's wildly diverse ethnic communities—was given the smallest allocation of any NEA division, less than 2 percent of the agency's budget. This program was abolished when the NEA's budget was slashed during the Gingrich revolution, and its activities were folded into an omnibus Heritage and Preservation Program, which still receives a tiny allotment, 3.5 percent of the endowment's budget.[24]

When Jane Alexander was chair at the NEA, she launched an aggressive public relations blitz, traveling throughout the country to generate support for her beleaguered agency. Prior to each speech, she showed a film extolling the endowment's accomplishments. The film didn't show any Mapplethorpe photos or even any Metropolitan Opera scenes. It

showed mostly traditional artists working in community settings: blue-grass musicians, African dancers, sweetgrass basketmakers, cowboy po-ets. Alexander knew perfectly well that the images that could effectively sell the NEA to a skeptical public were drawn from familiar, community settings. The artists depicted in the film were in reality the endowment's lowest funding priority. It is precisely these community-centered programs that have the most appeal to congressional representatives and many of their constituents, and it is ironic that while they receive the media spot-light the majority of funding flows to the large institutions. The disburse-ment of governmental arts resources fails to live up to the promotional rhetoric.

A practical solution to this problem of funding allocation could be the creation of a separate and independent National Endowment for Com-munity Culture. Funded on a level commensurate with the other two endowments, it could offer government a far more equitable and repre-sentative vehicle for the support of *all* the arts. This prospect was actually discussed during the debates over the original creation of the endowments. "It was a pretty straight-forward notion," recalls Bess Lomax Hawes, who went on to become director of the NEA's folk arts division. "[S]ince the Humanities Endowment basically addressed the needs of professional scholars and the Arts Endowment basically addressed the needs of pro-fessional artists (almost without exception those working within Europe-an 'high art' traditions), a third granting institution was required to look after the interests of people from the 'little traditions'—ethnic, tribal and local. It would have been, one must admit, simpler if things had worked out that way."[25] Given the prominence of traditional culture in govern-ment's cultural marketing campaigns, and the NEA's track record of fund-ing priorities, this is a proposal that could answer many current shortcom-ings. It deserves serious consideration.

The case can be forcefully made that, at current budgetary levels, the government's role in culture is effectively marginalized. What would it take to boost American cultural support to the level of Canada? Calcu-lated on a per capita basis, that would require the added annual expen-diture of just over $10 billion. To bring our arts expenditures up to the comparatively opulent level enjoyed in Germany would require $20 bil-lion. By contrast, the Pentagon in 2002 planned to spend $68 billion to buy 339 new F-22 fighter jets.[26] A cultural program that could generate astonishing results—and not incidentally, play a significant role in en-hancing national security—could be achieved with a 29 percent shift from the military's request.

The Pentagon knows how to play its politics: bits and pieces of the F-22 program are spread around numerous congressional districts all over the country. However, culture takes place in *every* congressional district. A real, substantial, and sustained commitment to government arts funding would reap enormous economic benefits. Moreover, by taking a leading role in cultural development, political control could be exerted over content. If politicians don't like the excessive sex and violence that is standard television fare, a national commitment to providing a noncommercial alternative should be a high priority. It is ironic that many of the same officials who claim to champion "family values" deny financial support for public broadcasting or the arts endowment.

✧ ✧ ✧

In practice, the NEA and the major arts-oriented foundations are very coordinated in their approach, which thoroughly dominates public cultural activity. All share a common reliance on peer-review panels for funding recommendations and are explicitly oriented toward short-term initiatives. The panels are dominated by academic specialists, respected and credentialed leaders who share a uniform, postmodern, culturally savvy, slightly cynical mindset. The NEA and big foundations go to great lengths to see that their panels are balanced by race, gender, and region, but they fail to engage viewpoints that might challenge their basic assumptions about what qualifies as culture worthy of support. High art, art-for-art's-sake, and the tyranny of the new are good; projects that fail to pass the *cutting edge* test, are not. This is true even of most funders who claim to support community culture. "If you take all the institutions together, and all their missions, and all their funding, and how they work," says Peter Pennekamp, "you end up with something that's totally cut up based on what funders expect, where the funding comes from, historical reasons. But very little of it has to do with how any given family living on the corner of 135th and Broadway actually leads their life."[27]

A more informed process could remove some of the decision making from foundation staff or panels of academics and place it in the control of workers who are actively making culture happen on a personal level every day. "[I]t's the practitioners now who are the new theoreticians," says White, "not the academics, not—I hate to say it—the consultants, not the people who are simply facilitating everybody into the pool."[28] As well-intentioned as they may be, outsiders (including foundation staff and trustees) are not equipped with the information that local practitioners possess about what is working and what is not, about how programs are

actually perceived within a community, and where funding can reap sustained community benefits.

A key report from the Urban Institute is emphatic on this point: "It is certain that without the integration of community values and realities with corresponding data about community conditions and dynamics, cultural and community-related policies cannot expect to be successful. But the integration of such values and collection of data relies on rethinking how all parties involved do their work. This, in turn, requires recognizing the connections among community arts and cultural practices and other policy areas or aspects of community life."[29] Local activists—artists, participants, ordinary citizens—should be welcomed to the decision-making table in a leading capacity. This applies not only to grant panels but to the internal foundation processes that devise whole granting programs and allocate broad areas of expenditure. Without the community's voice, funding will frequently miss its target.

This is true because, for the most part, funders are not nearly as interested in support of the community's culture as they are in pushing their own ideas of what it *should* be. I have often felt, after sitting through a panel meeting, that the conversation around the table would be substantially different if a truly representative body was gathered to make recommendations. If conservative Christians, labor union members, unassimilated ethnics, and urban hip-hoppers were part of the discussion, the assumption that Trisha Brown or Philip Glass are the exemplars deserving public support might not be so automatic.

Such a democratic discussion might steer our cultural priorities toward those that hold relevance to our communities, instead of to a highly educated elite. In dozens of planning meetings with African American communities, I have yet to hear a single person suggest that what they really need to strengthen their local culture is Bill T. Jones or the Urban Bush Women. This does not deny the exemplary artistry of these individuals but points out that their work is not representative of a community's sense of itself. It reflects the interests of a corps of high-art aficionados—mostly affluent white people on college campuses. As things stand, even a cursory look through the lists of actual governmental and foundation grants will attest that Jones and the Bush Women are part of relatively small pool of artists and organizations receiving a disproportionate share of public money year after year. All of us who serve regularly on the panels are accustomed to seeing the same names on application after application.

The arts funding structures we have in place are designed to support the work of these professional artists and tend to discourage community

participation. This is born of the same attitude that defines high art as valuable and denigrates popular culture. The explicit assumption is that the work of professionals is more worthy of support than that of *amateurs,* as those artists who work in community settings are designated. Professional artists' careers evolve differently from art in a community setting. Building culture in a community is not a project that can happen once and for all, but a process that takes years of sustained effort to bear fruit. It requires a long-term commitment from organizations, artists, and community members to realize a positive result. Successful professional artists, though, usually advance their careers through a series of short-term projects. They move from commission to commission, making this work now, and next year something new. Project-specific funding meshes with their professional trajectory, whereas it is counterproductive for community-based programming. A key report on the cultural economy points out: "Because public funding for the arts, and to a large extent private funding as well, tends to be project-oriented with results being measured by product, this is an essentially unavoidable condition."[30]

With only a handful of exceptions, all of the grants given by the NEA, NEH, or the major foundations are restricted to short-term, project-based funding. "The way funders have expressed their discomfort with community artists and thus hedged their bets," says a report from the Rockefeller Foundation, "has been to channel money largely through time-limited project grants, necessitating a perpetual cycle of packaging, fund-raising and repackaging that obscures the strong spine of the work, focusing attention on superficial differences that make an attractive project package."[31] The NEA supports only projects and discourages multiyear proposals. Most foundations restrict their grants to a single year of activity. Foundations claim that this preference is due to the vagaries of the market that control the total amount they can distribute from year to year, but this obscures the fact that their policies effectively prohibit the very kind of sustained support that any viable community cultural initiative requires.

A case could be made that the short-term project funding that is currently available is worse than no support at all. When a community gets mobilized for work on a project, only to have the funding disappear just as people are starting to participate, the results can easily turn to cynicism with the whole process. Community members can feel cheated or used, as though the artist or nonprofit was just taking advantage of them to get the grant subsidy. An awareness of this dynamic is currently working its way into foundation boardrooms. "We've been accustomed to

thinking in one- to three-year grants," says Penelope McPhee of the Knight Foundation. "Now we are gradually moving to thinking in three- to five-year grants, but I hope we'll be thinking in ten-year commitments to organizations and to outcomes."[32] Few foundations have followed into the three-year timeframe, let alone ten years. Seven-tenths of arts grants given in 2000 were designated for either capital support or short-term projects.[33]

❖ ❖ ❖

I am suggesting that the entire public arts infrastructure—from the mechanism of the tax deduction, to the domination of capital by foundations, to the decision-making process that screens out diverse opinions, to the counterproductive results of short-term funding policies—is inherently elitist and hostile to the aspirations of democratic culture. This is a complex, systemic problem. Our government and most of the arts-friendly foundations profess a policy of inclusion, and many program directors are sensitive to the needs of artists working in community settings. But they are all working within a structure that systematically denies support for the very things they claim to value. Public culture in America today is not very public.

That leaves the commercial sector. Popular culture cross-penetrates the public arts world at every turn. "In a day and age when three tenors can sell out Dodger Stadium, or an artist can have her artwork promoted on a bottle of Absolut vodka," notes Jennifer Gottlieb, "it is increasingly difficult to separate the nonprofit from the commercial."[34] Patrician art and plebian art meet in the marketplace, but corporations also play a direct role in funding the public side of the cultural equation. Corporate contributions represent a substantial portion of American cultural support, tallying over $875 million annually.[35] While this is significant, it is a factor that is rapidly diminishing. "Corporate philanthropy is in decline," reports the *Harvard Business Review*. "[O]ver the last 15 years, corporate giving as a percentage of profits has dropped by 50%."[36]

Little of this corporate funding supports programs that are relevant on a community level. Corporate contributors are beholden to no one but their directors and shareholders. Unlike individuals who decide to donate to their local arts center, few corporations are motivated by a sense of altruism toward communities; their contributions are investments in image. Some of the larger corporations, like the wealthy individuals who own them, have created charitable foundations to better control the flow of their dollars to the community (and to get the tax deduction). But do-

nations are still viewed as vehicles for shining up the corporate name with a particular group of customers. Many businesses are straightforward about this; donations are drawn from corporations' advertising budgets. Like any other promotional expenditure, they are expected to yield results in the form of corporate income.

The result is an apparently quixotic allocation of corporate donations that are dictated by business priorities. On rare occasions, minority communities can find themselves on the receiving end of this largesse, at least on a temporary basis. Some corporations need to do business in the ghetto or attract Latino customers. Banks accused of redlining have to seek out depositors and borrowers from the inner city, and what better way to demonstrate their open door policy than through the high-profile sponsorship of a local gospel choir's trip to the nationals. Fast food restaurants suffering from news reports of racially motivated seating and serving priorities (or worse) need to mend some fences if they are to keep selling chicken. Sponsorship of a big block party or ethnic festival, complete with banners spanning the street prominently pointing out the corporate donation, is just good business sense.

Relatively modest sums are adequate to give the public an impression that a corporation is their friend. Since most nonprofit arts organizations are perennially so strapped for cash, they are rarely in a position to refuse any donation. Their corporate sponsors want to buy advertising space, and they want it as cheaply as possible. What does it cost to have that enormous sign above the stage, implying that tonight's performance is brought to you courtesy of Nike or Budweiser? In every case, it is a small fraction of the cost of the production, rarely more than a few thousand dollars. "Recognize," says William Cleveland, "that public attitudes towards the arts are in large part determined by cultural arbiters who have a self-interest in the market-defined notions of artistic quality and success."[37] They'll put their logos on whatever serves their purposes. From the sponsorship plugs between segments of *All Things Considered* to the banners hanging from every major art museum, corporations are using culture as a vehicle for promoting their products.

Most of these donations support the kinds of programs that are likely to deliver the largest audiences. Businesses put their funds where the people are, so the corporate logos abound at Opryland or Disney's Epcot Center, with their well-scrubbed—and wildly populated—versions of traditional cultures. Meanwhile, the communities that developed the cultures on display in Nashville and Orlando, that nurtured their heritage over the generations, are generally left off the corporate maps—they don't

usually present a significant enough demographic profile to warrant the expenditure.

American public culture has a long track record of garnering support from industries with image problems. The so-called sin industries, such as tobacco, alcohol, and the oil industry, have been among the high-profile givers to arts charities. Philip Morris is a primary supporter of the Brooklyn Academy of Music; Texaco sponsored opera broadcasts every Saturday for years; before it collapsed, Enron was among the most generous corporate patrons of the arts in Houston. Within my own organization, we used to have annual debates about whether or not to accept a few thousand dollars from the Maine Yankee nuclear power plant—and suffer through the potential embarrassment of printing their logo on our posters and programs. The fact that we invariably did, comments on the precarious finances of public culture.

If cultural organizations weren't so small and splintered, they might exert some muscle in the marketplace. The arts sector—when you add up all the theater and ballet companies, musicians, painters, and writers—represents a substantial portion of the workforce. A recent study found that "[i]n aggregate, the entities within the Creative Cluster [of arts-based employment] employ nearly a quarter of a million people in New England—or 3.5 percent of all the jobs in the region—supporting an annual payroll of $4.3 billion."[38] This is equal to the size of the regional computer equipment economy and well ahead of health care technology. The arts sector is also growing at a rate almost double the economy as a whole. Similar comparisons almost certainly hold true for the Mid-Atlantic States, most of the Midwest, and the Pacific states.

The public arts sphere is firmly embedded within the larger economy. The commercial and nonprofit realms are codependent in its maintenance. As information technology advances, cultural workers, and the skills they bring to the economy, will continue to become more valuable. But many of our culture workers are missing a vital component of the creative matrix: access to their heritage. The ongoing debasement of local and ethnic cultures will hinder their ability to contribute as fully as they could. The creative economy needs the backing of its legacy in local cultures if it is to continue as an innovative force. "Creativity," says Richard Florida, "requires a social and economic environment that can nurture its many forms."[39] Without the resources offered by their heritage, our artists and our communities will be substantially limited in their creative

options. At present, neither the public arts infrastructure nor the private sector is oriented towards addressing the problem.

None of this presently occupies a place within our national political discourse. The House of Representatives is not considering legislation to radically restructure our system of tax deductions, remove wealthy patrons from the process of funding allocations, or bring our per capita arts expenditures up to the level of Portugal. But the continuously expanding diversity of America's population offers an opportunity for those who are now without representation in our public culture. Those communities constitute a large and rapidly growing demographic, a population with potentially significant political muscle that has scarcely been mobilized. Culture is just one of a host of issues that can call minority activists and voters into the political arena. It will take time and skill to inform our communities, create alliances across racial and linguistic lines, and build a progressive political force. Responsible cultural activists will have to turn far more of their attention to this imperative or accept accelerating marginalization for their work and constituencies.

Motivating progressive political action about art is a challenge that has yet to be answered. But culture, as we have seen, is embedded in group identity, a topic that engages the passion of a great many people. The place where identity politics often finds its voice in the public arena is in the ceaseless debate about American public education. The content of school curricula is an issue that puts culture onto the front porch of local and national politics. It is the wedge that can bring a discussion of how cultural resources are allocated onto the political agenda. It is also central to the ultimate success of our collective efforts to celebrate and sustain the cultural genius of our communities. Education is the domain where culture enters politics and in which cultural politics can have the most profound and enduring impact. The next chapter offers an examination of how community heritage is faring in our school systems and what we might be able to do about it.

6

Education

The events of September 11, 2001, cast the work of our schools in sharp relief. Because of the hour of the attacks, most children were in class at the time, and it fell to teachers to inform students and help them try to process the incoming data. "We didn't want to needlessly frighten them," said one of my teenage daughter's teachers, "but there was clearly a lot of information that they would need if they were to understand what was going on." Most important, students asked *why* this had taken place. Who were the terrorists? What motivated them? What is Islam? How could America have allowed this to happen? And as they watched the televised scenes of Arab children celebrating the attacks, they asked why the rest of the world seems to hate us so much. Real questions—and ones without easy or reassuring responses.

This de facto role as first-line emergency counselors to America's youth was unprecedented in this generation of educators, and it triggered a deep

Benoit Bourque from Québec introduces a young pupil to playing the spoons. Photo by Tonee Harbert.

introspection on the part of teachers and administrators, a reexamination of our schools' mission. As happens so often in moments of catharsis, what they saw was both encouraging and troubling. September 11 revealed extraordinary resilience and compassion among teachers, who rose to the challenge of addressing those knotty questions, even as they were themselves struggling to grapple with the impact of the events. But it also indicated some enormous gaps in the results of contemporary American education: why do so few of our students know what Islam is about, or where Afghanistan is on a map? The area of knowledge that has been largely left behind by our schools is culture, the engine driving events, like September 11, that now impact the life and future of every student.

"After 9/11 was the right time for schools to ask the big questions," writes Tim Walker of Teaching Tolerance. "Dialogues have to be initiated that look beyond curriculum," says Lew Smith of Fordham University. "What kind of students do we want to produce? Why are we doing what we are doing?" The conversation needs to include the entire school community, "not just inspired administrators or isolated classroom teachers."[1] Walker believes the response to a crisis like September 11 offers schools the opportunity to comprehensively examine what schools are all about, and assess how well they are carrying out their purposes.

"What is the mission of education in a democracy?" asks Benjamin Barber, president of Rutgers University. "In the first instance, democracy itself, just as a primary mission of democracy is public education. The spirit of inquiry (asking tough questions) coupled with the capacity to judge (offering provisional answers) defines both liberal education and education for liberty, both critical learning and deliberative democracy."[2] Without a citizenship educated to the moral responsibilities of democracy, Barber argues, the rights that Americans treasure are no more than rhetoric. Liberty takes practice. "But for all practical purposes, equality is not the condition of learning and experience but is produced by them. If education must create both liberty and equality, it becomes the foundation of all individual growth and all collective civilization. Nothing is more important."[3]

Liberty can be pretty abstract, and its nuance might be lost on politicians whose idea of education reform is to cut school budgets. But there is a compelling reason why even fiscal conservatives should get behind education: it pays. "Studies of national growth find a clear connection between economic success of nations and their human capital as measured by the level of education," points out economist Richard Florida. ". . . Research by Patricia Beeson, an urban economist at the University of Pittsburgh, supports this view. Her ongoing work explores how investments in various sorts

of infrastructure have affected city and regional growth since the mid-nineteenth century. She finds that investments in higher education infrastructure predict subsequent growth far better than investments in physical infrastructure like canals, railroads or highways."[4] Educated citizens not only participate in democracy, but they tend to create a lot more wealth, for themselves and for their communities, than do illiterates.

American schools are partway through a reformulation of vision and pedagogy in response to the requirements of the twenty-first century. Crises like September 11 push them to address the demands of citizenship. They are retooling for the future, and the shape of the new model is a matter of contention. "The industrial economy required a workforce that was 80% manual and 20% professional," says Ken Robinson, of the University of Warwick, in Britain. "Most of our education systems were designed to pick out this 20% of kids and give them privileged access to certain sorts of occupations. That model is changing irrevocably. We no longer live essentially in an industrial economy, and the work force we need now has a new pattern."[5] The new imperative is creativity. We don't need our schools to inculcate the habits of menial labor; the new economy needs a workforce that is trained in creativity. And that fundamentally implies a new and unprecedented attention to the arts.

Intimately linked to creativity, and the economic benefits that it bestows, is the knowledge of culture and its global importance. If students are to grow into the creative economy, the Others of the world are going to be their customers, their competitors, their colleagues. Our schools can help equip them to contend with the complex challenges that this multiethnic economy presents. Although many of our teachers lack the skills and proper training to focus in a meaningful way on multicultural education, there are signs that recognition of its importance is being driven forcefully home. "Ensuring safe and respectful learning environments for their students who are Muslim or Arab American was an urgent task for schools immediately following the 9/11 attacks," writes Tim Walker. "Muslim/Arab organizations were inundated with phone calls from concerned teachers and parents." The education community's response to the harassment, according to Marvin Wingfield of the American Arab Anti-Discrimination Committee, was encouraging. "I think there is a consciousness out there now that goes beyond the crisis management mode. Teachers have continued to express interest in educating about Islam. No question about it: the paradigm has shifted."[6] This new paradigm implies an enhanced focus on broad-based arts education, coupled with a global purview that explicitly embraces diversity in ethnicity, language, and belief.

Our schools do not have a positive track record when it comes to the arts and culture. "In most education systems throughout the world, the arts are at the margins," says Robinson. "They're optional, low status and not in the center of education provision. That's been the case now for the last 150 years. It's true in your system, it's true throughout Europe and Asia."[7] Given that our educational institutions are operated by people who are products of institutions in which neither narrowly defined *arts* nor broadly inclusive *culture* are given more than passing attention—this is not surprising. But the result is that students, our future citizens, are effectively untethered from their foundations in culture. "[I]t has become increasingly clear that millions of contemporary adults—particularly young adults—have grown up with little or no grounding in the arts, and do not even consider participating in an artistic discipline or attending an arts event or exhibit when choosing among their leisure and entertainment options," point out arts-education researchers Nello McDaniel and George Thorn. "They have little or no understanding of how the arts can be relevant and enriching to them, since the arts have not played a significant role in their growth and development; similarly, they see no role for or value in the arts for their families, their communities, or the nation as a whole."[8] At least a part of this is the result of a longstanding neglect of arts instruction within America's educational establishment.

Cultural concerns have generally been treated as ancillary to the main educational priorities. The three Rs of the nineteenth century, despite a hundred years of scientific educational reform, are still very much with us. In my own primary schooling, art was offered for an hour a week by a harried teacher whose charge was an entire district; we had music twice a week. By junior high school, art and music were available as electives only, and most students opted not to participate. A high school theater club met after school hours and attracted the same ten kids every year. That was the extent of our district's commitment to culture. By way of contrast, sports education was required on a daily basis right through high school, and for many it was still a requirement at college. Perhaps this scenario rings true for many readers.

A pitiful recounting, but in hindsight we enjoyed an arts-rich education compared to what most students get today. The last thirty years have not been good to the arts in American public education. The serial budget crises that have afflicted virtually every school district in the country have seen the arts curriculum reduced from elective to frill to, in many cases, a distant memory. If music, theater, dance, and visual arts are offered at all, only a small percentage of the student body is able to participate, and often

instruction is so sporadic that continuity is impossible. The general decline has been accompanied by demands by school boards and administrators for *results*—demands that often short-circuit the attention to process that is among the most valuable lessons that the arts can deliver. "Whenever cuts are to be made in a school's budget, courses in music are the first to be eliminated," says psychologist Mihaly Csikszentmihalyi. "Even when children *are* taught music, the usual problem often arises: too much emphasis is placed on how they perform, and too little on what they experience."[9]

Eliminating art from the classroom has not produced advances in math, science, or reading. The opposite has taken place. During the same years when art disappeared from the classroom, schools have watched as students' achievement levels in most areas have eroded. The politicized demands for "excellence" and higher standards are the result of public dismay at our schools' apparent failures, and have resulted in a series of reforms that are remaking the way schools work. The 2002 No Child Left Behind Act is a case in point. Within these policy shifts lies an opportunity for the arts and culture to assume a more central place in our children's education.

"Worldwide every post-industrialized nation is considering major reforms in education," states a recent publication of the Dodge and MacArthur Foundations and the Getty Trust, "and with these changes are opening real opportunities for the arts to make distinctive contributions to learning and development. Qualitative new practice in arts education is trickling into our schools—practice that not only opens the world of the arts to children, but also opens the world to children through the arts. And it does so at a time when research is showing substantial cognitive, social and emotional benefits to kids who participate deeply in the arts, regardless of socioeconomic class."[10] It is ironic that the steady attrition in arts instruction has gone on simultaneously with the development of what is now a large body of scholarly evaluation of the role of the arts within the entire construction of education. According to many different measurements assembled by numerous research teams, arts-rich instruction is among the most powerful vehicles for helping students achieve the excellence that our schools aspire to impart.

What's so special about arts education? "Our results show very clearly that the habits of mind and personal dispositions needed for academic success were nurtured in high-arts schools where young people have pursued several arts over a duration of time," writes a Columbia University research team. The "Learning In and Through the Arts" survey examined the artistic experiences of 2,046 children in grades four, five, seven, and

eight in both affluent and less-advantaged public schools in New York, Connecticut, Virginia, and South Carolina. "There was a negative correlation between schools with a paucity of arts instruction and all cognitive and personal dimensions of our study. Thus, schools interested in nurturing complex minds should provide a critical mass of arts instruction over the duration of young peoples' school lives."[11]

Aside from the skills involved in the practice of music, dance, or visual imagery, instruction in the arts develops abstract thinking, and teaches basic lessons about apprehending disparate phenomena. "In arts learning young people become adept at dealing with high levels of ambivalence and uncertainty, and they become accustomed to discovering internal coherence among conflicting experiences," continues the Columbia report. "Since young people live in worlds that present them with different beliefs, moralities, and cultures, schools should be the place where learning fosters the reconciliation of apparent differences."[12] Unlike math or science, points out Elliot Eisner of Stanford University, "the arts teach children that problems can have more than one solution and that questions can have more than one answer. If they do anything, the arts embrace diversity of outcome."[13]

Lack of an arts background puts students at a measurable disadvantage, state the Columbia researchers. "We also have clear empirical evidence that children, in what we have called the low-arts schools, are less able to extend their thinking. It appears that a narrowly conceived curriculum, in which the arts are either not offered or are offered in limited or sporadic amounts, exerts a negative effect on the development of critical cognitive competencies and personal dispositions."[14]

The benefits of extended arts exposure include superior performance on standardized tests. This holds true across the board, in all subject areas and in both wealthy and impoverished schools. The extent of this advantage has been carefully measured and monitored. It varies depending on the grade level of the testing, the subject being tested, and according to the amount of arts access offered by the target schools. In aggregate, students from arts-rich backgrounds test about 25 percent better than their peers in arts-poor schools. In some areas, the correlations are even more dramatic. Music students outstrip nonmusicians in math testing, in some instances by 35 percent.[15] High reading scores correlate directly with student involvement in drama. English proficiency jumps with arts involvement, particularly in expression of complex concepts. Participants in arts programs recorded "a five-fold increase in use of *if/then* statements, scenario building following *by/what/if* questions and *how about* prompts; more

than a two-fold increase in use of mental state verbs (consider, understand, etc.), a doubling in the number of modal verbs (could, might, etc.)."[16]

The arts also promote positive results in areas apparently exogenous to scholastic content, such as self-esteem, dropout rates, and excessive television viewing habits. "The main implication of this work," according to UCLA's Imagination Project, which tracked 25,000 students over ten years using the National Educational Longitudinal Survey, "is that the arts appear to matter when it comes to a variety of non-arts outcomes, some of them intended and some not."[17] The paucity of arts access within American schools is hurting our students, but its scarcity is so ingrained in the system that changing it seems beyond the capacity of individual educators. Even sympathetic teachers "will tell you that there is so much that they can't do because they are locked into a system," says educator Adelaide Sanford.[18]

That system has changed dramatically from what it was when most readers were in school. Education theory today is guided by mandated sets of Learning Outcomes that dictate what students are supposed to have mastered and when they are supposed to have learned it. There are graded outcomes disseminated (as recommendations only) by the U.S. Department of Education. Each state legislature has issued its own set of outcomes, applicable within their boundaries. Kansas raised a national controversy when its legislature passed a set of standards that mandated the teaching of creationism in science classes. Many local school districts have deployed yet another level of mandated standards that usually get even more specific than federal or statewide Learning Results. All of these outcomes are measured by an elaborate set of benchmarks and rubrics that can, theoretically, gauge exactly where a student stands in relation to the knowledge he or she is supposed to have attained. In some districts, the rubrics are taking the place of letter grades as a more precise way of assessing student progress.

The shift to benchmarks and outcomes offers educators an opportunity to infuse our classrooms with culturally rich curricula. Virtually all of the standardized outcomes are explicit in mandating a substantial arts curriculum. Arts education is a prominent winner in the Federal Education Act of 2002. The scholars who craft the legislation have seen the research. They also are unanimous in their emphasis on students' exposure to and understanding of diverse cultures and traditions.

In theory, these reforms should have a substantial and immediate impact in our schools, but there are several difficulties. Few districts are currently in a position to fund real and sustained arts education. After years

of abandonment, many school systems need to create arts programs from whole cloth—and the federal guidelines are not accompanied by new financial resources. And No Child Left Behind, while mandating multicultural and arts education, determines whether a school is "failing" through tests of math and English—administrators have little incentive to beef up their arts programs. Human resources are wanting as well: our teacher corps was trained at universities where, despite the concerns of conservative critics, education in cultural diversity receives scant attention. In most states, the Learning Outcomes amount to yet another unfunded mandate. Legislatures have demanded that schools attain very high standards but have generally not been forthcoming with the financial resources required to do so. Few municipal governments can stomach the tax increases necessary to improve their schools. As a result, many teachers and their unions have been slow to embrace full implementation of the Learning Outcomes. In many districts, we see use of the benchmarks and rubrics that relate to the traditional curriculum, but less ambitious efforts to infuse a cultural component into the schools. "It is ironic," says Eisner, "that at a time when educational reform pushes more and more towards standardized assessment, uniformity of program and homogeneity of aims, a field that provides balance to such priorities should be regarded as marginal."[19]

Shifting the old curriculum in a new direction presents a substantial challenge that can only be addressed by concerted effort over an extended timeframe. Teachers need their own grounding in diverse cultures before they can be expected to explore them with their pupils. Even if every teachers' college were to wholeheartedly adopt a multiculturalist agenda tomorrow, it would be a generation before informed practice trickled down to the primary and secondary classroom level. In the meantime, the elite sense of culture that still dominates all of our civic and educational institutions is passed along as the norm. "What we have been doing in our education system and in our support of the arts is saying that those values which *we* hold to be good are truly and innately good, in and of themselves," writes Robert Garfias in a critical NEA report. "Those other traditions which you have brought with you are quaint, exotic or political. You have to appreciate *our* stuff if you really want to understand 'art.' We have institutionally been treating the arts of the diverse populations of the country as something other than art."[20]

Historically, cultural education in America was thoroughly dominated by the European high arts. Our own aristocracy—all those industrialists and their descendants who started foundations—helped create a system

of higher education that could reify their own values. Despite generations of "liberalism" on campus, and American prominence in the international art marketplace, European high art is still the standard. Dinesh D'Souza, Allan Bloom, and Roger Kimball[21] might be scandalized by the deconstructionist tendencies of a few philosophy departments, but the canon is alive and dominant at college.

Examine the course offerings at any American conservatory. There might be a course on jazz, which has recently won acceptance within the academy now that it is no longer practiced as a popular art form. But unless the school has an ethnomusicologist on staff, all the rest will be focused on the European art-music tradition: keyboard harmony, voice-leading in chorale harmonization, the fugue, classical analysis, Chopin and the age of pianistic miniatures. The music department at Harvard, for example, lists seventy standard courses in its catalog—sixty-two of them concerned with the European canon. The Eastman School of Music offers thirty-three courses about "classical" music—and none whatsoever about music from the rest of the world. UCLA, which supports the most lavish world-music program of any university on the planet, lists a whopping 142 courses on non-Western music and ethnomusicology—but it still devotes twice as many classes to various aspects of European art music.[22] In music departments, at any rate, the canon remains as firmly in place as it ever was.

These days, students are demanding more classes in world-music traditions, but most universities are unprepared to hire academically trained ethnomusicologists to teach subjects that do not come with the appropriate academic lineage. Fewer still are ready to engage master artists from within an ethnic community, who matured within a tradition and possess an insider's knowledge of its nuance and complexity. "World Music" ends up being taught by graduate assistants who might have taken a class in "African Drumming" as undergraduates.

I give these examples from the discipline of music, which I know the best, but they are mirrored across the cultural spectrum. Rumors of the death of the canon have been greatly exaggerated. "The debate over the canon has been dominated by the fear that the canon is finite; add something and something else must be deleted," writes Lawrence Levine. "The fact is that if there ever was a time when universities could teach the entire canon, or even the entire canon in any single subject area, that time has long passed."[23] Our colleges may indeed be filled with "tenured radicals," but the content of their courses continue to reflect priorities that are extraordinarily conservative.

The result is that our schools are staffed by teachers, in every discipline,

who are frequently unprepared to contend with either a diverse student body or a curriculum that embraces diversity. This is particularly troubling for the rapidly growing proportion of refugee and immigrant children in our schools. With continuous immigration pressure, mostly from economic markets that have enjoyed the dubious benefits of large-scale American intervention for a hundred years or longer, schools in all corners of the country are suddenly awakening to a cultural diversity they never envisioned. Some are ill equipped to contend with a multilingual, multiethnic student body. They sometimes lack staff who speak the language of newcomers; they rarely have teachers that reflect the demographics of their students. The sheer diversity of the student body is a crisis for many American school districts. "How we receive students from diverse communities and how we learn from them has been largely ignored because we have come to think of differences as a problem, not as a resource," says artist and educator Amalia Mesa-Bains. "The challenge now is to integrate the knowledge that diversity is a strength into curriculum that will move beyond token multiculturalism."[24]

Doing this is difficult in an environment where anti-immigrant backlash continues to be a substantial presence on the political landscape. Movements to restrict aliens' rights, deny education or health care to noncitizens, or declare English as the "official" language are, regretfully, commonplace. "A serious discrepancy in our educational system has been pointed out repeatedly—that while a second (or even a third) language is required at the college and post-graduate level, development of a second language at the primary level is discouraged and even punished," write multicultural arts educators Susan Cahan and Zoya Kocur. Now, they say, "is an opportune time to reassess policies of linguistic racism."[25]

"The value of a subject of study is not only a function of its presence in the curriculum," says Eisner, "it is also a function of the amount of time the school devotes to it."[26] The lack of attention to culture in the curriculum sends a message to students about what counts and what does not. Administrators are under pressure to measure up or risk having their schools labeled as "troubled." I once had an enlightening discussion with the superintendent of a rural Maine school district. I was trying to give him a wonderful program of multiethnic dance instruction for his students, but he was supremely disinterested. "It sounds like a nice project," he confided to me. "But our district scored near the bottom in reading on the standardized tests. We're putting everything we've got into improving our reading scores, and don't have room for anything else." Money was not at issue here, it was a question of vision.

A school without vision will lose its students, whether they remain at their desks or not. According to the UCLA research team, over one-third of the student body, at every grade level and socioeconomic class, reported being "bored half or most of the school day."[27] Students are perpetually at loose ends because "much of what children do in school seems to be irrelevant to their lives, particularly in those schools where children are having the least successful experience," says Sanford. "The curriculum has little to do with those things that are pushing on them in their lives."[28]

✧ ✧ ✧

Newcastle upon Tyne is a decaying English industrial city situated in the midst of a region that has long been a powerhouse of traditional dance and music.[29] The Northumberland miners' songs and clog steps of the Lancashire factory girls once merged with a rich vein of fiddle tunes to produce a vibrant vernacular performance culture. But when Alistair Anderson, the greatest living exemplar of the typically Northern English concertina, ventured into a public school fifteen years ago, not a single student could recall having ever seen or heard one played before. Anderson left the school with the belief that unless something was done about it quickly, his was a tradition on its deathbed.

Anderson rang up a friend who was a band director at one of the local high schools and asked if he could borrow the band for a few weeks. He then proceeded to teach a group of student musicians how to play a handful of traditional Northumberland ceilidh dance tunes. No matter that these were melodies originally created for fiddles and concertinas, they were now vigorously performed on trumpets, clarinets, and tubas. After a few weeks of rehearsals, the band threw a dance in the school gymnasium. "You could almost see the lightbulbs flashing on in the kids' heads," Anderson recalls. "Here were their brothers and sisters, their parents, aunts and uncles, out on the floor having a wonderful time. And *they* were making it all happen." For a generation accustomed to getting its entertainment sitting in front of a television, this struck with the force of revelation.

Anderson repeated this experiment in student empowerment a few more times before realizing that he was onto something that could have broad implications for revitalizing his regional culture. He created an organization, FolkWorks, to help promote his plans. Soon he had produced an impressive curricular guide, complete with the standard regional dance tune repertoire, calls for the most popular dances, recorded samples to guide band directors in honing the proper sound, and tips on how to make a dance flow properly throughout the evening. FolkWorks started book-

ing master artists into schools to work with the student ensembles. This was soon followed by a similar set of materials focused on the Northern song traditions. The materials were widely distributed to teachers throughout Northumberland, and soon Anderson had a growing coterie of young musicians who were inflamed by ceilidh music and hungry for more.

Near Newcastle is the enchanting medieval town of Durham, home to a university that is closed during the summers. Anderson arranged to use Durham's dorms and other facilities for a summer music camp, where those supercharged teenagers could learn from master traditionalists while playing and dancing twenty-three hours per day. The first year, they ran one two-week workshop for teens. At this writing, FolkWorks annually offers six weeks of sessions for students and adults. After a few years, the earliest student converts began graduating and moving to the university or into the working world. A handful of the most talented musicians and dancers began asking questions about careers in folk performance. As a folk artist with long credentials, Anderson knew his way around the English folk club scene as well as anyone, and now he set out to provide a booking service for young artists, organizing national tours that could offer a first real experience of life as a touring musician.

All this activity notwithstanding, Anderson realized that he was only reaching a small segment of the population: band students. If his tradition was to stay alive and really thrive, he reasoned, it should become a part of the routine curriculum that is taught to every student in the county. To this end, FolkWorks initiated a series of teacher training workshops, offering teachers basic instruction in the Northern traditional song and dance repertoire along with a range of proven pedagogical techniques. The workshops span a week, plus a couple of in-service days per year, and participants are required, as a part of the class, to recruit their teacher replacements for the following year. Some of the instructors are graduates of past summer camps and FolkWorks touring initiatives. By the end of 2000, according to FolkWorks, they had trained teachers offering basic instruction in their regional performance traditions placed in every school in Northumberland. Currently, they are working with the university in Newcastle to develop a baccalaureate degree program in Northern dance and music traditions—apparently there had been substantial pressure for such a program from incoming music majors!

The model that Alistair Anderson and FolkWorks developed in Britain provided the impetus for the Center for Cultural Exchange to attempt a similar project in Portland. Like FolkWorks, the Center is fundamentally concerned with the support and enhancement of the heritage of its com-

munity partners. The basic components form an elegant circle: exposure of students to traditional artistry in the classroom results in community performance opportunities; these inspire the most interested and talented students to pursue extracurricular training; the best of these are given professional performance opportunities and are brought back for teacher training institutes; the teachers bring their new knowledge into their classrooms; and the cycle begins anew.

But while this system itself seems well suited to the maintenance of tradition, the question in Maine becomes, "What tradition?" Unlike Northumberland, where a comparatively homogeneous population might actually share some basic concept of what regional folk culture is all about, Portland reflects the multiethnic face that typifies much of America today.

There is no single culture for our students to focus on; rather, they must be prepared to contend with multiple cultures. While they may not choose to participate in most of the different cultures intersecting with their lives and work, twenty-first-century Americans will surely interact with people whose cultural reflexes are very different from their own. "As we look at the ways in which communication and culture affect learning we also have to consider the social and historical realities of different cultural groups," says Mesa-Bains. "Our struggle to bring together our teaching and learning to respond to specific cultural groups and their ways of learning means we have to begin to understand the experiences and histories of these cultural groups."[30] If our young people are to be adequately prepared to live in a multiethnic society, then they need to be equipped with some basic tools for understanding diverse cultures. The arts offer a direct path into the constellation of issues surrounding cultural diversity, engaging students both physically and intellectually and providing a springboard into the study of cultural equity, social ethics, historical analysis, politics, and religion. "Art," says New York City school chancellor Harold Levy, "auditions diversity" in our schools.[31]

"Developing an intercultural curriculum that is rich with the unique contributions and shared histories of many groups is no easy feat," continues Mesa-Bains. "For black youths to understand how racism and discrimination affects groups other than their own is an important intercultural lesson. Conversely, helping all students, including new immigrants, to understand and appreciate African American history and culture is a significant goal for an intercultural curriculum."[32]

What would a functioning, culturally diverse, arts-based curriculum look like? The Columbia research team offers a vision: "Taking our cue from the arts-rich schools in this study, we might envision an ideal cur-

riculum as one that offers in-depth, carefully sequenced teaching in several art forms for the entire span of young peoples' schooling. Teaching would be carried out by properly educated specialist teachers who are both committed to their own art forms and knowledgeable about the socio-cultural background and development of the young people they teach. An ideal curriculum would enable arts teachers to collaborate with each other, with teachers from other disciplines, and with visiting artists and other arts providers. This kind of curriculum requires careful planning."[33]

Envisioning the basic cultural toolbox with which our students should be equipped involves a process of gross simplification and egregious elimination. To really teach a single culture is a challenge; the whole world is well beyond the grasp of even the most sensitive and talented educator. However, it seems clear that every student should have a passing familiarity with several basic world-culture areas. For most Americans, these include European cultures; African American culture and its ancestral relative cultures across Sub-Saharan Africa; Latin American cultures including Mexico, Central and South America, and the Caribbean; Asian cultures, with special attention to Asian American nationalities specific to each school district; and the arc of Islamic cultures from North Africa to Afghanistan.

While clearly not exhaustive, and with a lot of room for tailoring to local demographics, these five core cultures combine to offer students a broad sensibility of who they are, who their neighbors might be, where they all come from, and how they fit together into the international mosaic. Current arts-education research reinforces the common-sense dictum that students will derive the most benefit from programs that are a routine part of their school experience, being repeated and reinforced over a period of years. Each American student needs to routinely experience artistry from each of these broad cultural domains on multiple occasions during their thirteen-year, K-12 scholastic career.

The point here is not to create a new burden for already harried classroom teachers but to develop mechanisms to assist them in the teaching of subject matter that is already mandated. The arts do not have to be segregated from the study of reading, mathematics, or science but can be most productively employed in conjunction with other disciplines through a holistic approach.

A fully interdisciplinary teaching environment would see continual cross-pollination and creative deployment of mutually supportive educational strategies. As anybody who has ever puzzled over the meaning of a spreadsheet but has intuitively grasped a concept when it was displayed

on a graph can testify, the visual arts can dramatically enhance the understanding of mathematics. Kids who immerse themselves in hip-hop are grappling with rapid-fire linguistic acuity that should be cause for celebration. For the first time in anybody's memory, they have made *poetry* pay! But you would never guess it from the classroom syllabi of most English teachers.

Julio Leitão wa Kabuaya is a master dancer from Angola who came to America to work with Dance Theater of Harlem and found his calling in teaching traditional dance to young people. He directs the award-winning African American youth performance troupe Batoto Yetu and teaches at several schools in New York and New Jersey. For Leitão, there is no division between teaching dance and teaching reading or math. "The interdisciplinary nature of dance is invaluable for reinforcing the academic lessons learned in the classroom while developing children's physical coordination, concentration and interpersonal skills," he says. African dance makes obvious connections with the social studies curriculum, but Leitão makes explicit connections across the disciplinary spectrum. For example, he writes, "I use the parallels between dance and basic language skills to develop an understanding of grammatical principles and the structure of language. Dance is a nonverbal form, but at the same time dance movements replicate words, dance phrases mirror sentences, a routine is like a paragraph, and a choreography is like a whole essay. The way in which dance movements and phrases build themes is comparable to the development of a main idea in reading and writing." Mathematics, too, is a part of his program: "Dance works with numbers and spatial relationships using musical phrases, beats and dance patterns. I show the children how the dance phrases they are learning follow mathematical patterns and I use each sequence to reinforce lessons in basic addition, subtraction, multiplication and division. For more advanced students, dance movements can be compared to the more abstract concepts of geometry and algebra."[34] Such fully integrated teaching will require far more intensive and ongoing collaborations between teachers and artists than is routinely practiced in most schools, but it poses an exciting challenge if educators can embrace the concept and put it to the test in daily practice.

Realization of this vision will require a broad shift in educational thinking. Rudy Crew, director of the Institute for K-12 Leadership at the University of Washington, insists, "[T]his reframing is far broader than the matter of adding the arts to the curriculum. This is about reframing education overall."[35] It means reimagining the working collaboration between

artists and teachers, and extensive training for both to mesh their skills and planning in the classroom. Every school district requires continuing education as a part of teachers' certification process; nonprofits have an opportunity to offer a genuine service to the schools by helping to link them with high quality and diverse artistry. Both schools and nonprofit cultural organizations can continue the circle of inspiration by creating extracurricular opportunities for young people to develop their skills and citizenship. Strategies should consistently empower students to explore as far as their imaginations will take them. "Process should be at the heart of an alternative cultural pedagogy," says media educator Steven Goodman. "It is the teacher's responsibility to preserve the integrity of process over product."[36] As happened in Northumberland, such a program could both contribute to the long-term sustenance of traditional heritage and create citizens who are knowledgeable and positively equipped for life in a diverse world. A quick glance around the globe, from Rwanda to Kosovo or East Timor, presents a stark picture of the social alternative.

✧ ✧ ✧

"Culture," writes Roadside Theater director Dudley Cocke, "carries a people's profound expression of their self-hood. Only when peoples can meet as equals, without the threat of domination, can they risk their art and culture. Cultural equity, then, is integral to democracy and the making of an American people from our many diverse strands."[37] The practice of cultural democracy requires a fundamental rebuilding of our schools and the lessons they impart to our children.

Schools that can fundamentally embrace artistic creativity as central to their missions and goals will excel; others will not. The accelerating pace of globalization places new demands on our schools that cannot be answered by retreating to yesterday's fondly recalled basics or the European canon. "Basic literacy skills and imitative learning adequate for following instructions on the assembly line, the workshop, or desktop terminal are simply inadequate to the demands of a creative and innovative society," writes Shalini Venturelli in a report on the requirements of the information economy. "Not basic education, but advanced intellectual and creative skills that emphasize interdisciplinary and independent thinking, should be required at earlier stages of the educational process and extend from preschool to grad school."[38]

"Our government keeps saying, 'We need to make the most of our human resources. We need to promote creativity to meet the demands of this century. We need to cope with rapid cultural change in a world of global

cultural development,'" declares Ken Robinson. The argument, he contends, doesn't have to turn on the arts: school reform is about economic self-interest. "Creativity and culture are two big issues for every government in the world. And the arts are about those two things. So it seems to me rather than say, 'Let's talk about the arts,' and then explain what they have to do with the agenda, let's just go straight to the main agenda and say, 'We're talking about creativity and culture.' And then we can show how the arts fit into it."[39]

The vision of a new, culturally diverse direction in education answers basic economic requirements but also demands explicit expression of ethical values that remain national challenges. It calls us to put into daily practice the ideals of freedom and equality that Americans profess to cherish but honor only in the breach. "If we are to restore our schools to democracy and return democracy to our schools, we need to reconsider the meaning of liberty in our own lives," demands Barber. "We are unlikely to teach the young to embrace liberty if we have laid our own aside in pursuit of safety or prosperity or national competitiveness; or if we have confounded liberty with the unbridling of consumer appetites and the unleashing of selfishness."[40]

Effectively turning the battleship of our educational structure presents an enormous challenge. The systems that are in place have gotten there through generations of evolution and are impervious to rapid change. Educational leadership needs to change; the universities that produce teachers and administrators need to change; and most important, the quality and nature of instruction on a daily, classroom level has to change.

All of this new activity will cost a lot of money, and taxpayers in every community will have to make it clear to their legislators that education is a priority that we cannot afford to ignore. Some districts may have to cut sports programs to afford the arts. This option should be seriously considered: the vast majority of schools will not turn out a single professional athlete, but virtually all will graduate students going on to careers that will demand fluency in design (art), teamwork (theater), technology (art and science), public relations (art and theater), conflict resolution (choreography), and creative thinking (all the arts). Current funding priorities are out of step with the realities of the twenty-first-century workforce that should be a concern of every superintendent.

The inequities built into the property-tax school funding mechanism are already under attack and are likely to begin changing in the near term. The development of alternative school funding plans offers an important opportunity to begin shifting priorities. Communities with strong and

diverse arts programs should be rewarded in the funding schemes. Districts without such programs should be offered strong incentives to create new initiatives.

This will require an unprecedented degree of political organization and savvy on the part of creative workers, a group well known for its individualism. There is a central role in this unfolding drama for artists, particularly those engaged in ethnic traditional culture. Nonprofits, too, are poised to advance their own missions as well as the educational infrastructure through moving aggressively into partnerships with schools and generating a range of choices for extracurricular learning. The funding community can stimulate this process. Foundations, says Robinson, "can provide opportunities for innovation. Systems cannot do that. They're not designed to do it."[41] But private funders are uniquely in a position to work experimentally and intensively, bringing key players and resources to bear and documenting the results. Philanthropy can prime the pump of school reform.

And our communities, parents, elders, and families must stand up and use their democratic powers to bring substance to the vision. Local school board politics elicits yawns from most Americans, but it is the forum where many of the issues of cultural sustenance and local economic viability will be decided. Putting a new approach to the test will require a commitment and sustained effort that are equal to the importance of the task. Our children's futures are at stake.

"In terms of a description of success, I'd like to tie that into more than just test scores," says Adelaide Sanford. "I think of the ability to succeed in terms of the humanistic definition of success, because if you think about the people of the Savings and Loans and the 'junk bond' scandals, and those who run companies causing environmental pollution, I guess they would all be considered school successes. But I wouldn't consider them successful in terms of what we are talking about. I think it reflects another tragedy of our system: that we only test and give grades and acknowledgment to the skills of reading and writing and math, rather than saying, now that you have these skills, what are you going to do with them? Are you going to make designer drugs? Are you going to make chemicals that are pollutants? How are you going to treat people and the world? We don't ask that. Therefore one can be considered quite successful and at the same time be a totally destructive person. A curriculum of diversity can humanize our definition of success."[42]

7

Mediation

A group of unhappy-looking Sudanese men sat on one side of the confer-
ence table. They'd come to protest against a daylong Sudanese conference
that we'd planned at our Center as a way of bringing the community
together.[1] Our ultimate goal was to foster cultural initiatives that would
grow from the discussions and feel compelling to community members
and their families. But this group of gentlemen didn't like the plan, and
they wanted the whole event to be cancelled.

On the other side of the table sat a couple of white administrators—the
director of the Center and the principal of a neighboring elementary
school that serves most of Portland's refugee families. With them was the
Sudanese staffer who had carefully planned the conference over a period
of many months and who worried that her work would now go for naught.
She had arranged for presentations by several authorities about Sudan
and its civil war, artistic presentations by local and visiting performers,

The author onstage with members of the Silver Leaf Gospel Singers. Photo by
Phyllis O'Neill.

and a traditional ethnic feast; she'd written a grant to the state human-
ities council and department of human services to raise some of the nec-
essary funds; she'd printed posters and flyers that she deposited in every
Sudanese family's mailbox; she had convinced a newspaper reporter to
write a detailed preview. And now these men from within her own com-
munity wanted to undo all her efforts.

The problem turned out to be extremely complex. Among the invited
speakers was a representative of the Sudan People's Liberation Army
(SPLA), one of the liberation insurgencies that has been fighting against
the Khartoum government for over a decade. But SPLA is not the only rebel
army operating in southern Sudan, and there has been periodic fighting
among the factions. Each of these factions is dominated by one or another
of the many Sudanese ethnic/linguistic groups, as is the central govern-
ment they all battle, so there are tribal rivalries at play as well. All of them
have accused the others of rampant human rights abuses, and indeed,
Amnesty International and the United Nations have cited both sides of
the civil war for committing a variety of atrocities.[2] The horrors that have
kept Sudan in a state of continual suffering for a generation had come
across the Atlantic with our new American refugees and were alive and
agitated in our conference room.

The accusatory visitors suggested that the Center was taking the side
of the SPLA, an army that they claimed was responsible for torturing and
killing their relatives back home. Our Sudanese associate disagreed, say-
ing that she only wanted the SPLA representative there so that everyone
in the Portland community could confront him about the SPLA's actions.
But, the gentlemen responded, how can we lodge a protest with the SPLA?
We still have relatives back in Sudan, and how can we know that they
won't then bear the brunt of retaliations? If the SPLA was allowed at our
conference, they insisted, they'd be outside picketing.

✧　✧　✧

Let's interrupt the story to analyze this scene. Who are the actors here?
What are their motivations? And where does the power reside?

The Sudanese initiative grew out of a longstanding commitment of the
Center for Cultural Exchange to support local cultures in whatever fash-
ion seems to make the most sense to community insiders. The Sudanese
refugee community had proven itself difficult to penetrate—the webs of
ethnicity and political affiliation are too thick for even well-informed
outsiders to fully grasp. So we had hired a Sudanese facilitator to help work
it out. But no matter whom you hire, that person is only going to have

the inside track on a single tribal group; the majority of the community is likely to view the facilitator's statements and actions with varying degrees of suspicion or, in some cases, outright hostility. Our Sudanese coordinator is motivated by the desire to bring her community together, and she is in a position of authority owing to her affiliation with an established institution, the Center. But because her links to certain community factions are weak, she cannot be fully informed or effective.

The dissenting committee consisted of self-appointed representatives of a few of the tribal groups furthest away from our staffer's perspective. As far as *they* could see, this whole event had been planned without their knowledge or participation and, moreover, included representation from a group that had done great harm to their people. If this is a Sudanese conference, they reasoned, it surely does not represent *our* perspective, and aren't we Sudanese, too? They demanded that the conference be cancelled, but they held no authority within the institution. The only leverage they had was through an extrainstitutional gambit, hoping to embarrass us enough, by their threat of picketing, to accede to their wishes.

The Center had an organizational stake in seeing the conference proceed. Its planning had absorbed thousands of dollars of staff time, commitments had been made to funders, and advertising had already guaranteed a substantial public turnout. Cancellation would be painful, picketing worse. However, the institution also held all of the power cards in this game. At the end of a tense meeting, all the black faces turned to the two whites. What are you going to do? they asked. We—not they— were the ones in a position to make the ultimate determination about what would happen. The ethnics were petitioning the white power structure for redress of grievances, and now it was up to us. The institution was the fulcrum around which this whole drama played itself out—we were the ones who had the organizational muscle to pull the many strings necessary to make the conference take place; we were the ones with access to the money needed to do it, and the media to amplify it. When the chips were down, we had the power.

Given all that I've had to say about the outsized power of wealthy elites, ossified academic systems, and fashion-obsessed funding structures, it may seem strange to now be investing the impoverished arts administrator with an aura of authority. The fact that we do hold significant power within our (admittedly limited) spheres of influence is testimony to how far down the economic food chain our artists and communities really are. The power that adheres to our position comes through our ability to play a mediating role among several distinct realms: artists, communities, audiences,

schools, funding sources, the red tape of civic bureaucracy, and the press and media. We are the glue that holds all these pieces in place long enough for something to happen. The power is invested in us—personally, as individual actors—and in the organizational infrastructure that permits us to do all this, our institutions.

To be a cultural mediator means to place oneself at the center of the intersecting circles of interest. How well, or ethically, one succeeds in facilitating a conversation among disparate players depends on knowledge, savvy, interpersonal skills, commitment, and perhaps most important, humility. It requires acknowledgment of, and respect for, the enormous knowledge, savvy, interpersonal skills, and commitment that every other player brings to the table. To really be a successful cultural mediator, one has to be willing to give the power away to others at every turn.

It's important to recognize how much access we enjoy more or less by accident. Most people who are in a position to take on mediative roles in shaping community culture are well educated and relatively affluent; they have absorbed the knowledge of how American society works over the course of lives lived in relative security. Dealing with city hall is not a terrifying ordeal; they go there to get things done, treating public servants like the functionaries that they are. None of this is true for most of our constituents. For many of them, governments only exist to torment innocent people. The police are to be feared—certainly not called for help, unless you are asking for trouble. It is not that they are somehow stupid or crazy: it is that their life experiences taught them how to live in a very different world than the one most mediators inhabit. The access that we enjoy to our civic institutions, to the pathways of money and power and information, was gained primarily by being born and raised within the dominant social structure. We assume this access reflexively, and it is enormously empowering. But it is a gift that we acquired by the accident of our birth, not a birthright.

These accidental skills combine with education, experience, and inclination to make an individual capable of facilitating community culture. Without someone in this key role, very little public culture would happen. Even the elite halls of Euroculture need skilled facilitation; communities need it even more, because they don't often have the strength of institutional backing to rely on. Surely, communities are capable of organizing themselves and producing meaningful events without the intervention of outside agencies. It happens all the time. But just as surely, the blinders of ethnic vision and the limitations of community reach can hobble such homegrown efforts. Community infighting can make progress impossi-

ble; the lack of media savvy can ensure that a broad public never learns about what is happening; nobody knows how to apply for a parade permit, so there is no parade. And sometimes community members simply cannot know or see opportunities that an enlightened third party can bring to the table. The mediator can't make anything happen without the community, but often the community can't budge without facilitation. The mediative role is worthy of careful scrutiny precisely because of the power it embodies over what people see, hear, and experience.

Unfortunately, the mediative role, with its many practical and ethical implications, is all but ignored in the training of culture professionals. Within the academy, theory is privileged, whereas education in the skills necessary to put theory into practice is relegated to haphazard on-the-job experience. "Understanding and mastery of practice," writes folklorist Robert Baron, "is critical for a discipline so grounded in ethnographic field research and increasingly engaged in the study, creation, and interpretation of representations, in academic as well as public spheres. However, until quite recently, practice remained at the margins of graduate training and is still virtually absent from academic discourse."[3]

Public arts organizations are sometimes referred to as *bridge* institutions, in that they attempt to form junctions among diverse constituencies. Robert Putnam would say that they generate *bridging social capital*.[4] Culture specialists, in the course of their work, call on knowledge of public institutions, academic priorities, funding sources, technical requirements, advertising, and promotions—as well as the nature of their intended audience, its assumptions and special needs, and the traditions of the community. They strive to serve the ethnic communities, the arts-aware audience, the general public, the university community, and their own organizational and financial needs. Such public actors "have sometimes been referred to as *cultural brokers*," writes Jack Santino. "Because we have access to public places, we have the opportunity to carve out the space for various kinds of presentations of many different cultural groups and traditional expressions."[5]

Of the varied constituencies with which the cultural broker works, none combines the degree of access to the many avenues of money and power that the broker possesses. Every community, and often various factions within a given community, has its own domain, maintaining its own institutions and traditions, separate from other groups and the general public. These regions may overlap to some extent, but they do not form congruent circles; in some cases they are mutually exclusive. Rarely do community-based groups have experience connecting with funding sourc-

es, the media, or city hall. Only the mediator has access to each circle of influence; he or she stands at the point of intersection, usually a point of the mediator's own device. Typically, in public presentation, it is through this focal point—the facilitation agent—that information flows among the constituent parts of the production.

"The role of the strategic broker is to marshal the resources necessary to do the job and to keep everyone's eyes on the general goals while encouraging creativity," writes Richard Kurin in *Reflections of a Culture Broker*. "Strategic brokers are symbolic analysts—they manipulate symbols, they simplify reality into abstract images, which are rearranged, juggled, experimented with, communicated to others, and then transformed back into reality. The tools of the trade are arguments, gimmicks, scientific principles, psychological insights, disciplinary knowledge, techniques for persuasion and amusement—all of which may allow for communication, problem solving, and emergent innovation."[6]

Very few arts administrators entered the field with the expectation of becoming mediators of sometimes contentious factions. The facilitative role places a series of challenges before those whose training was more likely to be in Renaissance painting or Bartok's string quartets than in conflict resolution. "It challenges us to think bigger and better about our reciprocity with the people we study, a reciprocity beyond short term remuneration for services rendered by informants," writes Dan Sheehy. Responsible mediation, he continues, involves making connections that embrace far more than is included within the frame of the performance or exhibit. "It challenges us to work cooperatively with specialists in areas such as folklore, theatrical presentation, media production, and political action."[7]

In addition, to survive in contemporary society, the mediator must grapple with the fiscal and institutional framework our economy presents. Real support for cultural heritage requires an institutional canon that can embrace the holistic concerns of traditional communities and interface effectively with the marketplace. This is not simply an ongoing need of public agencies but of the ethnic communities themselves. "Culture cannot survive in urbanized societies without some money and some bureaucracy," write ethnomusicologists Roger Wallis and Krister Malm. "The crucial link is human enthusiasm and action. Without this the finest goals of any cultural policy become worthless."[8] Fostering this link, this bridge, is the aim of most public cultural development initiatives. It is what mediators do.

✧ ✧ ✧

Any time an agent of one culture enters into the affairs of another with the intent of persuading or compelling individuals or groups to do something they wouldn't be doing in the ordinary course of events, an act of intervention occurs. The intervening party may be fully conscious of the position it holds vis-à-vis the subject culture; or, as in many public ventures, the extent of awareness may be less, or the interventionist may deny the nature of their program. In any case, the results of the intervention are frequently not what the parties involved might have imagined beforehand. The long-term effects of cultural intervention have a way of defying predictability, adding a powerful ethical counterbalance to benign motivations. It is frequently difficult to know whether we are truly preserving traditions or serving as the unwitting agents of change to the very things we seek to conserve.

The impulse to intervene in another culture is sometimes (though not always consciously) as enmeshed with the ideology of class and Western hegemony as it is with the high-minded rhetoric of modernist social advancement or contemporary cultural conservation. Good intentions, when dealing with the future of someone else's culture, are indeed not enough. The results can lead to distortions within communities' lives and livelihoods, such as the sanitizing of display to accommodate cultural tourism or the breakdown of indigenous institutions, which persist long after the intervening parties have returned to their own world.

Cultural mediators, as agents of the majority culture who engage representatives of other communities, are implicated in the power relations that sustain interventionist actions. Their programs, reconstructions of ethnic traditions, often presented to outsider audiences in decontextualized settings, bear within them issues of cultural importance. "Local aesthetics, beliefs, and practices are somehow transformed into interpretive performances or forums, and the resulting translation of private codes into public discourse is a dangerous business," says Burt Feintuch. "We must think long and hard about that danger. Certainly we must be sure not to underestimate the nuances and risks inherent in such programs. To do less would be to engender cultural intervention of the worst kind."[9]

"To engage with public issues and act in the public arena is to intervene—inescapably—in the lives of individuals and in the institutions that embody their collective will and vision," writes David Whisnant. "The question is not whether we shall intervene, but how and with what effects,

amid what particular set of historical, cultural, and political circumstances, and in the service of what values and social vision."[10] His primary concern is with the mechanisms by which political agendas are played out at the interface between cultures, particularly cultures of disparate economic and political power. Whisnant is not a cultural isolationist— he believes that, for better or worse, intervention accompanies involvement—but he is deeply suspicious of the missionary impulse and the blinding superiority that usually accompanies it. He finds many acts of cultural intervention to be inappropriately motivated by such sentiments, and he demands a careful scrutiny of the methods and morals of public cultural programs. "What ethical warrant has one to decide what is 'good' or 'bad,' progressive or not, 'useful' or not, in a culture other than one's own?" he writes in *All That Is Native and Fine,* a book that initiated a generation of self-reflective hand-wringing among academics. "How may one conserve certain cultural traits, values and practices (handicraft skills, or religious observances, or music) while partitioning them off from others (male dominance in the household, or parental authoritarianism) to which they are intimately tied but which are judged undesirable or nonfunctional? May cultural traditions that flourished amidst one set of historical circumstances be 'preserved' or 'reinforced' amidst another set? And if so, with what costs and benefits? And to whom?"[11]

Interveners' projects tend to be more reflective of their own social ideology than of a community's traditions. "The 'culture' that is perceived by the intervener," Whisnant suggests, "is rarely congruent with the culture that is actually there. It is a *selection,* an *arrangement,* an *accommodation* to preconception. . . . Thus, the culture that is 'preserved' or 'revived' is a hybrid at best." These endeavors—focused as they usually are on traditions of home and family life—can provide symbolic smoke screens for the more immediately transformative economic powers at work within their communities. "By directing attention away from dominant structural realities, such as those associated with colonial subjugation or resource exploitation or class-based inequalities, 'culture' provides a convenient mask for other agendas of change and throws a warm glow upon the cold realities of social dislocation."[12]

The results of intervention projects frequently are not predictable. Revitalization ends in commodification; artisans are encouraged to focus on their crafts, only to be marginalized by the marketplace; those who have accepted the missionary version of tradition become estranged from their own communities. Moreover, having come into the community endowed with the legitimacy of the academy or of a larger political power, inter-

veners frequently have an impact extending well beyond the limits of their projects. "An intervener," says Whisnant, "by virtue of his or her status, power, and established credibility, is frequently able to define what the culture *is*, to normalize and legitimize that definition in the larger society, and even to feed it back into the culture itself, where it may be internalized as 'real' or 'traditional' or 'authentic.'"[13] But cultural facilitators tend to have substantially different stakes in the evolution of cultural projects than do their community constituents. "As one looks closely at some of these cultural endeavors, especially if one attempts to understand them in the context of the region's economic history—one becomes gradually aware that the manipulation of culture inevitably reflects value and ideological differences as well as the inequalities inhering in class."[14]

Historically, this class-based ideology has manifested itself in a dominant relationship with other cultures, what Edward Said famously described as "a collective notion identifying 'us' Europeans as against all 'those' non-Europeans." Indeed, he continues, "it can be argued that the major component in European culture is precisely what made that culture hegemonic both in and outside Europe: the idea of European identity as a superior one in comparison with all the non-European peoples and cultures."[15] Said crystallized his argument in his classic study of *Orientalism*, which colors every interaction of the West with the Middle East—and by extension all cultures outside the Western European cultural canon. "Orientalism," he writes, "can be discussed and analyzed as the corporate institution for dealing with the Orient—dealing with it by making statements about it, authorizing views of it, describing it, by teaching it, settling it, ruling over it: in short, Orientalism as a Western style for dominating, restructuring, and having authority over the Orient."[16]

Regardless of our best intentions, cultural facilitators are implicated in this web of domination, and it subtly or explicitly colors the nature of the relationships that are central to our work. "Domination's definitions are linear, hierarchical, top-down, trickle-down, done to," says Dudley Cocke. "Equity's terms are circular, non-hierarchical, all around, done by. Domination calls for exclusion; equity values inclusion. Domination creates dependence; equity independence and self-reliance. . . . The paradigm of domination places efficiency (profit) before participation, product before process, mobility before attachment to place, the man-made order before the natural (and spiritual) worlds. It makes claims of objectivity, criticizing others for being too subjective. In the arts, it pretends to value formalistic concerns before concerns of content, because it takes its content of domination as a given."[17] If we are not continually cognizant of this truth

as we pursue cultural development initiatives, we indeed risk the integrity of our partners and our own humanity.

This is all about power. A representative of the wealthy or educated classes is in a position to effect change within ethnic communities, which is not available on a reciprocal basis. To even contemplate taking action in someone else's community implies that "one's viewpoint must be beyond and above, rather than tangled in, the pattern in the cultural weave," says Robert Cantwell. "This persistent blind spot in the panoptical ideology of cultural diversity remains its most vexing element."[18] The very presence of interveners is evidence of the loftiness of dominant cultural superiority—the privileged come from a place blessed with such plenty that individuals can freely commit their lives to working with those they perceive to be less fortunate. Naive or inadequately prepared programs are launched, "conceived," says Robert Garfias, "by individuals who attempt to speak for people of whom they have little real understanding nor to whom they have any real commitment. In channeling the resources and energies for such a venture, what they will have done is to usurp the voice of those for whom they claim to speak."[19]

Cultural mediators, then, must grapple with several intrinsic political and ethical dilemmas in the course of their work. Usually political progressives, they find that their work often focuses on preservation of extraordinarily conservative cultural traditions. Their work celebrates the vitality of traditional folkways in the face of a mainstream political culture that devalues them at every turn. Communities often receive their efforts with suspicion or hostility, especially within the context of contemporary multicultural society. In the end, despite having cast their lot with the working people of the world, they are still representative of an educated elite who use their power to effect change in directions that fit their own agendas. The political power equation substantially favors the folklorist over the folk.

Public cultural facilitation raises all of these issues—questions revolving around individual ethics. The implications behind such questions have caused a crisis of confidence within the disciplines of anthropology, folklore, and ethnomusicology and stand behind the larger cultural critique that theory has brought to the university. All of it attempts to deconstruct and reveal the roots and mechanisms of power, how one group of people maintains a position of dominance over many other groups. It also strives to fix responsibility for the sustenance of this dominance in the everyday functioning of the contemporary social order, and our own participation in its continuity. The moral imperative is for us to find an ethical response

in our own actions, a path that can recognize the webs of domination in which we move and systematically undermine them through consciously introducing relations of equity into every aspect of our work.

✧ ✧ ✧

How does this function in practice? The intensive work with specific constituencies that is demanded of cultural mediators can be both labor- and capital-intensive and places facilitators (and their institutional homes) on new and, sometimes, risky, terrain, demanding a reevaluation of who they are, what they are doing, and why. In trying to negotiate the maze of practical, aesthetic, ethical, and personal issues surrounding deep community work, a handful of concepts bear careful examination. The ten postulates that follow aren't quite rules of thumb; distinctions within each domain are too porous. But they are worth considering and remembering in the field. As a loose set of rules of engagement, they are open-ended proposals on how to more fully engage diverse communities in our national public culture. And while these suggestions arise from cultural work, they might apply equally to many other realms, including a variety of social service endeavors and commercial enterprises.[20]

1. Communities are self-defined.

A community, as we have seen, is any group of individuals who build identity within a common frame of reference. Most commonly, these touchstones are defined by birth (race, ethnicity, nationality), or proximity (neighborhood, workplace), but communities are built around all manner of religious persuasions, political causes, lifestyle choices, and personal hobbies. There are communities of homeless people and habitués of elite clubs, schoolteachers, drug addicts, Republicans, Puerto Ricans, and model airplane enthusiasts, apartment dwellers, Baptists, and bricklayers—any group attracting adherents around a common belief or attitude. Since participation in most communities is voluntary, one's view of a community and what is important within it may vary enormously from one person to the next.

Membership in a community is often a matter of self-identification for adherents, and it can be difficult for outsiders to perceive where that community's boundaries may lie. A cultural facilitator may be interested in developing a project to serve the *jazz community*—a reasonable proposition to almost everyone except jazz musicians and their devoted fans. As far as they're concerned, you must be talking about traditional jazz (called

Dixieland except by practitioners)—or swing, hard-bop or fusion, or "free" jazz, all communities that generally view each other with as much derision as they all heap on rock 'n' roll. As a facilitator, you can engage one of these subcultures, but it is impossible to interest even 50 percent of that mythical jazz community with a single program stream.

The nexus people make around a common cultural cause can be difficult to identify. In working with community groups, assessment of where individuals perceive their cultural allegiances and who the people are that share this sensibility is an indispensable first step. A definition of community that does not adhere to an internally prevalent concept will be just like the concept of *Africa*. It might seem like a perfectly sensible frame to most non-Africans but will do nothing whatsoever to engage any actual Africans.

The result is that the concept of community itself, of what it is and how one finds a place within it, is as varied as the perspectives of its members. Its definition is subjective and covers a spectrum from passionate and life-long believers to novices, fair-weather fellow travelers, and lapsed adherents, each of whom will have a different sense of their community, and all of whom are correct. For the facilitator, finding agreement around a defining communality can be a challenging task, but a community without a clear sense of itself as a coherent group will not be in a position to create effective programs.

2. Every community is unique.

Any substantial community-based work requires a steep learning curve for the prospective facilitator. There is no way to avoid it. Each culture is different, and approaches suitable in one instance are often ineffective or counterproductive in another. Some communities are highly stratified, with clearly acknowledged leaders acting on behalf of their membership; others are far more egalitarian in structure, without any obvious hierarchy of authority. Some communities are served by institutions providing a safe space for social interaction, and a key to grassroots organizational efforts; many lack any such facilities or formal structures. Some cultures celebrate their artistic traditions and valorize their virtuoso performers; in others, artists enjoy such low status that parents refuse to allow their children to participate in classes.

To effectively work within any community, the facilitator must first learn a great deal about how it functions, about how communication takes place within its indigenous frame. An understanding of local culturally

specific etiquette is the baseline for successful community work. This is not easily gained without a substantial time commitment, since it is assumed by the local insiders and may not be easily discussed. An outsider's questions about such things are frequently received with blank stares or laughter—they either don't understand what you're asking or they think it's hysterical that you have to ask.

Communities have their own priorities that must be honored. The dominant theme in a string of planning meetings with a group of local Vietnamese concerned the flag that would be displayed at the performances. The flag of the united Vietnam is anathema to most Vietnamese Americans, and committee members repeatedly argued that only the flag of the former South Vietnam should be allowed onstage. Nobody in the room had ever suggested otherwise, and I myself wondered why *any* flag even needed to enter the conversation. But this issue held such important symbolic significance for the local Vietnamese that it constantly dominated our meetings, occupying far more time and attention than the actual content of the programs. Contending with the flag issue, it became clear, was a prerequisite to any action with this community.

This kind of knowledge is unique and nontransferable. Surely, there are cultural affinities between one community and the next, just as there are commonalties among Romance languages. But what you learned last time probably doesn't apply for your next initiative. Greeks, Congolese, and Mexicans are not so concerned about the symbolic importance of their national flags. But they might have concerns about class or regional identification that would strike the Vietnamese as obscure.

3. Every community is fractured.

Communities are not monolithic. Each contains within itself diversity that is ignored by purveyors of stereotype but cannot be forgotten by the responsible cultural facilitator. Communities are divided by varying interests or political allegiances, by degrees of adherence to internal standards, by institutional affiliations, or by personal loyalties. Not infrequently such divisions result in the formation of factions within a community vying among themselves in an internal political dynamic invisible to most outsiders. This complexity is often compounded by economic and social issues. Sometimes, as in the Sudanese case that opened this chapter, the divisions within a community can be extraordinarily complex.

A lack of understanding of these ground-level realities can cripple organizational efforts and result in unforeseen faux pas that take endless

amounts of time to repair. Failure to invite the right mix of people to a planning meeting can inadvertently alienate whole segments of the population. Knowing who these people are, and their place within the local political matrix, is an important part of the facilitator's job. In almost every instance, there is no *one* person who can really speak on behalf of any community, although some assume that they can. If you've only got one perspective, you are surely missing a lot of the picture.

Contending with multiple factions without aggravating community divisions can be a challenge. During the Center's first tentative program in partnership with our local Afghan community, a dispute arose about sexually segregated seating at a public event. Some of the elder Afghans felt that, in accordance with their custom, women should be seated separately from the men; in this case, restricted to the small balcony in our facility. Younger Afghans laughed at this idea, saying that it was old-fashioned. One suggested that only the Taliban would enforce such an archaic restriction. As the mediators, we wanted to honor the insiders' customs but also held concerns for the general audience that would be in attendance as well as the Afghans. How would American feminists feel about being herded into the balcony? Regardless of what choice we made, we were certain to irritate one segment or another of the Afghan community.

In the end, the featured artist, a master *rebab* player, saved us from embarrassment by refusing to perform if the audience was segregated. The elders demonstrated their disapproval by staying away, but the onus did not devolve to the Center. When the Afghan Association planned their next event, the audience was segregated, and the event was well attended by all generations.

4. Community culture is personal.

It may be true that the broad arc of human history is guided by large impersonal forces, but on a local level heroic individualism is still alive and well. Community culture advances because of the dedication of the handful of individuals who care enough to make it happen. Every community has them. Malcolm Gladwell calls them *Connectors* and ascribes to them responsibility for bringing social phenomena to *the tipping point*, where they attract a critical social mass and become popularly known. "What makes someone a Connector?" writes Gladwell. "The first—and most obvious—criterion is that Connectors know lots of people. They are the kinds of people who know everyone. All of us know someone like this. But I don't think that we spend a lot of time thinking about the impor-

tance of these kinds of people. I'm not even sure that most of us really believe that the kind of person who knows everyone really knows everyone. But they do."[21] Connectors know who to call for a good party—and who to call to get some hard work done. They do it because they love it; organizing their fellows is built into their nature. They possess the fattest Rolodexes and delight in putting them to use. Without these Connectors, nothing happens. The commitment of these priceless individuals is the most important asset the cultural facilitator can enlist. Attention to their needs should be a high priority.

However, such Connectors in the community chain can often overshadow the contributions of quieter but no less important links. Reliance on one or two self-selected leaders may exclude participation of others whose assistance is needed if programs are to succeed. The loudest voices are not always the most effective workers. Also, consider that the movers and shakers are not always the pillars of a community whose sanction may be a prerequisite for broad participation. The facilitator's role is to balance the personalities involved and appropriately place them within the trajectory of a program, with sensitivity, good humor, and finesse.

5. You don't know enough to make decisions on behalf of any community.

Nobody does. You may think that you know a specific community well, but even ethnic insiders can only understand a portion of the diversity of opinion and outlook present within their communities. Just think of the range of aesthetic within popular American music: if you're an expert on hip-hop, you probably aren't up to date on the latest developments from Nashville, resurgent post–bop jazz, zydeco, the folkie singer/songwriter scene, or Christian pop, to name just a few of our thriving music subcultures. And within every one of *them* there is a spectrum of good and bad artistry; a dialectic among progressives and traditionalists; a hierarchy of fame, status, and money; and a network of social linkages with a group of initiated cognoscenti who reflexively understand all of this.

Unfortunately, many arts programmers assume that they do, in fact, have enough of an inside track to be able to assess a community's needs and program accordingly. Their programming usually reflects the interests and expertise of well-educated and affluent Anglo-Americans, rather than those of their supposed constituents. Programming an evening of dance and music from across Southeast Asia would probably strike most non-Asians as a sensible, even provocative, approach to presentation. I

once blithely engaged artists from Cambodia, Vietnam, and Laos to share the same bill, thinking the program would shed some light on the commonalities and distinctions across the region. But our Asian communities were unanimous in boycotting the event. It was only as the program played to a tiny audience of whites that I reflected on the fact that these three nationalities have been in a state of almost constant conflict for centuries. The artists had been too polite to tell me of my egregious error, and I didn't know enough to be able to make a relatively simple distinction until it was too late.

In a democracy, no individual should be in a position to dictate the content or method of others' cultural consumption or the public representation of others' cultures. The first step to engaging community is accepting the fact that you can't speak for it. If you don't have the direct participation of the community in the conceptualization of appropriate projects, neither will you have their participation in your programs.

6. The relationship is more important than the issue.

Every community-based cultural project encounters difficulties. Often these problems arise at the intersection where institutions meet action-oriented individuals. Indeed, a large share of the cultural facilitator's responsibility lies in the mediation of this interface, with the pathways of money and power on one hand and the streets of the neighborhood on the other.

Building and maintaining partnerships to cross this divide is an essential part of community building. In the making of art, process serves product; in making community, process is everything. Nobody would want to endure art made by a committee; community building thrives on endless committee meetings. The work consists of bringing together disparate parties, from the corner church and city hall, and including artists, funders, the media, and various community factions. The ostensible objective of this consortium may be to make something beautiful and memorable happen, but if that moment is cherished, it is only because of the connections tested among the participants during the process of creation. The impact of a project on a community will be in direct proportion to the extent of community involvement in its evolution. Maintaining that engagement takes precedence over whatever disputes may arise, and this ultimately relies on the personal connections that the mediator is able to sustain.

Building a successful relationship between facilitator and artist—one that is positive and satisfying to both—entails an open-ended dialogue allowing both parties to be expressive of their concerns and grapple with ethical discrepancies as they occur. This sort of relationship is not achieved in a single booking but is nurtured over many engagements, and it usually entails emotional involvement in an artist's life and work. Building the trust to be able to engage on a personal level is essential. "Feelings are facts," writes frequent artist-in-residence Sheila Kerrigan. "They are part of the working environment. We use our feelings to make our art. It is OK to have feelings and recognize them as they emerge."[22]

Culture workers become *involved,* and they find themselves becoming advocates for the performers with whom they have developed a bond of trust through working together. The mediator can use his or her specialized knowledge to assist artists from ethnic communities in a variety of ways. Artists need institutional backing as their careers advance—everything from applications for fellowships to procurement of visas or employment recommendations. This kind of advocacy is commonplace among cultural specialists, but it should not be forgotten that it is repaid in kind by the artists' sharing of themselves and their work. The advocacy efforts a presenter can undertake on an artist's behalf to ease his or her connection with mainstream culture reap a harvest of personal insight. Just as the keys to structural conundrums often boil down to personal relationships with individuals, the benefits—and responsibilities—of making the effort to foster these connections tend to be mostly personal as well. That means entering into relationships with artists and communities that are as thoughtful, sensitive, critical, and long lasting as the best personal friendships—which is precisely what community cultural facilitation is about.

7. Artists, communities, and institutions need each other.

This triangle is at the core of effective public culture. Each member of the triumvirate comes to the table with specific aspirations, values, and needs, presuppositions, and attitudes that must be adequately conveyed to the others to enable progress. Frequently, however, one or more of these crucial players is not fully engaged in the dialogic process. When the most important underlying values and assumptions of all three players are not made explicit at the start of a project, they are likely to cause disruptions somewhere downstream.

Communities bring their intimate understanding of home-front dynamics, about what works and what doesn't, about what is needed and what is superfluous, about what may be appreciated and what will be resented. They also bring their own local structures in which a cultural project might unfold, and a corps of experienced insiders who can navigate the internal political rapids. Their expertise is unequaled and absolutely essential.

Artists bring to the project a deep knowledge of their art and the traditions supporting it, knowledge rarely equaled within the community or institutions. Master artists are viewed within some communities as ambassadors representing political, intellectual, and social heritage as well as their artistic practice. Artists also bring a sensitivity to aesthetic nuance that pervades every aspect of their interaction with a community and pushes towards the advancement of cultural awareness. This same sensibility, however, can create barriers in situations in which an artist's aesthetics clash with those of the host community or an organization's requirements. We once had a group of Somali elders boycott a residency with a popular dance band when the group's female singer appeared in a photo without a headscarf.

Institutions bring financial and organizational resources that are important. Institutions are the acceptable vehicles for receiving philanthropic and public money for presentations of culture. Institutions bring expertise about funding guidelines, corporate sponsorships, media relations, personnel policies, and the care and feeding of trustees, all tangential to the creative process but necessary for its success. Some institutions are just too large to effectively move among artists and communities. Their organizational structure dominates their actions to such an extent that they cannot devote the time and energy to facilitation of community-based projects. Successful facilitators have made it a priority to orient their organizational ethos toward one of flexible involvement, creating mechanisms to sustain long-term commitments of their institutional resources to this kind of work.

The extent to which the three members of this partnership can understand and appreciate the special needs and contributions of the others is the essence of community cultural programming. If any leg of this stool is weak, the project collapses.

8. It's about repetition.

Curators, whose professional expectations entail using their knowledge to draw together exceptional arrays of talent, will never mount the same

show twice. Community cultural facilitation thrives on repetition. In fact, communities need a great deal of repetition if the lessons they reach for are to be absorbed. It turns out to be extremely beneficial for the artists as well.

Practice indeed makes perfect, and that means going back over the same aesthetic territory fairly often. This reverses the elite art/culture system that equates rarity with quality. In community culture, everybody has to learn the story, understand the tradition, and appreciate the artistry for art to have social value. When artists visit Maine for the first time, they are as strange to our community as it is to them. If they strike a responsive chord, we invite them back, and by the third or fourth visit, they're old friends. The tenor of their work shifts over the sequence of events. They get to know the skill levels and personalities of our community and adjust their own work accordingly, and the locals know what to expect from them and prepare for the work with forethought. Both parties are free to be fearlessly themselves, and both grow from the exchange. Some of our favorite artists have participated in a dozen or more separate residencies over five or six years, and our partners get more from their presence in each new cycle.

Building community takes time. A single season, an entire programmatic year, barely registers when you're trying to foster a community's cultural heritage. Multiple years, decades, are difficult for curators to grasp, but that's how long it takes for cultural seeds to grow within a community. Sudanese and Cambodian girls who entered the Center's programs as children have now advanced to become teachers of their younger siblings, passing the traditions along. If you're not there long enough to see the children you once encouraged grow into adulthood with the assurance that their heritage is intact, your time frame might need expansion.

9. Money is power, and it must be shared.

In America, money does the talking; in community building everybody has to have a voice. Because our funding system privileges institutions over artists and communities, the institutional partner in the creative trio will almost always be the source of fiscal support for the project. Organizations have the capacity for raising the funds most artists and communities simply don't have, so in this sense, they hold a preponderance of power in relation to their partners. "We talk constantly about partnerships," says Penelope McPhee of the Knight Foundation, " . . . but the scale is clearly tilted. No matter how much we go into these communities and talk with

people and say, 'We want you to tell us what the agenda should be, we're not telling you,' they say, 'Yeah, yeah, yeah, but tell us how we get the money.'"[23] Releasing a portion of this financial power is among the most important and difficult tasks community cultural facilitators must face.

Institutions must remember that money flows to them *for* the artists with whom they work and because of the benefits that money offers to the communities they serve. If responsible allocations of available funds are to be made, community representatives should be a part of the decision-making process. This means the free disclosure of budgets and the assumption of a shared sense of responsibility for managing financial resources during the course of the project.

Achieving a community buy-in to the fiscal needs of sustaining culture is extraordinarily difficult. The disbursement of funds can be among the most sensitive issues to be negotiated with community partners. Institutions are seen as rich—and they are, compared to their collaborators. The complexity of organizational finance is obscure to most community members. Some of them deserve to be handsomely compensated for their culture-building work; others are looking to make a fast buck. Community planners must be able to assess each situation and make appropriate judgment calls. In small communities, where everyone knows everyone, this is not an easy task, and mediators sometimes must use their institutional power to protect community cohesion.

Since there is almost never adequate funding to satisfy all participants, the task of determining allocations often falls to the facilitator. This means that you are often the bearer of disappointing news. There is little more disheartening for the mediator than to work diligently with a community, successfully apply for grant support—and then find that most of the participants are angry because they didn't receive as much money as they'd imagined. The fact that most professionals in the mediative role hold salaried positions that are not, like their constituents, subject to grant subsidy, does not help matters. The hard organizational work, fund-raising acumen, and production experience that made the project possible now seems to count for very little. Financial transparency is the only antidote to these difficulties.

By virtue of their access to money, mediators are positioned to bridge the gulfs between ethnic communities, academe, and the commercial marketplace. They have access to the public sphere, to the latest technological developments, and to validation mechanisms, as well as to a diversity of cultures that require these things to remain cohesive, to retain their vitality. Cultures may well be, as Alan Lomax claims, "equally ex-

pressive and equally communicative,"[24] but they are far from equally powerful within the national or international economies. The cultural mediator's job consists of bringing constituents into the marketplace of power and ensuring their fair treatment in this arena.

10. Quality is relative; quantity is deceptive.

Arts administrators who undertake community cultural projects find themselves plagued by questions about artistic quality. The local band just isn't as good as the international touring outfit you brought in last year. Don't we have an obligation to offer our audiences only the best? Aren't we doing the culture itself a disservice by presenting the enthusiastic but less than stellar amateur rather than the skilled professional? "A common complaint is that those connecting programming and community are doing so at the expense of artistic quality: that quality art and responsibility to community are mutually exclusive," write researchers Nello McDaniel and George Thorn. "Our observations of arts providers who are effectively connecting programming and community show that this argument is without merit. For any arts provider committed to professional work, quality is a given."[25]

The disputes over quality represent yet another hangover from the elite high-art traditions in which refinement of taste is a paramount arbiter. Among some cultures, the Eurocentric concept of what qualifies as *quality* is simply irrelevant. Concerns about vocal expressiveness or stage presence may not even enter into insiders' assessment of a performer's skill, which might be based on religious, medicinal, or social considerations. It was a successful performance if the corn grew or the patient got better.

One of the most famous musicological monographs, David McAllester's *Enemy Way Music*, concerns the author's quest to understand a particular Navajo ritual song. He wanted to find out what makes a performance *good:* to ascertain what criteria the Navajo use to measure the quality of a performance. McAllester finds that none of the musicological queries that he brings to the investigation—questions about melodic shape, modal scales, vocal quality, and performance practice—are understood by the Natives. For them, performance of the Enemy Way ceremony is all about putting to rest the spirits of Navajos killed in battle. The quality of the performance is measured by its success in eliminating ghostly visits to the dead Indian's relatives. Aesthetics are beside the point.[26]

Other times, *who* a particular performer is within a community plays as great a role in measuring the success of his or her performance as the

content of the performance itself. Sometimes, these events are not even perceived to be *performances* by the community but are assumed as part of the group's process of cohesion. We once engaged Liz Carroll, among the greatest living Irish fiddlers, to perform for a local ceilidh, and she brought out the local Irish community by the hundreds. But the most affecting moment of the evening was not Carroll's virtuoso playing but the rather sheepish performance of an a cappella song by one of the few older surviving Gaelic speakers in Maine. Bart Folan's rough baritone didn't even register on the qualitative charts beside Liz Carroll's incredibly nuanced performance, but it was so laden with meaning for those in attendance that it brought tears to many people's eyes. "There arises an intimacy close to love," wrote Lomax in 1960. "The performer gives you his strongest and deepest feeling, and if he is a folk singer, this emotion can reveal the character of his whole community."[27]

This does not imply that communities can do without exposure to those master performers. The demand for access to the finest talent is a recurrent theme among most community cultural endeavors. But the presence of international celebrities cannot exclude the participation of the local performers who probably play a more significant role in building the community and in leading it to appreciation of the finest exemplars of cultural practice. The quality of the process, in all of its sprawling complexity, is as important as the quality of the product.

This raises difficulties when it comes to measuring the success or failure of community programs. How do you evaluate something that exists within the hearts and minds of participants? Something as amorphous as the passion individuals may feel for practicing a portion of their heritage? A specific project is likely to play only an incremental role in achieving its overarching goals, which are likely to be as broad and ambitious as the institution's mission statement. Realistic assessment needs to separate the potential hoped-for results of a given initiative from the larger, more distant goals of community empowerment.[28] We hope that our Cambodian dance programs will nurture pride in Khmer heritage and keep it vibrant within our community, but that is an endless process. How can we know that what we are doing this year is making a positive contribution to that goal?

Quantitative measurement, the listings of numbers of patrons served and dollars collected, is always important for grant reports, but it may not be an effective tool for gauging the value of a project within a community setting. It does not address the real issues at stake in deep community work, which concern personal and collective identity and empowerment.

Details of exactly what happened, of who was there and who did what, come closer to drawing a picture of a community in action. People will vote with their feet: their presence is a strong signal that a project is useful to community members. If they stay away in droves, or if programs are enjoyed by outsiders but scorned by community members, the direction is wrong. The nature and frequency of program use can also reveal its importance in a community's dynamic. Are individuals engaged as participants, or as spectators? Once a year, or once a week? Is there a continuity of participation, individuals whose engagement is constant over long periods and thus clearly reflecting personal importance? Do the tangible fruits of an initiative show up in other, unrelated contexts? Sudanese dancers trained in our programs are now often asked to perform at local schools or fairs. Such quantitative measures can offer signs, though frequently obscure, to a project's impact. But the teaching of art is such an individualized, subjective process that the enumeration of such data cannot offer an adequate measure of program success. At best, it is partial and fragmentary; at worst, it can be misleading. Is a program that profoundly influences just one person considered a failure, or a success?

Qualitative evaluation, the assessment of the value of programs in individual's lives, defies easy measurement. But insight can be gained by observing how participants express themselves about their involvement in a project. The kind of language that is employed in conversation or on evaluative questionnaires offers a clue to the feelings of participants. The specific examples and anecdotes that they relate are a measure of the importance those experiences hold in their lives. The passionate commitment that we see in the energy of young dancers and musicians is among the most satisfying benefits of cultural administration, though it is intangible. Without such signals that the process is working, facilitation would be a joyless exercise.

Researchers Maria-Rosario Jackson and Joaquin Herranz posit a set of *guiding principles* for measuring community-based cultural initiatives. Evaluative instruments that fail to recognize the principles risk producing incomplete or misleading data. The framework that they suggest insists that "1) Definitions depend on the values and realities of the community. 2) Participation spans a wide range of actions, disciplines, and levels of expertise. 3) Creative expression is infused with multiple meanings and purposes. 4) Opportunities for participation rely on arts-specific *and* other resources."[29]

These guidelines connect to a growing body of theory on the mechanics of measuring complex community interactions. As organizations plan

and undertake ambitious projects, an emerging area of assessment concerns capacity: has the process of program development and realization enhanced a community's potential to collaborate fully in other areas? The Communication for Social Change initiative details seven outcome indicators that can be addressed to gauge capacity: "(1) leadership, (2) degree of equity and participation, (3) information equity, (4) collective self-efficacy, (5) sense of ownership, (6) social cohesion, and (7) social norms. Taken together, these outcomes determine the capacity for cooperative action in a community."[30] The ability to effectively evaluate each of these indicators within any group is in itself a dramatic assessment of the quality of work that it is undertaking.

Work within communities tends to raise as many questions as it answers. The most actively engaged cultural facilitators in the country will tell you that they are barely scratching the surface, that their efforts are scarcely adequate to the situations at hand. Perhaps this pervasive uncertainty is itself a benchmark of effective cultural facilitation. If you're not really sure where you are right now, about what kind of impact you are really having, of which segments of the community are actually engaged, about whether your work is a success or a waste of time—all of these doubts are perhaps a signal that deep community work is underway. It's sloppy, time-consuming, sometimes infuriating or heartbreaking work, and if you haven't experienced moments of confusion and self-doubt, you're probably not working effectively.

At its heart, cultural facilitation means deep involvement with people who are different from oneself, and a continual willingness to withhold judgment and let the differences lie in the open. More than this, it often means contributing your own time, resources, and reputation in service to a vision or process that you may not entirely share. If mediators are not willing to voluntarily step outside their own comfort zone to cede some of their power to constituents, public culture remains paternalistic. It is easy to go along with plans when you like them; the test is one's willingness to enable communities to pursue projects that stir misgivings, to lend support for an ethnic approach to an issue that disturbs your own sensibilities.

A related problem concerns the integration of culturally diverse staff members into organizations that exist within the dominant American nonprofit corporate structure. Almost all of our public institutions are constituted according to Internal Revenue Service guidelines as hierarchi-

cal directorships with responsibility vested in boards of trustees and compartmentalized staff positions. Most college-educated Americans are perfectly used to functioning in this system; it holds no mystique. But many minorities, particularly recent immigrants, come from communities where authority is exercised and delegated very differently and where roles may be far more fluid than in a typical corporate environment.

Agendas, time-limited discussions, and Robert's Rules of Order are not standard modes of communication in most cultures. Describing his childhood in Ghana, Kofi Annan says, "[I]n traditional African society people discussed issues. They talked and talked—you know, the tradition of palaver, you go under the tree and you talk. If you can't solve the problem, you meet the next day, and you keep talking till you find a solution."[31] Warren Feek, of the Communications Initiative, expands on this concept, using the example of the "talking stick" as used by several Northwest Native peoples. "[I]f you hold the talking stick in any community meeting then you can talk for as long as you like about whatever you like and in any way you want," he writes. "No one can interrupt. You can go for seconds or for days—and some people have—never letting go of the Talking Stick. When you feel you are finished you hand it to the next in line. The process continues with these very striking sticks being passed from hand-to-hand and all having the right to speak uninterrupted. No time management here. This is an ongoing dialogue process."[32] Feek goes on to question the communications models employed by Western professionals in their dealings with local communities: "Why does so much money, time and effort appear to be spent on communication strategies that are probably very foreign to the local communication forms?"[33]

The issue of *time,* and how it is variously regarded across cultures, can have serious repercussions. Northern Europeans and most Americans have an engrained attitude about timeliness that much of the rest of the world perceives as extremely rude. Punctuality, so important to the functioning of our lightning-fast consumer economy, is viewed as dysfunctional by most of the world's population. Making this transition is among the greatest obstacles facing many new immigrants. They don't show up an hour or two late because they're lazy or inconsiderate; they arrive at the time that, according to their own cultures, is respectful and appropriate. But that explanation, if it is even offered, rarely mollifies the employer who's been stood up for a meeting. All of the structures of American society are geared to the clock; you simply can't explain to a classroom full of waiting students that the guest artist's tardiness is "a cultural thing."

Such problems amplify around the office, since those cultural things

often extend in many directions, including attitudes toward social inter-action on the job, employee reportage and accountability procedures, and the handling of money. The Center once interviewed a recent refugee for a bookkeeping job. He had been the comptroller of a large corporation in Egypt, routinely dealing with large sums of money. Since recruitment of a culturally diverse staff is a constant priority within our organization, we were delighted that he'd applied. In his interview, however, it quickly became obvious that he had no knowledge of the payroll deductions and tax withholding that would be a major part of his job here. In fact, he expressed astonishment that we paid our employees by check: in Egypt, everyone in the corporation had been paid in cash, under the table, specifi-cally to avoid the prospect of taxation. To work within our institutional structure, this applicant needed substantial remedial education. To bal-ance his shortcomings with our institutional commitment to work sensi-tively with his community, our organization had a whole spectrum of issues to consider.

How much is it appropriate to bend organizational culture to accom-modate the needs of diverse constituencies? For many years, the Center has been careful to maintain a critical mass of ethnic community repre-sentation on our board of directors. It was felt that their presence would help to ensure that our formal policies and organizational trajectory were congruent with community needs. But in practice, the ethnic membership on our board has not played a substantial role in shaping overall direc-tion. Individual minority board members get deeply involved in the ini-tiatives that serve their own communities and for the most part leave the institutional management to the European American professionals that constitute the rest of the board. This may be partially because of the sense of unease with the corporate structure discussed above. But another signifi-cant factor is sheer exhaustion. In many cases, those who step—or are pushed—into leadership positions within minority communities are con-tinually besieged, both by their own constituencies and the greater civic structure. Most of our ethnic board members are stretched between com-mitments to their own evolving community projects, their jobs (many refugees work two of them!), and families—before having their presence demanded by nonprofit organizations, civic institutions, or the media. Burnout among minority community leaders is a serious and ongoing problem.

Ultimately, it is to these very leaders that we cultural mediators turn in the attempt to form a more genuinely democratic public culture. If, as I have suggested, our job is to give our power away to those with whom it

properly resides, it is these frazzled leaders whom we need the most. Community culture has to maintain its grounding in community, and it is community members that must recognize it, cherish it, and breathe vitality into it. Our job is not to dictate this but to create an open context where it can happen. It is the responsibility of each mediator to acknowledge the ethical implications of our efforts, to examine our motivations, and to exchange the dominance that is our inherited position for an association of equity with our partners. "In promoting initiative, creativity, self-directed and cooperative expression," say Don Adams and Arlene Goldbard, "community cultural development practitioners hope to shatter a persistent media-generated trance, assisting community members in awakening to and pursuing their own legitimate aspirations for social autonomy and recognition."[34]

Ethnic communities, performers, and visual artists need to address these same issues—without regard for what some cultural specialist may have recommended—and answer them in a manner satisfactory to their own needs. "We have to write our own history and interpret our own cultural symbols, our own language, and music and politics," insists Chicano activist Juan Tejeda. "So we need our historians and our anthropologists and folklorists to really arrive at the truth. I think other people probably can, but we *need* to do it."[35]

Doing this—returning the stewardship of folk cultures to the folk—holds tangible benefits for the dominant culture as well. Real and vitalized ethnic cultures are badly needed as a corrective to the bland inanity of commercial popular culture. America needs to actually address issues of race and ethnicity, not on the television screen but in person. America is a deeply divided country. "Everywhere I go," writes performance artist Guillermo Gomez-Peña, "I meet Anglo-Americans immersed in fear: They are scared of us, the other, taking over their country, their jobs, their neighborhoods, their universities, their art world. To 'them,' 'we' are a whole package that includes an indistinct Spanish language, weird art, a sexual threat, gang activity, drugs, and 'illegal aliens.' They don't realize that their fear has been implanted as a form of political control: that this fear is the very source of the endemic violence that has been affecting this society." Public culture, if it can be accomplished in an inclusive rather than an exclusive fashion, if it can provide a comfortable haven for insiders as well as outsiders, can be an agency for the alleviation of these anxieties. This can only happen when authentic cultures can meet and interact. When they do, says Gomez-Peña, "culture can help dismantle the mechanisms of fear."[36] Mediators are midwives to that culture.

✧ ✧ ✧

Now in the new millennium, American culture is permeated with a cynicism so deep that it calls into question the role of public institutions to foster our national heritage. In fact, large portions of the public have ample reason to feel that those institutions have never been responsive to their interests, needs, and aspirations. If it can effectively shed the image and reality of elitism, which have defined its agenda, the public sector holds a key to unlocking our national cultural resources. Opening the doors will now require an unprecedented effort of engagement, involving dramatically different attitudes and activities from those that have prevailed among arts organizations. Our continuing relevance will hinge, in part, on our response to this challenge.

Cultural and social service organizations can become the bridges linking communities with the resources of money and power. By their legal and institutional status, they are afforded a degree of access that many communities lack. The power that this represents needs to be refocused to make the nonprofit sector more effectively community oriented in its programs. Organizations with a mission of bestowing culture on their constituents need a lesson in humility: they need the lessons from their communities about what the local culture really is. They need to enlist community-based activists to help them to build grassroots capacity and, in the process, help to train local leaders in the mysteries of budgeting, grant writing, and fiscal management.

The entire nonprofit sector, like foundations, should be subject to periodic twilight reviews. Benchmarks could be established to measure the extent to which they are doing the public's work. The public should demand accountability for their effective benefits to the community—the tax deductions that fund them are public money, after all. Without an active and engaged local institutional infrastructure, the wheels of cultural democracy will slow and seize. Experimenting with institutional strategies to grapple with these demands—and there will be many different and useful models—offers an unprecedented challenge to the entire sector. With vision and energy, nonprofit cultural organizations could play a leading role in this transformation.

✧ ✧ ✧

Following the Sudanese stand off, a day of frantic phone calls and e-mails revealed some of the complexity of the controversy. The community was splintered not just along ethnic and political lines but also through per-

sonal rivalries that were aggravating the situation. A movement was afoot to replace an elder who was chair of the Sudanese Community Organization and who was slated to appear as a speaker at the conference but now joined those in opposition. Men from some segments of the community were unhappy about having to negotiate with women from another faction. The SPLA presence seemed to be the lever that raised all of this and more into the light. The Center's staff, of course, had been taken by surprise and could only apprehend most of this piecemeal, in an ongoing game of "telephone" that seemed to amplify every issue into a public relations disaster. What does the responsible mediator do now?

We tried to put the controversy into perspective. Our goal had never been to create a political crisis: the idea behind the conference was to bring the community together, but instead it was driving wedges between various factions. If we hoped to support cultural vitality among the Sudanese—all the Sudanese—then it didn't make sense to move forward with an event disputed by a significant portion of the community. We'd never see them walk through our doors again. On the other hand, if we cancelled, would we lose the participation of the faction that had supported the conference and who would then feel betrayed?

The solution we found was arrived at through repeated meetings with both the dissenting group and with the conference backers, and finally it was agreed on by consensus. The conference was to go forward, but the invitation to the representative of the SPLA was withdrawn. Instead, two members of the dissenting delegation were given seats on a panel discussing the situation faced by Sudanese in Portland. Some grumbling persisted among all parties, and the Center had to hire a couple of plainclothes police officers owing to heightened security concerns. But the conference took place with an overflow crowd of both Sudanese and Mainers, all of whom got a far more candid glimpse of community dynamics than any would have had without the controversy. After all the speeches ended without a violent word, and Emanuel Kembe's Sudanese reggae band took the stage, the relief in the room was palpably expressed through almost hyperenergetic dancing.

While such incidents feel like hell unfolding around the facilitator, they are the bread and butter of our craft. It is not usually the successes that hold the most valuable lessons. Those we must extract from our frequent failures. These are almost always attributable to our own cultural blind spots; somewhere, we have made an assumption that doesn't hold up in relation to this specific community. "We need a certain amount of humility and a sense of humor to discover cultures other than our own, a readi-

ness to enter a room in the dark and stumble over unfamiliar furniture until the pain in our shins reminds us where things are," says Fons Trompenaars. "World culture is a myriad of different ways of creating the integrity without which life and business cannot be conducted. There are no universal answers."[37] Effective mediation is perhaps the greatest gift we can offer to our partners. To accomplish it requires a continually re-visited sense of humility toward the majestic construction that *is* culture, and an awed sense of our own ignorance of its byzantine configurations. In grasping this totality, we remain, forever, beginners.

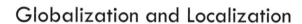

Globalization and Localization

When the great Sardinian vocal quartet Tenores di Bitti flew to the United States for a tour of a cappella folk choirs, they smuggled through customs several large Coke bottles filled with wine from their own presses.[1] I asked them why they brought so much wine along, and they explained that they weren't sure that they'd be able to find anything drinkable in America. Determined to prove to them that we, too, can make a good bottle of wine, I picked up an excellent California varietal and uncorked it at the after-show party. They liked the wine but showed far more interest in the cork.

Three of them remained huddled in a corner, carefully examining it for several minutes. Finally, one emerged and, holding the cork aloft, triumphantly announced, "É di Bitti!" It turns out that there are three major cork-producing regions in the world: Portugal, Morocco, and Sardinia. Their tiny hometown of Bitti lies in the middle of the Sardinian cork

A group of Congolese dancers choose to wear matching Harry Potter shirts for a performance. Photo by Phyllis O'Neill.

region—these are men who've spent their entire lives living amid cork trees. By examining the texture and grain of the cork, they were able to determine that it came from their village. Here we were, five thousand miles away in a small New England town, drinking a wine from California, and the cork came from their own backyard! A few moments later, the fourth member of the group arrived at the party. When shown the cork, he examined it for an instant and declared, "É di Sardegna!"

There's nothing new about foreign trade—we've surely been blithely popping Sardinian corks for decades. But since the end of the cold war, the exponential expansion of communications technologies; the rapid opening of formerly limited international markets; the unprecedented movement of people, goods, and capital; and the evolution of transnational corporate entities have coalesced into what many view as a "new world order." The extraordinary thing about the cork from Bitti is that such apparently incredible convergences have become commonplace. Walk into any shopping mall and check out the labels; you'll find products manufactured in every corner of the world masquerading as American consumer goods. Whether we like it—or even recognize it—or not, we're connected to the rest of the planet.

Globalization looms as the defining issue of our time, and culture is the fulcrum of the debate. Critics of globalization raise legitimate concerns about the cultural impact of unitary markets and multinational corporate dominance. For them, culture is among the primary casualties of the race for economic expansionism. "The nation states of the world have moved from the bi-polar system of the Cold War to a global system—integrating markets, nation states and technologies to a degree never witnessed before," writes Harvey Feigenbaum of George Washington University. "Globalization has stimulated world-wide growth and, for some, incomes are rising at unprecedented rates. But there is a backlash from those who have been, or think they have been, left behind. For some people, local, regional, or national cultures seem to be eroding under the pressure of global markets."[2]

Much of world has good reason to feel "left behind." According to the World Bank, 40 percent of the world's population—almost three billion people—subsists on less than two dollars a day.[3] These people see little evidence of Feigenbaum's unprecedented income levels. The reputed benefits of globalization remain elusive to the majority. "Just as trade, foreign investment and the flow of money have affected only a few regions of the world and left the rest untouched," says UNESCO's report on culture and development, "so this globalization of culture is fragmented

and only now beginning. . . . Globalization itself is an unequal and asymmetrical process," that appears to provide great benefits to few, but poses large threats to many.[4]

Even the champions of globalization look to culture as a means of deflecting their critics. Culture becomes a strategic vehicle that, properly deployed, can ameliorate the negative impacts of globalization; it can provide enough of a local flavor to economic development that it becomes acceptable within its own context. Proponents envision culturally sensitive development—a kinder, gentler globalization—as the key that can avoid the dangers of backlash and maintain the momentum of economic expansion.

Thomas Friedman's concern for the evolution of a culturally aware globalization is explicit: "How we learn to strike the right balance between globalization's inherently empowering and humanizing aspects and its inherently disempowering and dehumanizing aspects will determine whether it is reversible or irreversible, a passing phase or a fundamental revolution in the evolution of human society."[5] In Friedman's view, effectively contending with the olive trees is a necessary prerequisite to selling the first Lexus. He underscores the importance, the necessity, of finding a balance between what Evan Eisenberg calls "the two opposed faces of globalization. On one side, the maternal visage of Gaia; on the other, a morphed amalgam of Nike, McDonald's, Wal-Mart and Disney."[6]

Gaia, Coca-Cola, religious fundamentalism, and postindustrial economies meet on a political field that is framed by culture. Samuel Huntington's portentous "clash of civilizations" reduces geopolitical identity and action to an irreducible core—shared cultural norms.[7] Benjamin Barber argues that education and democracy can bridge the chasm between the two cultures that he sees haunting the globe: we can choose between "Jihad" and "McWorld."[8] The emerging conflicts between Philip Bobbitt's new "market state" leviathans are driven by the political need to protect cultures.[9] These thinkers represent very different positions on the ideological spectrum and substantially disagree with each other in many areas. They speak with a single voice, however, in pointing to the primary place that cultural matters occupy in determining the shape of global politics in the twenty-first century.

Culture is now on the international agenda in a way that it has never been in the past. It is simultaneously a primary point of dispute in the emergent debates over globalization and a primary determinant to how the debate is conducted and perceived within diverse communities worldwide. Further, the outcomes of contemporary policy debates, as they are

enacted and become history, will have fundamental implications for how local, regional, national, and global cultures shape themselves and our future. How globalization addresses or suppresses the facts of cultural diversity—and how every local culture contends with globalization—will be the subtext, if not the main story, of the twenty-first century.

<div align="center">✧ ✧ ✧</div>

"The story of mass migrations (voluntary or forced) is hardly a new feature of human history," comments Arjun Appadurai. "But when it is juxtaposed with the rapid flow of mass-mediated images, scripts, and sensations, we have a new order of instability in the production of modern subjectivities."[10] Both the migration and the culture shock characterize the recent boom in Maine's Hispanic population. For more than four hundred years, fishermen have harvested an amazing array of seafood from the waters of Maine's Casco Bay. Portland's fish-processing industry is among the busiest in the country. Over the years, there have been occasional shifts in the public's tastes: yesterday's "junk fish" might be tomorrow's delicacy. In colonial days, lobsters were scorned and generally used for garden fertilizer; today their importance to the state's economy is underscored by their appearance on our automobile license plates. Salmon has become a cherished table fish only in the last fifty years. Until quite recently, those who fish commercially viewed the lowly sea urchin as a net-fouling nuisance. Then an enterprising businessperson discovered that sea urchin is among the most expensive and desirable items served in Japan's many sushi bars. Furthermore, Japanese demand for the mollusk is such that their local waters are severely depleted.

Cod and haddock have been largely overfished in the Gulf of Maine, and catches are now restricted by court order. Until the early 1990s, nobody had ever taken a sea urchin from the floor of Casco Bay, which turns out to be the perfect urchin habitat. Soon the race was on. The new businesses required large numbers of unskilled laborers for the dangerous work of harvesting the urchins and the tedious work of cleaning and processing them for shipment to Japan. Since unemployment in the Portland region has remained low for over a decade, supervisors were forced to look for employees in the labor pools of Boston and New York, where a majority of newly available workers have recently been immigrants from Mexico, Central America, and the Caribbean. Almost overnight, Portland acquired a substantial Latino community. One of the local Catholic parishes started saying mass *en español,* and the schools scrambled to hire bilingual facilitators. The demand for a specific product on the opposite

side of the planet had spurred a boom in the Hispanic population of Maine.

Portland's Latinos have their own cultural interests, just like anybody else. In fact, they have a lot of different cultural interests, depending on how old they are and where they come from. Older Mexicanos like mariachi, and Dominicans prefer merengue; most young people are avid fans of an array of pop styles with roots in the different Caribbean dance rhythms overlaid with electronics and hip-hop attitudes. Whatever their preference, they don't find much of it in Portland. Maine's Hispanics find their culture through the Internet and satellite television, the media that carry their own programming. They download songs and buy cds, videos, fashions, even food, through the mail.

Or they go back to their homelands to stock up. Today's immigrants maintain a physical connection to their native countries that is unique to this generation. Most immigrants to the United States, from colonial times until very recently, came here and stayed. Many never imagined making the return trip, even if it was theoretically possible. This is no longer true. Visiting the home country has become commonplace. Contemporary immigrants from Asia, Europe, and Latin America are frequent flyers.

These globetrotting ethnics are honeybees of global culture, leaving a residue of cross-pollination wherever they go. They travel outbound from the United States with suitcases bulging with consumer goods for the folks back home: kitchenware, home electronics, clothing. They return with music, art, fashion, food. The traffic goes both ways. Diasporic communities *need* the linkages with their homelands; they need routine and regular contact to keep themselves in touch and culturally grounded. But so do the homelands need the challenges posed by their brethren abroad.

I am not addressing the material advantages of having a relative in Chicago sending money and Walkman disc players home to the folks in Honduras, although these are vitally important. I am concerned here with the cultural stimulation that expatriate communities exchange with their societies of origin. The enormous influx of foreign students to American colleges and professional schools is both a symptom and a generator of globalization. Those students in their millions take a sizeable slice of American culture home with them and spread it around their home countries. Conversely, they and their kin who opt to stay here help change the shape of our own cultural landscape. Detroit today is still a magnet for Arabs, as Boston is for Irish, and Los Angeles is for Mexicans; can we imagine any of these cities without their characteristic ethnic identities?

This is not just a reiterated suggestion that our local cultures need continual stimulation to refresh themselves. The linkages are much more important than that. As the pace of globalization increases, we need our diasporic communities to act as interpreters of international events. They are, in a very real sense, local ambassadors of some other land who have made their homes among us and can help us to understand the larger world. Following the September 11 World Trade Center attacks, I was fortunate to be included in the daily e-mail postings of a group of local Afghan refugees. They were in regular electronic communication with other Afghan communities throughout the United States and abroad. The perspective that they were able to offer, as the United States prepared to go to war against their homeland, was a sharp contrast to the pervasive drum beating in the media. If our political leaders had locals who could provide an insider perspective on events, their policies and actions could only stand to benefit. Cultural grounding could clarify some of the confusion that dominates so frequently in the international arena.

Unfortunately, as globalization has ratcheted up, the U.S. government has systematically isolated itself from international cultural concerns. According to *America's Cultural Capital,* a report from the Center for Arts and Culture, "At a time when the global interest in American culture and society is stronger than ever and when our cultural products have become ever more pervasive in world markets, the U.S. government has largely withdrawn from the realm of cultural diplomacy."[11] President Reagan withdrew the country from UNESCO; Clinton eliminated the United States Information Agency, folding it into the State Department; the International Programs section of the NEA was abolished; and most of the international cultural programs that had once been justified as propaganda tools of the cold war have been discontinued.

Simultaneously, successive administrations have pushed the global free trade agenda through eight consecutive rounds of the General Agreement on Tariffs and Trade (GATT) negotiations that ultimately resulted in the creation of the World Trade Organization (WTO). The emphasis was on opening markets to capital investment by pressuring governments to create political and economic systems that provide guarantees for investor safety. "The business of America is business," writes Geoffrey Wheatcroft, "and what American business has always believed in isn't free trade but free investment, a very different thing."[12] The gradual elimination of trade barriers, coupled with dramatic improvements in technology and transport, allowed companies to locate production facilities wherever costs were cheapest while marketing finished goods in the most lucrative markets.

This, of course, offered extraordinary advantages to the industrialized countries, particularly the United States.

In cultural affairs, this advantage has been unprecedented. As the government has shut down its own investment in the nonprofit cultural apparatus, its trade policies have fostered boom times for the American entertainment-industrial complex. "The United States tends to dominate international trade in cultural goods and services," writes Feigenbaum. "Even though a number of the world's major cultural producers and distributors are not owned by Americans, the predominance of U.S. content results in tension between U.S. foreign economic and trade objectives and the desire of other countries to preserve their cultural identities and foster indigenous cultural industries. Historically, U.S. government policies have tended to favor free trade in cultural products and services. Other nations, however, have restricted such trade because they are concerned by the dominance of U.S. cultural goods and services."[13]

Just like Americans, citizens of other countries value their cultural heritage, and want to protect it. "The problem, for many Europeans, Canadians, and Latin Americans, to say nothing of millions in the Islamic world," Feigenbaum continues, "is that globalization means Americanization. The uniformity of mass cultural offerings around the world has led cultural critics to see globalization as an international orientation toward the worst aspects of mass consumption and American products pitched to the lowest common denominator."[14] To many, globalization threatens the disintegration of the heritage that forms the roots of their identity as distinct peoples.

The results are predictable, though they don't show up on corporate balance sheets. When populations become alienated and estranged from the values that have traditionally bound their communities, they frequently become receptive to demagoguery that promises a return to former glories. This happened in Germany after World War I, in the Shah's Iran, and is happening now all over the world. "In many lands there has been a convulsive ingathering, a return to past traditions and a reaction towards tribalism," warns Javiar Pérez de Cuéllar. "We are witnessing religious revivalism everywhere: Islamic in the Muslim world, evangelical Christian fundamentalism not only in the United States but in East Asia, Africa and Latin America. Hindu revivalism is evident in India and a Judaic one in Israel. It is partly a reaction against the alienating effects of large-scale, modern technology and the unequal distribution of the benefits from industrialization. The concern is that development has meant the loss of identity, sense of community and personal meaning."[15]

The loss of community then feeds the growing income gap, as people feel less connection to, and responsibility for, others in their community, and thus more "entitled" to be selfish.

In purely economic terms, the costs of this backlash, which include the disruptions of revolution, warfare, and international terrorism, are incalculable. Market-driven social malaise is epidemic: witness the unprecedented flow of "economic migrants" throughout the planet. As transnational corporations have become the de facto governing forces in shaping the trajectory of global development, we have failed to devise mechanisms to address the cultural detritus left in the wake of their activities. The results of a culture trashed by development, though predictable, are not easily measured or repaired. Perhaps actual governments, elected or not, should develop a more skeptical attitude toward assumption of the costs of cleaning up these failures. A culturally nuanced view could trace at least the broad outlines of cause and effect and place economic responsibility where it belongs, with those who extracted profit from economic development, and left communities as ravaged physically, culturally, and economically as the coalfields of Appalachia.

"The Bretton Woods institutions such as the International Monetary Fund and the World Trade Organization might have been of some succor in the effort to construct a more democratic globalism if they had been used for the kinds of developmental and democratic purposes for which they were designed in postwar Europe," writes Barber. "Instead they have been cast by the democratic governments that control them as undemocratic instruments of private interest—seemingly the tools of banks, corporations, and investors that to an untoward degree also control the policies of the governments that nominally control them. Anarchism in the global sector is no accident. It has been assiduously cultivated."[16] Investor profits have become the sine qua non of international monetary policy, and other voices remain marginal.

According to the rules devised through GATT, the WTO, and the World Bank, local economies are only bit players when it comes to these profits. For them, the benefits are restricted to income—low-wage jobs for former farmers—as opposed to the generation of wealth. The real money flows to financiers and industrial capitalists in the developed world, primarily the United States. "Testifying before Congress in 1995, Lawrence Summers, then of the Treasury Department, disclosed that American corporations received $1.35 in procurement contracts for each dollar the American government contributed to the World Bank and other multilateral development banks," writes William Finnegan. "This was an unusually can-

did admission by a leading Bank supporter that one of its main activities is, in fact, corporate welfare."[17]

Politicians in the developing world are pressured to honor the interest payments that further enrich American bankers and speculators before they provide basic necessities like housing and medical care for their own people. "The most passionate critique of these interventions has emanated from impoverished countries where citizens have discovered that the price of securing World Bank largesse is too high to be borne," according to the Rockefeller Foundation's report *Community, Culture, and Globalization*. "Typically, in exchange for certifying governments for much-needed international credit, the IMF has demanded such measures as reductions in public expenditure (often achieved through job cuts, wage freezes or cuts in health, education and social-welfare services); privatization of public services and industries; currency devaluation and export promotion, leading to a conversion from local food production to cash crops, which in turn leads to greater impoverishment as citizens are forced to buy imported food; and so on."[18] When people see their governments making such choices, they often call the legitimacy of such governments into question. Such questioning sometimes leads to social disruptions and violence that erodes everyone's capacity for progress. The financiers who set these balls into motion are not accountable for the results. The costs in locally devastated economies fall on the poorest. American taxpayers assume the bill for the military expenditures needed to make the world safe for speculators.

The risks posed by globalization are not restricted to the market's nurture of religious fundamentalists and foreign terrorists. Within the developed countries, those who enjoy the apparent fruits of globalization may find the results equally disenchanting. Friedman imagines a spiritual crisis in America: "There is a danger that as a result of the Internetting of society, the triumph of all this technology in our lives and globalization über alles, people will wake up one morning and realize that they don't interact with anyone except through a computer," he writes. "When this happens, people will really become vulnerable to those preachers and New Age religious fantasies that come along and promise to reconnect us to our bodies, our souls and the olive tree in us all. That is when you will start to see *truly* crazy revolts against monotony and standardization—people being different for the sake of being different, but not on the basis of any real historical memory, roots or traditions."[19]

Religious fundamentalists, whether in America or the Middle East, may be threatened by the forces of development and modernity, but their calls

for a return to "traditional" values are always selective. Religious historian Karen Armstrong notes that the very term *fundamentalism* "gives the impression that fundamentalists are inherently conservative and wedded to the past, whereas their ideas are essentially modern and highly innovative."[20] It is often pointed out that Ayatollah Khomeini, a profoundly conservative Islamic "fundamentalist," was able to instigate and direct the revolution that brought him to power in Iran by long-distance telephone from Paris. Christian fundamentalists readily adapt to contemporary technology, serving their megacongregations through giant-screen, arena-style video monitors, Star Wars–caliber special effects every Sunday morning, and Internet-based digital political activism for conservative causes.

It is not just the produce of globalization that draws the fundamentalist reaction but the perceived values that go along with it. "What they seek is justice, not vengeance," Barber insists. "Their quarrel is not with modernity but with the aggressive neoliberal ideology that has been prosecuted in its name in pursuit of a global market society more conductive to profits for some than to justice for all."[21] Fundamentalists are happy to accommodate themselves to contemporary technology (including weaponry), which they put to use in the name of a different set of values than those they observe in the marketplace. These values are very specifically grounded in the cultural practice and traditional beliefs that are threatened by globalization.

It is not just religious extremists who are now turning the tools made available through globalization to their own purposes. This same technology appears to offer many marginal cultures the chance, finally, to be heard. Cheap, readily available digital recording technology has rapidly broken down many of the barriers to musical reproducibility. Suddenly, anybody can carry around a recording studio in a backpack. This ability for widespread production, coupled with the Internet's capacity for distribution, has created a revolution in the music and video industry that is only beginning to make itself felt.

Music represents one of the most prominent avenues available for smaller cultures to make themselves heard and recognized on a national and international level. Because of the extraordinary penetration of recording technology and the media, the music of indigenous peoples from all continents has become relatively accessible to anyone with the interest. In the United States, there has been a steady rise in the availability of "world music" (including pretty much everything outside the pop and classical music mainstreams), the development of educated cognoscenti knowledgeable about various obscure musical idioms and the opening of

new markets for touring musicians from ethnic cultures. As alternative kinds of presentation—that is, not driven by the demands of the mass market but tailored to the tastes of a small segment of the populace—these developments make the niche marketing of culturally specific arts economically viable and can offer adequate remuneration for artists from formerly marginal cultures.

Ted Levin, director of Yo-Yo Ma's Silk Road Project, has observed significant changes in the position of small and remote Central Asian cultures. "The question," he says, "is not whether music will be globalized. The question is on what terms. The only ethical solution is to put everyone on the same footing, to give them all the tools they need." Levin, the ethnomusicological promoter responsible for introducing Americans to the ethereal sound of Tuvan throat singing (a vocal technique that allows singers to sound multiple pitches simultaneously), sees a revival of traditions stimulated by the ease of recording and broadcast, coupled with a pervasive unsatisfied appetite for the new and authentic experience. In its battle with mass culture, local artistry can employ tools from Tokyo and production techniques lifted from Hollywood to offer local alternatives. "It's exactly the growth of technology and globalization that has reduced the scale on which you need to operate in order to represent yourself. A bunch of people running around with horsehead fiddles and minidisk recorders can be a match for the power of the entertainment industry."[22] On the level of individual products, Levin is surely correct, but the artist who rises from obscurity riding a fad is frequently forgotten just as quickly. Building sustainable systems for multidimensional endeavors that can compete with the entertainment-industrial complex requires more than adapting to new technologies.

In a sense, globalization offers an ultimate challenge and opportunity to local cultures to find the means to sell their wares to the world without rending them hollow in the process. Communities must rapidly develop both new skills and the sophistication and foresight to use them in service to their own needs. Jennifer Gottlieb writes that "globalization has created a more competitive environment when it comes to innovation and the creative process. With increased international competition in the cultural industries, the need to be fast, flexible and forward-thinking is all the more important."[23] For traditional cultures, the challenge is doing this without surrendering to the rampant slickification that appears to be the ticket to commercial visibility.

Culture has much to offer the globalized world. How can it be used to benefit, rather than exploit, local communities? Without an enormous

(and unprecedented) new commitment to meeting communities on an equitable footing, globalization appears to offer local cultures the same old-fashioned zero-sum game: surrender your heritage and natural resources, and watch a corporation reap the profits. But if communities can take advantage of the tools of globalization and invest their own social capital, the equation might begin to look more balanced, at least on a microlevel. There is, as many countries have now found, no way to avoid the avalanche; but perhaps it can be turned to local advantage. "The challenge for every nation is not how to prescribe an environment of protection for a received body of art and tradition," says economist Shalini Venturelli, "but how to construct one of creative explosion and innovation in all areas of the arts and sciences."[24] As the creative economy continues to expand, constructing a social and business environment that feeds culture will be imperative. "Given that creativity has emerged as the single most important source of economic growth," says Richard Florida, "the best route to continued prosperity is by investing in our stock of creativity in *all* its forms, across the board. This entails more than just pumping up R & D spending or improving education, though both are important. It requires increasing investments in the multidimensional and varied forms of creativity—arts, music, culture, design and related fields— because all are linked and flourish together."[25]

Devising a structure for this creative explosion can only happen on a local, community level if it is to be of use as an antidote to the worst aspects of rampant consumerism promised by globalization. It will be through decentralized, locally controlled initiatives that an alternative to corporate domination is brought to life. "The effort to counter the effects of globalization is not an equal fight. The forces of globalization have virtually unlimited capital and influence on their side. Yet on the other side we have the relentless resilience of spirit that characterizes human cultures," write Don Adams and Arlene Goldbard. "How we live depends to an astonishing degree on the narratives we create to contextualize and interpret raw experience. People make art even under the most extreme conditions of deprivation and oppression: in refugee camps, prison wards, homeless shelters. Even without material resources, with only their bodies as tools, humans demonstrate wonder, agency, strength and creative power, giving meaning to the past and present, reimagining the future. An essential task now is to mobilize those damaged by globalization—a category that encompasses the entire world—to realize and act on the causes of our suffering. Capital and influence are needed to turn the promise of community cultural development work to this task."[26]

✧ ✧ ✧

How could this vision of local community empowerment be linked to global cultural resources in a movement expansive enough to contain both extremes? Globalization feels like the antithesis of local culture, yet it offers the tools that may yet be local communities' salvation. If communities and cultures throughout the world need each other to survive, what kind of institutions can support their aspirations and provide the structures necessary to their advancement? How can local cultures plunge into the global marketplace and still maintain their own unique sense of themselves?

During the past ten or twelve years there has been much discussion among arts professionals in the United States about international exchange. Due to minuscule or nonexistent funds for public culture at home, much less abroad, America continues to be represented in the global marketplace by *Hollywood Squares* and its equivalents. Especially given the agitated political situation in much of the world, agreement exists among many nonprofit leaders that this should be changed, and the arts infrastructure is now challenged to respond. Several major foundations (Ford in 1994 and 1999, Pew in 1995, Arts International in 1998, Rockefeller in 2001, Duke in 2002) have commissioned studies or sponsored conferences of leaders to discuss how to expand the nonprofit sector's participation in global culture.[27] While these gatherings and studies addressed a wide range of approaches to international work, there are several clear and unanimous conclusions that emerge from their proceedings.

America (and the world) lacks an ongoing international infrastructure to support multilateral artist exchanges, project development, and touring. Ford noted the need to "[n]urture the continued development of networks that focus on international exchange" and "[f]urther explore methods to cultivate the infrastructures and collaborative capacities of countries selected for exchange."[28] The Rockefeller report recommended that "funders committed to international work should examine structural issues involved in international public/private partnerships and work to develop international mechanisms for strategically linking compatible interests. . . . In essence, what is lacking is a consistent mechanism for revealing international cross-sectoral interest that can be translated into more sustainable commissioning and touring strategies."[29] A new kind of infrastructure is clearly required if international collaboration is to be addressed by America's public culture sector.

One would think that programs developed by cultural organizations

might be sensitive to the nuance of cross-cultural and multicultural encounters. But past efforts to prime the international pump have stumbled precisely because of the exclusively American structures imposed on them by funders. If it is to work ethically in a global environment, this new infrastructure must be infused at every level with a transparent sense of reciprocity and equity, building long-term relationships that can have a chance for success. Arts International's Leadership Forum proceedings repeatedly stress that "relationships with international colleagues must be entered into with sensitivity to issues of reciprocal give and take; standard import/export models have limited applicability in the arena of international presenting. . . . [G]iven the scope and expense of many international projects, collaboration is essential, from the earliest stages of research and development, to commissioning, touring, marketing and education."[30] Ford's report *International Collaboration in the Arts* draws from a wealth of recent experience in stating, "The pursuit of intercultural collaborative practice necessitates constant attention to equity issues," and "International collaboration built upon sustained, long term relationships between artists are most likely to result in successful intercultural work."[31] But Ford's program funded only U.S.-based collaborative projects. It was all about bringing foreign artists to American audiences, with no reciprocity or connections made to the rest of the world.

What is needed now is a systematic approach to developing local cultures through multiple and ongoing multilateral collaborations. We need initiatives that are global in scope while remaining devoted to the locally specific cultural knowledge that informs traditional heritage. They should link artists and communities through a collaborative system based in the pervasive needs of communities for artistic access, public celebration, cultural cross-pollination, and long-term commitment. A model program would broadly encompass world culture areas and draw on the best local and regional expertise in traditional artistry. It could provide long-term engagements for artists, repeatedly and in different parts of the world, with a constant emphasis on collaboration, and allow the essential training of administrators through staff exchange programs as well. It should consistently take full advantage of each country's unique pool of resources. In addition to the highest level of artistry, these include local, national or regional funding opportunities, arts facilities, artist housing, technological access, media capabilities, and links to touring networks.

We need to nurture institutions that remain respectful of local practice while building capacity for undergoing the process of international col-

laboration, a process that requires a pool of mutual accommodation on everyone's part. All programs must reflect an explicit equity among participants, recognition of the multiple values adhering to cultural practice, and a balance to the financial advantages enjoyed by organizations in the developed countries. An ideal institution could function entrepreneurially on a supranational level, using each country's capacities to function within its own cultural ecology while maintaining a global perspective in utilizing and allocating resources.

I am proposing the development of collaboratives that could function as entities beyond the restrictions of any nationality—multinational nonprofit cultural organizations. Responsibility for decision making within these new institutions would be shared equally among the participants. Like any corporation with multiple sales outlets, each of the international branches would maintain its own organization, programming, and finances in keeping with local practice. Artistic leadership at each branch would include skilled specialists in the traditional cultures of their region, promoting the ability to act creatively on a local basis while serving as a hub for project development and touring. The branches could become major feeder mechanisms for cultural product everywhere, responding to specific needs from around the world. For instance, if the Venezuelan branch needed a program addressing the heritage of its African community, it might call upon the Dakar or Cape Town site to provide the most appropriate artistic response. Artists could take advantage of the unique physical and cultural access offered at each branch, moving to other sites according to the demands of the work. Each continent, then, would take advantage of the best, most thoughtfully conceived programs from across the globe.

In practice, this working group must be far more than a network that collaborates on touring a handful of programming ideas and occasionally co-commissions something; it should function as a single organization working in multiple localities (with touring extensions from each one) worldwide. McDonald's took over the world by offering the same, standardized meal at a thousand restaurants. This is its conceptual opposite: organizations that can offer not sameness but the breathtaking diversity of human cultural heritage all over the planet, every day.

I discussed this vision recently with the director of a large foundation, who suggested that it was a great idea but would never work. "The availability of financial resources is so uneven," she said. "The United States and Europe might have funding for these kinds of things, but most of the developing world does not. No American foundation is going to fund

programs that are taking place halfway around the world." This position is shortsighted and ultimately self-defeating for three reasons: global interconnectivity, a fresh approach to asset valuation, and hardheaded economics.

It is in the direct self-interest of governments, nongovernmental organizations, foundations, and corporations worldwide to support and sustain cultural heritage, because culture is the water in which the global economy must swim. "Recognizing that community cultural development practitioners are in many cases part of an advance guard against the destructive impacts of globalization," say Adams and Goldbard, "financial support for international and transnational opportunities for practitioners to exchange and learn is crucial."[32] Here in Maine, one cannot act to support local traditions without engaging the renaissance of Québécois culture to our north, the worldwide Celtic music movement, or current developments at the University of Fine Arts in Cambodia. In a very real sense, technology and the unprecedented mobility of millions of people have brought world cultures into such immediate proximity that they have become mutually interdependent. Sustaining heritage in Portland *depends on* what takes place in Phnom Penh. We need each other. "For those of us whose communities and cultures are at risk of being overwhelmed by the rising tide of products and images pouring out of the global commercial culture," says Mexican artist Martha Ramirez Oropeza, "it is of the utmost necessity that we pool our efforts to preserve our autonomous identities. Of course, this is not a battle we will win in our own lifetimes, but one that our children and theirs will have to continue."[33]

The conglomerates that market international mass culture promote the leveling of those autonomous identities; their business plans constantly seek the least common denominators of consumption on a global basis, thus accelerating the cultural debasement that Alan Lomax predicted. The nonprofit sector offers the only countervailing force, but its inability to act internationally allows the stereotype and distortion of pop entertainment to go unchallenged. "The distinction between the not-for-profit and commercial arts sectors is important because, devoid of its competition, the impact of U.S. commercial culture has become overwhelming," writes Roadside Theater director Dudley Cocke. " . . . [W]e should not be surprised that much of the world's view of America is confined to what is conveyed to them by Hollywood movies, commercial television and popular music—a mix of images, stories and themes that would give anyone reason to question our societal values."[34] The political consequences of continuing down this path should be obvious.

Generating the resources for a global approach to local cultural development offers a different path. And building a sense of equity across national and cultural boundaries is the first prerequisite for the development of a functional global culture network. But if most of the money supporting it can only come from a few industrialized countries, how is such balance possible? To surmount this hurdle, we need to look beyond a narrow financial definition of *value*. There must be an explicit recognition of the multiple kinds of contributions that are brought to the table by every culture throughout the world. The substance of this work involves the transfer, across national borders, of artistic practice, deep culturally specific knowledge, and time-tested strategies for survival.

Tradition bearers in the developing world surely can use American dollars, but in the marketplace of cultural practice, they too possess great wealth. The artistic heritage of nations that now find themselves on the developing side of the economic equation has endured multiple invasions, colonial occupations, beneficent and repressive political leadership—the full range of ideological and aesthetic challenges. That their artistic legacies have persisted, sometimes over millennia, points to an amazing strength and resilience. Relying on this depth of field, they have fostered strategies for survival that the West, with its nanosecond attention span, desperately requires. The West's thirst for deep wells of tradition is precisely the need that is reflected in the popularity of "world music" in the industrialized countries today. An exchange that the developing world can offer in abundance is access to the real item: heritage-based artistry as it lives within its own community, the antidote to its portrayal through the commercial sector. These are values that cannot be quantified by an accountant but must be explicitly recognized for equitable cultural exchange to take place. Art and dollars are indeed apples and oranges, but they can be deployed to balance each other.

International engagement makes common sense on a strictly financial level as well. Multinational corporations succeed by allocating their resources globally, seeking out the least costly raw materials and manufacturing, and selling products in multiple markets to take advantage of local opportunities. A functioning global heritage partnership will be in a position to do the same. Substantial disparities in economic conditions exist between the United States and India, Egypt, or China. Like any other global business, the partners could dramatically expand on the value of investment dollars by turning these differences to practical utility. Equity is good business.

The end goal of this new, widespread initiative is to use the tools offered

by the global economy and understandings generated through culture as a means of supporting local communities. It aims to enhance and cele-brate the lives of people in the villages and barrios that are overlooked by the consumption engines of the commercial sector. Just as the arts have become the favored vehicle for downtown revitalization efforts in the United States, culture offers a tool that communities can learn to employ on their own behalf. This process is already underway in many places. According to Kevin Healy, during the past fifty years, indigenous cultures in Bolivia "underwent a dramatic reversal from being cast by development planners as an 'obstacle' to development to being eventually embraced as an 'asset' or 'resource.'" During the 1950s and 1960s, Western-centric policies and neocolonial programs of cultural assimilation in government agencies and influential foreign aid programs, gradually gave way to "indigenous movements and NGOs that began changing the meaning of development by forcing the country to embrace its impressive cultural heritage. . . . The barriers of institutional discrimination began to come down, and organizations from civil society recovered and revitalized in-digenous resources such as native foods, crops, livestock, trees, pastures, medicinal plants, languages, art, organizational and land tenure forms in their community-based projects and programs."[35]

This all stems from the assertion of local, indigenous cultures. If Fried-man is right that we "stabilize globalization by democratizing globaliza-tion—by making it work for more and more people all the time,"[36] then we must see a dramatic increase in the amount and varieties of financial support that flows to such local community initiatives. Venturelli insists that "the financing of creative enterprises may need to move from mech-anisms available only to the few (e.g., bank loans, venture capital invest-ments, IPOs) to mechanisms available to the many (e.g., micro credits and loans), encouraging a wide variety of entrepreneurs from which a few winners will emerge."[37]

In other words, the practice of cultural democracy demands an equal expansion of economic democracy. The opening of free markets in goods, labor, and currencies, without a commensurate globalization of the dem-ocratic, civic institutions that can provide a just context for implementa-tion, will be dysfunctional and destabilizing. Bringing equity and demo-cratic accountability to the global economy is perhaps the only way to sustain globalization, and that implies a shift in focus from the big pic-ture of the NASDAQ or Nikkei averages to the microenvironment of each community. There are enormous untapped reserves of cultural capital hidden away in American neighborhoods—and those of our relatives

globally. The financial investment required to bring these resources onto the public stage are modest. The knowledge that is stored in that reservoir of community memory opens a vital economic door. "The revolution in communications technology and media has given American culture a worldwide reach that often overleaps restrictive policies some governments have used to build walls against it," states the report *America's Cultural Capital.* "In many respects, culture has become our most convertible currency. It enables us to reach beyond officialdom to a citizenry increasingly well educated and politically active, especially in parts of the world where authoritarian and totalitarian governments have fallen or are tottering. Indeed, American culture can reach into regions where American military might is seen as threatening, where American commercial activity and investment are regarded with ambivalence, and where American political aims are viewed with suspicion."[38]

Perhaps the American political bureaucracy remains sluggish in the realm of global culture precisely *because* of the fact that art can out-travel tanks or banks. Loans and arms maintain state control far more effectively than poetry. It's difficult to accept that a rock musician may be a more effective actor on the international scene than a general. But the shrinking globe is generating a reversal of hierarchies. The singer of ethnic-inflected rock music now really carries clout. We'd better devise some strategies for influencing *that* trend, or we'll be the ones feeling left behind by globalization.

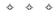

"It is easier to register the loss of traditional orders of difference than to perceive the emergence of new ones," writes James Clifford.[39] Fears that are generated by globalization grow from its obvious ravages of tradition in the race for the next new thing. The finite resources of cultural heritage are endangered, and require a range of strategic ameliorations. But globalization is also driving another edge of culture—the imperative of innovation. "Cultural diversity on a global scale has real economic and non-economic advantages," notes Feigenbaum. "It can encourage innovation. New ideas abroad can stimulate new ideas here."[40] The syntheses that arise as traditions encounter other cultures are resulting in the evolution of new cultural identities, recombinant, creole cultures that fairly explode with vitality.

"More than ever," writes Ulf Hannerz, "there is a global ecumene. The entities we routinely call cultures are becoming more like subcultures within this wider entity, with all that this suggests in terms of fuzzy bound-

aries and more or less arbitrary delimitation of analytical units."[41] Indeed, the borders between cultures become ever more porous as interactions expand, generating new idioms that defy classification and continuously adapt to accommodate the latest innovation. "Creole forms are never static," write Robert Baron and Ana Cara. "They are at no time fully formed; their protean nature continuously adjusts to their immediate interactive context, often improvising as they adjust. Creolization can thus liberate us conceptually from a notion of fixed or 'finished' products in culture to a focus on cultures in transition, allowing us to grasp the 'in-betweens,' the ambiguous spaces where cultural boundaries blur and disappear as hierarchical categories collapse into each other."[42]

New forms arise from physical crossings of international frontiers, but also less tangible but no less affective encounters with a diversity of cultures via the mass media and telecommunications systems, public transportation, grocery shopping, and participation in the political process. Passing over the Rio Grande is not necessary.

Many of these creole cultures are increasingly untethered. They do not exist in a place but rather in transit or in the ether. "These new forms of global culture are tied to the industrial and postindustrial world and are made possible by telecommunications technologies," says Richard Kurin. "They are themselves diverse. There is not a single global culture or 'new world order.' Rather, there are various global—i.e., nonlocalized and transnational—cultures, with their own languages, codes, and worldviews."[43] Central African *soukous* music, itself a syncretic union of Cuban rumba, Congolese percussive polyrthythms, and modern electronic instrumentation, evolved in the bars of Kinshasa. But for a generation most of its leading performers have made their homes in Paris, where they influence—and are influenced by—the full range of cosmopolitan cultural energy. What was once a local genre is now an international phenomenon, with audiences and a cadre of knowledgeable fans on every continent. A part of the reason that *soukous* dominates contemporary African pop is its fully transnational flavor.

And we now have various creole, border, and transnational cultures interacting with other cultural orphans. Homi Bhabha writes, "The borderline engagements of cultural difference may as often be consensual as conflictual; they may confound our definitions of tradition and modernity; realign the customary boundaries between the private and the public, high and low; and challenge normative expectations of development and progress."[44]

The creation within England's expatriate Pakistani community of *bhangra,* an amalgam of industrial-style *house* music and Indian *filmi* vocals is a case in point. This is art created by individuals able to move fluidly among multiple cultures. "Among today's post-ethnic youth, cultural diversity is casually presumed as a normal aspect of daily life, and in the highly fluid youth marketplace, cultural identities are adopted, exchanged and shed as simply and efficiently as if they were eBay transactions," report Joel Kotkin and Thomas Tseng. "The emerging post-ethnic sensibilities challenge many fondly held assumptions of the political class, the media and, perhaps most of all, certain academic elites, as they contradict the notion that American ethnic and racial divisions are rarely transcended or, conversely, that assimilation—the old idea of the melting pot—turns ethnic populations into proto-Episcopalians who eat white bread with cheese spread."[45]

This is living, global culture. As such, it points the direction that the rest of us are likely to follow. As Ted Levin says, every community needs to be given the same tools. To level the playing field, let's devise the strategies we need to get every community into the discussion. This is the only ethical response to the challenges that globalization offers, and the great opportunity of our time. "We have to expand the ability of people—regular people, common people, people at the grassroots—to create, debate, and manipulate their culture, and to share it with others," says Kurin. The alternative, as we see all too often on the daily news, is frightening. "When culture is not created, it dies. When people cannot share, they fight. And when the cultural dialogue stops, it is replaced with violence, death and destruction."[46]

Revolution

Ann Carlson, the visionary performer-choreographer-director, was asked to describe the purpose of her art on a fellowship application. She responded with a single word: "Revolution." The challenges addressed in this book can only be met through the combined ripples from a seismic shift in everyday personal activity. Realizing cultural democracy means instigating a revolution in ethical social conduct. It is a revolution that has to permeate every level of our communities, government, the educational system, and the business establishment; but it is a revolution that cannot be imposed from above. It must come from individual citizens taking control of their own cultures in every community.

What does it really mean to make cultural freedom accessible to all, on an equitable basis? Our work is situated in a world where the haves—Americans and Europeans—spend more on pet food than the estimated

Performance artist Ann Carlson, videographer Mary Ellen Strom, and a group of Sudanese teenagers accepting applause for their collective creation. Photo by Rosemary Siciliano.

total needed to provide basic health care and nutrition for everyone in the world.[1] The disparity of means is so great, and the historical forces that created this tragedy are so persistent, that any solutions seem more like Faustian bargains than practical strategies. Those of us who work in the cultural field are accustomed to subsisting on crumbs from the American corporate smorgasbord. But now the table is being upended, and culture offers one of the few alternative supports. We could demand much larger crumbs. Rather than propping up the old banquet—which didn't have the foods that most of us like to eat anyhow—can we use this opportunity to construct a new table?

During the civil rights movement of the 1960s, America passed through a remarkable moral awakening. Dr. Martin Luther King Jr. was explicit in his demands for an ethical soul-searching on the part of white Americans. "In the final analysis," King insisted, "the white man cannot ignore the Negro's problem, because he is a part of the Negro and the Negro is a part of him. The Negro's agony diminishes the white man, and the Negro's salvation enlarges the white man. What is needed today on the part of white America is a committed altruism which recognizes this truth. . . . "I doubt if the problems of our teeming ghettos will have a great chance to be solved until the white majority, through genuine empathy, comes to feel the ache and anguish of the Negro's daily life."[2]

Certainly, the social revolution that King imagined still remains only partially fulfilled, but just as surely, its accomplishments are manifest in most Americans' experience of life and citizenship today. The success of the movement in changing American values resulted from the compelling message of moral persuasion that King and his followers were able to deliver. Through their actions, white people were forced to examine the political and social realities of their time and acknowledge the moral legitimacy of the demonstrators' cause. In their many millions, white Americans came to accept that their own comfort and status were, at least partially, gained through unfair advantage over a whole race of people. We were dramatically shown that if we were *up,* it was at the grisly expense of someone else's *down.* The civil rights movement revealed the mechanisms of segregation's zero-sum game, and its triumph lay in the widespread recognition on the part of white Americans that legal restrictions on blacks' citizenship were simply wrong. As members of the polity that instituted those restrictions, and of the group that benefited from their continuance, whites found themselves implicated in a moral affront: they shared in the responsibility for what happened to people of color in this country. Acceptance of that moral responsibility, and the determination

to effect the legal and social changes needed to rectify the injustice, led to sweeping changes in America's attitudes about race.

This happened because a majority of white people woke up to the fact that they were on the wrong side of an ethical line. We discovered that the privileges our parents took for granted were actually illegitimate, and we put our political will to the task of obliterating our own legal monopoly on those privileges. It took historic acts of courage on the part of many blacks and whites to shake America out of its complacency and complicity; and it was a historic act of courage for the white political leadership (particularly Lyndon Johnson) to recognize the moral righteousness of the cause and act on it. The movement succeeded in making a moral claim on the consciousness of the dominant majority and insisting on changes that would have felt unthinkable without their clear justification.

The civil rights movement ran its course without completing its most significant work. Toward the end of his life, King turned his attention to the far more daunting challenges of wealth and poverty that stand in the way of the realization of true democracy. The practice of democracy, he preached, means more than the elimination of barriers to full participation. It means the active inclusion of every viewpoint in the collaborative construction of a just commonweal. "Gargantuan industry and government, woven into an intricate computerized mechanism, leave the person outside," he worried. "The sense of participation is lost, the feeling that ordinary individuals influence important decisions vanishes, and man becomes separated and diminished. When an individual is no longer a true participant, when he no longer feels a sense of responsibility to his society, the content of democracy is emptied."[3]

The necessity of universal participation to a functioning democracy was not acknowledged by our founding fathers, who crafted a constitution that enshrines grossly antidemocratic institutions. They didn't want participatory democracy and created a government explicitly structured to limit the influence of the people. As a result, a voter in rural, conservative Wyoming today wields sixty-eight times more political clout in U.S. Senate races than one in California.[4] Presidential elections are overturned by the Electoral College, an institution created expressly to *avoid* the results of popular democracy. Despite two centuries of political and social advancement, Congress continues to be overwhelmingly dominated by rich white men, a group that, statistically, represents less than 2 percent of the population.[5]

Dissatisfaction with these truths is a continuous thread running through our social and political history. Oliver Wendell Holmes, among the greatest

of American jurists, consistently used his rulings as vehicles for opening democratic participation to all. "Nearly every judicial opinion for which he became known constituted an intervention in that struggle," notes biographer Louis Menand, "and his fundamental concern was almost always to permit all parties the democratic means to attempt to make their interests prevail."[6] Social activist Jane Addams and educator John Dewey championed the same argument: "It is that a decision can be called democratic only if everyone has been permitted to participate in reaching it."[7] King's source of inspiration, Mahatma Gandhi, expressed identical views on the practical dictates of genuine democracy. "My notion of democracy," Gandhi pronounced, "is that the weakest should have the same opportunity as the strongest."[8] They all advanced the idea of democracy as a moral issue, and in the case of the civil rights movement, their persuasion prevailed.

Forty years after the climactic struggle, we're sleeping through a moral crisis that threatens more than a few urban centers. The pace of globalization and the rapidly expanding gulf between the privileged and the desperate present America with the same set of ethical dilemmas that were at the heart of the civil rights movement. Only this time, the stage where the drama unfolds is global, and the stakes are higher. This time, it is not just white folks but *all* Americans who stand in stark contrast to a large majority of humanity. Compared to the billions in the developing world who lack basic nutrition, shelter, and clothing, even our poor enjoy a level of access to goods and services that appears opulent. We are collectively the richest of the rich, and much of the consumption that we assume as our due is available to us only through the exploitation of those billions of Others.

We may, after years of struggle, have succeeded in at least partially opening the gates of democracy to all Americans, but our democracy, such as it is, stops at the U.S. border. What the American government and American corporations choose to do has dramatic importance for everyone on the planet. In many cases, decisions made in Washington or New York have a more immediate effect on conditions in developing countries than the deliberations of their own governments. But of course, voters in Indonesia, Zimbabwe, or Venezuela don't have the opportunity to cast their ballots in American elections or have a voice in determining corporate relocations. The rest of the world is suffering from a new form of taxation without representation, and we Americans, all of us, are playing the role of King George III, the tyrant.

My children come home from school with their homework about the

American Revolution. They are inculcated with the injustices that justified our revolt: the British king and parliament treated the colonies unfairly, and as a result, our independence was morally sanctioned. The message gets reiterated at every turn. Today, we need powerful voices—the voices of Thomas Jefferson, Mahatma Gandhi, and Martin Luther King—to teach us about our own complicity in the global moral failure of our time. We are the beneficiaries of enormous advantages that we did not create and that are possible only through the continued suffering of more people than we can fully imagine. America needs to be shown—again and again— the results of its consumptive habits: the enforced poverty that surrounds every third world city, the accelerating destruction of forests and oceans, the enslavement of children in sweatshops, the armies of civilian farmers maimed by land mines. And we need voices with moral stature to connect the dots for us, to show the straight lines between our cheap sneakers, patio furniture, and bloated armament industry—and the half of our planet that bears those burdens. We need a moral awakening like the one we experienced forty years ago. We need to realize and acknowledge that, vis-à-vis the rest of the world, we're standing on the wrong side of an ethical line. We need some new heroes who will not be afraid to tell us that it's *wrong* for one or two people to waste food when ten or twelve hungry people (some of whom helped produce that food) are living next door. We need a revolution in America's self-consciousness and world consciousness. We need a revolution.

Cultural democracy holds the promise to be a potent force in shaping the direction of this emergent global realignment.

✧ ✧ ✧

The world is poised at the edge of a historic redefinition of power and how it is applied among peoples. Observers from all sides of the ideological spectrum agree that political, economic, technological, social, scientific, religious, and cultural trends are increasingly volatile, often evolving in unforeseen directions. Assumptions that seemed unassailable yesterday are invalidated by today's headlines. It seems that we are rapidly heading, as Buckminster Fuller was fond of saying, toward "utopia or oblivion."[9]

The nation-state, which has dominated world political structures for five hundred years, is in rapid decline, superseded by new global corporate systems. "A new form of the State—the market-state—is emerging," writes Philip Bobbitt.[10] The uneven and inequitable nature of this globalization of economic power will largely define international relations, military

adventures, and the success or failure of market economics to answer the needs of the planet in the next century. "If globalization is ruled merely by the laws of the market applied to suit the powerful," laments Pope John Paul II, "the consequences cannot but be negative."[11] All of this is being driven forward at an accelerating pace by the further development and proliferation of computers and communications technology, "enabling," writes Thomas Friedman, "more and more people, with more and more home computers, modems, cellular phones, cable systems and Internet connections, to reach farther and farther, into more and more countries, faster and faster, deeper and deeper, cheaper and cheaper than ever before in history."[12] The same communications revolution that undermines old geopolitical structures also offers powerful and instantly accessible tools to jungle-based insurgencies, religious fundamentalists, neo-nationalists, and terrorists seeking weapons of mass destruction. All of these strive to destabilize current systems and institute rapid social change. "Terrorism historically is the weapon of the weak," wrote Samuel Huntington in 1996. "In the past, terrorists could do only limited violence, killing a few people here or destroying a facility there. . . . At some point, however, a few terrorists will be able to produce massive violence and massive destruction."[13] Clearly, this grim prediction has now come to pass.

Meanwhile, America's social landscape is being irrevocably altered by the confluence of long-term demographic, economic, and social trends. The rapid growth of minority populations is reflected in a workforce that is diverse as never before. The demands of our postindustrial economy have given rise to a new class of creative workers who will dominate the marketplace's future. The tastes and expectations of the Creative Class are already challenging long-held values and assumptions regarding every aspect of social intercourse, including attitudes about voting and civic participation, the nature of consumption, how we spend our leisure time, and the longing for genuine experience—the "state of contemplation, vigorous and expansive, of the highest force conceivable," that Bart Giamatti describes as the ultimate promise of the arts, sports, and religion.[14] The marketplace hasn't turned out to be a particularly effective vehicle for generating such epiphanies. Erstwhile distinctions between highbrow and lowbrow, art and marketing, have been obliterated for America's first "post-ethnic" generation. John Seabrook, in his book *Nob®ow*, writes, "In a world of relative values, the popular hit had a kind of currency that ideals about quality lacked. You could argue about what was 'good' (whose good?), but you couldn't argue with Soundscan and Amazon.com."[15] Everything bumps against everything else, without

distinction. Thus, the least-common-denominator experience in shopping that is typified by the success of Target stores also features the exquisite utilitarian product design of Michael Graves and fashions by Isaac Mizrahi—goods that even a few years ago would have been exclusively available at high-end boutiques.

Amid the frenzy of consumption, there is a powerful countercurrent of spiritual revival. Charismatic religions—basing their message in the direct and personal experience of each believer, rather than in the authority of received dogma—are by far the fastest growing segments of the religious world. The shallow nature of consumer culture is surely an important component of this growth. But religion commentator Phyllis Tickle suggests that the very products of modern consumption are also contributors to the spiritual revival. We worry that our children's life experience is dominated by the images they receive through the screens of their televisions and computers. Far from dulling their senses, Tickle argues, the computer has given us an entire generation accustomed to the presence and power of a "virtual world." As such, she sees our children as potential "spiritual travelers" who possess a unique capacity for apprehending and making use of alternative realities.[16] Technology has given our kids the intuitive ability to steer their own experience toward a different, and perhaps spiritually aware, future.

Nobel Prize–winning economist Robert William Fogel proposes that we are now in the midst of the "Fourth Great Awakening," a major religious revival that drives a political agenda, shaping government policies and social norms for many decades. "Historians of religion refer to such periods of religious revival as *Great Awakenings*," writes Fogel. "They generally recognize that the United States has experienced three Great Awakenings."[17] The awakenings are all brought on by religion's need to reconcile prominent moral quandaries. The First Great Awakening started about 1730 and eventually led to the mobilization of forces powerful enough to resist and then overthrow British rule during the American Revolution. When Cornwallis surrendered at Yorktown, he recognized the momentous restructuring of the global order by instructing his pipers to play "The World Turned Upside Down." The Second Great Awakening, beginning around 1800, galvanized the struggle to abolish slavery and resulted in the Civil War. The Third Great Awakening addressed the inequities of the industrial age of the late nineteenth and early twentieth centuries. It resulted in votes for women and the creation of the welfare state under Franklin Roosevelt—as well as America's experiment with Prohibition—

all innovations backed by the political muscle of a religiously motivated segment of the population.

The spark that ignites these broad movements, according to Fogel, is the introduction of new technologies. "While economic growth since 1700 has been relatively steady and technological change has accelerated," he writes, "there has been a recurring lag between the vast technological transformations and the human adjustments to those transformations. It is this lag that has provoked the crises that periodically usher in profound reconsiderations of ethical values, that produce new agendas for ethical and social reform, and that give rise to political movements that champion the new agendas."[18] We are now in the midst of a fourth such transformation, a response to postmodern consumer technology and its apparent lack of spiritual content. "Spiritual (or immaterial) inequity is now as great a problem as material inequity," he writes, "perhaps even greater." The solutions that are promised by this Fourth Great Awakening are predicated on answering the continuing dilemmas of equitable resource allocation but are fundamentally distinct from the kinds of economic strategies that Lincoln or Roosevelt championed. "[W]hatever their virtues in elucidating past issues, the economist's traditional measures of income inequality are now inadequate. . . . Such measures shed little light on the most intractable forms of poverty (those related to the unequal distribution of spiritual resources). Nor do they bear on the capacity of individuals to overcome the social estrangement that undermines their quality of life."[19] Rather, the demands of the Fourth Awakening are for enriched access to genuine experience, as reflected in each individual's immersion in a community sharing common values.

The evolution of the Fourth Great Awakening, which began in the 1960s and includes aspects of the civil rights movement as well as the rise of the religious right (which borrowed many tactics from the civil rights crusades), is based in the need of individuals to find connections that are not addressed by strictly economic considerations. It coincides with the enormous growth of the Creative Class, a group that also largely rejects prefabricated consumerism in favor of a quest for meaningful and unmediated experience. As these trends build, the relative importance of social capital to the successful functioning of community is enormously enhanced.

The collective direction of the long arcs of these geopolitical, economic, religious, and social trends is bringing us to an historic choice point, one of those hinges upon which turns a measure of human civilization.

Bobbitt writes: "[W]e are at one of a half dozen turning points that have fundamentally changed the way societies are organized for governance."[20] Malcolm Gladwell suggests that, like epidemic diseases, social phenomena can arrive at a Tipping Point, "the moment of critical mass, the threshold, the boiling point," when the exertion of even small actions properly directed can result in major shifts in human behavior.[21] "Look at the world around you," he writes. "It may seem like an immovable, implacable place. It is not. With the slightest push—in just the right place—it can be tipped."[22] The forces of cultural democracy that today seem scattered and irrelevant to broad global developments hold a key that, if turned along the fault lines of governmental, financial, educational, and social fronts, can become the levers that "tip" tomorrow's public policy and introduce an alternative system of values.

Bill Ivey, former chair of the NEA, draws together an array of disparate, but interconnected, indicators—the global reach of technology, the blurring or elimination of elite hierarchies in popular consumption, the focus on value-laden experience and community activism exemplified by Fogel's vision of the Fourth Great Awakening, the natural role of artists as the kind of change catalysts described by Gladwell—in an analysis of where culture fits in America's future. "Each of these observers—and these phenomena," he told the National Press Club, "hint at a cultural process that is more fluid than at any time in the past half-century. To be specific, each suggests an era of art, art making, and cultural heritage less burdened by associations of social class. Further, each points toward opportunities for a new, more aggressive engagement between culture and democracy."[23]

Building that connection, I have argued here, brings together an ethical urgency based in the human values shared by most of the world's population, with our pragmatic self-interest in prosperity and security. Twentieth-century conventions and institutions are inadequate to the task at hand; indeed, government and industry seem oblivious to the nature of the task. This has substantial security implications, as we learned on September 11. Our drive to bring consumerism and liberal democracy to the world has unintended side effects. "Suffering too has been democratized," writes Benjamin Barber, "and those most likely to experience it will find a way to compel those most remote from it to share the pain. If there cannot be equity of justice, there will be equity of injustice; if all cannot partake of plenty, impoverishment—both material and spiritual—will be the common lot. That is the hard lesson of interdependence, taught by terror's unsmiling pedagogues."[24] Our safety does not grow out of the

barrel of a gun. The principles of cultural democracy offer a kind of security that is outside the vision of war planners, but has the long-term potential to be a more effective deterrent.

The practice of cultural democracy has immediate and unprecedented economic ramifications too. "Unless we design *new* forms of civic involvement appropriate to our times," warns Richard Florida, "we will be left with a substantial void in our society and politics that will ultimately limit our ability to achieve the economic growth and rising living standards we desire."[25] Ignoring the requirements of the creative economy is a ticket to tomorrow's rust belt. "What is required instead is a shared vision that can motivate the specific actions we choose to take. This vision must reflect the very principles of the Creative Age: that creativity is the fundamental source of economic growth, and that it is an essential part of everyone's humanity that needs to be cultivated. Such a shared vision can provide a guiding path for any new groups that form and also imbue new direction in our existing institutions and governing bodies."[26]

This shared vision implies a new way of assessing the value of human and intangible assets that communities hold. The principles of financial accounting can only discount the very qualities that hold the most value as we look towards the future. Dee Davis, an activist on behalf of small communities in rural Appalachia, suggests that we all need a hardnosed examination of what it is that we really have:

> In "The Mystery of Capital," a book subtitled "Why Capitalism Triumphs in the West and Fails Everywhere Else," Hernando de Soto points out that throughout the Western world: "[E]very parcel of land, every building, every piece of equipment, or store of inventories is represented in a property document that is the visible sign of a vast hidden process that connects all these assets to the rest of the economy. Thanks to this representational process, assets can lead an invisible, parallel life alongside their material existence." De Soto goes on to explain that the rest of the world, the vast majority, also have homes, crops and businesses, but without clear title or deeds or articles of incorporation, they lack the essential representations needed for capital formation. For them capitalism fails. He argues that without a way to make the invisible visible, that is without a system for converting intangible assets to real value, the non-Western world cannot succeed as practitioners in a global market economy. Perhaps it is possible to follow this line of thought to make the case that local cultural assets are also intangible but real, that they have estimable value; but like unchartered businesses, they lack the essential representations to make their value manifest. . . .
>
> Perhaps the question then becomes not so much how to calculate the

value of local culture, charter it or weigh it, but more pertinently what is
the cost of losing it? In the same way an insurance company indemnifies
a homeowner for what it costs to rebuild a house lost in a fire, the next
step for all citizens is to imagine literally and figuratively what it would
cost to rebuild local culture lost because of inattention, poor policy, out-
migration or land degradation.[27]

Putting cultural democracy into practice protects against having to tally
the costs only after your heritage has been lost. Although it can and should
influence broad societal changes, it is implemented on a local level,
unique to every community. "Strong communities, not any institutions
within them, are the key to social cohesion," insists Florida. "As group
attachments break down, the community itself must be the social matrix
that holds us together."[28] David White suggests that cultural initiatives
can be the binding force: "But this idea that it doesn't just 'take a village,'"
he says. "You have to *create* a village. I mean in the sense that you have
to re-communitize communities, and have to exercise the practice of com-
munities."[29] This action takes myriad forms. It can mean engaging White's
contemporary choreographers to energize a group of street kids. It can
mean local school boards demanding that their students have access to
a rich arts curriculum instead of extracurricular sports. It can mean leg-
islators taking back the people's power to allocate financial resources for
the whole community's good—rather than continuing to cede decision-
making power to the wealthy. It can mean foundations voluntarily turn-
ing over assets to use by communities for projects of their own devising
or governments recognizing that a strong and sustained commitment to
traditional heritage is fundamental to a living national culture. It can
mean using local tourist culture as an economic tool to benefit its creators,
rather than corporate conglomerates, or building national security by
making aggressive cultural exchange programs a top priority. Cultural
democracy isn't a stand-alone commodity that can be tried out without
affecting the rest of the social agenda. A change in one sector implies
changes elsewhere. Cultural democracy touches everything: it *is* the so-
cial agenda.

It is an agenda that is being quietly explored by artists and communi-
ty activists all over the country. Some are supported by a variety of insti-
tutions—religious organizations, social clubs, a portion of the nonprofit
arts community, occasional progressive governmental divisions—but
many are solo practitioners, people who do it because they are passion-
ate about culture and community. Historically, these artists and collectives
have survived on the margins. But their turf is precisely where the twen-

ty-first century will define itself. A recent report of the informal arts in Chicago (wonderfully subtitled *Finding Cohesion, Capacity, and Other Cultural Benefits in Unexpected Places*) stressed that community-based cultural activity "helps to build individual and community assets, by fostering social inclinations and skills critical to civic renewal. These include greater tolerance of difference, trust, and consensus building, collaborative work habits, use of innovation and creativity to solve problems, the capacity to imagine change and the willingness to work for it."[30] This is local action with far-reaching implications.

Indeed the pressures of globalization dramatically heighten the importance of culture as a major player in the international economy. Whether, and how, the world is to be "developed" will turn as much on culture as on economics. "All forms of development, including human development, ultimately are determined by cultural factors," writes Javier Pérez de Cuéllar. "Indeed, from this point of view it is meaningless to talk of the 'relation between culture and development' as if they were two separate concepts, since development and economy are part of, or an aspect of, a people's culture. Culture then is not a means to material progress: it is the end and aim of 'development' seen as the flourishing of human existence in all its forms and as a whole."[31] Cultural democracy offers a new, up to the minute, and continually revised vision that addresses these multiple issues. It is a way out, and a way in.

What does your community need to keep its culture vital? Our work in grassroots cultural development and the growing body of literature in the field repeatedly demonstrate the importance of four interlocking conditions for cultural sustainability. These postulates are based in plain common sense, but it is remarkable how seldom they are addressed by public institutions that portray themselves as supporters of culture. Taken individually, all are meaningful and worthwhile. But none offers the full spectrum of activity that vibrant communities demand. Taken collectively, these four imperatives form a synergistic whole vastly greater than the sum of its parts.

✧ First, every community needs routine and predictable access to masters of its traditional heritage to help it absorb and refine cultural practice. In larger communities, these culture bearers may be local and easily accessible. In many smaller cities and most rural areas, artists must be imported, often from other countries. If it is to have local significance,

interaction between artists and constituents must occur on a routine basis and be widely recognized within the community.

Step dancing, the virtuosic solo performance style that is the imprimatur of Québécois culture, nearly died out in the Franco-American communities of southern Maine. Local artists recognized this loss, and through one of the Center's programs arranged to bring championship dancer Benoit Bourque from Montreal for an extended residency.[32] Bourque is an extraordinarily charismatic performer, and he cut a large swath through the local French community, recruiting new dancers everywhere. That residency was followed by another, and then another. Soon there was a regular cadre of step dancers performing their new routines at every dance. One of them wrote an apprenticeship grant to study further with Bourque; a stream of Mainers started heading to Québec for more lessons and inspiration. Benoit Bourque has now come to Maine for over twenty residencies, most of them organized by other supporters of his work—the Center performed its catalytic function. And step dancing is no longer on the endangered species list in Maine.

Bourque successfully connected a community with the affect offered by the practice of its own culture. Artists are able to elicit such bonds and create their own frames in which meaning is felt and acquired. Another example involved a group of Jewish women who gathered in their rabbi's study for rehearsals with choral director Joshua Jacobson.[33] Jacobson, who is a scholar of Hebraic musical traditions, had selected several pieces for an upcoming performance. Among them was "Tsen Brider" (the ten brothers), a haunting lament about the loss of successive brothers to the Gestapo during the Holocaust. Finally, the last is taken away; none remain. In the midst of the rehearsal, as Jacobson was explaining how a vocal phrase echoed the eerie sound of European sirens, one of the singers, an older woman, broke down in tears. Sobbing, she said the music, the imagery that it conjured, was just too much for her to bear. The rehearsal abruptly stopped and the other singers gathered to comfort the woman, who after a time was able to explain that she was a survivor of the camps and had lost her entire family just as depicted in the song. Jacobson gently suggested that perhaps we'd practiced enough for the evening, but the woman insisted that the rehearsal continue. "The music, and its message, must be heard." And now none could sing without tears flowing from every eye. Jacobson had connected a community with its own sense of itself and its history, and the singers found rich meaning in their own participation in that process.

✧ Second, communities and artists need a prominent and public platform for demonstrating and celebrating the vitality of their heritage. This is an important internal imperative—communities need to celebrate themselves. But there is also a need, especially for minority cultures, to convincingly demonstrate the strength of their distinct identities to the local mainstream, as well as to other minorities.

On the island of Bali, in Indonesia, every village has two vital centers of communal activity: the temple and the *banjar*. A banjar is a designated place within the village—usually it's a large thatched-roof pavilion without any walls—where the community gathers to do its business. It's where the village *gamelan* rehearses every week; it's the place where the puppeteer, the *wayang,* stages his re-creations from the Ramayana; it's where people eat, dance, argue, and vote. Few American communities have a banjar to call their own, but we should start building them. Without a forum to display excellence, culture remains hidden and cannot renew itself.

In our mediated society, this is not always an easy fit. "In many parts of the world," notes dance critic Elizabeth Zimmer, "the notion of putting people called artists into a place called a theater, with structural separation between performer and audience and formal standards of decorum, is completely foreign. Even the concept of 'art' may be foreign."[34] The cultural gulf between audience and object can be enormous, and culture facilitators are challenged to arrange their presentations with an explicit recognition of the compromised nature of public display. If the balance swings too far toward the public's comfort zone, the results are misleading; the insiders' need for quality and authenticity trumps the audience's hopes for ease of understanding. Public mediators bear the responsibility of accepting communities at face value, as culture bearers, the carriers of traditions that are inextricably linked with a diversity of other traditions and, most particularly, with the mainstream society. If cultural traditions can be presented as a part of the world, rather than as an adjunct to it, then the community members can be accepted as people, as living individuals rather than exotics or constructions of an academic theorist.

Doing this means continuous engagement on several fronts, but most particularly with the communities whose cultures are being publicly represented. There is a new paradigm in cultural display, and it demands participation. "Simply put, museum curators, programmers and cultural presenters have to rely on a much firmer and sharper focus on *situated* scholarship—that is, research and analysis located in contemporary con-

texts, presented to the communities, leaders, and polities affected," writes Richard Kurin. "Gone are the days of singular, monological, acontextual studies of civilizations, countries, communities, villages and cultures. Studies that fail to situate their subjects in a contemporary world of multiple, if not contending cultural narratives and ways of communicating them are perilously misleading."[35]

✧ Third, artists and communities require continual exposure to the stimulation and cross-fertilization of encounters with other cultures, both related and distant. Without this process of refreshing themselves, local cultures stagnate and decline. Diasporic communities worldwide need ongoing exchange with the evolving cultures of their homelands. "A cultural policy whose aim is cultural democracy must be based on the expressions and manifestations within the individual subcultures and must strive to bring these subcultures into contact with each other through the media of communication," says Jørn Langsted. "Such a cultural policy places emphasis on culture that is coming into being and developing, rather than on stagnant, conservative culture."[36]

A residency with Seamus Egan, the great Irish multi-instrumentalist, happened to coincide with a week of gospel workshops by Gary Hines, director of the choir Sounds of Blackness.[37] We thought Egan might like to see what was happening in the African American program and so brought him along to one of the choir rehearsals. The choir was in its full gospel glory that night, singing at the Green Memorial AME Zion Church, and Egan was impressed. His esteem turned to consternation when Hines insisted that he treat the congregation to a tune. "That church was really not my natural performing environment," he confided afterward, "and I had no idea what to expect." Nevertheless, he assembled his flute and launched into a set of reels that were, in their own way, as inspired as the singing that preceded them. It took the combined choir about four bars before they were on their feet, clapping on the backbeat and shouting their approval exactly as they would have had he been Mahalia Jackson. As Egan left the stage to a standing ovation, Hines led the choir in a unison shout. "Seamus!" they yelled, "You go, boy!"

Such encounters leave a mark. This is information an artist can use. Six years later, Egan has emerged as among the most talented of a pool of young artists who are drawing on multiple aesthetic traditions to create new, global styles. A gospel reel no longer seems like a nonsequitur. It's a reflection of life in the restless border zones where many artists now reside. "What is theoretically innovative, and politically crucial," suggests

Homi Bhabha, "is the need to think about narratives of originary and initial subjectivities and to focus on those moments or processes that are produced in the articulation of cultural differences. These 'in between' spaces provide the terrain for elaborating strategies of selfhood—singular or communal—that initiate new signs of identity, and innovative sites of collaboration, and contestation, in the act of defining the idea of society itself."[38]

"We don't see these as dangerous times, as do the paranoid monoculturalists," says novelist Ishmael Reed. "We see these as times fraught with hope and change."[39] Creole culture, the constantly shifting paradigm of the latest encounter, embodies that change. It's a place where responsible cultural mediators belong, and it's a place with a vital social message. As Nick Spitzer states: "Louisiana and some of the other New World societies have a lot to teach Americans and the world on how people could get along. The artforms that came out of these societies, whether it's upriver to rockabilly or downriver to jazz, are among the most significant music styles that America has produced. They represent our ability to fight, feud, love, and produce new things that are fabulous, that nobody else can get."[40] We need to keep our crossing zones well lit.

❖ And finally, to be effective, community cultural support needs to be both comprehensive and secured long-term. This is true of any cultural development program but is especially pertinent to international work, which often requires years to plan and mature. Project support is inherently self-defeating. Since this is virtually the only way funds are currently disbursed, public cultural organizations must then assume the burden of committing themselves to their constituents' programs exactly as they would to their own collections or physical plant. If the project support runs out, that cannot mean the end of the program; it means finding other sources of funding. When one corporation withdraws its support, the museum doesn't close its doors. Our institutions need to retool their priorities to put the needs of local communities on a par with the art and artifacts of other times and places. Friedman stresses that "we have something tremendously special in America. But if we want to preserve it, we have to pay for it, we have to nurture it."[41]

Doing this carries with it an implication that the results of such support will not always, or even often, feel satisfying to everyone. Our communities are amazingly diverse, and the tastes of one are not often shared by the many. We must be willing to continue to support cultural expression, even if it is outside of our domains of understanding and apprecia-

tion. This is a corollary to traditional definitions of free speech—it doesn't qualify as freedom unless it is extended to those with whom you disagree. Artistic expression needs, if anything, even more freedom of movement. To be whole and healthy, it requires license for artists to go to extremes. This is more than an anticensorship harangue. It is the recognition of a basic tenet of artistry, squarely at the foundation of cultural expression. "Artistic creation, like scientific research and development, generates many failures for every high profile success," writes Bruce Seaman. "Yet, while few would deny the critical role played by traditional R & D in the future growth of any economy, the arts continue to struggle to find the right formula to ensure a stable future for 'artistic R & D.'"[42]

For our communities to grow fully into themselves, this must change. Breaking down the phobias that surround the strange customs of every outsider group has multiple benefits. It leads to domestic tranquility as well as offering the stimulant of creativity that make societies successful. Pérez de Cuéllar states that "cultural freedom, by protecting alternative ways of living, encourages creativity, experimentation and diversity, the very essentials of human development. Indeed, it is the diversity of multicultural societies, and the creativity to which diversity gives rise, that makes such societies innovative, dynamic and enduring."[43] If we hope to endure, we'll have to get organized.

✧ ✧ ✧

This quartet of nutrients that enriches the soil in which culture grows— access to artistry, a safe space for practice, the stimulation of encounters with other cultures, and long-term sustaining support—are situated in a matrix of national and transnational institutions. The government—local, state, and federal—is invested with discretionary power over much of the money that could realize these cultural imperatives. Schools and nonprofits are all supported to varying degrees by the state. Government determines the nature of tax policy that supports cultural activity (or not). All of these institutions are, supposedly, the province of the people, and their priorities could be a reflection of the popular will. Political action to shift the government's positions is available to every citizen. What could a new culture-friendly government agenda look like?

As suggested earlier, a ten-fold increase in government arts expenditures would be an appropriate and affordable long-term investment. The creation of a new Endowment for Community Culture should be considered. There are many other creative possibilities for public action. Most govern-

ment construction projects currently mandate 1 percent of gross expenditures for art; percent-for-art mandates could be extended to private construction or renovation of spaces open to the public, including stores, offices, shopping malls, highways, even stadiums. America's towns and municipalities could create a new elective office of local Artist Laureate. The Artist Laureate's salary could be indexed to the median national income—$33,676 in 2001.[44] These positions would be awarded to emerging artists of all kinds—painters, singers, theater directors, sculptors, fiddlers, poets—anyone whose work was judged important by their communities. If the art wasn't up to the community's needs, they could vote in an artist more to their liking at the next election. Funding this new office in each of America's 18,000 incorporated towns[45] would cost $606 million—one-third the cost of a single Sea Wolf submarine (the Navy thinks we need thirty of these).[46]

All of this activity could be coordinated by a new cabinet-level Office of Cultural Affairs that would act as a bridge to the executive and legislative branches. In this capacity, it could assist the president and State Department in systematically deploying American cultural forces around the globe as ambassadors of goodwill to help counter the stereotypical image of America purveyed by the media and commercial sector. Cultural diplomacy could become a lynchpin of our foreign policy.

The new ministry might also play a key role in setting professional standards for cultural administrative professionals. The field of cultural administration currently has no governing body, universally acknowledged qualifications, or standards of conduct for professionals. As the field expands, the importance of an informed and accountable workforce will only grow. Working in partnership with universities, government initiatives could nurture a new generation of cultural leaders, trained to address contemporary challenges and respond with creativity and a commitment to culturally democratic alternatives.

Government also holds the potential to regulate the linkages between cultural activity and the private sector, a power that has not been well exercised. The twentieth century in its totality, and the last third in particular, has ushered in the triumph of the corporation, to the point where government's role has been reduced to that of an occasional media presence. Corporations represent the real power in global economics, politics, and culture, too. Unlike the legislature or executive, corporations are unaccountable to the public; indeed, Congress, the White House, and the foundations often seem to be little more than extensions of corporate

power. Cultural democracy is at odds with the continuance and growth of this corporate dominance. Corporate rule is the same hamburger on every plate; cultural democracy is everybody eating whatever they like.

The movement to curtail corporate power has been accelerated by the rapidity of globalization, and it is now evident in the street demonstrations at every convening of the custodians of corporate rule, the WTO, World Bank, and IMF. Fledgling organizations such as CultureJammers and publications such as *AdBusters* have appeared—apparently out of nowhere—to fuel popular challenges to the hegemony of the CEOs.[47] They represent a personalized moral response to the ravages of unfettered market capitalism that is as powerful and socially important as last century's civil rights movement or the abolitionist movement in the nineteenth century, more fuel for the Fourth Great Awakening. How we deal with the corporations will define the shape of our lives, and those of every person alive today.

Although the Supreme Court decided over a hundred years ago that corporations were, essentially, people, and entitled to all of the same rights as human beings, this is not a self-evident truth.[48] Corporations do not live or die; they are not bound by the rules of social interaction that define human communities. They are separate, outside the web of mutual obligation, the multiplicity of non-zero-sum games that characterize human interactions. Cultural democracy will continue to be marginalized as long as corporate power over the fabric of our communities is not tempered with the same responsibilities of citizenship that every individual carries. A first step in bringing corporations to account will be to legally test and revoke their claims to personhood. As the society that grants them the privilege of existing, we have the power to restrict their activities to those that are compatible with a clean, just social order.

Corporate charters are granted by the state, and the state has the power to revoke them. Corporations that despoil the environment, exploit workers, or mislead customers require an aggressive political response to their continued existence. As the gigantic economic and social forces that they are, corporations need to become accountable for the impact of their actions on our communities. A practical mechanism to regulate responsible corporate citizenship would be to demand submittal of cultural impact statements—just like environmental impact plans—as an integral part of each corporation's activity. Corporations receiving any form of public money, including tax incentives, should have to demonstrate that their operations are not despoiling our cultural, as well as natural, envi-

ronment. They should be subjected to periodic review, to determine if their activities have fostered the social good—or not.

Finding the legal and practical means to bring corporations under democratic control has implications that concern every community, but resonate globally. Whether the world becomes more fully integrated or descends into violence hinges on this issue. If the global economy is to expand to answer the needs of the many, rather than the few, developing such constraints is essential. "Only the globalization of civic and democratic institutions is likely to offer a way out of the global war between modernity and its aggrieved critics . . ." writes Barber. "It responds directly to the resentments and spiritual unease of those for whom the trivialization and homogenization of values is an affront to cultural diversity and spiritual and moral seriousness. But it also answers the complaints of those mired in poverty and despair as a consequence of unregulated global markets and of a capitalism run wild because it has been uprooted from the humanizing constraints of the democratic nation-state. By extending the compass of democracy to the global market sector, public globalization can promise opportunities for accountability, participation, and governance to those wishing to join the modern world and take advantage of its economic blessings; by securing cultural diversity and a place for worship and faith insulated from the shallow orthodoxies of McWorld's cultural monism, it can address the anxieties of those who fear secularist materialism and are fiercely committed to preserving their cultural and religious distinctiveness."[49]

Cultural democracy has much to offer in this struggle, both as a paradigm for interaction among diverse peoples and a vehicle for attaining global development goals. Culture, taken in aggregate, is the largest industry in the world. It holds the potential to lead global commerce and political discourse in new directions. The practice of cultural democracy offers one of the very few substantive alternatives to the religious fundamentalism that threatens many societies and, in a larger sense, all societies. Cultural development is a healthy, moral antithesis to the rampaging armies of young men with guns who currently hold so much of the world hostage.

We need new global organizations that can reach past the corporations and governments to the community level on every continent. Communities need the worldwide linkages, but we lack the institutional infrastructure to realize this imperative. New institutions, capable of accelerating multilateral international exchange need to be developed everywhere.

Governments worldwide should aggressively implement the proposals in the U.N.'s *Declaration on Cultural Diversity*.[50] The assumptions and attitudes addressed within this document provide a concise guide for an approach by national governments to sensitive cultural development. Incorporating the doctrines promoted through the declaration into all evolving international free trade agreements could offer a safeguard to indigenous cultures worldwide.

The global must become, tangibly, local. The real battles in the evolution of globalization will take place in small local neighborhoods. Cultural democracy offers a tool for those communities to employ. "The heart of the work is to give expression to the concerns and aspirations of the poor and excluded, stimulating social creativity and social action, advancing social inclusion," write Don Adams and Arlene Goldbard. "It asserts the value of diversity and fosters an appreciation both of difference and of community within difference. In valuing both material and nonmaterial cultural assets of communities, it deepens participants' comprehension of their own strengths and agency, enriching their lives and their sense of possibility." But cultural democracy's benefits extend well beyond the confines of culture. "It brings people into the civic arena with powerful tools for expression and communication, promoting democratic involvement in public life. It creates public, noncommercial space for full, embodied deliberation of policies affecting citizens. The work is inherently transnational, with strong roots in immigrant communities and deep commitments to international cooperation and multidirectional sharing and learning."[51] Cultural democracy demands a revolution. It isn't about carrying pictures of Chairman Mao. It's about learning to paint our own pictures.

✧ ✧ ✧

I have tried in these pages to indicate some possibilities for action in various areas—a generous embrace of art and cultural diversity in our schools, accountability of our governments for resource allocation that reflects the needs and realities of today's communities, the democratization of private philanthropy, the development of meditative institutions capable of carrying the work forward. Fresh progressive work is needed within every community.

Cultural development doesn't happen in isolation. The realization of cultural democracy, as Rachel DuBois foresaw, requires completing America's political and economic revolutions as well. Without commensurate advances across the spectrum of civil society, it is difficult to imagine cul-

tural democracy emerging as more than an occasional local phenomenon.

Karl Marx believed that socialism could not happen in isolation, and it may be the same with cultural democracy. According to Marx, a single country could never achieve socialism, which he envisioned as a global fusion of proletarians in mutual aid. (Lenin believed the same thing, and when no other countries rushed to join his new Soviet state, he was forced to devote the last few years of his life to struggling with the awful consequences. Socialism never did happen in the Soviet Union, as it devolved into the tragedy of Stalin's megalomania and xenophobia, hardly a vision of socialist brotherhood.) Cultural democracy claims its roots in the same soil that nurtured the original socialist vision of peace and brotherhood in a world free of exploitation; the same fertile ground that has supported the advocates of American social justice through the travesties of Jim Crow and depression, union wars and foreign wars, government suppression and popular celebration. But through most of the last half century, the progressive side of the American spirit has been in retreat. Our successes are in skirmishes, but the tide flows strongly against us. Most often, progressives work in relative isolation, and like socialism, they have a hard time surviving in just one country.

Cultural democracy demands a new social coalition, a formation of new bonds around a shared interest in building communities. This is not a question of left-leaning or right-leaning politicians but of community organizers from widely divergent positions who can come together with a common goal: revitalizing the place they all call home. In this, evangelical Christians and feminists, Rotarians and anti-IMF protesters, share a common interest, if they can reach beyond themselves to find it. "Diasporic public spheres, diverse among themselves, are the crucibles of a postnational political order," writes Arjun Appadurai. "The engines of discourse are mass media, and the movement of refugees, activists, students and laborers. It may well be that the emergent postnational order proves not to be a system of homogeneous units (as with the current system of nation-states) but a system based on relations between heterogeneous units."[52] Building these relationships among diverse constituencies is the prerequisite for shaping our own democratic cultures.

John Brown Childs theorizes that the gathering of disparate progressive forces is a fundamental demand of our zeitgeist. "[A]round the world many are poised on the edge of an important development within which is emerging a twenty-first century mode of organizing for justice and dignity that I call *transcommunality*. By transcommunality I mean the con-

struction and developmental interaction occurring among distinct auton-
omy-oriented communities and organizations, each with its own partic-
ular history, outlook and agenda."[53] Finding junctures of commonality
that are shared across cultures and between communities can build a
synergistically powerful vehicle for effecting change. "Transcommunali-
ty must be distinguished from an inward-focused identity politics (com-
mon to many vanguard leftist and ethnic-nationalist leadership elites)
that consciously cuts off its participants from contact with others in the
name of racial, ethnic, or ideological claims of purity," Childs continues.
"By contrast, a transcommunal identity politics celebrates and asserts
distinctive and essential community/organizational allegiances that can
serve as multiple bases for common action with others."[54]

Artists and other creative practitioners are positioned to lead this new
dispensation. Their work is central to the emerging economy, and will only
expand in its value. Art, particularly art that draws from the wellsprings
of tradition, frequently transcends class and political boundaries, speak-
ing equally to many members of a community. Some of the corporations
that support our work at the Center for Cultural Exchange are indiffer-
ent to our rhetoric about diversity; they fund our programs because bank-
ers love dancing to a great salsa band as much as anybody else.

Cultural practice in its community setting also provides well-worn tem-
plates for the very kind of sustained, inclusive, democratic processes that
are the antithesis systems of domination and exploitation. The myriad
internal networks that have sustained heritage across generations embody
profound lessons that the world needs to call on now. They carry the in-
structions for how to be a responsible citizen. "I want to be clear, the idea
here isn't about dance," says David White about developing grassroots
arts resources, "the idea here is about these relationships between artists
and communities and creating cultural citizenship."[55] Opera director Peter
Sellars is emphatic in heralding the place of artists in bringing critical
thinking, creative problem solving and true citizenship to our communi-
ties: "We actually have to reinvent ourselves as part of a new ecology back
into the very fiber of society," he says. "That's what the Greeks were about.
They made theater the preparation for jury duty. They discussed there,
publicly, the most undiscussable things, and that's why they had artists
engaged in creating the mental and spiritual health that could rebuild
and replenish the society. Today we need artists in the prison system, in
the police system, and in the hospitals. Being a true artist . . . is about being
in the heart of the community, and reminding the community that it has
a soul."[56]

Cultural activists, Gladwell's Connectors, put cultural democracy to the test every day, creating both art and community. "The community connections of people who participate in the arts and culture are a potential resource for community organizers, funders and policymakers who are seeking ways to strengthen communities," says Christoper Walker of the Urban Institute. "When community builders recognize arts and cultural participation as a form of civic participation and as a potential path of engagement to other forms of civic participation, new possibilities for engaging people take shape."[57] These possibilities, like the coalition that can bring them to realization, go well beyond the realm of culture to touch many aspects of our lives. But in every case, bringing the community into the process offers the key to success. "There's been interesting work coming out of other fields that touch on the arts," says Peter Pennekamp. "Public health, after a huge amount of trying to change people's behavior, starting with tobacco, discovered that you couldn't change people's health. . . . The truth is, from every piece of public health research, if the community doesn't own an outcome, the outcomes simply aren't as good."[58]

When communities participate in determining the desired outcomes, and in shaping their evolution in practice, the results transcend mere economics. This is work that nurtures people's souls, development of a community's spiritual resources. The confluence of broad historic trends, rampant social dislocation, and the consequent abandonment of longstanding cultural mores that Ivey posited offers an opportunity to bring forward an alternative. The forces of divisiveness are pervasive, but culture is perhaps the only bridge that can be built on foundations of mutuality. Economics and politics will follow if culture can lead. But culture has to get organized: first, to preserve and advance itself; second, to spread its gospel among the young; third, to build alliances that can begin to exercise power in the political arena; and finally, to change global economic structures from within.

In proposing his Cultural Bill of Rights, Ivey stated, "I believe that, in response to what we know, we must assert, on behalf of our citizens, a moral claim to art, art making, heritage, and creativity."[59] If Ivey's vision of cultural democracy is ever to flourish, it will do so on the wings of a broadly based revolution in American attitudes that forces the reevaluation of current economic, social, and political hierarchies. If we can begin to take the substance of our professed beliefs seriously—both our cherished liberties and our oft-neglected responsibilities—cultural democracy can be an important factor in shaping the next phase of our history by infusing new life into every community. "The equation is simple enough,"

writes Barber: "no community, no communication; no communication, no learning; no learning, no education; no education, no citizens; no citizens, no freedom; no freedom—then no culture, no democracy, no schools, no civilization. Cultures rooted in freedom do not come in fragments and pieces. You get it all, or you get nothing."[60]

Notes

Introduction

1. The Cambodian cultural initiative described here was part of a series of encounters with ethnic communities that ultimately took shape as the House Island Project, produced by Portland Performing Arts (now the Center for Cultural Exchange), with funding provided by the Wallace–Reader's Digest Foundation and the National Endowment for the Arts.

2. Huntington, *Clash of Civilizations,* 21.

3. See United Nations Economic, Social, and Cultural Organization (UNESCO), *Culture, Trade, and Globalization,* PricewaterhouseCoopers, "Global Entertainment and Media," and Financial Times, *World Desk Reference.*

4. Harris, "From the Collectors Perspective," 155.

5. Madeja, "Arts as Commodity."

6. *Cheap Imitation* was a piece John Cage composed for the Merce Cunningham Dance Company. It exactly replicates the rhythmic pattern of an Erik Satie composition but replaces all the pitches with those obtained by chance operation.

7. Lomax, "Appeal for Cultural Equity," 125.

8. Pérez de Cuéllar, *Our Creative Diversity,* 176.

9. Friedman, *Lexus and the Olive Tree,* 31.

10. Godfrey, "Optimizing America's Cultural Policies."

11. Brand, *Clock of the Long Now,* 2.

12. For my introduction to Rachel DuBois and her conception of cultural democracy, I am indebted to Maryo Gard Ewell of the Colorado Arts Council. DuBois's statements throughout are quoted in Ewell, "Arts and Community Strengthening."

13. Langsted, *Double Strategies,* 3.

14. Report of the 1976 Oslo Conference quoted in Langsted, ibid., 4.

15. Pérez de Cuéllar, *Our Creative Diversity,* 26.

16. Ibid., 25.

17. UNESCO, *Universal Declaration.*

18. Quotations excerpted from UNESCO, *Universal Declaration,* Article 1, Article 4, and Article 7.

19. Cleveland, "Bridges, Translations, and Change," 85.

20. Reagon, "Battle Stancing," 70.

21. Brand, *Clock of the Long Now*, 38. The idea of art and culture as different levels in the grand scheme of civilization is drawn from Brand's writing.

22. Tylor, quoted in Stocking, *Victorian Anthropology*, 300.

23. Kroeber and Kluckholm, *Culture*, quoted in "Concept and Components of Culture," 874.

24. Appadurai, *Modernity at Large*, 12.

25. Graves, "Introduction," 5.

26. Barber, *Aristocracy of Everyone*, 5.

27. Oliver Wendell Holmes, as recounted in Menand, *Metaphysical Club*, 431.

28. Ivey, "American Cultural Bill of Rights," 3.

29. Adams and Goldbard, *Creative Community*, 55.

30. Robert Winslow Gordon and the chiefs, as recounted to the author by folksinger and song collector Michael Cooney.

31. "Those roles which, being neither those of Hero not Heroine, Confidante nor Villain, but which were nonetheless essential to bring about the Recognition or the dénouement, were called the Fifth Business in drama and opera companies organized according to the old style."—Tho. Overskou, from the epigraph to Davies, *Fifth Business*.

32. Losito, "Culture and Development," 2.

33. Childs, *Transcommunality*, 7.

34. Pérez de Cuéllar, *Our Creative Diversity*, 25.

Chapter 1: Communion

1. The Gary Hines/Thuli Dumakude initiative was part of the House Island Project, produced by Portland Performing Arts, with funding provided by the Wallace–Reader's Digest Funds and the National Endowment for the Arts.

2. Graves, "Introduction," 5.

3. Wright, *Non Zero*, 5.

4. Putnam, *Bowling Alone*, 22. See *Bowling Alone* for a more extensive discussion of social capital in its myriad manifestations.

5. Fox, *Five Books of Moses*, 884.

6. In the speech announcing his Fourteen Points, on January 8, 1918, Woodrow Wilson put forth his conception of self-determination of peoples: "What we demand in this war, therefore, is nothing peculiar to ourselves. It is that the world be made fit and safe to live in; and particularly that it be made safe for every peace-loving nation which, like our own, wishes to live its own life, determine its own institutions, be assured of justice and fair dealing by the other peoples of the world as against force and selfish aggression. All the peoples of the world are in effect partners in this interest, and for our own part we see very clearly that unless justice be done to others it will not be done to us." The full text is

available at the Web site of the Harold B. Levy Library at Brigham Young University <www.lib.byu.edu/~rdh/wwi/1918/14points.html>; it is available at many other sites as well.

7. Abrahams, "Phantoms of Romantic Nationalism," 5.

8. Sowell, *Ethnic America,* 3.

9. Juan Tejeda, Chicano music director of the Guadeloupe Cultural Arts Center, San Antonio, Texas, in conversation with the author, 1991.

10. Jabbour, "Ethnicity and Identity," 7.

11. Lawrence Levine, *Opening of the American Mind,* 163.

12. Graves, "Music of Southern Maine French Canadian Communities," 26.

13. Graves, "Democratizing Culture."

14. Putnam, *Bowling Alone,* 402.

15. Joe Kaloyanides Graziosi, in conversation with the author, 1997.

16. Bourdieu, *Distinction,* 2.

17. Trompenaars, *Riding the Waves of Culture,* 22.

18. Graves, "Democratizing Culture."

19. Hall, *Beyond Culture,* 213.

20. Kotkin and Tseng, "Happy to Mix It All Up," B01.

21. Clifford, "On Collecting Art and Culture," 152.

22. Ahmed Hassan, Albino Badane, and the Center for Cultural Exchange's Somali and Sudanese planning committees, in conversation with the author, 2002. The Center's *African in Maine* initiative was funded by Americans for the Arts and the National Endowment for the Arts.

23. Center for Arts and Culture, *America's Cultural Capital,* 1.

24. Pennekamp, "Ghosts," 162.

Chapter 2: Tradition and Innovation

1. Pérez de Cuéllar, *Our Creative Diversity,* 28.

2. Kurin, "Folklife in Contemporary Multicultural Society," 10.

3. Glassie, "Tradition," 399.

4. Wilson and Udall, *Folk Festivals,* 18. Joe Wilson has spoken and written with eloquence about the popular linguistic disrespect that is paid to some of our most highly skilled traditional artists.

5. Toelken, *Dynamics of Folklore,* 226.

6. Titon, *Powerhouse for God,* 9. Jeff Todd Titon's writings offer some of the clearest theoretical descriptions of folklore and its position within American mainstream culture.

7. Ibid., 8.

8. Ibid., 8.

9. Vogel, "Always True to the Object," 192.

10. Cantwell, "Feasts of Unnaming," 297. Italics mine.

11. Bhabha, *Location of Culture,* 2.

12. Fiddler Guy Bouchard, in conversation with the author, 1996. Many performers of Québécois traditional music found the assumption of political activism off-putting. According to Bouchard, who had just founded the folk group La Bottine Souriante, traditional music was largely appropriated by separatist politicians, who promptly forgot about it once the referendum was defeated.

13. Crew and Sims, "Locating Authenticity," 163.

14. Briggs, "Metadiscursive Practices," 387.

15. Abrahams, "Phantoms of Romantic Nationalism," 4.

16. Ibid., 21.

17. Graves, "Music of Southern Maine French Canadian Communities," 29.

18. National Endowment for the Arts (NEA), Folk Arts Program grant guidelines.

19. Staub, "Folklore and Authenticity," 169.

20. Ibid., 172.

21. Burt Feintuch, director of the Center for the Humanities, University of New Hampshire, in conversation with the author, 1991.

22. Toelken, *Dynamics of Folklore,* 79.

23. Hal Cannon, founding director, Western States Folklife Center, Elko, Nevada, in conversation with the author, 1991.

24. Toelken, "Heritage Arts Imperative," 196.

25. Toelken, "Fieldwork Enlightenment," 28. Toelken's account of his harrowing ethical dilemmas over the course of a career of field research among the Navajo is a landmark of contemporary reflexive scholarship. Over the strenuous objections of many colleagues, Toelken allowed hundreds of hours of primary source tape recordings to be destroyed rather than risk the consequences of their potential misuse (according to Navajo tradition).

26. Cornel West, quoted in Anderson, "Public Intellectual," 48.

27. Jabbour, "Ethnicity and Identity," 7.

28. Ibid., 8.

29. Baron and Cara, "Introduction," 4.

30. Nick Spitzer, in conversation with the author, 1991.

31. Seamus Egan's workshop took place for the Lewiston, Maine, Creative Arts Program in 1996.

32. *Removed from the Palace,* the collaboration between English choreographer Jonathan Lunn and Cambodian performers Sam-Ang Sam and Chan Moly Sam was commissioned by the Center for Cultural Exchange in 1994, with funding from the National Endowment for the Arts, the New England Foundation for the Arts, and the Maine Arts Commission.

33. Chris Strachwitz and the birth of zydeco, as recounted by Joe Wilson, executive director of the National Council for the Traditional Arts, in conversation with the author, 1992.

34. Chris Strachwitz quoted in Wald, *Arhoolie Records,* 20; Joe Wilson, in conversation with the author, 1992.

35. Lomax, "Appeal for Cultural Equity," 125.

36. Piazza, "Lincoln Center and Its Critics," H26.

37. Lippard, *Mixed Blessings,* 20.

38. Spitzer, "Monde Créole," 61.

Chapter 3: Presentation and Participation

1. Schechner, "Magnitudes of Performance," 5.

2. Ibid., 27.

3. See Goffman, *Presentation of Self.*

4. MacCannell, *Tourist,* 93.

5. Schechner, "Magnitudes of Performance," 4.

6. Csikszentmihalyi, *Flow,* 6.

7. Ibid., 109.

8. MacCannell, *Tourist,* 26.

9. Giamatti, *Take Time for Paradise,* 38.

10. Turnbull, "Liminality," 80. See also Turner, *Anthropology of Performance.*

11. Turner, *Anthropology of Performance,* 140.

12. Schechner, "Magnitudes of Performance," 28.

13. Bauman and Sawin, "Politics of Participation," 297.

14. Hawes, "Folk Arts," 89.

15. Cantwell, "Ideology and Magic," 160.

16. Garfias, "Cultural Diversity and the Arts."

17. Hall, *Beyond Culture,* 92.

18. Robert Browning, director of the World Music Institute in New York, in conversation with the author, 1991.

19. Nick Spitzer, director of the Folk Masters Series at Wolf Trap and Carnegie Hall, and subsequent host of *American Routes* on public radio, in conversation with the author, 1991.

20. Gomez-Peña, "Multicultural Paradigm," 18.

21. Giamatti, *Take Time for Paradise,* 21.

22. Adams and Goldbard, *Creative Community,* 17.

23. Gurian, "Noodling Around with Exhibition Opportunities," 177.

24. Graves, "Rules of Engagement," 79.

25. Menand, *Metaphysical Club,* 311.

26. Csikszentmihalyi, *Flow,* 41.

27. Wali, Severson, and Longoni, *Informal Arts,* 9.

28. McCarthy and Jinnett, *New Framework,* 23.

29. McDaniel and Thorn, *Learning Audiences,* 13.

30. Cocke, "Who's in the House Tonight?" 15. "Often," says Cocke, "people are very aware of what's being proposed and transpiring." Personal communication with author, March 2003.

31. Dudley Cocke of Roadside Theater, in conversation with the author, 2001.

Chapter 4: Conservation and Commercialization

1. Guralnick, *Last Train to Memphis,* 102.
2. Feintuch, *Conservation of Culture,* 5.
3. Hunt and Seitel, "Cultural Conservation," 38.
4. Lippard, *Mixed Blessings,* 11.
5. Charles Seeger, *Studies in Musicology,* 335.
6. Kirshenblatt-Gimblett, "Mistaken Dichotomies," 44.
7. Ibid., 149.
8. Clifford, "On Collecting Art and Culture," 146.
9. Ibid., 147.
10. Florida, *Rise of the Creative Class,* 187.
11. Salaam, "African American Cultural Empowerment," 128.
12. Schechtman, "Introduction," 16.
13. Kelly, "Where Music Will Be Coming From," 29.
14. Mason, "Ishmael Reed," 35.
15. Bill Cosby quoted in Wolcott, "Cos Célèbre," 96.
16. Vulliamy, "Music and the Mass Culture Debate," 180.
17. Kurin, "Folklife in Contemporary Multicultural Society," 13.
18. Clifford, *Predicament of Culture,* 14.
19. Barber, "Serving Democracy," 13.
20. Center for Arts and Culture, *America's Cultural Capital,* 2.
21. Florida, *Rise of the Creative Class,* 5.
22. Ibid., 243.
23. Gottlieb, *Creative Economy Initiative,* 7.
24. Seaman, "National Investment in the Arts," 31.
25. Gottlieb, *Creative Economy Initiative,* 18.
26. Florida, *Rise of the Creative Class,* 182.
27. Gottlieb, *Creative Economy Initiative,* 15.
28. The NEA estimated cultural tourism for 1999 at 92.4 million visitors. See NEA, *Fact Sheet.*
29. Florida, *Rise of the Creative Class,* 218.
30. Walker, Jackson, and Rosenstein, *Culture and Commerce,* 7.
31. Savoy, *Cajun Music,* xi.
32. MacCannell, *Tourist,* 3.
33. Ibid., 101.
34. Schechner, "Magnitudes of Performance," 4.
35. Evans-Pritchard, "Tourism, Ecology, and Cultural Heritage," 6.
36. Ibid.
37. Jaime Litvak King, "Cultural Property and National Sovereignty," 206.
38. Pérez de Cuéllar, *Our Creative Diversity,* 184.
39. See Charles Seeger, *Studies in Musicology.* Charles Seeger was instrumental

in shaping the folk revival himself, and also as the father of Pete, Mike, and Peggy Seeger; as grandfather of Tony Seeger; and as household employer of Elizabeth Cotton, composer of "Freight Train."

40. The Weavers, *Weavers' Songbook.*

41. Pete Seeger, *Incomplete Folksinger,* 450n. Pete Seeger has long advocated for a special fund into which copyright holders of traditional material could pay for distribution to the communities where the music originated.

42. Anthony Seeger, "Intellectual Property," 37. As the first director of the Smithsonian Folkways imprint, Tony Seeger contended with a byzantine collection of legal issues involving traditional music (including songs copyrighted by his uncle Pete), anthropological field recordings, and reissues of commercially produced recordings.

43. Kurin, "Culture on the 1990's Agenda," 12.

44. Jack Lang quoted in Kurin, *Reflections of a Culture Broker,* 272.

45. Kurin, "Culture on the 1990's Agenda," 12.

46. Seaman, "National Investment in the Arts," 36.

47. Sen, "Matter of Choice."

48. Alan Lomax quoted in Pareles, "Life Giving Voice," 15.

Chapter 5: Donation and Deduction

1. Johnston, "You Can't Take It with You," 23.

2. Crossette, "Kofi Annan's Astonishing Facts," sec. 4, p. 16.

3. Aldrich, "That's Rich," 20.

4. NewTithing Group statistics quoted in Aldrich, "That's Rich," 20.

5. Foundation Center, "Foundations Today Tutorial."

6. Ibid.

7. See Focke, "Snapshot," 3.

8. Foundation histories available on foundation Web sites.

9. Beene, "On My Mind," 5.

10. White, "Built to Last," 8.

11. See conference proceedings available online at <www.giarts.org>.

12. White, "Built to Last," 8.

13. Foundation Center, "Top 50 Recipients."

14. See Focke, "Snapshot," 5.

15. Stehle, "Competitive Disadvantage," 18.

16. Pablo Eisenberg, "Lack of Guts."

17. Porter and Kramer, "Philanthropy's New Agenda," 57.

18. Strom, "Foundations Roiled by Measure," 1.

19. NEA, *NEA Research Division Note #74,* 9.

20. Barber, "Serving Democracy by Serving the Arts," 12.

21. Biddle, *Our Government and the Arts,* 236.

22. According to Americans for the Arts' National Arts Information Clearing-

house, private donations to arts and cultural activities in 2000 totaled $11.5 billion. The NEA's budget that year was $115 million.

23. NEA, *Grants to Organizations,* 4.
24. NEA, *Annual Report,* 8.
25. Hawes, "Aspects of Federal Folklife," 7.
26. As reported on National Public Radio's *Morning Edition,* May 30, 2002.
27. Pennekamp, "Beyond Art," 16.
28. White, "Built to Last," 8.
29. Jackson and Herranz, *Culture Counts in Communities,* 42.
30. DeNatale and Ito, *International Collaboration,* 24.
31. Adams and Goldbard, *Creative Community,* 96.
32. McPhee, "Beyond Art," 10.
33. See Renz, "Arts Funding Update," 3.
34. Gottlieb, *Creative Economy Initiative,* 13.
35. PBS Online Forum, "Art of Corporate Sponsorship."
36. Porter and Kramer, "Competitive Advantage."
37. Cleveland, "Bridges, Translations, and Change," 89.
38. Gottlieb, *Creative Economy Initiative,* 13.
39. Florida, *Rise of the Creative Class,* 5.

Chapter 6: Education

1. Smith quoted in Tim Walker, "What Has Changed?" 3.
2. Barber, *Aristocracy of Everyone,* 262.
3. Ibid., 7.
4. Florida, *Rise of the Creative Class,* 222.
5. Robinson, "Arts Education's Place," 5.
6. Tim Walker, "What Has Changed?" 2.
7. Robinson, "Arts Education's Place," 4.
8. McDaniel and Thorn, *Learning Audiences,* 6.
9. Csikszentmihalyi, *Flow,* 112.
10. Christy et al., Introduction, 1.
11. Burton, Horowitz, and Abeles, "Learning In and Through the Arts," 45.
12. Ibid., 43.
13. Eisner, "Ten Lessons the Arts Teach," 7.
14. Burton, Horowitz, and Abeles, "Learning In and Through the Arts," 44.
15. Test scores are drawn from the Imagination Project of UCLA's Graduate School of Education and Information Studies; Catterall, Chapleau, and Iwanaga, "Involvement in the Arts."
16. Heath, "Imaginative Actuality," 27. Italics mine.
17. Catterall, Chapleau, and Iwanaga, "Involvement in the Arts," 17.
18. Sanford, "Affirming Diversity," 17.
19. Eisner, "Ten Lessons the Arts Teach," 8.

20. Garfias, "Cultural Diversity and the Arts."

21. See D'Souza, *Illiberal Education*; Bloom, *Closing of the American Mind*; and Kimball, *Tenured Radicals*.

22. For the Harvard, Eastman, and UCLA course statistics, see online catalogs at <www.harvard.edu>, <www.eastmanschool.edu>, and <www.ucla.edu>.

23. Lawrence Levine, *Opening of the American Mind*, 98.

24. Mesa-Bains, "Teaching Students," 35.

25. Cahan and Kocur, *Contemporary Art and Multicultural Education*, xxvii.

26. Eisner, "Ten Lessons the Arts Teach,"12.

27. See Catterall, Chapleau, and Iwanaga, "Involvement in the Arts."

28. Sanford, "Affirming Diversity," 6.

29. The FolkWorks story is modified from an essay I wrote for an in-house Center for Cultural Exchange publication in 2000. I am deeply indebted to Alistair Anderson and his codirector Ros Rigby for their inspirational work and warm hospitality.

30. Mesa-Bains, "Teaching Students," 34.

31. Harold Levy quoted in Ivey, "American Cultural Bill of Rights," 6.

32. Mesa-Bains, "Teaching Students," 36.

33. Burton, Horowitiz, and Abeles, "Learning In and Through the Arts," 44.

34. Leitão, "5th and 6th Grade Program," 2.

35. Crew, "Reframing Arts in Education," 27.

36. Goodman, "Media Education," 22.

37. Cocke, "Appalachia, Democracy, and Cultural Equity," 39.

38. Venturelli, "From the Information Economy," 19.

39. Robinson, "Arts Learning Experiences," 23.

40. Barber, *Aristocracy of Everyone*, 262.

41. Robinson, "Closing Remarks," 33.

42. Sanford, "Affirming Diversity," 8.

Chapter 7: Mediation

1. The Center for Cultural Exchange Sudanese Conference took place during June 2001. It was primarily organized by Juan Lado and was funded by the City of Portland, the Maine Humanities Council, the Maine Department of Human Services, and the Maine Community Foundation.

2. Information about the SPLM/SPLA and Sudan's civil war is available online at Amnesty International's Web site at <www.amnesty.org>.

3. Baron, "Theorizing Public Folklore Practice," 185.

4. See Putnam, *Bowling Alone*, 22.

5. Santino, "Tendency to Ritualize," 129.

6. Kurin, *Reflections of a Culture Broker*, 19.

7. Sheehy, "A Few Notions about Philosophy," 335.

8. Wallis and Malm, *Big Sounds from Small Peoples*, 120.

9. Feintuch, *Conservation of Culture,* 10.

10. Whisnant, "Public Sector Folklore as Intervention," 233.

11. Whisnant, *All That Is Native and Fine,* 20.

12. Ibid., 260.

13. Ibid.

14. Ibid., 8.

15. Said, *Orientalism, 7.*

16. Ibid., 3.

17. Cocke, "Appalachia, Democracy, and Cultural Equity," 37.

18. Cantwell, "Feasts of Unnaming," 286.

19. Garfias, "Cultural Diversity and the Arts," 10.

20. The section following is a reworking of Graves, "Rules of Engagement," which was also reprinted in *Culture as Community,* a publication of the Center for Cultural Exchange.

21. Gladwell, *Tipping Point,* 38.

22. Kerrigan, *Performer's Guide.*

23. McPhee, "Beyond Art," 13.

24. Lomax, "Appeal for Cultural Equity," 126.

25. McDaniel and Thorn, *Learning Audiences,* 29.

26. See McAllester, *Enemy Way Music.*

27. Lomax, "Saga of a Folksong Hunter," 48.

28. See Bond, Boyd, and Rapp, *Taking Stock,* 15.

29. Jackson and Herranz, *Culture Counts in Communities,* 21.

30. Figueroa et al., "CFSC Model," iv.

31. Kofi Annan quoted in Gourevitch, "Optimist," 58.

32. Feek, "Annan and a Talking Stick," 2.

33. Ibid., 4.

34. Adams and Goldbard, *Creative Community,* 19.

35. Juan Tejeda, in conversation with the author, 1991.

36. Gomez-Peña, "Multicultural Paradigm," 21.

37. Trompenaars, *Riding the Waves of Culture,* 194.

Chapter 8: Globalization and Localization

1. The Tenores di Bitti were participants in the Center for Cultural Exchange's *Vocal Chords* tour in 2000, a project funded by the National Endowment for the Arts and the New England Foundation for the Arts.

2. Feigenbaum, "Globalization and Cultural Diplomacy," 7.

3. Population and income statistics are quoted from the World Bank's Web site at <www.worldbank.org>. The World Bank's numbers have been criticized for being arbitrary and misleading. The bank has an interest in demonstrating the efficacy of its programs and to do so has "defined" poverty as per capita income of anything less than two dollars per day. Thus, by their measure, someone subsisting on three or four dollars per day would not be considered impoverished.

Using this measurement, the bank thinks there is substantially less poverty in Mexico or Trinidad than the U.S. Census Bureau says there is in the United States. Actual global poverty rates are enormously greater than the bank's statistics and are growing.

4. Pérez de Cuéllar, *Our Creative Diversity,* 28.

5. Friedman, *Lexus and the Olive Tree,* 433.

6. Evan Eisenberg, "All the World's a Band," 32.

7. See Huntington, *Clash of Civilizations.*

8. See Barber, *Jihad vs. McWorld.*

9. See Bobbitt, *Shield of Achilles.*

10. Appadurai, *Modernity at Large,* 4.

11. Center for Arts and Culture, *America's Cultural Capital,* 8.

12. Wheatcroft, "Other Side of Globalism," 5.

13. Feigenbaum, "Globalization and Cultural Diplomacy," 8.

14. Ibid., 19.

15. Pérez de Cuéllar, *Our Creative Diversity,* 28.

16. Barber, *Jihad vs. World,* xxii.

17. Finnegan, "Economics of Empire," 45.

18. Adams and Goldbard, *Community, Culture, and Globalization,* 18.

19. Friedman, *Lexus and the Olive Tree,* 474.

20. Armstrong, *Battle for God,* xii.

21. Barber, *Jihad vs. McWorld,* xv.

22. Ted Levin quoted in Evan Eisenberg, "All the World's a Band," 32.

23. Gottlieb, *Creative Economy Initiative,* 8.

24. Venturelli, "From the Information Economy," 12.

25. Florida, *Rise of the Creative Class,* 320.

26. Adams and Goldbard, *Creative Community,* 106.

27. The author participated in one of the Arts International forums and served on the Advisory Committee for the Rockefeller Foundation study.

28. Fitzgibbon, *Study Exploring Opportunities,* ii.

29. DeNatale, *Developing an Effective System,* 48.

30. Mindy Levine, *Leadership Forum,* 2.

31. DeNatale and Ito, *International Collaboration in the Arts,* 38.

32. Adams and Goldbard, *Creative Community,* 86.

33. Oropeza, "Huehuepohualli," 49.

34. Cocke, "End Cultural Isolationism."

35. Healy, "New Book on Culture and Development," 13.

36. Friedman, *Lexus and the Olive Tree,* 444.

37. Feigenbaum (paraphrasing Venturelli), "Globalization and Cultural Diplomacy," 18.

38. Center for Arts and Culture, *America's Cultural Capital,* 8.

39. Clifford, *Predicament of Culture,* 15.

40. Feigenbaum, "Globalization and Cultural Diplomacy," 37.

41. Hannerz, *Cultural Complexity*, 218.

42. Baron and Cara, "Introduction: Creolization and Folklore," 4.

43. Kurin, *Reflections of a Culture Broker*, 271.

44. Bhabha, *Location of Culture*, 2.

45. Kotkin and Tseng, "Happy to Mix It All Up."

46. Kurin, *Reflections of a Culture Broker*, 284.

Chapter 9: Revolution

1. Crossette, "Kofi Annan's Astonishing Facts," sec. 4, p. 16.

2. Martin Luther King Jr., *Words of Martin Luther Ling, Jr.*, 22.

3. Ibid., 19.

4. Wyoming, the least populous state with 493,782 residents has the same representation in the U.S. Senate as California with its thirty-four million citizens, making one Wyoming voter sixty-eight times more powerful than one Californian. In fact, California's two senators are "balanced" by forty-four from the twenty-two smallest states needed to equal California's population. It is hard to conceive of a less *democratic* body than our Senate.

5. If we assume "rich" to mean the top 5 percent of Americans—those whose income is over $142,000 annually—then the math is as follows: 100% of the population x 5% (rich) x 69% (white) x 49% (male) = 1.7% rich white males, a very small group as a percentage of our population, but overwhelmingly dominant in national governance. Of the 107th Congress, 86 percent is male, and 87 percent is white. Determining those that are rich before taking office is difficult owing to the extravagant vagaries and potential loopholes of personal finance disclosure. Based exclusively on minimum reported ranges of assets, 54 percent of U.S. senators are worth more than $500,000, and thirty-seven are millionaires. Would we consider any other nation to be "democratic" if it were continuously ruled by the same 1.7 percent of the population for two hundred years?

6. Menand, *Metaphysical Club*, 64.

7. Ibid., 432.

8. Gandhi, *All Men Are Brothers*, 177.

9. Fuller, *Utopia or Oblivion*, 265.

10. Bobbitt, *Shield of Achilles*, xxi.

11. Pope John Paul II quoted in Barber, *Jihad vs. McWorld*, xxviii.

12. Friedman, *Lexus and the Olive Tree*, 47.

13. Huntington, *Clash of Civilizations*, 187.

14. Giamatti, *Take Time for Paradise*, 28.

15. Seabrook, *Nob®ow*, 71.

16. Tickle, Interview, NPR's *First Person*, September 13, 2003.

17. Fogel, *Fourth Great Awakening*, 18.

18. Ibid., 8.

19. Ibid., 1.

20. Bobbitt, *Shield of Achilles,* xxv.

21. Gladwell, *Tipping Point,* 12.

22. Ibid., 259.

23. Ivey, "American Cultural Bill of Rights," 4.

24. Barber, *Jihad vs. McWorld,* xxiv.

25. Florida, *Rise of the Creative Class,* 316.

26. Ibid., 318.

27. Davis, "Full Faith and Credit," 186. Also see de Soto, *Mystery of Capital.*

28. Florida, *Rise of the Creative Class,* 324.

29. White, "Built to Last," 7.

30. Wali, Severson, and Longoni, *Informal Arts,* 10.

31. Pérez de Cuéllar, *Our Creative Diversity,* 24.

32. Benoit Bourque's work in Maine began through the Center for Cultural Exchange's House Island Project in 1995 and has continued through several different residency and touring initiatives. His apprenticeship program was funded through the Maine Arts Commission.

33. Joshua Jacobson, director of the Zamir Chorale, worked in Portland through a grant from the Wallace–Reader's Digest Funds.

34. Zimmer, "The World at Your Door," 14.

35. Kurin, *Reflections of a Culture Broker,* 280.

36. Langsted, *Double Strategies,* 2.

37. Seamus Egan and Gary Hines were both participants in the Center's House Island Project, 1994–1997. Egan subsequently founded the Celtic group Solas.

38. Bhabha, *Location of Culture,* 1.

39. Ishmael Reed quoted in Wong, "Redefining the Mainstream," 12.

40. Nick Spitzer, in conversation with the author, 1991.

41. Friedman, *Lexus and the Olive Tree,* 435.

42. Seaman, "National Investment in the Arts," 43.

43. Pérez de Cuéllar, *Our Creative Diversity,* 26.

44. U.S. Census Bureau, "Money Income in the United States."

45. See National League of Cities Web site <www.nlc.org>.

46. U.S. General Accounting Office, "GAO Report New Attack Submarine."

47. There is great information at <www.adbusters.org>.

48. The Supreme Court's 1886 *Santa Clara v. Southern Pacific Railroad* decision defined corporations as persons; therefore they were protected by the Fourteenth Amendment from governmental interference. Numerous challenges to this precedent are currently being mounted.

49. Barber, *Jihad vs. McWorld,* xii.

50. The full text of UNESCO's *Declaration on Cultural Diversity* is available online at <http://www.unesco.org/confgen/press_rel/021101_clt_diversity.shtml>.

51. Adams and Goldbard, *Creative Community,* 105.

52. Appadurai, *Modernity at Large,* 22.

53. Childs, *Transcommunality,* 10.

54. Ibid., 11.
55. White, "Built to Last," 7.
56. Sellars, "Commentary."
57. Walker, "Arts and Culture," 4.
58. Pennekamp, "Beyond Art," 2.
59. Ivey, "American Cultural Bill of Rights," 7.
60. Barber, *Aristocracy of Everyone,* 228.

Works Cited

Abrahams, Roger. "Phantoms of Romantic Nationalism in Folkloristics." *Journal of American Folklore* 106, no. 419 (1993): 3–37.

Adams, Don, and Arlene Goldbard, eds. *Community, Culture, and Globalization.* New York: Rockefeller Foundation, 2002.

———. *Creative Community: The Art of Cultural Development.* New York: Rockefeller Foundation, 2001.

Addams, Jane. *Democracy and Social Ethics.* New York: Macmillan, 1913.

Aldrich, Nelson. "That's Rich: It's a Good Thing That Noblesse Can Sometimes Oblige—Because Our Tax Policies Don't." *New York Times Magazine,* April 21, 2002.

Amdur Spitz and Associates, eds. *Learning and the Arts: Crossing Boundaries.* Conference proceedings. Chicago: Amdur Spitz, 2002.

Anderson, Jervis. "The Public Intellectual." *New Yorker,* January 17, 1994.

Appadurai, Arjun. *Modernity at Large: Cultural Dimensions of Globalization.* Minneapolis: University of Minnesota Press, 1997.

Armstrong, Karen. *The Battle for God.* New York: Ballantine Books, 2000.

Barber, Benjamin. *An Aristocracy of Everyone: The Politics of Education and the Future of America.* Oxford: Oxford University Press, 1992.

———. *Jihad vs. McWorld.* New York: Ballantine Books, 1995. Reprinted with a new introduction. New York: Ballantine Books, 2001.

———. "Serving Democracy by Serving the Arts and the Humanities (Traditional Perspectives, Unique Modern Conditions)." In *Creative America.* Washington, D.C.: President's Committee on the Arts and the Humanities, 1997.

Baron, Robert. "Theorizing Public Folklore Practice—Documentation, Genres of Representation, and Everyday Competencies." *Journal of Folklore Research* 36, nos. 2/3 (1999): 185–201.

Baron, Robert, and Ana C. Cara. "Introduction: Creolization and Folklore—Cultural Creativity in Process." *Journal of American Folklore* 116, no. 459 (2003): 4–8.

Baron, Robert, and Nicholas Spitzer, eds. *Public Folklore.* Washington, D.C.: Smithsonian Institution Press, 1992.

Bauman, Richard, and Patricia Sawin. "The Politics of Participation in Folklife Festivals." In Karp and Levine, eds., *Exhibiting Cultures*, 288–314.

Beene, Melanie. "On My Mind." *Grantmakers in the Arts Reader* 11, no. 1 (2000): 5.

Bhabha, Homi K. *The Location of Culture*. New York: Routledge, 1994.

Biddle, Livingston. *Our Government and the Arts: A Perspective from the Inside*. New York: American Council for the Arts, 1988.

Bloom, Allan, *The Closing of the American Mind*. New York: Simon and Schuster, 1987.

Bobbitt, Philip. *The Shield of Achilles: War, Peace, and the Course of History*. New York: Knopf, 2002.

Bond, Sally, Sally Boyd, and Kathleen Rapp. *Taking Stock: A Practical Guide to Evaluating Your Own Programs*. Chapel Hill, N.C.: Horizon Research, Inc., 1997.

Bourdieu, Pierre. *Distinction: A Social Critique of the Judgment of Taste*. Cambridge, Mass.: Harvard University Press, 1984.

Brand, Stewart. *The Clock of the Long Now*. New York: Basic Books, 1999.

Briggs, Charles L. "Metadiscursive Practices and Scholarly Authority in Folkloristics." *Journal of American Folklore* 106, no. 422 (1993): 387–434.

Burton, Judith, Robert Horowitz, and Hal Abeles. "Learning In and Through the Arts: Curriculum Implications." In Fiske, *Champions of Change*, 35–46.

Cahan, Susan, and Zoya Kocur, eds. *Contemporary Art and Multicultural Education*. New York: The New Museum/Routledge, 1996.

Cantwell, Robert. "Feasts of Unnaming: Folk Festivals and the Representation of Folklife." In Baron and Spitzer, *Public Folklore*, 263–306.

———. "Ideology and Magic in the Festival of American Folklife." *Journal of American Folklore* 104, no. 412 (1991): 148–63.

Catterall, James, Richard Chapleau, and John Iwanaga. "Involvement in the Arts and Human Development." In Fiske, *Champions of Change*, 1–18.

Center for Arts and Culture. *America's Cultural Capital: Recommendations for Structuring the Federal Role*. Washington, D.C.: Center for Arts and Culture, 2002. Available online at <www.culturalpolicy.org>.

Center for Cultural Exchange. *Culture as Community: Grassroots Collaborations in Action*. Portland, Maine: Center for Cultural Exchange, 2000.

Childs, John Brown. *Transcommunality: From the Politics of Conversion to the Ethics of Respect*. Philadelphia: Temple University Press, 2003.

Christy, Alexandra, Nick Rabkin, Janet Rodriguez, and Vicki Rosenberg. Introduction. In Amdur Spitz and Associates, *Learning and the Arts*, 1–3.

Cleveland, William. "Bridges, Translations, and Change: The Arts as Infrastructure in 21st Century America." *High Performance* (Fall 1992): 82–89.

Clifford, James. "On Collecting Art and Culture." In *Out There: Marginalization and Contemporary Cultures*, edited by R. Ferguson, M. Gever, T. Minh-ha, and C. West, 141–90. New York: New Museum of Contemporary Art/MIT Press, 1990.

———. *The Predicament of Culture: Twentieth Century Ethnography, Literature, and Art*. Cambridge, Mass.: Harvard University Press, 1988.

Cocke, Dudley. "Appalachia, Democracy, and Cultural Equity." In Vega and Greene, *Voices from the Battlefront*, 31–40 .

———. "End Cultural Isolationism." Community Arts Network, 2001. Available online at <www.communityarts.net>.

———. "Who's in the House Tonight?—Inviting Audiences Not Just to Observe, but to Participate in Creating Theater." In *Building Audiences: Stories from America's Theaters*, edited by Rory MacPherson and Bruce Trachtenberg, 15–21. New York: Lila Wallace–Readers Digest Fund, 1997.

Crew, Rudy. "Reframing Arts in Education." In Amdur Spitz and Associates, *Learning and the Arts*, 27–28.

Crew, Spencer R., and James E. Sims. "Locating Authenticity: Fragments of a Dialogue." In Karp and Levine, *Exhibiting Cultures*, 159–75.

Crossette, Barbara. "Kofi Annan's Astonishing Facts!" *New York Times,* September 27, 1998.

Csikszentmihalyi, Mihaly. *Flow: The Psychology of Optimal Experience.* New York: Harper and Row, 1990.

Davies, Robertson. *Fifth Business.* London: Penguin Books, 1970.

Davis, Dee. "Full Faith and Credit." In Adams and Goldbard, *Community, Culture, and Globalization,* 173–88.

DeNatale, Douglas. *Developing an Effective System for the Commissioning and Touring of International Work: A Report to the Rockefeller Foundation.* Boston: New England Foundation for the Arts, 2001.

DeNatale, Douglas, and Karen Ito. *International Collaboration in the Arts.* New York: Ford Foundation/Arts International, 1999.

D'Souza, Dinesh. *Illiberal Education. The Politics of Race and Sex on Campus.* New York: Free Press, 1991.

Eisenberg, Evan. "All the World's a Band, and Here's How It Sounds." *New York Times,* April 28, 2002.

Eisenberg, Pablo. "A Lack of Guts and Intellectual Vigor Hobbles the Foundation World." *Chronicle of Philanthropy,* February 21, 2002. Available online at <www.communityarts.net/readingroom/archive/33eisenberg.php>.

Eisner, Elliot. "Ten Lessons the Arts Teach." In Amdur Spitz and Associates, *Learning and the Arts*, 7–14.

Evans-Pritchard, Diedre. "Tourism, Ecology, and Cultural Heritage." *American Folklore Society News* 22, no. 2 (April 1993): 6–7.

Ewell, Maryo Gard. "The Arts and Community Strengthening." Script of speech given at conference of the Michigan Association of Community Arts Agencies, November 8, 2000. Available online at <www.communityarts.net/readingroom>.

Feek, Warren. "Annan and a Talking Stick." In *The Drum Beat,* Communications Initiative electronic mailing list, Issue 195, May 5, 2003. Available online at <www.comminit.com/social-change.html>.

Feigenbaum, Harvey. "Globalization and Cultural Diplomacy." Art, Culture, and

the National Agenda Issue Paper. Washington, D.C.: Center for Arts and Culture, 2001. Available online at <www.culturalpolicy.org/pdf/globalization/pdf>.

Feintuch, Burt, ed. *The Conservation of Culture: Folklore and the Public Sector*. Lexington: University Press of Kentucky, 1988.

Figueroa, Maria Elena, D. Lawrence Kincaid, Manju Rani, and Gary Lewis. "CFSC Model for Measuring Process and Outcomes." Communication for Social Change Working Paper Series. New York: Rockefeller Foundation and Johns Hopkins University Center for Communication Programs, 2002.

Financial Times. *World Desk Reference*. New York: Dorling Kindersley, 2003.

Finnegan, William. "The Economics of Empire: Notes on the Washington Consensus." *Harper's Magazine*, May 2003.

Fiske, Edward, ed. *Champions of Change: The Impact of the Arts on Learning*. Washington, D.C.: Arts Education Partnership, 2000.

Fitzgibbon, Cecelia, with Elizabeth Peterson and Robert Wisdom. *A Study Exploring Opportunities to Strengthen U.S.-Based Collaborations with Performing Artists of Africa, Asia, and Latin America*. Boston: New England Foundation for the Arts/Ford Foundation, 1994.

Florida, Richard. *The Rise of the Creative Class*. New York: Basic Books, 2002.

Focke, Anne. *A Snapshot: Foundation Grants to Arts and Culture, 1999*. Seattle: Grantmakers in the Arts, 2000.

Fogel, Robert William. *The Fourth Great Awakening and the Future of Egalitarianism*. Chicago: University of Chicago Press, 2000.

Foundation Center. "Foundations Today Tutorial: Profile of the Funding Community." The Foundation Center, 1995–2002. Available online at <www.fdncenter.org/learn/classroom/ft_tutorial>.

———. "Top 50 Recipients of Foundation Grants for Arts, Culture and Humanities, circa 2000." The Foundation Center, 2002. Available online at <http://fdncenter.org/fc_stats/listing02.html>.

Fox, Everett, translator. *The Five Books of Moses*. New York: Schocken Books, 1995.

Friedman, Thomas. *The Lexus and the Olive Tree*. New York: Anchor Books, 1999.

Fuller, R. Buckminster. *Utopia or Oblivion*. New York: Bantam, 1969.

Gandhi, Mahatma. *All Men Are Brothers*. Compiled and edited by Krishna Kripalani. Ahmedabad: Navajivan Trust, 1960.

Garfias, Robert. "Cultural Diversity and the Arts in America: The View for the '90s." Report to the National Endowment for the Arts. Washington, D.C.: NEA, 1989.

Giamatti, A. Bartlett. *Take Time for Paradise: Americans and Their Games*. New York: Summit Books, 1989.

Gladwell, Malcolm. *The Tipping Point: How Little Things Can Make a Big Difference*. New York: Little, Brown, 2000.

Glassie, Henry. "Tradition." *Journal of American Folklore* 108, no. 340 (1995): 395–413.

Godfrey, Marian. "Optimizing America's Cultural Policies: A New National Initiative, 1998–2000." Philadephia: Pew Charitable Trusts, 1998. Available online at <www.pewtrusts.com>.

Goffman, Erving. *The Presentation of Self in Everyday Life.* New York: Doubleday, 1959.

Gomez-Peña, Guillermo. "The Multicultural Paradigm: An Open Letter to the National Arts Community." *High Performance* 12, no. 3 (1989): 18–27. Reprinted in *Warrior for Gringostroika* by Guillermo Gomez-Peña. St. Paul: Graywolf Press, 1993.

Goodman, Steven. "Media Education: Culture and Community in the Classroom." In Cahan and Kocur, *Contemporary Art and Multicultural Education,* 18–23.

Gottlieb, Jennifer, ed. *The Creative Economy Initiative: The Role of the Arts and Culture in New England's Economic Competitiveness.* Boston: The New England Council, 2000.

Gourevitch, Philip. "The Optimist." *New Yorker,* March 3, 2003.

Graves, James Bau. "Democratizing Culture." Text of Speech to the National Council for the Arts, Washington, D.C., March 2001.

———. "Introduction: Culture and Community." In *Celebrating Community: A Cultural Plan for the City of Portland,* 5. Portland, Maine: City of Portland Planning Office, 1998.

———. "Music of Southern Maine French Canadian Communities." In *American Musical Traditions: Vol. 4, European American Music,* edited by Jeff Todd Titon and Bob Carlin, 25–30. New York: Schirmer Reference/Gale Group, 2002.

———. "Rules of Engagement: Facilitating Community Cultural Programs." *Journal of Applied Folklore* 4, no. 1., (1999): 79–90.

Guralnick, Peter. *Last Train to Memphis: The Rise of Elvis Presley.* Boston: Little, Brown, 1994.

Gurian, Elaine Heumann. "Noodling Around with Exhibition Opportunities." In Karp and Levine, *Exhibiting Cultures,* 176–90.

Hall, Edward T. *Beyond Culture.* New York: Anchor Books, 1976.

Hannerz, Ulf. *Cultural Complexity: Studies in the Social Organization of Meaning.* New York: Columbia University Press, 1992.

Harris, Leo. "From the Collector's Perspective: The Legality of Importing Pre-Colombian Art and Artifacts." In Messenger, *The Ethics of Collecting Cultural Property,* 155–76.

Hawes, Bess Lomax. "Aspects of Federal Folklife." *Practicing Anthropology,* 7, nos. 1, 2 (1985): 7–8.

———. "Folk Arts." In *1982 National Endowment for the Arts Annual Report.* Washington, D.C.: NEA, 1983.

Healy, Kevin. "New Book on Culture and Development." *Talk Story,* no. 19. Washington, D.C.: Smithsonian Institution Center for Folklife and Cultural Heritage, 2001.

Heath, Shirley Brice. "Imaginative Actuality: Learning in the Arts during the Non-school Hours." With Adelma Roach. In Fiske, *Champions of Change,* 19–34.

Hunt, Marjorie, and Peter Seitel. "Cultural Conservation." In *Festival of American Folklife* program booklet, 38–39. Washington, D.C.: Smithsonian Institution/National Park Service, 1985.

Huntington, Samuel P. *The Clash of Civilizations and the Remaking of World Order.* New York: Touchstone, 1996.

Ivey, Bill. "An American Cultural Bill of Rights." Remarks at the National Press Club, Washington, D.C., December 18, 2000.

Jabbour, Alan. "Ethnicity and Identity in America." *Folklife Center News* (newsletter of the American Folklife Center/Library of Congress, Washington, D.C.) 15, no. 2 (1993): 6–10.

Jackson, Maria-Rosario, and Joaquin Herranz. *Culture Counts in Communities: A Framework for Measurement.* Washington, D.C.: Urban Institute, 2002.

Johnston, David Cay. "You Can't Take It with You." Review of *The Myth of Ownership,* by Liam Murphy and Thomas Nagel. *New York Times Book Review,* April 21, 2002.

Karp, Ivan, and Steven Levine, eds. *Exhibiting Cultures: The Poetics and Politics of Museum Display.* Washington, D.C.: Smithsonian Institution Press, 1991.

Kelly, Kevin. "Where Music Will Be Coming From." *New York Times Magazine,* March 17, 2002.

Kerrigan, Sheila. *The Performer's Guide to the Collaborative Process.* Portmouth, N.H.: Heinemann, 2001. Available online at <www.communityarts.net/readingroom/>.

Kimball, Roger. *Tenured Radicals: How Politics Has Corrupted Our Higher Education.* New York: HarperCollins, 1990.

King, Jaime Litvak. "Cultural Property and National Sovereignty." In Messenger, *Ethics of Collecting Cultural Property,* 199–208.

King, Martin Luther, Jr. *The Words of Martin Luther King, Jr.* Selected by Coretta Scott King. New York: Newmarket Press, 1983.

Kirshenblatt-Gimblett, Barbara. "Mistaken Dichotomies." *Journal of American Folklore* 101, no. 140 (1988). Reprinted in Baron and Spitzer, *Public Folklore,* 29–48.

Kotkin, Joel, and Thomas Tseng. "Happy to Mix It All Up: For Young Americans, Old Ethnic Labels No Longer Apply." *Washington Post,* June 8, 2003.

Kroeber, A. L., and Clyde Kluckholm. *Culture: A Critical Review of Concepts and Definitions.* New York: Vintage, 1952. Quoted in "The Concept and Components of Culture." *Britanica Macropaedia.* Vol. 16. London: Britanica Macropaedia, 2002.

Kurin, Richard. "Culture on the 1990's Agenda." In *Festival of American Folklife* program booklet. Washington, D.C.: Smithsonian Institution/National Park Service, 1993.

———. "Folklife in Contemporary Multicultural Society." In *Festival of American*

Folklife program booklet. Washington, D.C.: Smithsonian Institution/National Park Service, 1990.

———. *Reflections of a Culture Broker.* Washington, D.C.: Smithsonian Institution Press, 1997.

Langsted, Jørn. *Double Strategies in a Modern Cultural Policy.* Cos Cob, Conn.: Management Consultants for the Arts, 1990.

Leitão, Julio. "5th and 6th Grade Program for Public Schools." Unpublished paper courtesy of the author, 1999.

Levine, Lawrence. *The Opening of the American Mind: Canons, Culture, and History.* Boston: Beacon Press, 1996.

Levine, Mindy, preparator. *Leadership Forum on Presenting International Work.* Proceedings of meeting. Lee, Mass.: Jacob's Pillow Dance Festival, August 1998.

Lippard, Lucy. *Mixed Blessings: New Art in a Multicultural America.* New York: Pantheon, 1990.

Lomax, Alan. "Appeal for Cultural Equity." *Journal of Communication* 27, no. 2 (1977): 125–38.

———. "Saga of a Folksong Hunter." *Hi Fi/Stereo Review,* May 1960. Reprinted in "The Alan Lomax Collection Sampler." Cambridge, Mass.: Rounder Records, 1997.

Losito, Cristina. "Culture and Development: A New Paradigm." Center for Creative Communities, 2000. Available online at <www.communityarts.net/readingroom>.

MacCannell, Dean. *The Tourist: A New Theory of the Leisure Class.* New York: Schocken Books, 1976.

Madeja, Stanley. "The Arts as Commodity." *Culture Work* 2, no. 3 (June 1998). Institute for Community Arts Studies, University of Oregon. Available online at <http://aad.uoregon.edu/culturework/culturework6.html>.

Mason, Keith. "Ishmael Reed Talks about Multiculturalism, the Media, and Fighting Back." *High Performance* 12, no. 3 (1989): 34–35.

McAllester, David. *Enemy Way Music.* Cambridge, Mass.: Peabody Museum, Harvard University, 1954.

McCarthy, Kevin, and Kimberly Jinnett. *A New Framework for Building Participation in the Arts.* Santa Monica, Calif.: Rand Corporation, 2001.

McDaniel, Nello, and George Thorn. *Learning Audiences: Adult Arts Participation and the Learning Consciousness.* Washington, D.C.: Kennedy Center for the Performing Arts/Association of Performing Arts Presenters, 1997.

McPhee, Penelope. "Beyond Art: A Community Perspective." Transcript of remarks at the Grantmakers in the Arts annual conference, November 2001. Available online at <www.giarts.org>.

Menand, Louis. *The Metaphysical Club: A Story of Ideas in America.* New York: Farrar Strauss Giroux, 2001.

Mesa-Bains, Amalia. "Teaching Students the Way They Learn." In Cahan and Kocur, *Contemporary Art and Multicultural Education,* 31–38.

Messenger, Phyllis, ed. *The Ethics of Collecting Cultural Property: Whose Culture? Whose Property?* Albuquerque: University of New Mexico Press, 1998.

National Arts Information Clearinghouse. Washington, D.C.: Americans for the Arts, 2002. Available online at <www.artsusa.org>.

National Endowment for the Arts. *Annual Report.* Washington, D.C.: NEA, 2000. Available online at <www.arts.endow.gov>.

———. *Fact Sheet: Cultural Tourism.* Washington, D.C.: NEA, 2000. Available online at <www.arts.endow.gov/about/facts/cultourism.html>.

———. *Folk Arts Grant Application Guidelines.* Washington, D.C.: NEA, 1991.

———. *Grants to Organizations: Application Guidelines FY 2003.* Washington, D.C.: NEA, 2002.

———. *NEA Research Division Note #74: International Data on Government Spending on the Arts.* Washington, D.C.: NEA, 2000. Available online at <www.arts.endow.gov>.

Oropeza, Martha Ramirez. "Huehuepohualli: Counting the Ancestors' Heartbeats." In Adams and Goldbard, *Community, Culture, and Globalization,* 31–50.

Pareles, Jon. "A Life Giving Voice to the Voiceless." *New York Times,* March 7, 1989.

PBS Online Forum. "The Art of Corporate Sponsorship." 1998. Available online at <www.pbs.org/newshour/forum/february98/sponsorship>.

Pennekamp, Peter. "Beyond Art: A Community Perspective." Remarks at the Grantmakers in the Arts annual conference, November 2001. Available online at <www.giarts.org>.

———. "Ghosts." In Vega and Greene, *Voices from the Battlefront,* 159–64.

Pérez de Cuéllar, Javier. *Our Creative Diversity: Report of the World Commission on Culture and Development.* Paris: UNESCO Publishing, 1995.

Piazza, Tom. "Lincoln Center and Its Critics Swing Away." *New York Times,* January 16, 1994.

Porter, Michael, and Mark Kramer. "The Competitive Advantage of Corporate Philanthropy." *Harvard Business Review* 80, no. 12 (December 2002): 56–69. Article purchased from *Harvard Business Review Onpoint,* product number 242x, n.p.

———. "Philanthropy's New Agenda: Creating Value." *Harvard Business Review* 77, no. 6 (1999): 57–68.

PricewaterhouseCoopers. "Global Entertainment and Media Industry Will Reach $1.4 Trillion in 2007 Despite Weak Economy, Defense Spending Increases." 2003. Available online at <www.pwcglobal.com/extweb/ncpressrelease.nsf/DocID/D34E8B94A65A EF0C85256D42006B3F2D>.

Putnam, Robert. *Bowling Alone: The Collapse and Revival of American Community.* New York: Simon and Schuster, 2000.

Reagon, Bernice Johnson. "Battle Stancing: To Do Cultural Work in America." In Vega and Greene, *Voices from the Battlefront,* 69–82.

Renz, Loren. "Arts Funding Update." New York: The Foundation Center, 2002.

Robinson, Ken. "Arts Education's Place in a Knowledge-Based Global Economy." In Amdur Spitz and Associates, *Learning and the Arts,* 4–6.

————. "Arts Learning Experiences." In Amdur Spitz and Associates, *Learning and the Arts*, 18–23.

————. "Closing Remarks." In Amdur Spitz and Associates, *Learning and the Arts*, 32–33.

Said, Edward. *Orientalism*. New York: Pantheon, 1978.

Salaam, Kalamu ya. "African American Cultural Empowerment: A Struggle to Identify and Institutionalize Ourselves as a People." In Vega and Greene, *Voices from the Battlefront*, 119–34.

Sanford, Adelaide. "Affirming Diversity and Humanizing Education." In Cahan and Kocur, *Contemporary Art and Multicultural Education*, 5–17.

Santino, Jack. "The Tendency to Ritualize: The Living Celebrations Series as a Model for Cultural Presentation and Validation." In Feintuch, *Conservation of Culture*, 118–31.

Savoy, Ann Allen. *Cajun Music: A Reflection of a People*. Vol. 1. Eunice, La.: Bluebird Press, 1984.

Schechner, Richard. "Magnitudes of Performance." In Schechner and Appel, *By Means of Performance*, 19–49.

Schechner, Richard, and Willa Appel, eds. *By Means of Performance: Intercultural Studies of Theater and Ritual*. New York: Cambridge University Press, 1990.

Schechtman, Robert. "Introduction: Victor Turner's Last Performance." In *The Anthropology of Performance* by Victor Turner, 7–20. Baltimore: PAJ Publications, 1986.

Seabrook, John. *Nob®ow: The Culture of Marketing—The Marketing of Culture*. New York: Knopf, 2000.

Seaman, Bruce. "National Investment in the Arts." Washington, D.C.: Center for Arts and Culture, 2002. Available online at <www.culturalpolicy.org>.

Seeger, Anthony. *Folk Heritage Collections in Crisis*. Washington, D.C.: Council on Library and Information Resources, 2001.

Seeger, Charles. *Studies in Musicology, 1935–1975*. Berkeley: University of California Press, 1977.

Seeger, Pete. *The Incomplete Folksinger*. New York: Simon and Schuster, 1972.

Sellars, Peter. "Commentary: Pitch to Artists." PRI's *Marketplace*, June 9, 2003.

Sen, Amartya. "A Matter of Choice." *Little India*, February 1997.

Sheehy, Daniel. "A Few Notions about Philosophy and Strategy in Applied Ethnomusicology." *Ethnomusicology* 36, no. 3 (1992): 323–36.

Soto, Hernando de. *The Mystery of Capital: Why Capitalism Triumphs in the West and Fails Everywhere Else*. New York: Basic Books, 2000.

Sowell, Thomas. *Ethnic America: A History*. New York: Basic Books, 1981.

Spitzer, Nicholas R. "Monde Créole: The Cultural World of French Louisiana Creoles and the Creolization of World Cultures." *Journal of American Folklore* 116, no. 459 (2003): 57–72.

Staub, Shalom. "Folklore and Authenticity." In Feintuch, *Conservation of Culture*, 166–79.

Stehle, Vince. "The Competitive Disadvantage of Foundation Giving." *Grantmakers in the Arts Reader* 11, no. 1 (2000): 18–20.

Stocking, George W. *Victorian Anthropology.* New York: Free Press, 1987.

Strom, Stephanie. "Foundations Roiled by Measure to Spur Increase in Charity." *New York Times,* May 19, 2003.

Tickle, Phyllis. Interview on NPR's *First Person,* September 13, 2002.

Titon, Jeff Todd. *Powerhouse for God: Speech, Chant, and Song in an Appalachian Baptist Church.* Austin: University of Texas Press, 1988.

Toelken, Barre. *The Dynamics of Folklore.* Boston: Houghton Mifflin, 1979. Revised and expanded edition. Logan: Utah State University Press, 1996.

———. "Fieldwork Enlightenment." *Parabola* 20, no. 2 (Summer 1995): 28–35.

———. "The Heritage Arts Imperative." *Journal of American Folklore* 116, no. 460 (2003): 196–205.

Trompenaars, Fons. *Riding the Waves of Culture: Understanding Diversity in Global Business.* London: Economist Books, 1993.

Turnbull, Colin. "Liminality: A Synthesis of Subjective and Objective Experience." In Schechner and Appel, *By Means of Performance,* 50–81.

Turner, Victor. *The Anthropology of Performance.* Baltimore: PAJ Publications, 1986.

United Nations Economic, Social, and Cultural Organization. *Culture, Trade, and Globalization.* Paris: UNESCO, 2003. Available online at <www.unesco.org/culture/industries/trade/html>.

———. *Universal Declaration on Cultural Diversity.* Paris: UNESCO, 2001. Available online at <www.unesco.org/confgen/press_rel/021101_clt_diversity.shtml>.

United States Census Bureau. "Difference in Population by Race and Hispanic or Latino Origin, for the United States: 1990 to 2000, PHC-T-1 Table 4." Washington, D.C.: USCB, 2001.

———. "Money Income in the United States." Washington, D.C.: USCB, September 2002. Available online at <www.census.gov>.

United States Government Accounting Office. "GAO Report New Attack Submarine: Program Status." Letter Report, 12/03/96, GAO/NSIAD-97–25. Washington, D.C.: GAO, 1996. Available online at <www.gao.gov/archive/1997/ns97025.pdf>.

Vega, M., and C. Greene, eds. *Voices from the Battlefront: Achieving Cultural Equity.* Trenton, N.J.: Africa World Press, 1993.

Venturelli, Shalini. "From the Information Economy to the Creative Economy: Moving Culture to the Center of International Public Policy." Washington, D.C.: Center for Arts and Culture, 2001. Available online at <www.culturalpolicy.org>.

Vogel, Susan. "Always True to the Object, in Our Fashion." In Karp and Levine, eds., 1991.

Vulliamy, Graham. "Music and the Mass Culture Debate." In *Whose Music? A Sociology of Musical Languages,* edited by John Shepherd, Paul Virden, Graham Vulliamy, and Trevor Wishart, 179–200. Somerset, N.J.: Transaction Books, 1977.

Wald, Elijah. *Arhoolie Records 40th Anniversary Collection 1960–2000: The Journey of Chris Strachwitz.* Compact disc box set notes. El Cerrito, Calif.: Arhoolie Productions, 2000.

Wali, Alaka, Rebecca Severson, and Mario Longoni. *Informal Arts: Finding Cohesion, Capacity, and Other Cultural Benefits in Unexpected Places.* Chicago: Center for Arts Policy at Columbia College, 2002.

Walker, Chris, Maria Jackson, and Carole Rosenstein. *Culture and Commerce: Traditional Arts in Economic Development.* Washington, D.C.: Urban Institute; Santa Fe, N.M.: Fund for Folk Culture, 2003.

Walker, Christopher. "Arts and Culture: Community Connections—Contributions from New Survey Research." Urban Institute, 2002. Available online at <www.urban.org>.

Walker, Tim. "What Has Changed?" Teaching Tolerance, 2002. Available online at <www.tolerance.org>.

Wallis, Roger, and Krister Malm. *Big Sounds from Small Peoples: The Music Industry in Small Countries.* London: Constable, 1984.

Weavers, The, eds. *The Weavers' Songbook.* New York: Harper and Row, 1960.

Wheatcroft, Geoffrey. "The Other Side of Globalism." *New York Times Book Review,* September 5, 2002.

Whisnant, David. *All That Is Native and Fine.* Chapel Hill: University of North Carolina Press, 1983.

———. "Public Sector Folklore as Intervention." In Feintuch, *Conservation of Culture,* 233–47.

White, David. "Built to Last: Linking Communities of Grantees." Remarks at Grantmakers in the Arts annual conference, November 2001. Available online at <www.giarts.org>.

Wilson, Joe, and Lee Udall. *Folk Festivals: A Handbook for Organization and Management.* Knoxville: University of Tennessee Press, 1982.

Wolcott, James. "Cos Célèbre." *New Yorker,* July 12, 1993.

Wong, Shawn. "Redefining the Mainstream." *Art View* 10, no. 3 (1991): 11–12.

Wright, Robert. *Non Zero: The Logic of Human Destiny.* New York: Pantheon, 2000.

Zimmer, Elizabeth. "The World at Your Door." *Inside Arts* (Washington, D.C.: Association of Performing Arts Presenters) 5, no. 1 (Spring 1993): 14–19.

Index

James Bau Graves is a cultural animateur whose work concerns the development of communities through cultural planning and production. He is the cofounder and director of the Center for Cultural Exchange in Portland, Maine. As a public ethnomusicologist, he has conducted extensive field research among many of the ethnic communities of New England and has been among the most active presenters of international and ethnic traditional performance in the Northeast. He is a musician and composer and has collaborated with choreographer/director Ann Carlson, jazz ukulele virtuoso Joel Eckhaus, and numerous folk and ethnic bands. He has appeared on or produced numerous vinyl albums and compact discs, most recently as a member of the Bardezbanian Middle Eastern Ensemble. He lives in North Yarmouth, Maine, with his wife and professional partner, Phyllis O'Neill, and their two children.

The University of Illinois Press
is a founding member of the
Association of American University Presses.

Composed in 9.3/13 ITC Stone Informal
with Twentieth Century MT Medium display
at the University of Illinois Press
Designed by Dennis Roberts
Manufactured by Sheridan Books, Inc.

University of Illinois Press
1325 South Oak Street
Champaign, IL 61820-6903
www.press.uillinois.edu